THE BANHAM LECTURES

THE
BANHAM
ESSAYS ON

LECTURES
DESIGNING THE FUTURE

edited by
jeremy aynsley and harriet atkinson

with a foreword by mary banham

oxford + new york

English edition
First published in 2009 by
Berg
Editorial offices:
First Floor, Angel Court, 81 St Clements Street, Oxford OX4 1AW, UK
175 Fifth Avenue, New York, NY 10010, USA

Berg is the imprint of Oxford International Publishers Ltd.

Library of Congress Cataloging-in-Publication Data

A catalogue record for this book is available from the Library of Congress.

British Library Cataloguing-in-Publication Data

A catalogue record for this book is available from the British Library.

ISBN 978 1 84788 302 5 (Cloth)

Typeset by JS Typesetting Ltd, Porthcawl, Mid Glamorgan
Printed in Great Britain by the MPG Books Group, Bodmin and King's Lynn

www.bergpublishers.com

CONTENTS

ACKNOWLEDGEMENTS

The editors would particularly like to thank Mary Banham for her generous support and enthusiasm for this publication. In addition, we would like to thank all the staff and students on the RCA/V&A History of Design course who have organized and attended the Banham Memorial Lectures over the last twenty years, and the Design History Society for its invaluable support of the series. Many thanks also go to Spike Sweeting, Catherine Gregg, Miranda Zahedieh, Kimberley Chandler and Olivia Jackson for all their work on the book's text and pictures; to staff at The British Library Sound Archive and Simon Taylor at RCA for their generous support in reproducing recorded Banham Lectures material; to Dr Frederic J. Schwartz at University College London and Dr Lynne Walker at the Institute of Historical Research for acting as referees for funding applications. Special thanks go to Wilhelmina Bunn and Elizabeth Bisley for their assistance in the final stages of editing. The editors also acknowledge generous financial support towards this publication from the Banham family; the Research Committee of the Royal College of Art; the Committee of the Design History Society and the British Academy. Many thanks go also to our editor Tristan Palmer, to Emily Metcalf and the staff at Berg Publishers. Finally, our thanks go to Oxford University Press for giving us permission to reprint material that has previously appeared in the *Journal of Design History*.

FOREWORD
mary banham

From quite an early age my husband, Reyner Banham, had taken a keen interest in art, architecture and design, particularly industrial design. On leaving school in the summer of 1939, he embarked on a career in aero-engineering at the Bristol Aeroplane Company in Filton. The Second World War broke out almost immediately, putting an end to the planned course of study and resulting in his being reserved for service at Filton throughout the war, where he and his colleagues were needed to keep fighting planes repaired and airworthy.

After the war, he studied art history at the Courtauld Institute, followed by a Ph.D. where his director of studies was Nikolaus Pevsner. At the same time, he started work at the *Architectural Review*, then a journal of standing, where his interest in architecture developed apace.

The history of both art and architecture was long established but it was not until considerably later that design history became a serious study, mostly in the polytechnics in industrial cities, where much of the subject studied was still manufactured. Banham's enthusiasm was sparked immediately and he spoke at most of the early conferences organized in those same cities. He wrote regular articles for journals on industrial design and taught courses in many colleges and university departments in England and overseas. After leaving London in 1976 to teach in the USA, he continued writing for English and European magazines and gradually became a sort of European correspondent in the States.

At his death, Reyner Banham had retired from the University of California, and was about to take up a professorship at the Institute of Fine Arts, New York University. Under normal circumstances, his current campus would most probably have offered a Festschrift. As this could not happen, the present volume of Reyner Banham Memorial Lectures can be seen as an appropriate replacement.

The speakers for the series have been chosen for their work in design history, as well as some artists and architects who were well known to, and worked with, Banham himself. Over the twenty years, distinguished scholars and practitioners from many countries have taken part, and most have responded generously with material for this book. Banham himself was delighted about the speed with which the study of design history grew. The list of speakers makes it clear how international that interest has become. Interest in Banham's work has proved enduring, as I am aware from the ongoing number of students and writers who ask me for interviews.

Banham held very strong views on the way industrial design and architectural theory developed in the last years of his life. His regular articles, broadcasts and television appearances made these views abundantly clear. Some of the articles were selected for the book *A Critic Writes: Essays by Reyner Banham*, a volume produced for the specific purpose of introducing a new generation to what he regarded as the more ephemeral side of his work.[1] For that reason there is much that is humorous, spontaneous and frequently surprising in this anthology of lectures, given by colleagues who have become dear friends.

NOTE

1. Mary Banham et al. (eds.) *A Critic Writes: Essays by Reyner Banham* (Berkeley: University of California Press, 1996).

INTRODUCTION
jeremy aynsley and harriet atkinson

As the most influential writer on design and architecture in Britain in the second half of the twentieth century, Reyner Banham is not easily categorized. His life and career spanned the years of Brutalism and Pop Art, the Anti-Design Movement, ecological critique, and the early stages of postmodernism, all of which he held firm views about. Commentators have pointed out that the work of Reyner Banham is so diverse that it is unlikely that many readers will have covered his entire oeuvre.[1] Originally trained as an engineer, then as an art and architectural historian, Banham's interests encompassed architecture, urban design and planning, industrial design, popular culture and Americana, as well as the iconography of objects of everyday life. His writings could cover anything from megastructures and architectural visions of the future to the humble ice-cream van.

As Mary Banham explains in her Foreword, in usual circumstances a Festschrift would have been arranged by Reyner Banham's university on his death. However, because he happened to be between jobs in California and New York, Mary brought the idea of a commemorative event to London.[2] The Reyner Banham Memorial lectures, from which this volume of essays is drawn, reached their twentieth year in spring 2008. The lecture series, begun shortly after Peter Reyner Banham's untimely death in 1988, has provided the opportunity for reflection on his continuing legacy, while adding new insights into the interpretation of those fields in ways that might be seen as still in the

'Banham tradition'. This might be described as a form of the interpretation of modern architecture and design, with a keen interest in the iconography of popular design and an emphasis on the lasting impact of technology on the imagination of architects and designers. Organized by the joint postgraduate programme in History of Design run by the Royal College of Art and the Victoria and Albert Museum in London, together with the Design History Society (UK), the event has been held in the museum's impressive lecture theatre, a space well known to Reyner Banham himself, and quickly became a vital date in the calendar of those interested in new thinking in the fields of architecture, design and visual culture. It is entirely appropriate that the name and work of Reyner Banham should be extended to future generations in the fields of art, architectural and design history – students are always an important presence in the audience – and especially for the lectures to be hosted by those engaged with design history, a discipline for which Banham could be claimed a founding figure.

The perception of Reyner Banham's breadth of influence in many fields has guided the selection of speakers over the years. They have come from distinct yet related spheres, among them distinguished architects and architectural historians, industrial designers and design theorists, design historians and historians of technology. As a journalist, Banham frequently turned his attention to the unexpected and, on occasion, the previously unimaginable. A brief selection from the titles of his articles, which total over 1,000, reveals his willingness to bridge high and low, to be irreverent, and open new territories for future generations of enquiry. They encompass 'Coffin-Nails in Handypacks' (*New Statesman*, 1962), 'Who is this "Pop"?' (*Motif*, 1963), 'Notes Towards a Definition of US Automobile Painting as a Significant Branch of Mobile Modern Heraldry' (*Art in America*, 1966), 'First Bus to Psychedelia' (*New Society*, 1968), 'Troglodyte Metropolis' (*New Society*, 1974), 'Buffalo Industrial' (*Little Journal*, 1979) and the posthumous 'A Black Box: The Secret Profession of Architecture' (*New Statesman and Society*, 1990).[3]

In addition to this quick-witted journalism, as several contributors to this volume develop in more detail, one overriding intellectual concern for Banham was a sustained engagement with the legacies and continuing relevance of modernism in architecture and design. This was something that preoccupied him throughout his career. Even when writing about subjects that were apparently far removed from the traditional territory of modernist architectural discourse, the point seemed to be to continue a dialogue or critique of its orthodoxy. It was first addressed in Banham's doctoral thesis at the Courtauld Institute, supervised by Nikolaus Pevsner, which was to be published as *Theory and Design in the First Machine Age* (1960). The argument of this foundational text is analysed in detail by Gillian Naylor in this collection, and further commented on by several other contributors.[4]

This volume extends the range of previous anthologies of Banham's own writings such as *Design by Choice* (1981), a selection of Banham's writings made by Penny Sparke, herself a founding figure of British design history and student of Reyner Banham, and *A Critic Writes: Essays by Reyner Banham*, edited by Mary Banham, Paul Barker, Sutherland Lyall and Cedric Price. It makes space for a consideration of the Banham tradition and, importantly, its extension into new territories. It has become customary, although by no means obligatory, for speakers to open lectures with comments on their relationship with Peter Reyner Banham, whether based on personal acquaintance or through his writings. No single description can encompass the complete achievements of Reyner Banham, but when considered alongside each other, among the most compelling are the descriptors 'historian of the immediate future', 'engineer art critic', champion of *une architecture autre* and 'one partially Americanized European'.[5] We have used Reyner Banham's own words as a

frame for organizing the Banham Lectures – many now reworked as essays – into the four parts of this book.

PART I: IN THE REAR-VIEW MIRROR: BANHAM REVISITED

The five essays in the first section of the book explore the tools and methods of Banham's scholarship and offer reflections on the lecture, the relationship between writing about design and architecture, the essay, and the challenges introduced by architectural photography and visual thinking about buildings. Architectural historian Tim Benton opens with an assessment of Reyner Banham as teacher and lecturer. Benton took his reference from Banham's *The Architecture of the Well-Tempered Environment* (1969), an exploration of the mechanical services that provide life support in the built environment. By contrast, Benton's lecture, 'The Art of the Well-Tempered Lecture: Banham and Le Corbusier' (2008) applies the conceit to explore the structure of argument in the art history lecture, reflecting on the author's experience of Banham as a lecturer and a structure of argument made possible through the sequence and play of images, or 'sequence of visual statements, exclamations, discoveries and contradictions'. He then addresses his main subject, the visually illustrated lectures given by Le Corbusier in Paris, Geneva and Lausanne in 1924–25, which the architect called 'his films'. These prompted a substantial critique from Le Corbusier's contemporary, Léandre Vaillant, and it is this exchange and the underlying principles of image juxtaposition used to form visual arguments that become the focus of Benton's analysis.

By contrast, architectural historian Adrian Forty places Banham in the context of other critics and theoreticians who have used design metaphors to analyse architecture. In the lecture 'Of Cars, Clothes and Carpets: Design Metaphors in Architectural Thought' (1989), Forty looks at the ways in which architects and architectural theorists and critics have, since the nineteenth century, used the production of artefacts, both hand-made and industrially manufactured, to construct theories. Drawing on examples from, among others, artist and writer John Ruskin, nineteenth-century German architect Gottfried Semper and architect and theorist Adolf Loos, Forty situates Reyner Banham's writings within this tradition before going on to stress that for Banham, comparisons between architecture and design could not always be meaningfully sustained.

Design historian Gillian Naylor continues the theme of Banham as a pioneer in the study of design history and theory. In 'Theory and Design: The Banham Factor' (1997) she focuses on the contribution made by Banham in his first book, in broadening the interpretation of modern design and architecture, in particular, by the 'rediscovery' of Futurism. Naylor describes Banham as a modernist who was preoccupied with modernism's 'other', what Baudelaire described as 'the transient, the fleeting and the contingent in modern life', as opposed to the 'eternal and the immutable'. Naylor, like several other contributors to this book, stresses the importance of Banham's revision of Pevsner's own position. By campaigning for an avant-garde that celebrated state-of-the-art technology, and by accepting and dissecting the role of consumption, Banham democratizes design for the design historian, divorcing object analysis from what he describes as 'fine art criticism'.

Photographic curator and historian Mark Haworth-Booth, in 'Reyner Banham and Photography' (2006), discusses Banham's ground-breaking writing on the history of photography, as well as the use of photographs within his writings. This essay considers Reyner Banham's involvement with

photography from various points of view. Banham wrote about the medium in an important early essay, 'Photography', which appeared in the *Architectural Review* in 1953; he took photographs, from early in his career, for his articles and books, perhaps most evocatively in *Scenes in America Deserta* of 1982, and he also made use of the photographs of others in his publications. In addition, Banham's writings influenced photographers and he was in turn represented by them in their work.

The final essay in this first section evokes something of Banham's light-hearted approach to looking at the world around him through a visual essay that draws on an imaginary conversation with Banham. Architect Peter Cook's lecture, 'Peter Would Enjoy These: Looking at the Edges of the Architectural Vocabulary Plus a Description of the Kunsthaus Graz' (2007), takes the form of a résumé of contemporary architecture and fringe cultural phenomena that would have amused Reyner Banham. It develops the subject of 'high' and 'low' architecture and the various funny things that can be looked at as giving clues about the environment and 'culture': non-buildings, odd juxtapositions, kiosks, and what the author calls 'daft ideas and projects'. Cook is inspired by the way that Banham made us look beyond our narrow culture, considering that without such spirited and inspired digs in the ribs, we very quickly go back to pompousness in architectural thinking.

PART II: FROM VEHICLES OF DESIRE TO SUNDAE PAINTERS: SEEING THINGS THE BANHAM WAY

The five essays in the following section are written by those who have been inspired, by Banham's work, to interpret design through iconography and style in ways that Banham himself pioneered. Historian of the domestic interior, Elizabeth Collins Cromley, in 'Sleeping Around: A History of American Beds and Bedrooms' (1990), tests Banham's claim that we should take common design seriously by looking at some aspects of the most familiar household space, the bedroom and its contents. The subject, part of a larger project on the history of American domestic space, was chosen because beds present themselves as the most obvious and apparently the most transparent of any household object, yet the meaning of the bedroom seemed the most taken for granted of all rooms in the house. The bedroom also provides an opportunity to break down some of the established boundaries between design history and architectural history, since architectural space, the activities in that space, and the designed objects that enable those activities, all enact their meanings in concert.

Industrial designer Frank Dudas, inspired by Banham's own writings on the subject, turns his attention to Detroit car styling, an area which at the time of its origin was derided by those whose interests were in 'good design'. In '"Flash Gordon" and American Auto Design in the 1950s' (1991), Dudas shows how the look of the 'Flash Gordon' weekly comic strip, created by Alex Raymond, influenced adolescent designers of the future in the 1930s. Dudas suggests that the cars that Americans produced between 1952 and 1958 revealed the inspiration from Raymond's drawings, just as he, in turn, had been influenced by these contemporary design movements. For the lecture, Dudas photographed 1950s cars in a wrecking yard, complete with weeds and trees growing through their bodywork. Seeing it as the right thing to do with industrial artefacts that were so temporal, his talk compares them to the fantastical and futuristic details found in the Flash Gordon comic strip.

Jeffrey L. Meikle, Professor of Art History and American Studies, gave the lecture 'A Paper Atlantis: Postcards, Mass Art and the American Scene' (2000). The subsequent essay explores a topic

that recalls Reyner Banham's celebration of American popular culture and his enthusiastic travels through the US, in particular though its reference to *A Concrete Atlantis: US Industrial Building and European Modern Architecture* (1986), his study of American grain silos and their impact on the imagination of European modernist architects. Meikle's focus extends the idea that built form can be transformed through its dissemination in (photo)graphic form. From 1931 into the early 1950s, the US market for inexpensive postcards was dominated by the so-called 'linen' postcard, which was developed, designed, printed and marketed by Curt Teich & Co. of Chicago. To a historian, the encyclopaedic geographic iconography of Teich's linen cards, and of those printed by competitors, suggests popular middle-class attitudes about nature, wilderness, technology, mobility and the city during a self-conscious 'machine age'. For a collector, on the other hand, these cards, which are certainly authentic survivors of their time, evoke postmodern nostalgia for a lost world portrayed through the inaccurate representations of pasteboard images.

Since its formal development as a university subject, design history has seen a fruitful exchange between feminist theory and history, and its own attention to the gendered dynamics of design is the subject of several of the essays in this volume. In this section, Penny Sparke and Pat Kirkham both show how a gendered perspective can contribute to a broadening of the Banham view: respectively on architectural taste and modernism, and the husband and wife collaboration of Elaine and Saul Bass.

Questions posed by architectural and design historians have expanded since Banham's most intense engagement with design in the 1960s and 1970s, a time when emphasis was still placed on what might be called a masculine discourse of design as production. This change in intellectual focus was considered by Penny Sparke in the lecture 'From Production to Consumption in Twentieth-Century Design' (1994), which argued for the importance of injecting a debate about 'feminine' taste into discussions relating to architectural modernism and the need to expand that discussion to include ideas emanating from within domesticity and the feminine sphere. Sparke suggests that while Banham set the agenda for much of this questioning, it was the responsibility of writers, and especially women who had lived through the subsequent critique of the machine-age myth, to take up this mantle.

Design historian Pat Kirkham, in 'Saul Bass: A Life in Design and Film; Saul and Elaine Bass: A Collaboration in Film and Life' (2004), offers a reflection on the husband and wife design team, an extension of her earlier work on the office of Charles and Ray Eames. Kirkham's essay starts by paying homage to Banham, his connections with Saul Bass, his ability to bring history alive and to validate the popular. Kirkham then considers the wide scope of the collaboration between designers Saul and Elaine Bass, from graphic design to film title sequences, short films and one feature film, the titles and short films undertaken, from 1960. The main body of the essay considers similarities and differences between the Bass film work and the graphic design, areas that marked their own particularly creative take on modernity.

PART III: *UNE ARCHITECTURE AUTRE?* LOOKING AT THE OVERLOOKED

Reyner Banham contributed to architectural writing, criticism and history in a number of key ways: he dealt with the interior and exterior of buildings alike; he embraced the ugly, the ephemeral as well as the remarkable, and he was always ready to challenge the canon. Contributors to this section

continue this tradition, turning their attention to those parts of buildings and cities traditionally overlooked by architects and architectural historians, for which Banham invoked the term 'une architecture autre'. This phrase has been explained by Anthony Vidler as 'a call for an architecture that technologically overcomes all previous architecture, to possess an expressive form'.[6]

In the early 1990s, architectural historian Charles Saumarez Smith, director of the National Portrait Gallery in London at the time, was responsible for selecting an architectural practice to reconsider the overall organization of space and to provide a master plan for the gallery's future development. The lecture 'Architecture and the Museum: A Relationship Between Form and Function' (1995) addressed the absence of a readily accessible secondary literature examining the changing form of museums in the post-war period and how decisions had been made about the relationship between their form and their function. Saumarez Smith discussed the changing public role and responsibilities for museums and galleries since the Second World War and also the changing status of architecture as an art form. He proposed four tendencies as models for the interpretation of museum design in recent decades and analysed their aesthetic vocabularies.

In 'Non-Plan Revisited: Or the Real Way Cities Grow' (1998), writer and broadcaster Paul Barker takes the opportunity of the Banham lecture to reflect on the legacy of an architectural debate originated in the pages of New Society, the weekly British magazine of social enquiry. In 1967, 'Non-Plan: An Experiment in Freedom' was published as a special issue of New Society, a collaboration between the urban geographer Peter Hall, Reyner Banham, the architect Cedric Price, and Paul Barker, the magazine's editor. It attacked the perverse and often futile effect of attempts to impose criteria of urban form and aesthetic design from above. Instead, its own approach to popular choice was akin to social anthropology. The essay examines how the concept arose and spells out some of its implications, both ideological and practical, taking two recent case studies of North London inter-war suburbia and of a shopping mall and its surroundings.

The visionary architect Cedric Price (1934–2003), in 'Time: Architecture's Touchstone' (2001), addressed his belief that time, which he described as 'the fourth dimension', should be central to designers' perceptions of the world and their plans for building for the future. However, he bemoaned the fact that it is too often disregarded by architects who believe that their work should exist indefinitely, despite a building's changing use and potential context. Drawing on a remarkable visual range, Price's lecture set out to bridge the intellectual gap between scientists and philosophers currently developing theories of time and contemporary architectural thinking, which often denied time as a relevant element.

The last essay in this section derives from the lecture given by architectural historian Beatriz Colomina, 'Enclosed by Images: Architecture in the Post-Sputnik Age' (2002). Colomina begins with a discussion of Banham's influence on her work as an architectural historian, and how his method as a lecturer and use of images within his discussions had been a source of inspiration for her own work. The essay then discusses husband and wife design team, Charles and Ray Eames's multi-screen presentations at three international exhibitions of the 1950s and 1960s. She explores the designers' investigation into our understanding of the space of exhibitions. Pioneering the presentation of information on multiple screens in very quick time, Colomina argues that the Eameses conceived of built form as a multi-channel information machine and, equally, of multimedia installations as a new kind of architecture.

PART IV: APPARATUS, CLIP-ON, GIZMO, SOFTWARE, HIGH-TECH: FUTURISM, DESIGN AND TECHNOLOGY

The essays in the final section of this volume are by those who share Reyner Banham's enthusiasm for design's engagement with the future, with predictions and premonitions, and who admire the acute observations he made about seemingly ordinary objects of industrial manufacture. They also discuss the changing nature of the designed object in an age of computers, the digital and virtual.

In 'A Historian of Science and Technology Confronts Gender and Design' (1996) Ruth Schwartz Cowan examines the nature of household appliances from a gendered point of view. Taking as her starting point the 1995 conference, 'Re-Visioning Design and Technology: Feminist Perspectives' at the City University of New York, Schwartz Cowan questions assumptions about the nature of industrial goods, attitudes towards their form, and the place of the female consumer and designer in this discourse. Through her extended comments on the design of a vacuum cleaner, Schwartz Cowan confronts the perceived gap between feminist critique of the industrial design profession and ambitions of women in the technical professions of engineering, science and design.

A further reflection on the character of industrial design was given by designer and design theorist Tomás Maldonado, 'Materials and Dematerialization: The Future of Industrial Design' (1992). The author draws on the metaphor of 'cold' and 'warm' design. By 'cold' design he means the object of mass consumption and industrial production, whereas 'warm' design refers to artisanal objects with handcraft or artistic properties. Maldonado then complexifies this separation by characterizing the then current state of Italian design before developing his discussion of the concept of dematerialization and its implications for consumer electronics. He questions the nature of objects and their relationship to virtual reality in the context of design theories for the future.

Artist Richard Hamilton, a pioneer of computer art, uses this medium to present an interactive discussion and reflection on the Duchampian archive in 'An Unknown Object of Four Dimensions' (1999). In 1966 Marcel Duchamp's manuscript notes from the period 1912–20 were reproduced as a facsimile edition called À l'infinitif, which then became known as The White Box. The lecture revisits Hamilton's study of the White Box and its subsequent reconstruction. In 1999, the year of the lecture, Hamilton produced an homage to the White Box, which he titled Marcel Duchamp: In the Infinitive – A Typotranslation.

Tom Karen's lecture, 'Designing the Future: An Industrial Designer's Perspective' (2005) offers reflections on the priorities of a successful designer whose career coincided with Reyner Banham. Karen discusses his friendship with Banham and their shared fascination with visionary design. Working on a multiplicity of projects, largely as director of Ogle Design Ltd., Karen's profile ranged from white goods and children's toys to vehicle design and affordable housing. Offering many insights into the designer's thought processes and the circumstances around design innovation, he concludes that it is important for designers to 'make virtues out of necessities' while following their wider imagination.

The volume closes with the essay by cultural and film historian Christopher Frayling, 'Rotwang and Sons: The Soul of the Designer in the Machine Age' (2003). Like Banham before him, Frayling recognizes the important and enduring connection between film, design and the industrial world. For this lecture, he traces the tradition of depictions of the scientist-designer in popular movies. Rotwang, the evil design genius behind Fritz Lang's modernist *Metropolis* (1926), laid down the

ground rules for future cinematic depictions of the perils of over-reaching, from Frankenstein to Dr Strangelove. Stanley Kubrick's *Dr Strangelove* (1963) was a direct descendant of Rotwang, but he was also a parody of Dr Wernher Von Braun, uniting two traditions of public discourse about mid-twentieth-century design. The essay traces an intertextual debate on these competing visions and relates them to a battle, carried out in the public domain, over the soul of the designer in the machine age.

NOTES

1. Nigel Whiteley, *Reyner Banham, Historian of the Immediate Future* (Cambridge, MA and London: MIT Press, 2002), pp.xiv–xv.
2. The lectures were organized by Charles Saumarez Smith until 1994. They have subsequently been organized by Jeremy Aynsley.
3. These titles appear in *A Critic Writes: Essays by Reyner Banham*, selected by Mary Banham, Paul Barker, Sutherland Lyall and Cedric Price (Berkeley, Los Angeles, London: University of California Press, 1996).
4. The subject of *Theory and Design* was subsequently extended in *Age of the Masters – A Personal View of Modern Architecture* (1962) (London: The Architectural Press, revised edition, 1975).
5. These have been referred to variously in Whiteley ibid.; Adrian Forty, 'Reyner Banham, "One Partially Americanized European"' in Louise Campbell (ed.), *Twentieth-Century Architecture and its Histories* (London: Society of Architectural Historians of Great Britain, 2000), and Anthony Vidler, *Historians of the Immediate Present, Inventing Architectural Modernism* (Cambridge, MA and London: MIT Press, 2008).
6. Vidler, ibid., p.134. The term was first used in Banham's essay, 'The New Brutalism', *Architectural Review*, 118, no. 708 (December 1955, p.361).

Part I

IN THE REAR-VIEW MIRROR: BANHAM REVISITED

To find the junior *avant-garde* admiring with equal fervour peasant houses on Santorin, and the chrome-work of Detroit cars; the Cutty Sark, Chiswick house, *Camels* cigarette packs and Le Corbusier's chapel at Ronchamp; Pollock, Paolozzi and Volkswagens – all this sounds like the complete abandonment of standards. In fact it is nothing of the sort – it is the abandonment of stylistic prejudice, and its replacement by the concept of 'the style for the job'. This abandonment opens the way for a more viable integration of design with practicalities of machine age existence.

'Machine Aesthetes', *New Statesman* 55, 16 August 1958

1.

THE ART OF THE WELL-TEMPERED LECTURE
BANHAM AND LE CORBUSIER
tim benton

According to a reported account in the *Journal of the American Institute of Architects*, published in January 1925, the architect Le Corbusier began his lectures in 1924 by projecting 100 glass transparencies, divided into five sequences, without commentary.[1] Apparently, this visual barrage took ten minutes to complete, although it may only have seemed that long[2] (Figure 1.1).

Le Corbusier called these slide sequences his 'films'. Each of the five sequences of slides was introduced by a caption card, in the style of the silent cinema, with white letters on black. More importantly, from my point of view, Le Corbusier regarded these 'films' as carrying an argument, of pursuing, in his own words, 'the awesome strides of logic'. I have become fascinated by the different ways in which images can be used for argumentation and by the significant differences between oral and written presentation.[3] For this reason, I have tried to conserve the oral character of this paper; it is to be read as a lecture on lecturing. I'll return to Le Corbusier and his visual rhetoric, but first, in the tradition of the Banham lecture, some words about our patron.

Reyner Banham was a kind of godfather to the Open University course 'A305 The History of Architecture and Design 1890–1939', which I helped to design and write

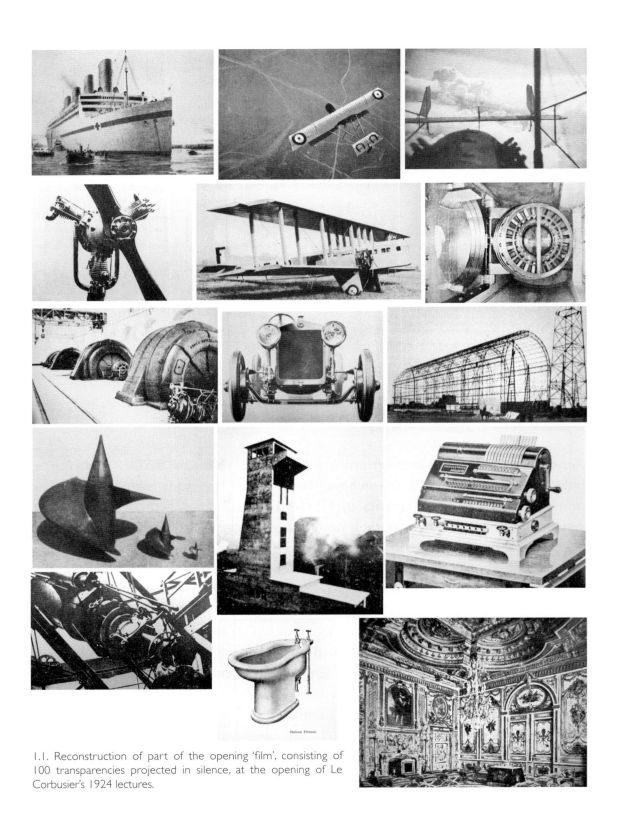

1.1. Reconstruction of part of the opening 'film', consisting of 100 transparencies projected in silence, at the opening of Le Corbusier's 1924 lectures.

in 1975. He contributed Unit 21, on Mechanical Services, derived in part from *The Architecture of the Well-Tempered Environment*, whose second edition came out in 1973, and a radiovision programme on the reform of the skyscraper.[4] He and Mary even came down to Sussex University and taught at the Summer School in 1975.[5]

I vividly remember Banham lecturing at the Courtauld Institute, around 1967, where he spent the first ten minutes excusing himself for not having prepared a 'proper' lecture. By 'proper' lecture, of course, he meant the silver English, polished, 'well-structured' performances of a Michael Kitson or an Anita Brookner.[6] These lectures were invariably monographic and had a set structure. They began with a thematic introduction, spiced with evocative quotations, which placed the listener in the centre of the action. Then, after a short pause, you would hear: 'Jacques-Louis David was born on 30 August 1748, in Paris...' and the narrative proper would begin. Banham's apologetic distancing from these performances signalled both his respect for the institution of scholarship and a recognition that his kind of material could only fit awkwardly into this Alexandrian mould. It was also, in the nicest possible way, a claim for moral superiority over his teachers. And it was a perfect introduction to the point of his lecture, which he expressed in an anecdote (Figure 1.2).

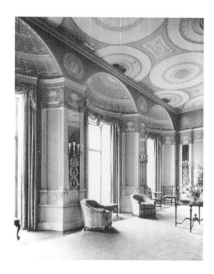

1.2. Music room, Home House, 20 Portman Square, former slide room of the Courtauld Institute.

Apparently, while sitting in the slide room of the Courtauld Institute, preparing a lecture, he looked out past the cast-iron railings, and there was a white 1951 Cadillac. He had, he said, a moment of revelation: the lines of the car were 'like Ingres'. This was an epiphany for him in abandoning his modernist resistance to sumptuous streamlining in industrial design. Of course, to the cognoscenti of the Courtauld Institute, the reference to Ingres was an insider comment, in praise of line over colour, a kind of Classicism over Romanticism. It was precisely art historians such as Anita Brookner who were reinterpreting Ingres, previously considered hopelessly academic and conservative, as a deeply erotic and, in a sense, modern artist. So, Banham's comparison worked perfectly on both wings: Ingres was as much a problem for modernist art historians at the time as voluptuous brightwork was for followers of the Modern Movement in architecture. To admire Ingres and a white Caddy was distinctive, knowing and transgressive at the same time.

Banham's anecdote is a perfect nugget of rhetoric; it addresses its intellectual and physical context – the serried ranks of Courtauld staff and students and the Adam building where the lecture took place – and uses the Warburgian weapon of visual confrontation to juxtapose the repressed eroticism of an unfashionable master with the abundant and sensuous expression of unacceptable American capitalism.

For if Banham rejected parts of the high art history lecture, he was a master of the very Wölfflinian technique of visual comparison. Art history developed as a discipline in the tradition of the left and right projector screens and the basic grammar of art historical comparison – modern versus traditional, classical versus baroque, our man versus a lesser mortal, good versus bad – as well as the games of sequence: succession in time, development of an idea or shock intrusion. Selection and 'play' of images lie at the heart of this tradition and constitutes part of the argument. To construct an art history lecture, in this tradition, begins with the selection and ordering of images. There is a section entitled 'Lectures' in the Banham papers in the archives of the Getty Research Institute, but these mostly consist of lists of slides. Banham prepared his lectures as a sequence of visual statements, exclamations, discoveries and contradictions, as many of us do. Selecting and ordering these images, and thinking about them, was a kind of engine for collecting the quotations and factual material for the verbal argument. It was Roland Barthes who speculated that,

> It is even probable that rhetoric has a single structure, shared, for example, by dreams, literature and images. Thus the rhetoric of the image (that's to say the classification of connotations), is specific [in some ways...] but general in the sense that rhetorical figures and tropes are nothing other than formal relationships of elements.[7]

Creating effects with images, therefore, in this sense is the same as constructing arguments about the visual.

Back to Le Corbusier and his 'films' (Figure 1.1). This is how Le Corbusier commented on his 100-slide film, during his lecture on 10 November 1924 at the Salle Rapp, Paris:

> You have just seen on the screen a heterogeneous sequence of images; this sequence, shocking for many people, at any rate striking, makes up the more or less everyday spectacle of our existence and we are at a moment when every day we are presented with such troubling innovations, such striking contrasts that we feel disturbed and in every case powerfully moved.[8]

In fact, the 'films' constitute the *Zeitgeist* argument, which was traditionally used to make the case for modernist architecture. The argument runs something like this:

- The material world has been radically transformed by industrialization;
- This transformation has produced a 'New Spirit' – *'l'esprit nouveau'* (at least among those who know how to look and understand);
- Ergo: the sensitive architect is driven to produce a radically new architecture in conformity to the times.

This is not a logical proof, since there is no necessary connection between the material world of machines and the world of the spirit, but it was the dominant rhetorical argument of the 1920s.

The transparencies in the films had the job of illustrating this scenario. Pictures of nineteenth-century engineering structures were followed by fearsome symbolic images of mechanization – bank vaults, marine propellers, impersonal machines – and then followed by images demonstrating the confusion of modern man faced with these phenomena (eclectic architecture and false modernism or Art Nouveau and Art Deco). The 'New Spirit' was illustrated by the kind of images used in *Vers une architecture*: works of 'pure calculation' that achieved formal perfection through simple geometry. The 'films' ended with a sequence of Le Corbusier's 'all-time greats' of architecture: the Parthenon, the Pantheon, Michelangelo's St Peter's Basilica and the steps of the Laurentian Library, and the staircase of the 100 steps at Versailles.

These 'films' also performed another role. They constituted a test of taste, a test of modernity. For example, a sequence of images of modern life (machines, bridges, silos) was followed by a view of the Palace of Fontainebleau (see Figures 1.1 and 1.3, top row, which shows a Bugatti engine compared to a room in Fontainebleau Palace). How Banham would have enjoyed all this!

Le Corbusier gave the lecture in Geneva on the 14 February, and then repeated it in Lausanne the next day. When he delivered his lecture in Lausanne, Le Corbusier told his audience:

> When I showed you the sequence with the Château de Fontainebleau, which is, after all, a beautiful thing, you manifested the distance which now separates you from that aesthetic and from the spirit of those who created it.
>
> Yesterday I was in Geneva and I showed the same films, but [the same sequence] had a quite different effect. When I showed the view of Fontainebleau, instead of your laughter, there was the normal respect at the sight of a beautiful thing.[9]

The implication is clear: old-fashioned Geneva is compared to modernist Lausanne, a message guaranteed to flatter his audience.

When he repeated his lecture on 12 June at the Sorbonne, the sequence of slides leading up to the Fontainebleau gallery worked particularly well. We know this because one of Le Corbusier's old enemies, Léandre Vaillant, was in the audience and he wrote a most perspicacious review of the lecture in the *Paris Journal*:

> …after a sequence of images of the same type, three or four perhaps – an ocean liner, an aeroplane, an automobile, he suddenly follows up with a different kind of image: the gallery of the Château of Fontainebleau. Immediately, we snigger. Why? Is it because all understanding of Renaissance architecture and any taste for decoration has atrophied in us, simply impossible to comprehend for a man of the present? Surely not! It's a nervous reflex, the result of a psychological manipulation to create a desired effect.[10]

It is worth reflecting on the delicious condition of the lecturer who lectures on lectures. We all know that lectures belong to the genre of theatre: ephemeral, and difficult to predict and control. They are profoundly contingent on the audience, time, place and mood. Like disabused post-modernists, for example, we no longer snigger at the image of Fontainebleau. Nor, eighty years on, are we alarmed by the cutting-edge images of modernity with which Le Corbusier shocked his audiences in 1924. The effects of the lecturer work or they don't work, and they work differently on different audiences and in different circumstances. Vaillant had another example of Le Corbusier's shock technique:

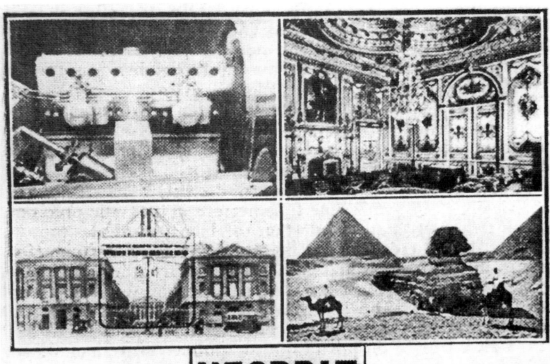

Moteur Bugatti.
Coupe transversale du paquebot « Paris ».

Château de Fontainebleau.
Les Pyramides.

L'*Esprit Nouveau*, revue internationale de l'activité contemporaine.

1.3. Page of illustrations from 'L'Esprit nouveau en architecture', *Bulletin de l'Ordre de l'Étoile d'Orient*, p.27, reproducing two of the rhetorical effects used by Le Corbusier in his 'films'.

1.4. Illustration added to the article 'Usurpation: le folk-lore', *L'Esprit nouveau* No. 21 (April 1924) in the republication in *L'Art décoratif d'aujourd'hui*, 1925.

1.5. 'Autres Icones; les musées', *L'Esprit nouveau* No. 20 (1 February 1924).

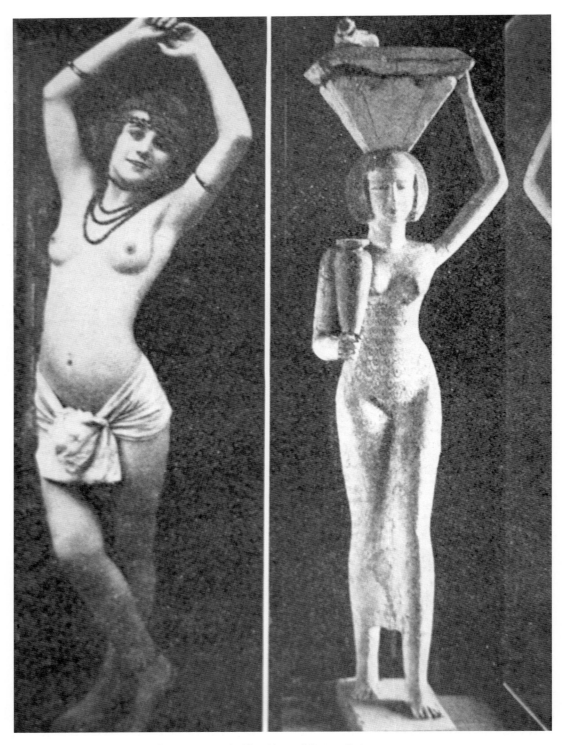

1.6. Comparison of nude and Egyptian statue in *L'Art décoratif d'aujourd'hui*.

If you project on to the screen, after showing five or six female monkeys borrowed from the ZOO, a figure by Maillol, or if you present a sequence of sanitary fittings and then the Egyptian bread carrier from the Louvre, the surprise will make people laugh.[11]

Now, a photograph of two monkeys playing a violin and guitar was added to the article 'Usurpation: le folk-lore', when it was published as the third chapter of *L'Art décoratif d'aujourd'hui*, and it is very likely that this image was used by Le Corbusier in his lecture (Figure 1.4).[12] Incidentally, it is inconceivable that Le Corbusier would have used this picture to make fun of a Maillol, since he had an undying admiration for this sculptor.[13] Le Corbusier also famously introduced his essay '*Autres icones: Les musées*' with a bidet in splendid, curvaceous Pirsoul earthenware (Figure 1.5) and illustrated the Egyptian sculpture in the article '*Nature et création*', so this, too, was probably a comparison made in the lecture (Figure 1.6).[14]

Vaillant goes on to accuse Le Corbusier of demagoguery and, far worse, of 'romanticism'; '*Il n'agit point par la logique, mais par la suggestion brutale. Il ne prouve pas, il frappe*' ('He doesn't work by logic but by brutal suggestions. He doesn't prove, he strikes'). One could hardly wish for a better definition of rhetoric. Le Corbusier used this technique of the sequence followed by an abrupt change of content in his publications, although this device has been insufficiently noted.[15]

Another rhetorical device in Le Corbusier's deployment of transparencies was the antithetical juxtaposition which reveals the internal contradictions of a situation (Figure 1.7). I remember that this was a particular favourite in the 1960s and early 1970s when we tried to slice through capitalist ideologies by juxtaposing two views of a person or thing which mercilessly exposed its hypocrisy, mendacity or vanity. This is how he commented on this comparison in the version of this lecture given at the Salle Rapp in Paris on 10 November:

> Just now I showed you the ocean liner *Paris*, which you regarded as a remarkable thing, superb. Then, from the same ship, I showed you the [Art Deco] salon, which certainly left you feeling depressed; it seems in fact astonishing to find at the heart of such a perfectly ordered construction such a contrast, such a contradiction, such a lack of coherence between the great lines of the ship and its interior decoration.[16]

Another sequence dealt with American banks. This was his comment (Figures 1.8 and 1.9):

> Then I showed you the interiors of some American banks; they are of such clarity and precision, such fitness for purpose that we are nearly ready to call them beautiful. The architect must have a great deal of talent and be motivated by logic and great clarity of mind. Now, in *The Bankers' Magazine*, which published these works, this man included an invitation to visit him and, as an attraction, he had the bright idea of showing the interior of his own office... This photograph shows a room furnished with Renaissance pieces, to the point of including a suit of armour in the corner, halberd in hand, and immense Louis XIII table with enormous turned and carved legs, rich carpets, tapestries... Can you imagine that the man who chooses to furnish his own office like this was capable of designing those interiors, which are works of pure logic![17]

Interestingly, although I was able to identify this image of the office of the architect Alfred C. Blossom in *The Bankers' Magazine*, Le Corbusier did not publish it either in *L'Esprit nouveau* or *L'Art décoratif d'aujourd'hui*, either for reasons of copyright or due to the rather poor quality of the image.

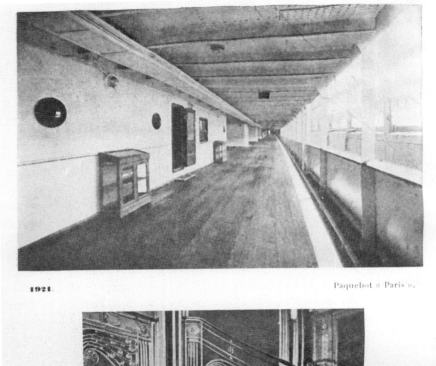

1921. Paquebot « Paris ».

1921. Brandt (Paquebot « Paris »).

1.7. The ocean liner *Paris*; comparison of promenade deck and staircase by Edgar Brandt, published in *L'Art décoratif d'aujourd'hui*, 1925, p.160.

East End of Reception Room, Office of Alfred C. Bossom

An Invitation

Bankers visiting New York, for the A. B. A. Convention are most cordially invited to visit the Architectural Offices of Alfred C. Bossom at 680 Fifth Avenue, (between 53rd and 54th Streets) who designed and supervised the building of the First National Bank of Jersey City, illustrated on the following pages.

A view of one of the office rooms is shown above. You are urged to come and examine plans and illustrations designed recently for institutions in all parts of the country.

Alfred C. Bossom
Bank and Office Building Specialist
680 Fifth Avenue, New York

1.8. Advertisement in *The Bankers' Magazine* by the architect Alfred C. Blossom, inviting bankers attending the A.B.A. convention to visit his office.

1.9. Office in the City National Bank of Tuscaloosa, USA, from 'L'Art décoratif d'aujourd'hui', *L'Esprit nouveau* No. 24, June 1924.

As Vaillant remarked, the technique of the antithesis was a common figure among modernists: Le Corbusier and Ozenfant became past masters at it in the pages of *L'Esprit nouveau*. Vaillant explains:

> He proceeds by regularly spaced antithesis; now, the antithesis is a perfectly good philosophical device for searching for truth.18

Figure 1.3 is a page in the published version of Le Corbusier's lecture at the Salle Rapp in November, which he composed after reading Vaillant's criticism in June. We have noted an example of the kind of antithesis which he used in the lecture: on the left a Bugatti engine and on the right a room from Fontainebleau. Vaillant again:

> The antithesis is a rhetorical argument of the most emotive kind, the kind used to stir a crowd. Demagoguery doesn't have need of the syllogism. It works with violent contrasts. The sequence of images used by Le Corbusier to captivate his audience might as well have been given the title of Notre Dame de Paris: *ceci tuera cela.*19

Now, Le Corbusier prided himself on his logic and even used the word 'syllogism' in his notes for a lecture in Brussels in 1926:

This implacable syllogism:

Premise 1: Our cities were conceived before the automobile
Premise 2: The automobile has killed the city
Ergo: The automobile must save the city.[20]

For the student of logic, this is clearly not a workable syllogism. There is no necessary dependency of the conclusion from the premises. Vaillant also explicitly criticized the kind of visual argument illustrated in the second row of pictures, an ocean liner compared with the Hotel Crillon and the pyramid of Cheops (see also Figure 1.10):

Now here is an image which demonstrates that the length of an ocean liner is longer than the pyramid of Cheops and higher than the Arc de Triomphe. New symptom of the disease of Romanticism![21]

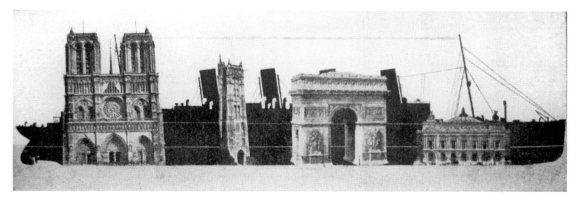

1.10. The liner *Aquitania* compared to Notre Dame, the Tour St Jacques, the Arc de Triomphe and the Hotel Crillon in Paris. *L'Esprit nouveau* No. 8 (May 1921).

For Vaillant, this was a category error:

The pathos of dimension, the prestige of quantity. For the clear-sighted aesthetician, grandeur lies in proportion and compositional relationships. The trope of the huge ocean liner lacks any grandeur … the suggestion of limitless scale or of dimensions running to hundreds of zeros, the awe produced by mind-blowing statistics; these yet again are tools passed on by old-fashioned Romanticism and present-day advertising; the last refuge of an imagination gone crazy. In rhetoric, we call this hyperbole.[22]

It's interesting that the power of Le Corbusier's visual rhetoric overran his actual arguments and caused confusion and misunderstanding. Vaillant, in fact, got Corbusier's attitude to functionalism completely wrong. This was Vaillant's conclusion:

And this is where the error becomes blatant, though not to the blind. Conformity to function is not beautiful in itself. Beauty begins once function has either been satisfied or put on one side.[23]

Le Corbusier replied angrily on 3 July:

> I can't allow Vincent (i.e. Vaillant) to have me say precisely the opposite of what I said … I showed as the climax of my argument the Parthenon, Michelangelo's Laurentiana Library steps, another Parthenon and my film ended with the 100 steps at Versailles, the Sphynx and the Pyramids. And I said explicitly: 'Man is left panting…'[24]

Note that these men are discussing 'arguments', but what they're actually writing about is a series of transparencies divided by a few words on caption cards:

> Then Mr Vincent has me say about the Parthenon things which I could never say and which are really serious (let the audience bear witness). You don't confuse God with bidets (this based on a caricature of what he had me say): 'Your toilet … is more beautiful than the Parthenon because its form is purer. It is a Parthenon.'
> Mister Vincent, do you really take me for a 'noc fini'?
> I have always cited the Parthenon as the most stunning example of architectural beauty.[25]

A gloss on 'noc fini': 'noc' is *verlan* – the backwards slang of Parisian argot. We can translate 'noc fini' as 'complete ass'.

Le Corbusier finished his film with a sequence of the best that world architecture could show, intending to indicate that this was the standard to which modern architects should aspire, even in the new conditions of modernity. His final caption card included the words to which he refers: '*l'homme demeure pantelant*'. By this he meant that the human spirit was shocked and crushed by the machine, but that through an act of creativity he could come to terms with it. Only by creating perfect forms, as the Greeks and Michelangelo had done, could the situation be resolved. Where Vaillant had understood the images of machine age modernity to be an end in themselves, Le Corbusier saw them as a challenge to be mastered and turned into art. Clearly, the rhetoric of the image doesn't always communicate. Le Corbusier typically used images in lectures in three ways. He used slides of the modern world to establish the premise: the challenge of modernity, leading to the deduction that architecture should be radically changed. These sequences were also a test of the audience's taste, of their 'modern spirit'.

Then comes the most important part of the lecture, the exegesis, where Le Corbusier would demonstrate, in drawings, the principles of modern architecture. These drawings constitute what rhetoricians call inductive logic: drawing out general principles from examples or illustrations. This is how Le Corbusier described his practice as a lecturer:

> I never prepared my lectures. This improvisation is a wonderful thing. I drew … and when you draw on the basis of key words, you create something. And all my theory, my introspection and retrospection on the phenomena of architecture and urbanism, derives from these improvised and illustrated lectures.[26]

The autofiction of improvisation is part of the myth of the successful lecturer. But to create something is to establish your authority as an artist. This is part of the *ethos* of classical rhetoric. In fact, Le Corbusier prepared his lecture drawings in advance, making sketches that he would follow quite closely on the blackboard in front of the audience[27] (Figure 1.11).

According to Quintilian, an effective orator is a virtuous and noble man who can talk well ('*vir bonus diciendi peritus*').[28] Transposing this tag into the field of architecture, you might say

1.11. Page of notes for the lecture at Lausanne, February 1924.

that a good orator is an excellent architect who can draw well. The concluding part of every Le Corbusier lecture is that of the peroration, where the orator shows himself triumphant and awaits his audience's approval. Invariably, this consisted of a sequence of transparencies of Le Corbusier's own work (Figure 1.12).

To expose yourself in a lecture has this in common with an exhibition in a gallery: it depends on the visual and it encourages exaggeration. Le Corbusier had learned this lesson in November 1922, when his exhibition in the Salon d'Automne of a 16-metre diorama of the *Cité contemporaine pour trois millions d'habitants* shocked the world's press into paying him much more attention than he had achieved with all his articles in *L'Esprit nouveau*. As the critic of the *Tribune de Lausanne* wrote:

> The crowd jostles in front of Le Corbusier's diorama ... representing a future city such as Gulliver might have seen in Brobdignac, with huge towers lining avenues wider than rivers.[29]

And Le Corbusier's own surprise at his reception emerges from a letter to his parents:

> The crowd is open-mouthed ... and attentive: they are respectful and interested. This isn't painting any more and nobody is laughing. Am struck by how people are prepared to stop and look at architectural things.[30]

1.12. One of Le Corbusier's boxes of slides for his American lecture tour in 1935.

He learned here that to take an idea to its extreme was more effective with the public than arguing the difficult pros and cons of real-life town planning. It was this exhibition that launched Le Corbusier's career as a public speaker. Six months later he was lecturing to an audience consisting of the top town planners in Europe, including Ebenezer Howard and Raymond Unwin, several dozen French mayors, ministers and top architects, in the first international conference of the Society of French Urbanists in Strasbourg. This is where he decided, for maximum irritation value, to adapt the general plan of the *Cité contemporaine* to the Right Bank of Paris, which two years later would be exhibited as the *Plan Voisin de Paris*, at the '*Exposition des Arts Décoratifs Modernes*'. And from then on he was lecturing uninterruptedly until his death, all over the world.

I don't know when Banham did his first lectures or whether they were particularly memorable, but he shared with Le Corbusier the understanding of the shock value of titles and the witty and unsettling use of images. I never heard him give a stand-up formal lecture to a very large audience. I suspect he didn't vary his style that much. Banham didn't make drawings, at least not in lectures that I heard him give, but he did draw a great deal on his personal experience. His *auctoritas* was based in part on this behind-the-scenes understanding of what really goes on and a formidable, sometimes even pedantic, precision of factual information. He came across, in fact, as the builder who has learned Latin. Just as Ruskin taught his young ladies to observe nature in every pore,

Banham taught us to open our eyes to industrial design. I remember rushing out of my house in Stockwell to photograph an Airstream camper that took up residence further down Larkhall Lane. There was a whole world of art out there, in the form of industrial design, if we could only see it. This is the transformative magic of art history and Banham was an expert at it.

I'm going to illustrate this with some memories of a lecture he gave at what was effectively the precursor conference of the Design History Society, held in Newcastle in September 1975 (which was just when the first cohort of Open University A305 students were sitting their exams) (Figure 1.13). Banham's title had a ring to it – 'Detroit Tin Revisited' – and it picked up a theme he had worked with at least since his 'Vehicles of Desire' piece in *Art*, twenty years before, in 1955.[31] In part, this was a piece of classical iconography, tracing the connections between automotive styling, advertising images, pop art and the question of sex and the motor car. His aim was to upstage Marshall McLuhan by a more precise identification of imagery and its signification, while carrying the battle into the camp of poor old English po-faced functionalism. A starting point was to expose Walter Gropius's rationalist cladding of an Adler cabriolet as just as much of a styling job as that of the Detroit professionals. Then he turned to styling as art (Figure 1.14). As a stickler for connoisseurial pedigree, he began the lecture by identifying a unique work – 'Brian's Caddy': the white 1951 (or was it 1953?) Cadillac 156TV belonging to Brian Tait-Russell:

1.13. Cover of proceedings of the conference 'Design 1900–1960', Newcastle 1975.

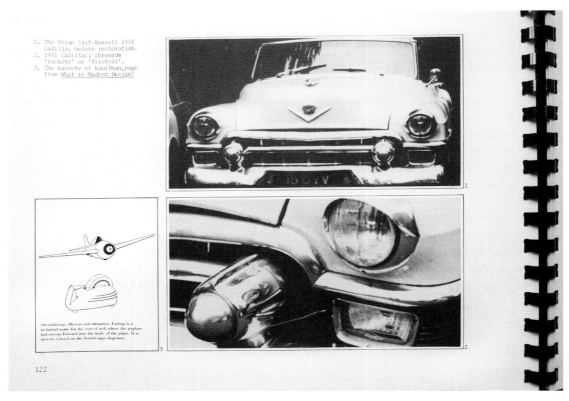

1. The Brian Tait-Russell 1951 Cadillac before restoration.
2. 1951 Cadillac; chromium 'rockets' or 'Bristols'.
3. The naïveté of Kauffman; page from *What is Modern Design?*

Streamlining, efficient and imitation. Fairing is a technical name for the curved web where the airplane tail sweeps forward into the body of the plane. It is naïvely echoed on the Scotch-tape dispenser.

122

1.14. Page spread from 'Detroit Tin Revisited', Banham's lecture at the 'Design 1900–1960' conference, Newcastle upon Tyne, 1975, showing the Brian Tait-Russell white Cadillac.

> You have to say which Cadillac it is because it is one of the very few surviving with its original paint, so it has certain art historical qualities like discovering a Caxton in its original binding, or something like that.[32]

To attend to the details of Detroit tin as art was still a struggle in the 1970s. Banham used the scholastic ladder of understanding, from bodily sensations to spiritual ecstasy. He did not hesitate to call the protuberances in the Cadillac's bumpers 'Bristols', or explain to us the erotic significance of the stylists' term, 'Frenching'.

Like Adolf Loos, he could use the metaphor of fashion not as a reproach, but as an aspiration. Le Corbusier, too, could use this analogy. Writing to the wretched William Cook to urge him to replace the wrongly specified glass in his house with much more expensive plate glass, he said, 'A young man setting out for the ball doesn't wear a paper collar.' This wasn't just a matter of architectural detailing, it was far more important, a question of elegance (Figure 1.15).

Banham drew it all together with an analysis of car styling, ladies' underwear and the late 1950s paintings by Richard Hamilton. Specific as ever, Banham identified the source of one of Hamilton's titles, 'Hers is a Lush Situation', in the review of the 1954 Buick, in February 1955, by Deborah Allen.

7. Exquisite forms of auto-erotic symbolism and verbiage.
8. Intergalactic pretensions of the 1954 Oldsmobile.
9. Oldsmobile Rocket 88 Engine -- with orbital accompaniment.
10. Pulp media as orbital imagery transmitters.
11. Cockpit of Oldsmobile space-age Mitty-mobile, 1954.
12. Cockpit of the real thing; Republic Aviation Jet-trainer.
13. Chrysler Corporation 'Flight-sweep Line' in its pure form.

1.15. Page layout from Reyner Banham's lecture 'Detroit Tin Revisited', Newcastle, 1975.

> The Buick … is the most revolutionary car in this spread. It is logical, but only by its own standards, was not designed to sit on the ground, or even roll on the ground; it is perpetually floating on currents which are built into the design … the driver sits at the dead calm at the centre of all this motion: Hers is a lush situation.[33]

Out goes the rationalism of fitness for purpose, of truth to materials, of less is more. But this wasn't a descent into the bathos of postmodernism or a further devaluation of symbols (Banham uses Giedion's critical term for the decoration of Napoleonic interior design). Banham's lecture was, in an unlikely form, a tribute to the power of art, a celebration of the visual and a reassertion of Le Corbusier's tag that 'Architecture is the masterly, correct and magnificent play of volumes brought together in light', though Banham might have insisted here a bit more on Ingres's line rather than volume. For Banham, as for Le Corbusier, the issues that matter turn out to be formal, despite all the discussion of structure, process and function, and the terms of the debate are strictly visual. Selection and juxtaposition of images therefore formed the basis of the arguments, whatever the contextual scaffolding these arguments might have.

Snazzy titles, empirical research, seeing anew, powerful and unexpected contrasts, witty and articulate analysis and disturbing conclusions: these are the fundamentals of the well-tempered lecture and Reyner Banham was very good at it.

NOTES

1. Lecture given at the V&A Museum on 29 February 2008.
2. Fondation Le Corbusier (FLC) X1(3)62.
3. Tim Benton, *Le Corbusier conférencier* (Paris: Moniteur, 2007). Tim Benton, *The Rhetoric of Modernism: Le Corbusier as a Lecturer* (Basle and Boston: Birkhäuser, 2009).
4. Reyner Banham, *The Architecture of the Well-Tempered Environment* (Chicago: University of Chicago Press, 1969).
5. Next year, bizarrely, the course was exhibited at the Venice Biennale. Also in 1976, it was Banham who picked up the silver medal for TV13, on the Villa Savoye, at the International Union of Architects' conference in Madrid, after he himself had been awarded the Jean Tschumi prize the previous year.
6. Kitson and Brookner, in their different ways, were stars of the 1960s Courtauld Institute. Kitson was an expert on Claude Lorraine and Brookner on David, and both had roots in English literature. Kitson went on to become Director of Studies at the Paul Mellon Centre for Studies of British Art, while Brookner became a Booker Prize-winning novelist, while continuing her career as art historian.
7. 'Il est même probable qu'il existe une seule forme rhétorique, commune, par exemple, au rêve, à la littérature et à l'image. Ainsi la rhétorique de l'image (c'est-à-dire le classement des connotations) est spécifique dans la mesure où elle est soumise aux contraintes physiques de la vision (différentes des contraintes phonatoires, par exemple), mais générale dans la mesure où les "figures" ne sont jamais que des rapports formels d'éléments', Roland Barthes, 'Rhétorique de l'image', *Communications* 4: 40–50, cited by J. J. Robrieux, *Eléments de rhétorique et d'argumentation* (Paris: Dunod, 1993), p.27. Robrieux also refers to the piece by Jacques Durand which, following up on the challenge presented by Barthes, attempted a systematic analysis of visual tropes 'qui, poursuivant le défi lancé par Barthes, essaya un analyse systématique des figures visuelles' (J. Durand, 'Rhétorique et image publicitaire', *Communications* 15: 70–95).
8. 'Vous venez de voir passer sur l'écran une suite hétéroclite d'images; cette suite, choquante pour beaucoup, frappante en tous cas, constitue le spectacle à peu près quotidien de notre existence, et nous sommes en un moment où chaque jour se proposent à nous telles innovations troublantes, tels contrastés si saisissants que nous en sommes bousculés et en tous cas toujours fortement commotionnés', from 'L'Esprit nouveau en architecture', a lecture delivered at the Salle Rapp, Paris, 10 November 1924, transcribed stenographically and published in *L'Ordre du Bulletin de l'Étoile de l'Orient*, March 1925 (FLC X1(3)64 and in Le Corbusier, *Almanach d'architecture moderne, documents, théorie, pronostics, histoire, petites histoires, dates, propos standarts, apologie et idéalisation du standart organisation, industrialisation du bâtiment*, 172 clichés, 200 pages (Paris: G. Crès et cie, 1925), p.23.
9. 'Au moment où on a passé le Château de Fontainebleau qui est pourtant une chose fort belle, vous avez manifesté la distance qui vous sépare maintenant de cette esthétique et du sentiment qui anime les créateurs de cette œuvre. Je me suis trouvé à Genève dans un milieu tout différent à projeter les mêmes films, ce qui a provoqué un effet contraire; quand la vue de Fontainebleau passa, au lieu de votre rire, ce fut l'admiration habituelle à la vue d'une belle chose' FLC (C3(6)17). For a detailed explanation of my identification of the manuscripts for these lectures, see Tim Benton, *Le Corbusier conférencier* (Paris: Moniteur, 2007), pp.190–91.
10. '…à une suite d'images du même type, trois ou quatre, paquebot, avion, moteur, il fait succéder brusquement une image isolée et différente: la galerie du Château de Fontainebleau. Immédiatement on ricane. Pourquoi? Parce que la compréhension pour l'architecture renaissante et le sens décoratif seraient atrophiés en nous, inassimilables pour l'homme de notre temps? Eh, non! C'est un réflexe nerveux, résultat d'un calcul psychologique applicable au besoin, à la démonstration contraire', Léandre Vincent (pseudonym of Léandre Vaillant), 'Divagations intempestives', *Paris Journal*, 20 June 1924 (FLC C3(6)38).

11. 'Que l'on fasse passer à l'écran, après cinq ou six spécimens de guenons empruntées au Jardin des Plantes, une figurine de Maillol ou, après autant de modèles de faïences hygiéniques, la porteuse de pain égyptienne du Louvre, la surprise fera rire.' Ibid.

12. The article was published in *L'Esprit nouveau* no. 21, published at the beginning of April 1924, whereas the book was only published in 1925.

13. See, for example, the long letter recounting the day and night spent in Maillol's studio (during the sculptor's absence, on 1–2 August 1915) in his letter to William Ritter of 13 January 1917 (FLC R3(19)103). Le Corbusier also owned drawings and lithographs by Maillol (FLC R3(19)32, letter to William Ritter 22 May 1916).

14. 'Autres icones: Les musées' was published in *L'Esprit nouveau*, no. 20, 1 February 1924 (no pagination) and 'Nature et création' in no. 19, December 1923; see also Le Corbusier, *The Decorative Art of Today* (Cambridge, MA: MIT Press, 1987), p.15.

15. There is also an example of the interrupted sequence: thirteen pages of art nouveau and art deco decorative art interiors from *Art et Décoration* interrupted by the vestibule of Perret's Théâtre des Champs Élysées, an image of the industrially produced Maisons Voisin and the images of the *Paris* (Le Corbusier, *The Decorative Art of Today*, Cambridge, MA: MIT Press, 1987), pp.143–62.

16. 'Vous avez vu tout à l'heure le paquebot *Paris*, par exemple, qui vous est apparu comme une chose remarquable, superbe; puis, de ce même paquebot, on vous a montré le salon, lequel certainement, a jeté un froid dans vos esprits: il paraît, en effet étonnant de trouver au cœur d'une œuvre si parfaitement ordonnée, une telle antinomie, un tel contraire, un tel manque de liaison, à vrai dire une telle contradiction, divergence totale entre les grandes lignes du navire et sa décoration intérieure…', Le Corbusier, 'L'Esprit nouveau en architecture', ibid. Two images of the *Paris* making this contrast were included in a sequence of illustrations added to *L'Art décoratif d'aujourd'hui* and not in the original articles (ibid., p.158).

17. 'A côté de cela, on vous a montré des intérieurs de banques américaines: ils sont d'une telle netteté, d'une telle précision, d'une telle convenance, que l'on est bien près de les trouver beaux. Ils ont été faits par un architecte qui a certainement beaucoup de talent, qui semble devoir être animé par la logique et une grande clarté d'esprit: or, dans le *Bankers' Magazine* qui publie ses œuvres, cet homme a inséré une invitation aux lecteurs à lui rendre visite et, pour les attirer, il n'a rien trouvé de mieux que de publier l'intérieur de son cabinet de travail. Et sur cette image, on voit une pièce meublée de meubles Renaissance, avec même, dans un coin, une armure de guerrier, hallebarde à la main, une immense table Louis XIII avec d'énormes pieds tournés et sculptés, des tapisseries Dire que l'homme qui meuble ainsi son cabinet est le même qui a conçu ces intérieurs de banques, œuvres de pure logique!' Le Corbusier, 'L'Esprit nouveau en architecture', ibid. The kind of images he probably showed were those in *L'Art décorative d'aujourd'hui*, chapter 6 – 'Besoins types: meubles types', and chapter 7, first published in *L'Esprit nouveau* nos. 23 and 24, May and June 1924, respectively.

18. 'Il procède par antithèses régulièrement accouplées. L'antithèse est, aussi peu que l'analogie, une formule philosophique servant à la recherche de la vérité', Léandre Vincent, 'Divagations intempestives', *Paris Journal*, 20 June 1924 (FLC C3(6)38).

19. 'C'est un argument de la rhétorique; le plus émouvant, le plus fait pour éblouir les foules. La démagogie n'a que faire du syllogisme. Elle s'épanouit au jeu des contrastes violents … La série de projections par quoi M. Lecorbusier [sic] capte son auditoire pourrait utiliser le titre qui a servi pour le prologue de "Notre Dame de Paris": ceci tuera cela.' Ibid.

20. 'Ce syllogisme implacable: nos villes ont été conçues avant l'automobile l'automobile a tué la grande ville l'automobile doit sauver la g[rande] v[ille].' (FLC C3(8)48)

21. 'Mais voici une image qui nous montre avec évidence que la longueur du paquebot *France* est supérieure à la hauteur de la pyramide de Chéops et sa hauteur à celle de l'Arc de l'Étoile. Nouveau symptôme du mal romantique!' Vincent, ibid.

22. 'Le pathos de la dimension, le prestige de la quantité! Pour l'esthéticien lucide, la grandeur réside dans les rapports rythmiques des parties, elle est fonction du sens de la proportion. Le schéma du paquebot immense est dénué de grandeur … La suggestion de la masse ou du chiffre à ribambelle de zéros, le saisissement produit par de mirobolantes statistiques, voila bien d'autres procédés passé des mains du romantisme de jadis en celles de la publicité d'aujourd'hui, dernier refuge de l'imagination en délire. En rhétorique, cette surenchère superlative a nom hyperbole.' Ibid.

23. 'Ici l'erreur éclate; sans éclairer les aveugles. La conformité à la fonction n'est pas une beauté par elle-même; ce n'est qu'une prémisse de la beauté. Celle-ci commence quand la fonction est accomplie ou éliminée.' Ibid.

24. 'Je ne puis admettre que Vincent me fasse penser (afin de "m'avoir") exactement le contraire de ce que j'ai dit … j'avais placé tels des sommets, le Parthénon, la Laurentienne de Michel-Ange, encore un Parthénon et mon film se terminait sur L'Escalier des 100 marches de Versailles et sur le Sphinx et les Pyramides: "L'homme demeure pantelant." 'M. Le Corbusier répond', *Paris Journal*, 3 July 1924 (FLC C3(6)38).

25. 'Puis M. Vincent me fait dire à propos du Parthénon des choses que je n'ai jamais prononcées et qui sont graves. (J'en prends à témoin mes auditeurs.) On ne mêle pas Dieu à des bidets! (Après une caricature du Parthénon qu'il m'attribue): "Votre cabinet de de toilette … est plus beau que le Parthénon car plus pur de formes. Il est un Parthénon. M. Vincent, me prenez-vous décidément pour un noc fini? J'ai toujours cité le Parthénon comme l'exemple le plus bouleversant de la beauté architecturale.' Ibid.

26. 'Je ne préparais jamais de conférences … Cette improvisation est une chose formidable: je dessinais … au début je travaillais avec des craies, des craies de couleur au tableau noir, encore fallait-il qu'il y en ait. Et quand on dessine autour des paroles, on dessine avec les paroles utiles, on crée quelque chose. Et toute ma théorie – mon introspection et ma rétrospection sur le phénomène Architecture et Urbanisme – vient de ces conférences improvisées et dessinées.' Recorded in an interview in the 1950s, *L'Aventure Le Corbusier*, Fondation Le Corbusier.

27. For a more detailed discussion of Le Corbusier's use of drawings in his lectures, see Tim Benton, *The Rhetoric of Modernism: Le Corbusier as Lecturer*, ibid.

28. Quintilian was the celebrated orator and rhetorician of the first century AD, whose twelve-volume *Institutio Oratorio* (published around AD 95), gave an account of the Roman citizen's education, including that in rhetoric.

29. '…la foule s'écrase devant le diorama de Le Corbusier-Saulnier (un nom qu'on connaîtra, comme un Suisse Romand), représentant une cité future avec ses maisons géantes, comme Gulliver dût en voir à Brobdignac, jalonnant des artères bien percées, plus larges que des fleuves', FLC (X1(2)53.

30. 'La foule bée […] déferle, on est respectueux et intéressé. Ici ce n'est plus de la peinture et on ne rit pas. Suis frappé de voir combien les gens s'arrêtent devant les choses de l'architecture', FLC (FLC R1(6)192).

31. The lecture was published in T. Faulkner (ed.), *Design 1900–1960: Studies in Design and Popular Culture of the Twentieth Century* (Newcastle upon Tyne: Newcastle upon Tyne Polytechnic, 1976), pp.120–40.

32. Ibid., p.120.

33. Deborah Allen, review of the 1954 Buick in *Industrial Design* magazine, February 1955, cited by Banham, ibid., pp.130–31.

2.

OF CARS, CLOTHES AND CARPETS
DESIGN METAPHORS IN ARCHITECTURAL THOUGHT
adrian forty

INTRODUCTION

Like many of the first generation of design historians, I owe a large debt to Reyner Banham. There were, I think, several reasons why Banham, although primarily a critic and historian of architecture, was interested in the design of artefacts. One was his fondness for gadgets. Another was that he regarded the design of non-architectural objects as setting a standard against which architecture could be judged. Behind his remarks about cars, electric mixers or sunglasses, there are usually lessons for the architect. Banham was by no means the first person to use the design of artefacts as a critical tool for thinking about architecture – far from it, as I am going to show – but his use of the analogy was original and served quite special purposes of his own.

Most of the major renewals in architectural thought over the last 150 years have been greatly assisted, if not actually made possible, by analogies from artefacts. Whether or not this will continue, I cannot say, but I believe that design metaphors still have life

left in them as tools of architectural criticism: they can help us to think more clearly about architecture and its place in the world.

Metaphors are the stock-in-trade of architectural aesthetics. In the other visual arts, the question of resemblance was traditionally at the centre of aesthetic debates, but not in architecture, which imitates nothing directly except other architecture. Discussions about architectural value have therefore always resorted to objects outside architecture, whether from the divine, the natural or the human world, and these references have to take the form of analogies or metaphors. In the history of architectural thought, the longest established metaphors are with nature, music, and the human body, all of which have an authority going back to Vitruvius. What, however, none of these metaphors offer is any reference to the human labour involved in making buildings.

This did not matter until the nineteenth century, when major changes in the social relations of work brought about by the advance of capitalism forced people to change their ideas about architecture; they had to recognize that the work of making buildings, which was no longer organized in the same way as it had been, was a major factor in the resulting architectural effect. In order to think about the part production contributed to the aesthetics of architecture, they needed a fresh set of metaphors; those they turned to were drawn from the manufacture of artefacts, the other great realm of human material production. If there is one idea I would like to leave with you, it is this: the significance design analogies have in enabling us to think about human labour as part of the aesthetic of architecture.

THREE CRITIQUES AND SOME CONSEQUENCES

Turning now to some of the critiques of architecture that have relied upon artefacts, my first example is the theory of labour put forward by John Ruskin. Ruskin's general aim as an architectural thinker was to establish what was wrong with the architecture of his time; he identified a long list of faults, but there are two recurrent themes: firstly, the disregard for nature, and secondly the alienation of labour. The theory of the alienation of labour – or, as Ruskin put it, the loss of the freedom of the workman – was put forward in the chapter called 'The Nature of Gothic' in volume two of *The Stones of Venice*, and Ruskin regarded it as his most original contribution to architectural thought.[1] In 'The Nature of Gothic' he identifies the qualities of 'savageness' and imperfection as the fundamental characteristics of Gothic architecture. He argues that the loss of these features in the architecture of his own time was due to the modern system of the division of labour, which had created a separation between those who did the thinking and those who merely executed other people's ideas; under these conditions, the workman's sole aim, since he no longer had to think about what he was making, was to achieve a perfection of finish. Denied the opportunity to exercise his intellect upon the object of his labour, the workman had become a mere slave to production. This state of affairs contrasted sharply with the condition of the medieval craftsman, who was called upon both to think up what he was making as well as to actually make it; and because so much of the medieval craftsman's effort went into the conception, he was, so Ruskin argued, often impatient with the execution, and unconcerned if, in certain respects, the results were imperfect. Gothic architecture, consequently has, Ruskin says:

> the sort of roughness, and largeness, and nonchalance, mixed in places with the exquisite
> tenderness which seems always to be the sign-manual of the broad vision, and massy power

of men, who can see past the work they are doing, and betray here and there something like disdain for it.[2]

What made this theory so compelling was that it applied not just to building, but to all labour with a material result. Ruskin made sure of this by including other products apart from architecture within the argument; his main example was the contrast between old Venetian glass and modern glassware:

> Our modern glass is exquisitely clear in its substance, true in its form, accurate in its cutting. We are proud of this. We ought to be ashamed of it. The old Venice glass was muddy, inaccurate in all its forms, and clumsily cut, if at all. And the old Venetian was justly proud of it. For there is this difference between the English and Venetian workman, that the former thinks only of accurately matching his patterns, and getting his curves perfectly true and his edges perfectly sharp, and becomes a mere machine for rounding curves and sharpening edges; while the old Venetian cared not a whit whether his edges were sharp or not, but he invented a new design for every glass that he made, and never moulded a handle or a lip without a new fancy in it. And therefore, though some Venetian glass is ugly and clumsy enough when made by clumsy and uninventive workmen, other Venetian glass is so lovely in its forms that no price is too great for it; and we never see the same form in it twice. Now you cannot have the finish and the varied form too. If the workman is thinking about his edges, he cannot be thinking of his design; if of his design, he cannot think of his edges. Choose whether you will pay for the lovely form or the perfect finish, and choose at the same moment whether you will make the worker a man or a grindstone.[3]

Let us leave Ruskin now, bearing in mind two things: firstly, that within his argument, the new is always inferior to the old; and secondly, that by including artefacts, he turned the argument from merely a critique of architecture into a critique of his own society and its methods of production.

The second of my three critiques to have used design metaphors is the theory of architectural meaning developed by the nineteenth-century German architect Gottfried Semper. Unlike Ruskin, for whom design metaphors served to add emphasis to his ideas about architecture, Semper was to base his entire theory of architecture upon the applied arts. Also, and this makes his theory more complex, he not only used metaphors to advance his ideas, but his whole purpose was to show that architecture was itself metaphorical.

Semper's is by far the most ambitious of the theories of architecture that refer to artefacts. Semper's basic view was that the purpose of architecture was to communicate a subject, a theme; this subject – since Semper belonged to the Hegelian tradition – was the idea, the civilizing instinct, of each age.[4] The problem about the architecture of his own time was, Semper thought, its failure to communicate its subject effectively. The stylistic chaos of the nineteenth century had, in Semper's view, produced an architecture that was incoherent and meaningless. Semper's aim was to restore to architecture the capacity to represent meaning by recovering the basic principles, the roots of architectural expression.[5]

For the purposes of my argument, what is so interesting about this enterprise is that Semper set about it not by looking at architecture, but by looking at the industrial arts, at the history of artefacts. The surprising thing about his great work of architectural theory, the two volumes of *Der Stil*, is that it is almost entirely about the crafts: the whole of the first volume is about textiles,

and the second is about ceramics, woodworking and masonry. Although Semper says a lot about architecture in the course of the book, he never deals with it directly. Odd as this may seem, Semper explained that he thought that 'The industrial arts are ... the key to understanding architectural as well as artistic form and rule in general'.[6] Knowing this, the omission of architecture from *Der Stil* and his failure to complete the projected third volume on architecture do not seem quite so strange.

How, then, did Semper arrive at the idea that the key to architecture lay in the industrial arts, and how did he justify this unconventional view? There are various answers as to where the idea came from. First of all, he spent the years from 1850 to 1855 in England, where he not only saw the Great Exhibition, but got to know Henry Cole, who appointed him as a teacher in the newly formed Department of Practical Art. Semper later said that it was contact with Cole and his circle that convinced him that 'The history of architecture begins with the history of practical art'.[7]

The second source of Semper's ideas was almost certainly French. The longstanding theory of the transmutation of materials had proposed that the origins of architecture lay in carpentry, of which stone construction was a metaphorical representation. Semper, however, extended this idea after reading a little book published in 1850 by the French artist Jules Ziegler, *Études Céramiques: recherche des principes du beau dans l'architecture, l'art céramique et la forme en général*. Ziegler argued that the origins of Greek architecture lay not in building at all, but in pottery; simple timber huts, he said, had been constructed all over Europe in prehistoric times, so there must have been other reasons apart from the timber hut theory why it was only in Greece that architecture developed. Ziegler's suggestion was that, in order to have a conception of architecture, one must have an appreciation of abstract form, and this, he suggested, the Greeks acquired through their pottery industry, which was historically older than their architecture. By the potter's constant exercise of aesthetic judgement in making pots, and the customers' in choosing them, the pottery quarter of ancient Athens became a kind of school of taste, where the Greeks acquired their ideas of formal beauty. Semper followed Ziegler in assuming that the applied arts preceded architecture in all civilizations; he says 'The arts were far advanced in their application to adornment, weapons, implements and vessels thousands of years before monuments were built' and, like Ziegler, he thought pottery was a principal origin of architecture.[8]

Whatever the contribution of these various sources to Semper, Semper's mature thought goes far beyond any of them. *Der Stil* opens with the proposal that just as linguists have discovered that words in different languages have developed from common roots, so it should be possible to study art in the same way and identify the original type forms from which all subsequent artistic forms were derived.[9] Semper's problem was, of course, how to find these type forms. In fact he reproduces Ziegler's table of the grammar of pottery forms (Figure 2.1), showing how all forms are derived from the cube and the sphere, but Semper's theory is much more sophisticated than this purely abstract formulation. What Semper proposed was that the type forms of artefacts are the outcome of the materials of which they are made, of the techniques of working those materials, and the purposes for which they are intended, all combined together so as to convey a specific idea. To illustrate this we can take one of his examples, the difference between the Greek hydria and the Egyptian situla. The form of the situla is perfectly adapted to drawing water from a river, and is

Grundformen der Töpferei. (Nach Ziegler.)

2.1. Pottery type forms from Gottfried Semper, *Der Stil in den technischen und tektonischen Künste*, vol. 2, 1863, p.80.

characteristic of a culture living on a flat plain by a slow-moving river (Figure 2.2). Of the hydria, Semper says its:

> function is not to draw water, but rather to catch it as it flows from the spring. Hence the funnel form of the neck and the basic form of the body, whose centre of gravity is located as near as possible to the mouth of the vessel. The Etruscan and Greek woman carried the hydria on her head, upright when it was full, and horizontal when it was empty.[10]

Each form thus represents most succinctly not only its purpose, but also communicates the characteristics of the culture from which it came.

In Semper's theory, meaning is generated in two ways. The first, which I have already illustrated, applies to type forms that draw attention to their own purposes. We can take other examples

Situla. Hydria.

2.2. Situla and hydria from *Der Stil*, vol. 2, p.4.

from the volume on textiles: the wreath is a basic type form, produced by binding sprigs together, and it perfectly represents the idea of that process. The knot, which Semper says 'is probably the oldest technical symbol', appears in the forms of basketwork and weaving.[11] These examples are all instances of what Semper calls 'self-illuminating symbols', that is, forms that communicate through their appearance the process by which they are made.

The second way Semper says meaning is generated is through metaphor, through the transfer of a motif developed in one material to another: two examples Semper gives are the basketweave pattern on the form of the pot (Figure 2.3), and the sarcophagus with stone-carved ropes inherited from the binding of the mummy. In both cases, the decorative forms are fictions; they transfer the idea of a previous process to the new material. However, by far the most important of Semper's examples of the creation of meaning through metaphorical transformations of forms from one material to another is that of the woven rug and the wall. Semper argues that the original dwellings historically preceding architecture were the tents of nomads, which were lined and divided internally with hanging carpets. Thus the rug is the antecedent of the solid wall (Figure 2.4). In early architecture, Semper argues, the form of the wall was derived from the carpet, and he illustrates the tomb of Midas, where the wall pattern is that of a carpet, translated into another medium, stone. From such examples, Semper goes on to put forward the general principle that 'Solid walls are only an inner invisible scaffolding, hidden behind the true representative of the wall: the coloured woven carpet'.[12] Semper is thus able to argue that the symbol of the wall is as clothing or cladding, and that good architecture communicates this as, for example, in the illustration of the wall surface of a room in Pompeii. In short, therefore, the ability of the architect lies in being able to use historically

Irdenes Gefäss mit modellirtem Netzornament
(Toskanella).

2.3. Pot with basketwork decoration from *Der Stil*, vol. 2, p.84.

2.4. Tomb of Midas from *Der Stil*, vol. 1, p.429.

developed type forms, such as the carpet, to bring out the symbolic properties of the materials, techniques and purposes in hand. For Semper, the mistake of his contemporaries was that:

> They proceed from the erroneous supposition that the question of style is principally a constructive question and they do not acknowledge the inherited traditions of art symbolism.[13]

It was these traditions of symbolism that Semper hoped to recover through his study of artefacts and type forms.

What, then, did Semper's use of artefacts as a theory of architecture achieve? Firstly, it enabled him to refute the theory of structural rationalism – that is the idea that form is derived from structural principles – the theory developed most extensively by his French contemporary, Viollet-le-Duc. Secondly, it provided an effective counter-argument to theories that saw architecture as developing by natural evolution according to principles of its own. By stressing the importance of the human creative process, both in developing the basic type forms and in using them metaphorically, Semper put an end to the eighteenth-century idea that architecture followed a path the same as, or analogous to, nature. His stress upon the industrial arts made human production, both in the sense of technical skill, and also above all in the sense of imagination and symbol formation, into the basis of all architecture. Although Semper's concept of production was entirely different from Ruskin's, both were able, through their reference to the applied arts, to establish human effort and social life as the starting points for thinking about architecture.

I come now to my third case of design metaphors contributing to architectural thought, and that is in the theory of modernism. Wherever in Europe in the last decade of the nineteenth and the first decades of the twentieth century people started to talk about the 'modern' and to discuss the question of a modern style, they looked to contemporary artefacts for clues as to what the modern might look like. Perhaps the best-known examples are Adolf Loos's essays about plumbing and menswear. That critics looked to the design of artefacts to provide references for modern architecture may well be partly due to Semper, whose ideas were well known in German-speaking countries.

Design metaphors played a particularly important part in modernist architectural thought, and were put to a variety of uses. Briefly, these were as follows. First of all, many architects regarded machines and machine-made objects as the source for the geometric, abstract forms, which they thought were the most representative feature of the 'modern'. The sections in Le Corbusier's *Towards a New Architecture* called 'Eyes Which Do Not See', dealing with ships, aeroplanes and cars, are as good an illustration as any of this point of view, but it appears in Dutch, German and Russian thought too. This particular application of design metaphors was a major theme of Reyner Banham's *Theory and Design in the First Machine Age*, and it is too well known to need repeating here.

The second use of design metaphors in modernism was to legitimize the principles of structural rationalism, most particularly the requirement to achieve the most with the least, to give the maximum effect with the minimum of means. Here, the economy of materials and the legibility of the structure evident in products of engineering such as bridges, railway engines and steamships were held up as examples for architecture to follow. Since structural rationalism was not itself a modernist theory, but belonged to the nineteenth century, it is natural that we should find earlier instances of this analogy in, for example, Viollet-le-Duc's *Lectures on Architecture*.[14] The only change

is that the early twentieth-century critics were much more emphatic about the lessons architects should be learning from engineering. For example, Hermann Muthesius in 1913 criticized architects' attachment to massiveness as follows:

> Some people might maintain that true architecture is concerned with the enclosure of inner spaces, and that as such enclosure demands massive walls, the roof of a hall or large space made of iron with a glass covering could in no way be regarded as aesthetically pleasing.

Such a view, says Muthesius, is proved wrong both on historical grounds, since Gothic architecture achieved its effects precisely through the latter approach, and also by the analogy with engineering:

> To condemn a delicate and slender form as artistically unworkable for appliances and tools must appear as sheer nonsense. On the contrary we admire a fine surgical instrument because of its elegance, a vehicle because of its pleasing lightness, a wrought-iron bridge soaring over a river because of its bold use of the material.[15]

Again, like the notion that machines justify the use of abstract geometric forms, structural rationalism is well-enough known for me to need say no more about it.

The third sort of design analogy in modernism occurs when the theorist wanted to draw attention to building production. It is here, particularly, that the car comes into its own as a symbol. When Le Corbusier says 'une maison comme une auto',[16] he is explicitly inviting a comparison between the labour-intensive methods of building production in Europe at the time and the new American methods of management and factory organization; it is to Taylorism and Fordism that he refers.[17] The great success of Henry Ford in manufacturing a cheap car through standardizing the design of its components and limiting production to a single model was widely admired in Europe in the 1920s, and held up as the ideal to which all production should aspire. Similarly, the Taylor system of management, with its strict application of the principle of the division of labour and teaching the worker 'the one best way' to do his task, so as to bring about greater efficiency and productivity, was well known in Europe, especially in Germany, where it had been introduced into industry before 1914. In the 1920s, many European architects were convinced that automobile production provided the key to the reform of building production and the lowering of building costs. For example, the German architect Bruno Taut wrote in 1924:

> The problem of house building must be tackled along lines that are valid in industry for the production of machines, cars and similar objects. The success of Henry Ford in car production is in part based on the fact that he selects his raw materials in the best possible way ... Exactly the same can be applied to house building.[18]

As an exemplar for the rationalization of building production, the car was important in modernist architectural thought throughout the 1920s and, indeed, the analogy between car production and building production has been made regularly ever since.[19] Within Le Corbusier's metaphor, the car also had a secondary meaning, in that he believed that the results of Taylorized and Fordized work led to aesthetic perfection in the product.[20] However, this particular metaphor lost its meaning when General Motors introduced style obsolescence and the annual model change to the Detroit automobile industry: market pressures forced the Model T out of production, and its history as a type object ended in 1926 when Ford started introducing new models. It is from around then that

car design (though not car production) went into eclipse as an architectural analogy; by the 1940s routine attacks on Detroit car styling provided regular catharsis for European modernists.[21]

If design metaphors played their part in the development of modernist architectural thought, they also had a role in the historical interpretation of modernism. The early historians of modernist architecture approached their subject from the standpoint of German idealism, and believed that in order to explain the modern style they had, in Wölfflin's words, to do 'nothing other than to place it in its general historical context and to verify that it speaks in harmony with the other organs of its age'.[22] Just how this idea could work in practice we can illustrate from the work of the Viennese art historian, Alois Riegl, working in the 1890s. In his *Late Roman Art Industry*, Riegl wanted to establish the identity of the late Roman style by looking at architecture, painting, sculpture and the applied arts all together. He took, for instance, S. Apollinare in Ravenna and a little Roman dish, and argued that, as far as the artistic element is concerned, both objects are the same.[23] This surprising observation he justified on the grounds that neither the church nor the dish are spatially bounded objects, as both have the potential for extension beyond their physical limits; the church because it has no contained unity of form like earlier Roman buildings such as the Pantheon, the dish because the pattern is infinitely extensible, as his drawing shows (Figures 2.5a and 2.5b). By establishing the common element, Riegl is able to claim that both embody the same artistic will.

The early historians of modern architecture, heavily dependent upon the methods of Wölfflin and Riegl, saw their job as being to show that the modern artefact and the modern building spoke with the same spirit. Of course, it all depended on what artefacts the historian chose, and in *Space, Time and Architecture* (1941), Sigfried Giedion had to cross the Atlantic to find artefacts which were acceptably modern: his examples were things like tools and locks, whose special character was their simplicity and anonymous design. But Giedion's attempts to find enough examples of artefacts

2.5 (a) Late Roman bronze enamel dish and (b) drawing showing expansion of central pattern from *Spätrömische Kunstindustrie*, pp.191–2.

representing the spirit of the modern were doomed to failure, despite his Herculean attempt in *Mechanization Takes Command* (1948). It was all very well for him to say of Alvar Aalto's cantilever chair 'This emotional need [to defeat gravitation] is as innate to our own time as the buttress to the Gothic and the undulating wall to the baroque', but how was he to explain all the non-cantilevered reproduction chairs filling the furniture shops of Europe?[24] Giedion's solution was to get rid of them by classifying them as 'transient facts', and to retain as 'constituent facts' only those objects that fully corresponded to the modern. Other apologists of modernism were more evangelical and put forward an argument that ran roughly as follows: the legitimacy of modern architecture as a genuine style depended on its identity with modern products, but if these did not match up to the criteria of architectural modernism, then, rather than let the identity of modernism be called into question, it was necessary, in order to save the theory, to reform the design of the objects themselves. What Nikolaus Pevsner found so distressing about the electric fires with artificial coal effects and reproduction furniture that he described in his *Enquiry into Industrial Art in England* (1937), was that they did not fit with his wish for all the objects of the age (and particularly those which ought to have been most modern) to speak in harmony – they betrayed the legitimacy of modernism. In a rather similar way, Herbert Read's view of design in *Art and Industry* (1934) was formed by the wish to make design conform to the same standards of modernity as held in the other arts. I have said enough to make it clear that part of the origins of design history, at least those bits deriving from *Mechanization Takes Command* and Pevsner's *Pioneers of the Modern Movement* (1936), arose not simply from an interest in the design of artefacts as such, but out of the need to validate modern architecture.

This would be a good moment to say something about Reyner Banham's use of design metaphors. Although Banham had no doubt that there was a relationship between architecture and design, such that each could draw lessons from the other, he was well aware of the difficulties the modernists had got themselves into by trying to make designed objects meet architectural criteria:

> To blame the automobile, for instance, for not answering to a code of visual practice adapted to buildings is as inconsequential as it would be to censure the apple for not having a rough bark, or the peach-tree for not having a downy skin. It is not merely that the car and the building are made of different materials, that one is mobile and the other static, but that the manner of consuming the two products is so different.[25]

Banham insisted that product design be taken on its own terms. By so doing, and recognizing how it differed from architecture, it would once again become possible for architecture to learn from analogies with design. There were two areas in particular where Banham believed that comparisons between architecture and design reflected badly upon architecture. The first was architecture's failure to take advantage of the rapid technical developments in consumer goods – in particular, miniaturization, the development of electronic control systems, and high-quality finishes, all of which had potential implications for architecture. The second was what architects could learn about designing for consumer aspirations. This was where cars came back into their own as metaphors. Detroit car styling, condemned by the modernists as culturally degenerate, was rehabilitated by Banham and his fellow members of the Independent Group:

> automobiles ... which are themselves environments for human activities, provide a standard of comparison for the activities of the architectural profession. They may ruefully compare the scale of constructional work produced by the automobile culture with that

entrusted to architects; they may enviously admire the apparently close communion that exists between users and producers, the direct way in which designers and stylists seem to be able to apprehend the needs of motorists and satisfy them, and they may also draw from the work of stylists some sobering conclusions about the possibility of tailoring aesthetics to fit the aspirations or social status of the clients.[26]

For Banham, then, product design was in some respects a superior activity to architecture – and certainly a more advanced one; and for the most part architects' genuflexions to product design were worthless, since they generally neglected to recognize it for what it was. One can understand why Banham was so enthusiastic about design history: he saw in it a potential corrective to architecture.

THE FUTURE OF METAPHORS

What future do design metaphors have in architectural thought? Although some of the ideas suggested by such metaphors are now deeply unfashionable – like the application of style obsolescence in consumer goods to architecture – it is clear that metaphors as such are going to continue to be used. We shall have to go on seeing architecture *as* something, and it is more than likely that we shall continue to see it in terms of other human products; possibly analogies will be made with different sorts of artefacts, or we may see the revival of artefacts which have been out of favour. Dress is one analogy that has returned to favour. Dress was always tricky for modernists because, although they liked the rationality of modern dress, they disliked the arbitrariness of changes in fashion, which did not match up to their belief in the unity and ultimate perfectibility of architectural style.[27] Now that stylistic variation and fashion are being acknowledged again in architecture, critics are referring to dress more often.

One interesting new metaphor has been suggested by the contemporary architect, Robert Adam.[28] He proposes that the contemporary spec-built house, despite its traditional appearance, is a truly modern, high-tech building, and justifies this by the concept of the skeuomorph. We have already seen a skeuomorph in the basketwork pattern on Semper's pot, and Adam's argument is that this persistence of old elements in new types is a fundamental law of human material production. He quotes the 'Qwerty' typewriter keyboard, originally designed to keep the most used letters of the typewriter apart so that the keys would not jam, but no longer necessary with the PC; nevertheless, the Qwerty keyboard has survived. In the same way, he says that the traditional exterior of the spec-built house is not something to be moralized about; it is simply conforming to the principles of human production, a fact to be acknowledged. The modernists were contemptuous of skeuomorphs, because they saw them as preventing objects from being truly modern; Adam has cleverly inverted their argument, proving that industrial culture, far from being a model for unadulterated progress, in fact legitimizes tradition.

I have suggested that the greatest value of metaphors from the world of consumer goods is as a way of drawing attention to the significance of the processes of production in the making of judgements about architectural quality. Here particularly we need to look for new metaphors, since it is perfectly apparent that the old modernist analogy of making a building like a car is no longer viable. The modern international division of labour whereby a car is designed in Germany, made in Spain and sold in Britain is just not a suitable metaphor for building. Since in practice building is a unique combination of craftwork and industrial production, architectural commentators might

find it more use to look for analogies in the crafts again in order to discuss the nature of the process. I cannot predict what new metaphors will emerge in architectural thought, any more than I could say what new metaphors will enter everyday language, but I have – I hope – made it clear that I think they will continue. I also think that design historians should keep an eye on how architectural critics are using metaphors, and make sure that they do not start misrepresenting design. If design metaphors are to be any use, it is no good if they are based on fantasies about design. In short, I suggest that the better we understand design, the better we shall understand architecture.

POSTSCRIPT

Even after death Reyner Banham retained his capacity for surprise. In his posthumous essay 'A Black Box', published in 1990, Banham cast doubt on the value of comparisons between non-architectural objects and architecture, saying that they had 'left the body of architecture confused rather than reformed'.[29] Had I known of this essay when I gave the lecture in 1989, my argument would have been rather different.

NOTES

1. Ruskin states the importance he attached to 'The Nature of Gothic' in *Lectures on Architecture and Painting* (1854), reprinted in E. T. Cook and A. Wedderburn, (eds.), *The Works of John Ruskin*, vol. XII, pp.100–101. (All subsequent references to Ruskin are to this edition of his complete works.) For the significance of 'The Nature of Gothic', see Mark Swenarton, *Artisans and Architects. The Ruskinian Tradition in Architectural Thought* (London: Macmillan, 1989), chapter 1.
2. Ruskin, *Works*, vol. X, p.268.
3. Ruskin, *Works*, vol. X, pp.199–200.
4. *Über Baustil*, Zurich, 1869; translated by J. W. Root and F. Wagner as 'The Development of Architectural Style', *The Inland Architect and News Record*, Chicago, vol. XIV, Dec. 1889, pp.76–78.
5. See Michael Podro, *The Critical Historians of Art* (New Haven: Yale University Press, 1982), chapter IV, on which this interpretation of Semper's theory is based.
6. 'Attributes of Formal Beauty' (1856–59), in Wolfgang Herrmann, *Gottfried Semper. In Search of Architecture* (Cambridge, MA: MIT Press, 1984), p.224.
7. Lecture, 1853, from Semper, H., *Gottfried Semper. Ein Bild seines Lebens und Wirkens*, Berlin, 1880, p.4, quoted by Ettlinger (Ettlinger, L. D. 'On Science, Industry and Art. Some Theories of Gottfried Semper', *Architectural Review*, vol. 136, July 1964, pp.57–60). See also Herrmann, op. cit., 3.
8. Semper M.S., quoted in Herrmann, op. cit., p.86.
9. Semper, G., *Der Stil in den technischen und tektonischen Künsten*, Frankfurt, 1860 and 1863; vol. 1, 1860, p.1. English translation: *Style in the Technical and Tectonic Arts*, by H. F. Mallgrave and Michael Robinson (Los Angeles: Getty Publications, 2004).
10. Ibid., vol. 2, 1863, p.5.
11. Ibid., vol. 1, p.180.
12. Semper, *Die Vier Elemente der Baukunst* (Brunswick, 1851), p.58, quoted in Ettlinger, op. cit.
13. *Über Baustil*, 1869, op. cit.
14. Vol. 1, lecture VI; English edition, London, 1877, p.183.
15. Hermann Muthesius, 'The Problem of Form in Engineering' (1913), translated in Tim Benton et al. (eds.), *Form and Function. A Source Book for the History of Architecture and Design 1890–1939* (London: Crosby Lockwood Staples, 1975), p.116.

16. Le Corbusier, 'Maisons en Série', *L'Esprit nouveau*, no. 13, p.1535; reprinted in *Vers une architecture*, Paris, 1923.
17. See M. Mcleod, '"Architecture or Revolution": Taylorism, Technocracy and Social Change', *Art Journal*, Summer 1983, vol. 43, no. 2, pp.132–47; and M. Mcleod, 'Urbanism and Utopia. Le Corbusier from Regional Syndicalism to Vichy' (Princeton University Ph.D. thesis, 1985).
18. Bruno Taut, 'Die industrielle Herstellung von Wohnungen', *Wohnungwirtschaft*, 17/18, 1924, vol. 1, p.157, quoted in K. Wilhelm, 'From the Fantastic to Fantasy', *Architectural Association Quarterly*. vol. 11, no. 1, 1979, p.7.
19. See Brian Finnimore, *Houses from the Factory, System Building and the Welfare State* (London: Rivers Oram Press, 1989); and Colin Davies, *The Prefabricated Home* (London: Reaktion, 2005).
20. Amadée Ozenfant and Charles-Edouard Jeanneret, *Après le Cubisme* (Paris, 1918), p.26; and Le Corbusier, *Towards a New Architecture* (London, 1946), p.255.
21. For example, W. Gräff 'On the Form of the Motor Car' (1925–26) in Benton et al., op. cit., p.222.
22. H. Wölfflin, *Renaissance and Baroque* (1888), English translation, Collins, London, 1984, p.79.
23. Alois Riegl, *Spätrömische Kunstindustrie* (1901), trans. R. Winkes, as *Late Roman Art Industry* (Rome: Giorgio Bretschneider, 1985), p.43 and p.205.
24. Sigfried Giedion, *Mechanization Takes Command* (New York: Oxford University Press, 1948), p.504.
25. Reyner Banham, 'The Machine Aesthetic', *Architectural Review*, vol. 117, April 1955, p.228.
26. Reyner Banham, 'Stocktaking', *Architectural Review*, vol. 127, February 1960, p.96.
27. For example Marcel Breuer, 'Where Do We Stand?' (1934), reprinted in Benton et al., op. cit., p.180. The whole question of the relation between modernist theory and dress has since been extensively investigated by Mark Wigley, *White Walls, Designer Dresses* (Cambridge, MA and London: MIT Press, 1995).
28. Robert Adam, lecture at RIBA, February 1988, published in *Building Design*, 4 March 1988, pp.32–33.
29. 'A Black Box: The Secret Profession of Architecture', was published in *New Statesman and Society*, 12 October 1990, pp.22–25. Reprinted in *A Critic Writes: Essays by Reyner Banham*, selected by Mary Banham *et al.* (Berkeley and London: University of California Press, 1996), pp.292–99.

3.
THEORY AND DESIGN
THE BANHAM FACTOR
gillian naylor

I will start by confronting what I have called the 'Banham factor' – Banham's approach to 'Theory and Design' – and its implications for design historians.[1] For although he was primarily an architectural historian and theorist, he frequently refers to himself as a design historian; so I have tried to concentrate on what he says about objects, although I have had, of course, to relate his interpretations to his architectural theory.

Debates about the Banham factor today can be problematic: it is less than ten years since he died, so it is probably too early to 'historicize' him. Again, his 'theory' of design was founded in a belief in technological progress, so that some of his assumptions about lifestyle, expendability and generally being 'with it' (or 'digging it') strike a hollow chord in today's social and political climate. And he wrote so much: the bibliography in *A Critic Writes* lists sixteen books, and a mind-boggling cornucopia of articles and reviews – for the *Architectural Review*, for *New Statesman*, for *New Society*, and a range of other journals, as well as broadcasts for BBC radio and television.[2] And the articles and the journalism complement the books: he uses them to promote his theories, to comment on his research, to think aloud, and to inform as well as challenge his readers. So trying to cope with him is like trying to cope with Ruskin, although he would not have appreciated the comparison, but like Ruskin he can be sublime – 'spot on' is more appropriate – and he can be infuriating, because he was one of those historians who used 'his' interpretation of the past to judge the present, and to predict as well as prejudge the future.

Banham was also a professor, in the fullest sense of the word: Professor of the History of Architecture at University College, London (1968); Director of Environmental Studies at the State University of New York (1976); Professor of Art History at the University of California (1980) and, just before he died, Professor of Architectural History at the Institute of Fine Arts in New York. He was also a modernist and very much a man of his time: here he is in the 1960s (Figure 3.1), a hero of modern life – 1960s modern life, of course, not 1970s 'on yer bike' modern life. And man and machine are in motion: he's in command of what is now a suitable subject for a design historical case study, the Moulton bike (see Plate 1). He's wearing what seems to be a dress suit, not the ubiquitous duffle coat. He hasn't got bicycle clips, but he's wearing a cloth cap ... a toffish cloth cap as far as I can see; his shoes are shining, and his beard is patriarchal. And he's obviously in

3.1. Reyner Banham on a Moulton bicycle, London, 1960s.

control there, and making a complex and male-oriented statement ... about design, class, mobility and modern life.

This is a new 'New Spirit' that Banham is addressing and dressing up for. He's riding an urban bike – it is a bike, he says, that has 'put a new class of men in the saddle' – 'the middle-class urban executive radicals'.[3] It's a designer bike and it's got some interesting gizmos – its springing, for example, and that 'simple ring of polythene on the chain-wheel' that protects one's clothes from oil, and which liberates 'the rider from that badge of social shame: trouser clips'.[4] This is a clean machine that signals 'the disappearance of the proletarian cyclist': the working classes – as he says in his paper on 'The Atavism of the Short-Distance Mini-Cyclist'[5] – don't ride bikes any more – they've all got Populars and Cortinas and Minis. So this is a 'progressive bike' ... and 'progressive people, the people who are going to have to make social action, have got, somehow, to learn to ride with the real culture of the working classes as it exists now'.[6] By implication, of course, he is one of their representatives.

Now I have taken these quotations from articles that Banham was writing in the 1960s, when the photograph was taken. *Theory and Design in the First Machine Age*, the book that established his reputation as a historian, was based on his Ph.D. supervised by Nikolaus Pevsner at the Courtauld Institute, and was first published in 1960.[7] By then Banham was working for *Architectural Review*, writing for *New Statesman* and other journals as well as broadcasting and, of course, was active and proactive with the members of the ICA's Independent Group, attempting to define and demonstrate what they considered to be 'the real culture of the working classes'.

All these biographical data are, of course, familiar, but they are worth repeating, because they help to contextualize him, or at least to indicate where he was coming from, and how he was defining himself and, more importantly, what he was defining himself against. Banham was born in Norwich in 1922; the 'working class is where I come from', he tells us.[8] He was a 'scholarship boy' and this inheritance, he believed, 'gave him the right to speak about various subjects'; he left school in 1939 and began a management course at the Bristol Aeroplane Company. And this background in engineering meant, as so many of the mini-biographies about him have told us, that he understood – and made it his business to know – how things worked.

After the war, he began to review art exhibitions for local newspapers, and this led him to the Courtauld Institute in 1949, the Ph.D., and the publication of *Theory and Design in the First Machine Age*, under the tutorship of Pevsner. Now this first book, *Theory and Design*, is in some ways Pevsnerian, in that history is presented in terms of predisposing causes, successions, legacies, movements, and victories of style. But Banham, of course, is no Pevsner clone, his book is not about pioneering the one true style – it is about 'developments in architectural form and ... architectural thought in an industrialised epoch'[9] and it concentrates – with verve, conviction and scholarship – on the positive responses of some theorists and some designers (in this case, mainly architects and artists) to the mechanization of their environment.

And this means that Banham, like Pevsner, is both selective and judgemental in his interpretation of the past. According to Banham, it is the responses to technology, and industrialization, and the new 'that divide the men from the boys', and justify the inclusion of the men, and the exclusion of the boys, from consideration in the text. The book, or the thesis, concentrates on those thinkers and doers who 'could no longer treat the world of technology with hostility or indifference'.[10] So William Morris, so important and so puzzling to Pevsner, gets very short shrift here, as do many of his successors.

According to Banham, Voysey, for example, was 'a muddled-headed thinker' because he claimed that 'he only wanted to improve and continue the native cottage vernacular of southern England', and so failed to recognize, or to accept, that he really belonged to the Modern Movement:

> His [Voysey's] work excels by the sharp definition of one smooth, plain surface from another, the fine precision of his arrises and the bold geometry of his forms, and yet he was quoted in 1908 as saying that he preferred 'the soft effect of the outline of an old building where the angles were put up by eye, compared with the mechanical effect of the modern drafted angle'.[11]

So Banham, unlike Pevsner, also distinguishes the men from the boys by their approaches, or attitudes, to style. In the Banham canon there is no one true style – there is 'The Style for the Job', a definition he attributes to James Gowan, and he defines what he means when he writes, in an article in the *New Statesman* in 1964, about the Stirling and Gowan Engineering Building for the University of Leicester (see Plate 2). The building succeeds, he says,

> because job and style are inseparable ... [the architects] had neither time, money nor ground space for disembodied speculation about style; the character emerges with stunning force from the bones of the structure and the function it shelters.[12]

The building has, he says,

> regained a good deal of the bloody-minded elan and sheer zing of the pioneer modernism of the early twenties. Largely, I think, this is because it really does seem to be a natural machine-age architecture of the sort that must have been in the minds of the Werkbund's founding fathers or Antonio Sant'Elia.[13]

So for Banham, the Engineering Building regains a past that he had identified in *Theory and Design*. In that text – thanks to the recent research and scholarship that he acknowledges in his dedication – Banham was able, unlike Pevsner in *Pioneers*, to include a major section on De Stijl ... of seminal significance, especially because of Dutch contributions to European Constructivism ... but, and more significant to his personal convictions ... one whole section is devoted to Futurism and the Futurists (those 'freaks and fantasts' according to Pevsner).[14]

And I would like to suggest that it was this discovery of Futurism and the Futurists while he was researching *Theory and Design* that defined Banham's modernism and his interpretation of modernity: the manifestos and intentions of the Futurists confirmed his conviction that technology and technological invention, especially when interpreted by the avant-garde, held the key to the future. It also confirmed his assumption that design history involved the study of the products of industrialized and industrializing cultures, and therefore of industrial and/ or mass-produced design ('Most of the US had no pre-industrial culture', he once wrote – he would change his mind later – every respectable historian changes his or her mind). In the conclusion to *Theory and Design* he writes:

> In cutting themselves off from the philosophical aspects of Futurism, though hoping to retain its prestige as Machine Age Art, theorists and designers of the waning twenties cut themselves off not only from their own historical beginnings, but also from their foothold in the world of technology.[15]

This discovery, or rediscovery, of Futurism also had its impact on the agents provocateurs of the Independent Group. Here is Banham, on the BBC in 1959, describing 'the point in time [it's around 1954] where Futurism suddenly became important for myself, and for the circle of friends on whom, at that time, I sharpened my wits and tried out my theories'. He'd been reading Boccioni's *Pittura Scultura Futurista*, where Boccioni is describing:

> the ... anti-artistic manifestations of our epoch – café-chantant, gramophone, cinema, electric advertising, mechanistic architecture, skyscrapers ... night-life ... speed, automobiles, aeroplanes and so forth.[16]

Now these convictions, as I said, help to define the nature of Banham's modernism. To bowdlerize Baudelaire, he is the historian/proselytizer/champion of 'the transient, the fleeting and the contingent' in modern life; Pevsner, on the other hand, was the defender of modernism's 'eternal and immutable'[17] ... and Pevsner's convictions were, of course, largely determined by his age, his training as an art historian, and above all by his experience of Fascist Europe.

It is hardly surprising that 'theorists and designers of the waning 1920s' made few references to their Futurist forebears, given the Futurists' subsequent political affiliations. But while Banham acknowledges that the Futurists were 'spiritually bankrupt' in 1914, he can dismiss the politics because of the relevance – to him, and to his contemporaries – of the message. And, of course, similar ideological vs. political confrontations arise with Pop and the Americanization of British culture. American politics were causing some problems in the age of McCarthyism, and Banham confronts the issues, or attempts to confront the issues in 'The Atavism of the Short-Distance Mini-Cyclist', a memorial lecture to Terry Hamilton, Richard Hamilton's first wife. The date is 1964, and it is in this lecture that Banham describes his childhood in Norwich and the 'live culture' of the place:

> The emphasis and most of the content of this culture was American ... Now if this is where we came from, it left many of us [he's talking about the Independent Group] in a very peculiar position, *vis-à-vis* the normal divisions of English culture, because we had this American leaning and yet most of us are in some way Left-oriented, even protest-oriented... It gives us a curious set of divided loyalties. We dig Pop, which is acceptance culture, capitalistic, and yet in our formal politics ... most of us belong very firmly on the other side.

He concludes:

> Pop is now so basic to the way we live, and the world we live in, that to be with it, to dig the Pop scene, does not commit anyone to left or to right, nor to acceptance or protest about the society we live in. It has become the common language, musical, visual, and (increasingly) literary, by which members of the mechanised urban culture of the Westernised countries can communicate with one another in the most direct, lively and meaningful way.[18]

Now wherever we stand on its morality – and it is problematic in view of subsequent developments – it is this championship of high modernism's 'other' that distinguishes Banham, and defines him as an architectural historian and as a design historian. There has been, he says, a 'domestic revolution' that is demonstrated in the form of 'small machines – shavers, clippers, hairdryers;

mixers, grinders, automatic cookers, washing machines, etc., etc.' There have been other revolutions in the media and mass communications represented by the cinema, the radio, and television ... and there has been that great revolution in personal mobility – the transformation of the automobile, 'that symbolic machine of the First Machine Age'.[19] In the 'First Machine Age', as he points out, most of these things (apart from the cinema) contributed to the convenience and comfort of the middle-class intelligentsia. Now, however, these things and more are available to the masses: they are churned out and into all parts of the globe in super-abundance, and they are expendable – here today and gone tomorrow – a situation anticipated by the cultural or anti-cultural revolutions that had been signalled by the Futurists half a century earlier.

So when Peter and his friends exited from the ICA in the early 1950s, they were celebrating the New Brave World of consumption – a world of abundance, expendability, irreverence for the past, and contempt for Establishment values. And since he was a critic as well as a historian of design, he could never be objective about objects, or about the defenders of certain modernist faiths. He had no time for those 'aesthetic fumbletrumpets who were forever galloping into print with ill-drawn analogies between machinery and abstract art',[20] nor did he have much time for the 'standards' which, according to the Council of Industrial Design, distinguished the good from the bad. An object was appropriate if – like the Moulton bicycle – it was styled for the job and, above all, if it was a 'goodie', not, of course, in the sober, Council of Industrial Design sense of good design. An object was a 'goodie' if its 'sole object was to be consumed ... like soft-serve ices, disposable sanitary towels, coke and chewing gum'. I'm quoting from 'Who is This "Pop"?' – first published in *Motif* in 1963.[21]

Banham takes design or object analysis beyond connoisseurship and the preoccupation with the 'good', or with 'distinction', and confronts the role of consumption in modern life. He challenges the high modernist historians' preoccupation with what he calls 'fine-art product criticism', and their 'mystique of form and function under the dominance of architecture'.[22] Since we live in a throw-away economy, he says, and since mass-produced goods are expendable, they must be 'excluded from the categories of Platonic philosophy'. I am quoting again from 'A Throw-Away Aesthetic', a seminal article that was first published under the title of 'Industrial Design and Popular Art' in the American magazine *Industrial Design* in 1960. It is in this article that Banham suggests alternative approaches to the interpretation of objects or design analysis: it is what products signal, what forms of symbol system they belong to or adopt, and their iconography that is important, he says.

> Unlike criticism of fine arts, the criticism of popular arts depends on an analysis of content,
> an appreciation of superficial rather than abstract qualities, and an outward orientation
> that sees the history of the product as an interaction between the sources of the symbols
> and the consumer's understanding of them.[23]

Design historians, of course, are now deeply involved in research into patterns of consumption, i.e. people's reactions to the goods that are and were available to them, how these goods were promoted and retailed, and who bought what and why. These are painstaking, uphill tasks and they involve long sessions in many archives, the microcosm of research that precedes interpretation. What Banham is signalling here, however, is what might be described as a semiological – or Barthesian – approach to the interpretation of objects, not necessarily in this case as a methodology for the

historian, but as a means of product assessment for the critic, and, equally important, as a means of enabling the industrial designer to anticipate consumer needs and so produce popular art.

> These trends ... indicate the function of the product critic in the field of design as popular art: Not to disdain what sells but to help answer the now important question, what will sell? Both designer and critic, by their command of market statistics and their imaginative skill in using them to predict, introduce an element of control that feeds back information into industry. Their interest in the field of design as popular symbolism is in the pattern of the market as the crystallisation of popular dreams and desire – the pattern as it is about to occur. Both designer and critic must be in close touch with the dynamics of mass-communication.[24]

Now the case studies, or objects Banham uses to demonstrate this thesis are, of course, mainly cars, especially Detroit cars (those symbolic machines of the 'Second Machine Age') (Figure 3.2). And his approach to their design analysis, as Penny Sparke points out in her introduction to his *New*

3.2. Ford Mustang.

Society (1967) article on the Ford Mustang, 'is highly reminiscent of the art historian "going to work" on the iconography of a Renaissance painting'.[25]

But at the same time, the car for Banham, in its role as symbol, mini-environment, and mobile home, was more than a thing in itself – it showed the way to go, or the way things were going – and for Banham it signalled the future, or Futurist demise of domestic architecture as we know it. 'A home is not a house', he declares in *Art in America* in 1965.

> Untold thousands of Americans ... have already shed the deadweight of domestic architecture and live in mobile homes which, though they may never be actually moved, still deliver rather better performance as shelter than do ground-anchored structures costing at least three times as much and weighing ten-times more.[26]

The car presupposes what he describes as a 'Standard-of-Living Package' (Figure 3.3). It works, he says, and he goes into great detail as to how and why it works ... and it could replace 'the

3.3. François Dallegret, 'Transportable Standard of Living Package'.

monument' which, he says, is so ponderous, so labour-intensive, and so energy-consuming that he cannot understand why Americans are still hung up on it:

> except out of some profound sense of insecurity, a persistent inability to rid themselves of those habits of mind they left Europe to escape. In the open-fronted society, with its social and personal mobility, its interchangeability of components and personnel, its gadgetry and almost universal expendability, the persistence of architecture-as-monumental-space must appear as evidence of the sentimentality of the tough.[27]

But one has to be tough, of course, to confront Banham's future: the last book he completed was *The Visions of Ron Herron*, which was published in 1994. And in it he confirms his conviction that 'The new state of art of architecture can only be found through a penetrating understanding of what state-of-the-art technologies are about'. And in response to Giedion, who had attacked Archigram's Walking City (see Plate 3) as 'an inhuman urban vision', he replies:

> What got crushed under the mighty feet of this stalking vision was not 'humanity', but the empty claims of the 'functionalism' that had once been the driving energy of modern architecture ... and ... Had the panicked hung around a bit, they would also have seen that marvellous, witty and life-enhancing later drawing of four or five walking cities gathered together in friendly linked intercourse.[28]

Now reaction, positive or negative, to such utopian or dystopian visions confirms the dilemma of the avant-garde: the Archigram experiments, originating in the 1960s, were intended to promote 'a new generation of architecture [which] must arise with forms and spaces which seem to reject the precepts of "modern", yet in fact retain these precepts'.[29] Their forms are 'modern' because they reject the static formalism premised by high modernism; they were a response to new modernities – the potentials of space-age technology, twentieth-century mobility, and the message of the automobile, and they were heirs to Buckminster Fuller's proposed solutions to the housing problem.

And it was this determination to confront the implications of the present that makes Banham such a brilliant and such a biased interpreter of the past. But if he left a lot out, he put a lot in. For example, *A Concrete Atlantis: US Industrial Building and European Modern Architecture*,[30] the last book to be published in his lifetime (in 1986), is a brilliant 'revisionist' account of the European modernists' reactions to American industrial building; the sort of buildings that were illustrated in the Werkbund journals and in Erich Mendelsohn's *Amerika*. It starts with an account of a visit he made to Cannery Row in Monterey, California, in the early 1980s, and his encounter with 'the abandoned installations of American industry'. These were, he says, the 'observational parts, or fieldwork' of the study, and the fieldwork leads him first to an analysis of the surviving buildings (which he claimed were based on out-of-date technologies), and then to a re-examination of the modernists' reactions to these buildings (most of them had only seen the photographs) – this section includes a masterly re-reading of the Fagus factory – and then to a reinterpretation of the European modernists' mythologizing of the American factory and the American factory system.

Now Banham, whether we agree with him or not, writes with authority, whether he is writing about the present or the past. His scholarship and his opinions were based on research – not necessarily because he wanted to demonstrate that he was a scholar – which he was – or that he specialized – but because he wanted to *know*. And this is apparent in what we might describe as his journalism, as well as in his books … the material world is there to be enjoyed, and questioned. Waiting for Sagebrush Airways flight 665 he becomes fixated by the badge 'resplendent on the uniformed bosom of the female deputy sheriff', who had just checked in his baggage. Fortunately there's a larger version on her office door, so he does not have to concentrate on her bosom. The pleasure of seeing a sheriff star under a microscope, as it were, was suddenly terminated by a dread thought which persistently afflicts all those who profess the trade of design historian. Who designed it? Sheriff stars can't just happen; some person or group had made decisions, based on taste or tradition, standing orders or divine revelation, and had thus determined its form and iconography.[31]

And so the quest begins – in libraries, which get him nowhere, among police authorities – don't ask a policeman (they tend to get truculent if you make enquiries about how their insignia are made), but he does finally manage to track down a firm he calls the Acme Star and Badge Co. – it's not their real name, as he'd had to promise not to divulge it. And so he visits a factory, locates the pattern shop, finds out how the things are produced and distributed, locates an archive, and muses about the iconography. Now this is for an article in *New Society*. It's not done for Brownie points, nor for income, he just needs to find out.

'O Bright Star' demonstrates the quest, the need to establish the facts, locate the sources, and interpret them, whether he is writing about the Fagus factory, or an ice-cream van, or potato crisps. Banham calls himself a hands-on historian, like Henry-Russell Hitchcock, his predecessor as Professor of Architectural History at the Institute of Fine Arts in New York. He knew his buildings, had been there, seen them, and he knew how they were built, and architectural mastery

of space and construction could, from time to time, make him halt in his tracks and look again. For example, in spite of his dedication to the avant-garde, and his alleged contempt for the muddle-headed Arts and Crafts, and in spite of his conviction that it is 'something of a dead-end', he can't help loving the Gamble House (see Plate 4). He stayed there from time to time as a guest of the University of Southern California and he loves it not only because of the craftsmanship – the Greenes' 'way of ordering the visible elements of the structure, a repertoire of usages for shaping ends, fixing brackets, notching corners, strapping joints, pinning mortises' – and not only because of the handling of space 'which lends an air of ease and relaxation on every floor', but because it is still a living house – there is no museum chill there – and because it is still pervaded by the spirit of the Gambles, especially Aunt Julie.[32] (Unlike the Getty, which is certainly not pervaded by the spirit of the Romans, 'no blood was ever spilled there . . . nor wine, nor sperm, nor other vital juice. No-one ever puked in the pool or pissed in the fountains').[33]

And he has this same Gamble-type empathy with Mackintosh's School of Art. 'Alienation of Parts' was published in the *New Statesman* in 1960 when Banham was in the middle of his Pop idolatry phase – but he can see and read the space and the structure and the craftsmanship closely, tenderly and intelligently. One problem, though: like Pevsner, he can't cope with some of the twiddly bits – the metalwork, he says, is the 'manic depressive limit . . . over-wrought to the point of dematerialisation, like a three-dimensional Matthieu painting a thin hand-writing in space'.[34]

So how are we to cope with such a provocative and dogmatic historian/critic, who wanted, like Pevsner and Hitchcock before him, to 'go out into the world and change things'.[35] The solutions he had to offer premised 'almost unlimited supplies of energy' – this is from the introduction to *Theory and Design* – and faith in the benign as well as radical potential of technology, just as Morris believed in the benign and radical potential of the human race. But Banham's superhuman super-cultures, like his working-class subcultures, assumed a superstructure of equally benign capital that would unite, as well as internationalize, the world. And this, obviously, historicizes him as a historian – he grew up in the Depression and in the war, but he came of age, metaphorically, in 1960s London. So any attempts to categorize him and assess him involve a confrontation with 1960s man – politically committed, perhaps, in their terms of reference, but undoubtedly politically incorrect in the eyes of the next generation. The world of 1960s architectural man is inhabited by dolly birds, who might have thought they were liberated – but they certainly weren't. The advent of the new computer technology, he says in 1963, 'will replace your secretary and set her free for full-time pre-marital sex'.[36] In fact, I have only found two serious references to women in my searches through his writing about design: one is to Penny Sparke, who selected the essays for *Design by Choice*, and the other is to Catharine Beecher, the pioneer of domestic mechanization. So there is great potential for gender studies here.

And what about the crafts? At the beginning of *Theory and Design* he states that 'The precious vessel of handicraft aesthetics that had been passed from hand to hand was dropped and broken, and no one has bothered to pick up the pieces'.[37] Designers as well as theorists, have, of course, been picking up the pieces ever since and the crafts are regaining their twentieth-century history; they are also now vital to the avant-garde.

So there is much that is problematic here, but I am old enough, or perhaps too liberally wet, to believe after my great read-in that the pluses outweigh the minuses. For Banham is a great read, because of the provocations, rather than in spite of them. Although he did not have much time for what he called 'art pottery', he democratized design for the design historian – divorcing it from the

aura of the 'good', and relating it to the world of consumption. And the numerous extracts I have quoted demonstrate that he could write, and get the information over. He used his research, his field studies, and the informed evidence of his eyes to hammer home the message. He could make himself understood. Being the guru of Pop and the avant-garde didn't mean that he had to adopt the arcane language of the guru – he went straight to the point, and we've no need to grope through a blanket of linguistic and methodological obscurities in order to locate the message. He used the narrative mode – which might be academically suspect – to construct a narrative that the historian might not agree with, but it is a narrative that cannot be ignored when we are trying to interpret twentieth-century histories. And in spite of its confidence, and its iconoclasm, it does include self-questioning, and remembrance of things past.

I'd like to conclude, therefore, with Banham's narrative of his discovery of the desert: *Scenes in America Deserta* is a remarkable book that he published in 1982; it is, he says, a very personal book, and he signs it Peter Reyner Banham. In it, he describes the landscapes of the deserts he discovered in America, his reactions to the 'landscape that has served mankind so long as a metaphor of hell and death, of beauty and morality, of the transience of life and the persistence of living beings'. They provoke many thoughts, about man-made environments, the nature of beauty, the nature of landscape, the nature of landscape painting (and how the painters of the Norwich School shaped his perception of the Norfolk landscape), and he concludes:

> Clearly the desert has done to me what it has done to many of us desert freaks – it has made me ask questions about myself that I never would have asked … I have not done what one is supposed to do in deserts … I have not 'found myself'. If anything, I have lost myself, in the sense that I now feel I understand myself less than I did before.[38]

So it is up to us now to try to relocate him – he's probably due for a dose of Banham-bashing – like he indulged in Pevsner-bashing – although he admired and respected him. Like Pevsner, like Giedion, and like so many of the pioneers, Banham was a man of his time, and we need to understand him if we are to understand that time.

NOTES

1. This lecture was delivered at the V&A, London, on 14 March 1997.
2. *A Critic Writes: Essays by Reyner Banham*, selected by Mary Banham, Paul Barker, Sutherland Lyall, Cedric Price (Berkeley: University of California Press, 1996).
3. Reyner Banham, *Design by Choice*, (ed.) Penny Sparke (London: Academy Editions, 1981), p.120.
4. Ibid.
5. 'The Atavism of the Short-Distance Mini-Cyclist', in ibid., p.88.
6. Ibid., pp.84–89.
7. Reyner Banham, *Theory and Design in the First Machine Age* (London: Architectural Press, 1960).
8. *Design by Choice*, ibid., p.84.
9. *Theory and Design*, ibid., p.37.
10. Ibid., p.12.
11. Ibid., p.48.
12. *A Critic Writes*, ibid., p.96.
13. Ibid., p.98.

14. Nikolaus Pevsner, *Pioneers of Modern Design*. Foreword to the Pelican edition, (Harmondsworth: Penguin Books, 1960), p.17.
15. *Theory and Design*, ibid., p.327.
16. 'Primitives of a Mechanized Art', in *A Critic Writes*, ibid., pp.44–45.
17. Charles Baudelaire, *The Painter of Modern Life, and Other Essays*, translated and edited by Jonathan Mayne (London: Phaidon, 1965).
18. 'The Atavism of the Short-Distance Mini-Cyclist', ibid., pp.85–89.
19. *Theory and Design*, ibid., pp.9–10.
20. 'Machine Aesthetes', in *A Critic Writes*, ibid., p.27.
21. *Design by Choice*, ibid., p.94–96.
22. Ibid., p.90.
23. 'A Throw-Away Aesthetic', in *Design by Choice*, ibid., p.93.
24. Ibid.
25. Ibid., p.127.
26. Ibid., p.57.
27. Ibid., p.60.
28. Reyner Banham, *Visions of Ron Herron*, (London: Academy Editions, 1994; completed 1987), p.57 and p.60.
29. Quoted from Martin Pawley, *Architecture Versus Housing* (London: Studio Vista, 1971), p.113.
30. *A Concrete Atlantis: US Industrial Building and European Modern Architecture, 1900–1925* (Cambridge, MA and London: MIT Press, 1986).
31. 'O, Bright Star...' in *A Critic Writes*, ibid., p.247.
32. 'The Master Builders', in ibid., p.169.
33. 'Lair of the Looter', in ibid., p.202.
34. 'Alienation of Parts', in ibid., p.65.
35. 'Actual Monuments', in ibid., p.282.
36. '(Thinks): Think!' in *Design by Choice*, ibid., p.116.
37. *Theory and Design*, ibid., p.12.
38. Peter Reyner Banham, *Scenes in America Deserta* (London: Thames & Hudson, 1982), p.228 and *passim*.

4.

REYNER BANHAM AND PHOTOGRAPHY

mark haworth-booth

This essay on Reyner Banham and photography is structured as six segues.[1] First, his general view of photography; second, his ideas about photography in architectural history; third, Banham as a user of photographs in his books: his role, as it were, as photo editor; fourth, his own photographs; fifth, his writings on the photography of others; and, finally, photographs of Banham himself.

Banham's general view of photography was conditioned by growing up in the 1930s surrounded by picture magazines, cinema and mass culture in general.[2] It was also conditioned by his being one of a number of bright sparks who chose not to turn their backs on mass or popular culture when they became adults and intellectuals. They came together in the early 1950s as the Independent Group (IG) in the then young Institute of Contemporary Arts. Their role in the rigorous study of popular arts segued – that word again – into the creation of Pop Art. Banham was a major critical voice for the IG's ideas, artworks and exhibitions. One of his first articles for the *Architectural Review* is titled 'Photography'. It is simultaneously an adroit rumination on the medium and a puff for an exhibition put together by members of the IG: 'Parallel of Life and Art' at the ICA in 1953. Perhaps it hasn't been anthologized yet because the writing is so much connected with the photographs that illustrated the piece. However, it is a breathtaking performance from the opening paragraph:

The veracity of the camera is proverbial, but nearly all proverbs take a one-sided view of life. Truth may be stranger than fiction, but many of the camera's statements are stranger than truth itself. We tend to forget that every photograph is an artefact, a document recording forever a momentary construction based upon reality. Instantaneous, it mocks the monumental; timeless, it monumentalizes the grotesque.[3]

I'm not sure who else in Britain at the time – except perhaps other IG members like Lawrence Alloway, Richard Hamilton or Nigel Henderson – could have thought up those wonderful sentences. I think that only Banham could have crafted them so well. Such a nuanced view of photography contrasts with the stark pronouncement made the following year by the then director of the Victoria and Albert Museum (V&A), Sir Leigh Ashton, who wrote to Roger Mayne that 'Photography is a purely mechanical process into which the artist does not enter'.[4] Banham then goes straight to an image from the show (Figure 4.1):

> In the strange photographic record of a ladies' gymnasium of 1910, the camera's unwinking eye, incapable of embarrassment or mirth, perpetuates an anthology of poses as unlikely as those in a Pollaiuolo engraving, in a geometrical setting as rigid as a Piero della Francesca. But in perpetuating what can have been no more than a ludicrous and uncomfortable moment and presenting it to us with a surface texture which, after countless processes

4.1. Anonymous photograph of ladies exercising in a gymnasium, from the exhibition 'Parallel of Life and Art', Institute of Contemporary Arts, London, 1953.

of reproduction and re-reproduction, has become an autonomous entity on its own, this old greying photograph functions almost as a symbol, an image, a work of art in its own right. It has so little, now, to do with the record of any conceivable reality that it is hardly rendered any less, or more, probable by being turned upside down.[5]

He goes on to make an essential point about photography as a medium with its own properties:

> ...the photograph, being an artefact, applies its own laws of artefaction to the material it documents, and discovers similarities and parallels between the documentations, even where none exist between the objects and events recorded. Thus photographs make us see connections between a head carved in porous whalebone by an Eskimo and the section of a plant from Thornton's *Vegetable Anatomy*.[6]

This visual wit is typical of the organizers of the exhibition: Nigel Henderson, Eduardo Paolozzi and the architects Alison and Peter Smithson. It is also typical of a book Banham revered, László Moholy-Nagy's *The New Vision* (1928). Moholy famously juxtaposed a photograph showing the texture of the skin of a 130-year-old man from Minnesota with that of an apple that appears to be about the same age. A pair of illustrations from the ICA exhibition connected a Jackson Pollock drip painting with the shell of a guillemot's egg:

> Any equivalence between a painting by Jackson Pollock and the surface of a guillemot's egg is certainly unconscious and probably coincidental, but we could never clear our minds of the suspicion that the visual education of Mr Pollock cannot have been utterly innocent of pictures of bird's eggs – he is, after all, a camera-eyed Western artist.[7]

Banham recognized that photography 'is creating a new visual environment'. However, he didn't leave matters there. Even in a short article, Banham returned to one of his core themes: how does this medium shape up in terms of real experience? This is the part of his article that is, I think, both peculiar to him and particularly revealing of those core beliefs:

> The camera, with its strong moral claims to truth and objectivity now over a century old, has established its manner of seeing as the common visual currency of our time, and we come to think of the photographic experience as the equivalent of personal participation. But we should ask ourselves who would be truly richer – one who possessed photographs of every surviving building of the Classical world, or Sir John Soane, who had measured every stone of the orders of the Coliseum and could quote its intercolumniation even in his old age.[8]

This point segues into the next of our topics: Banham's ideas about the uses of photography in architectural history. He was not merely sceptical of the perfect black-and-white photograph of the classic architectural masterpiece, which looks as pristine as a sculpture, and as unoccupied by people – users – as sculptures generally are. This is a running theme in Banham's work – how photography can lead to a false construction of architecture. I'm going to illustrate this by an extreme case in which false construction is not only metaphorical but *literal*. It comes from Banham's last book, *A Concrete Atlantis* (1986). He is discussing the famous flat roofs of modernism and the fact that they often leaked. There were plenty of examples of pre-1900 leak-proof flat roofs in Europe, so why should the modernist ones fail? The cause was, he argued, photographic:

If the modernist versions leaked, they must have had some [design] source outside local, current, and commonsense building practices. This was indeed the case: too many of [the roofs] were purely formalistic structures that had never been studied first hand. Their designers had not seen the originals and had no opportunity to examine and understand how they should be designed, detailed, and constructed. And this brings up a matter of extraordinary historical importance. In so far as the International Style was copied from American industrial prototypes and models, it must be the first architectural movement in the history of art based on photographic evidence rather than on the ancient and previously unavoidable techniques of personal inspection and measured drawings.[9]

Banham cannily notes that the pictures that inspired the architects appeared to be news photographs, not 'art' photographs, which come with their own admission of subjectivity. He notes that Walter Gropius referred to his collection of such photographs as 'news clippings'. The photographs seemed as forthright as the structures. They 'represented a truth as apparently objective and modern as that of the functional structures they portrayed'.[10] Not only that, Banham adds later in the book, if the photographs did not provide the evidence required, architects were not above tampering with them. For example, in his book *Towards a New Architecture* (1923, translated into English 1927) Le Corbusier published a photograph of a grain elevator in Buenos Aires. He miscaptioned it 'Canadian', and gave it a flattering skyline by 'whiting out every one of its numerous pediments'.[11] Paul Venable Turner, in *The Education of Le Corbusier* (1977), illustrated the same building as reproduced by Gropius in 1913 and as doctored by Corb in 1927.[12]

The same increasingly grainy photographs of concrete 'functional' buildings passed from book to book, Banham noticed, accumulating new errors as they went, or obliterating essential details like, for example, the inch-thick chamfering on columns which protected them against frost spalling (splintering). European modernist architects, he wrote, 'having never seen the original buildings … had to discover such usage for themselves, painfully, often too late, and usually at the clients' expense'.[13] Banham was not interested in these handsome and innovative functional buildings as mere rhetorical devices – he wanted to know them up close and learn what they did and how they and their actual purposes changed – a theme to which we shall return.

The use and reuse of photographs segues into our third topic: Banham as a user of photographs in his books, his role, as it were, as photo editor. Those who know Banham's books may recall the name of Cervin Robinson, the American architectural photographer whose distinguished works often appear in them. In March 2005, I battled through a New York blizzard to talk to Cervin in his apartment on the Upper West Side. Over a welcome whisky, he told me something that set me thinking about Banham as photo editor, hence this segue. When Cervin was assembling his book *Architecture Transformed*, a history of architectural photography, he asked Banham's advice.[14] Two comments stand out. Banham advised against a hackneyed, too-often reproduced, photograph of a building being demolished. Accordingly, Cervin chose a more recent, less familiar one. Secondly, and this is what got me thinking, Banham recommended that the book should finish with a really strong final picture. The last photograph in Cervin's book fulfils this brief. It shows, very elegantly framed, the Philip Johnson studio at Greenwich, Connecticut. The photographer is Timothy Hursley and the date 1980. The flash of a passing bus in the background does several jobs, one of which is giving some context – the site is by a road of reasonable size – and the other symbolic: this may be the final photograph but the book is a snapshot and the history will continue.

There are rich pickings for anyone wanting to study Banham as user of photographs. The photo archive of the Architectural Press was recently transferred to the Royal Institute of British Architects (RIBA). This represents his earlier books. The photographs used in his later ones are preserved in the Getty Research Institute (GRI). The RIBA boxes contain excellent photographs by the architectural specialists, such as Robinson, Hedrich Blessing, Steiner & Nyholm and Ezra Stoller, plus some unexpected ones from Nigel Henderson and the Australian modernist Max Dupain. At the GRI, we find photographs commissioned by Banham from Julius Shulman for *Los Angeles: The Architecture of Four Ecologies* (1971), not all of which were used.

Although I have spent some fascinating hours going through the folders in the GRI, I am actually interested in a particular aspect of the LA book. When I recently had another look at it, in light of Cervin Robinson's remarks, I noticed for the first time Banham's skill as a picture editor. He chose photographs from many sources, including ones by himself (of which more later), and a startling photograph by Marvin Rand of the Hunt house in Malibu, architect Craig Ellwood, from 1955.[15] Here we see a kind of perfect, hermetic, architectural minimalism that seems to be a signature LA style. Ellwood perfected the style for use at industrial scale in buildings for Xerox Data Systems at El Segundo, near LAX (1966).[16] Banham's book closes (apart from the epilogue) with this project and Cesar Pelli's Teledyne Systems building (1968) at Northridge in the San Fernando Valley. These stylish essays in Case Study architecture as applied to industry (and represented by Marvin Rand's equally stylish photographs) provided, I believe, the jumping-off point for the epic series by Lewis Baltz, *The New Industrial Parks Near Irvine, California*. This seminal study was published in 1974 and reissued in 2000. Baltz is a star of the 'New Topographics' movement, which had a global impact on photography, and I know from our conversations over the years that Baltz is a big fan of Banham's LA book. Thus, Banham not only used photographs well but – a point I'll develop further on – arguably inspired new photographic ideas to come into play.

Banham also made excellent use of Ed Ruscha's now canonical photographs of LA parking lots, including examples from the series published in booklet form as *Thirty-Four Parking Lots in Los Angeles* (1967). Surely no one else had noticed and made a point of photographing these essential parts of the LA terrain, let alone published them as an artist's book. Ruscha's conceptual art piece became, through Banham's influential book, part of the general conceptualization of Los Angeles. However, I couldn't help wondering if Banham was using (or even – shock-horror – misusing) the Ruscha photographs merely as information. Surely, when we look at a very elongated, skinny Ruscha in the LA book we must wonder if it had been cropped to fit the format.[17]

Just as I was pondering this dark possibility one afternoon in the National Art Library at the V&A, I noticed I was sitting opposite Gerald Cinamon, who designed the book back in 1971. No, he would never have cropped a photograph, Cinamon said. But if he was given it already cropped... My argument that Banham was an astute photo-fancier looked as if it might falter, until I went back to the original *Thirty-Four Parking Lots* publication, a copy of which is conveniently held by the National Art Library, and saw that Ruscha's very unusual format for this photograph (so long that it needed a folding flap at the right edge) had been completely respected.

Banham, the picture editor, reserved even more visually striking cards for the final two chapters of his book on LA. Here he unleashes the iconic Julius Shulman, Case Study house 22, Hollywood Hills, 1959, architect Pierre Koenig: the supreme architectural fantasy of greater Los Angeles, followed closely by another iconic picture, Hockney's then recent *A Bigger Splash* (1968). And what does he sign off with? Well, naturally, Ed Ruscha's *Hollywood* silkscreen print (also 1968). Banham

was quick to spot what have subsequently become seemingly inevitable icons and he used them in the most dramatic way, laid out with expansive elegance by Gerry Cinamon.

Our fourth segue is Banham as photographer. When he started working for the *Architectural Review* in 1952, it was expected that staff writers would take occasional pictures for their articles, using an Architectural Press Rolleiflex. This was the good-quality German twin-lens reflex camera, introduced in 1929, that was used by Bill Brandt, Brassaï, Lee Miller and many other documentary photographers of the 1930s, 1940s and 1950s. Robert Elwall and his colleagues at the RIBA have been looking for black-and-white Rollei photos from the 1950s by Banham in the Architectural Press archive, but so far without success.

Banham took photographs from early on in his career, according to Mary Banham and their son Ben. A German folding-bellows camera was followed by a Yashica 44 – basically a smaller version of the Rollei – taking 44mm-square negatives. There are black-and-white, square-format photographs by Banham in the GRI. The holdings are listed under general headings and this data can be viewed online. Photographs made with the Yashica 44 were taken for the LA book, which opens with Banham's *Chaos on Echo Park*. There are plenty more Banham photos in the book, both of 'Pop' subjects, such as the decorated surfboards he liked to write about, and less obvious architectural and environmental subjects, such as Johnie's hamburger joint on Wilshire Boulevard's Miracle Mile (Figure 4.2). Banham comments on the content of his photograph:

> Somewhere underneath the fantasy lurks a plain rectangular flat-roofed building, around which a purely notional butterfly roof has been sketched, but turned down front and back to give a sheltering form not unlike the nominal mansard roofs that give the name to the Gourmet Mansardic style of restaurant architecture. On the front this roof is garnished with lettering, and the whole structure is flanked by entirely independent signs, one merely lettered, the other humorously [sic] pictorial. And a crowning non sequitur – an enormous sign which is part of the structure but advertises something entirely different.[18]

Cinamon (perfectly properly) cropped Banham's square-format photographs, omitting an empty street in front of Johnie's, for example – as one can see from looking at the full-frame prints at the Getty. Cinamon edited out an empty sky to tighten up Banham's *Townscape of Freeway-Land*[19] (Figure 4.3). This observant photograph looks like a prefiguration of the New Topographics movement already mentioned, which was first named and displayed at an exhibition at George Eastman House, Rochester, New York, in 1975. The New Topographics photographers examined actual land-use, 'landscape as real estate', as Baltz termed it.[20]

Banham's photograph contrasts the domestic space of a picket-fenced lawn with an intermediate area where a hot-looking auto is parked beside a chain-link fence, and then contrasts it again with the emphatically public space of a freeway perched on a newly constructed and planted escarpment. Banham did not deplore the encroachment of the public on the private: he remarked instead that planting on the slopes of freeways 'can make a contribution to the local environment that outweighs the disturbance caused by their construction – a view of a bank of artfully varied tree-planting can be a lot more rewarding than a prospect of endless flat backyards'.[21]

Quite soon after taking the photographs for that book, Banham moved on, like many others at the time, to a more convenient, semi-professional camera: a second-hand Pentax, one of the new Japanese single-lens reflexes (SLR). Among its many advantages was that it was 35mm, the format

4.2. Reyner Banham, uncropped gelatine-silver photograph of *Johnie's Wilshire, Miracle Mile*, 1962.

of the lecture slide, and that it offered through-the-lens-metering. He began to make many more of his own slides when he moved away from the slide libraries of Bloomsbury, first to Buffalo and then to Santa Cruz. He eventually graduated to a Nikon G4, a fine, professional-quality SLR with a 50mm lens, which is usually thought of as equating to normal vision: he never acquired wide-angle or telephoto lenses. He knew enough to photograph what he needed. No doubt he agreed with Moholy, writing in *Vision in Motion* (1947), that 'the illiterate of the future will be the person ignorant of the use of the camera as well as of the pen'. With these cameras, Banham made the thousands of slides that he used in lectures and which were sometimes reproduced in his books and articles.

4.3. Reyner Banham, uncropped gelatine-silver photograph of *Townscape of Freeway-Land*.

I recall the night in 1993 when Mary Banham handed them over officially to the photo library of the Architectural Association. With an appropriate sense of occasion, the AA sent a 1950s Chevy to bring Mary from her flat in University Street to Bedford Square. Valerie Bennett, head of the photo library, photographed Mary in the Chevy carrying off the regal wave with great style. The Chevy was parked outside 36 Bedford Square all evening and Banham's slides, projected from carousels, made a lively display in the gallery.[22] As the AA website gives an excellent overview of the Banham slide collection, I thought I would refer to a few subjects in some depth, although it will not be possible to illustrate them extensively here. First, Banham's slide titled *Concrete Central Elevator*, which was designed by A. E. Baxter and constructed on the Buffalo River, in New York

State, in 1915–17. Banham photographed it in 1978. First he photographed it from a distance and in context, then moved closer. He returned in 1979 and photographed it looking heroically ship-shaped from below. He photographed it on a brighter day in 1979, capturing a potentially useful detail, titled *Detail*. He photographed inside and captured not only human scale but that important feature of the chamfered columns, discussed earlier, which provided protection against frost spalling or splintering (see Plate 5).

The book Banham was preparing when he became terminally ill was on high-tech architecture. There is a fine series on the McMath Solar telescope designed by Skidmore, Owings and Merrill. It is sited at Kitt Peak, west of Tucson in Arizona and was constructed from 1962 onwards. There is a dramatic exterior view, photographed in 1980. Banham moved closer in and photographed upwards. Other photographs display the geometry of the structure. Then Banham moved inside to photograph the guts of the construction. The finale is titled *Heliostat* and records the instrument, involving a mirror mounted on an axis moved by clockwork, by which a sunbeam is steadily reflected into a telescope.

The final series I chose to project in the lecture version of this essay records one of Banham's favourite desert places. This is the abandoned spa, the brainchild of Curtis Howe Springer, at the wonderfully named Zzyzx in the Mojave Desert in California. It was intended to be the last word in spas (literally, of course). Banham photographed a general view of the place as – it initially appears – an oasis of great promise. His photographs show the water looking amazingly plentiful. He photographed the view from one of the old windows. This evocative place, on the road from LA to Las Vegas, is lovingly described in Banham's *Scenes in America Deserta* (1982). The poorly printed illustrations in that book don't do it justice. I concluded this section of my lecture with three slides from the Banham collection in the Architectural Association by Tim Street Porter, who made them in 1980 for the book. They show how well Banham chose his photographer for this project. Street Porter photographed Zzyzx from above. He also photographed Banham on site and elegantly captured, in a beautifully constructed view, the nearby Great Soda Lake. The photograph was presumably made on the occasion described by Banham in the opening words of 'The Eye of the Beholder', Chapter 11 of the book. This passage testifies to Banham's acute sensitivity to desert light:

> A little above the Soda Lake, the trail turned so that we could suddenly see much further down it, toward the Cowhole Mountains, and the truck stopped almost of its own accord. We leapt out, each with his camera, amateur to the left [and] professional to the right, as if our lives depended on it. This was not in any sense a life-or-death emergency, it was rather an emergency of impending visual disaster. No one would be killed, maimed, or deprived of anything of material value but in a matter of seconds – at best, a couple of minutes – it would be too late to capture something of infinite value in my eyes.[23]

Thus, although he recognized his own amateur status, light was sometimes an important subject for Banham. The notes of my discussion with Tim (on a visit in 2005) show that we agreed that Banham's photographs were 'unstudied' – it is what is in them rather than how they were taken that matters. As it happens, we can see exactly what the amateur and the professional did when one turned left and the other right at Soda Lake. There are slides by Banham and Street Porter in the AA's Banham archive that include the same bit of fencing.[24] Banham's view is a relative muddle compared to the elegant image by Street Porter already mentioned: Banham was using a 50mm lens

while his colleague used a 35mm camera with a long lens, mounted on a tripod. The same technical difference explains the varying success of each man when they photographed each other cycling at Silurian Lake: Street Porter's long lens at once magnified the cyclist and flattened the background (as we shall see in a later section).

Banham did not only teach from slides. He bought a Super-8 camera in the early 1960s. He used it on the West Coast of the United States to film buildings – peopled and in use. It is part of his core need to test artefacts against experience. These became a regular part of his lectures. Unfortunately, they were stolen from the Banhams' London house some time in the mid-1970s, probably, Mary Banham conjectures, because the thieves assumed they were blue movies. Having looked at some of his slides, I would like to quote another passage from Banham's 1953 essay, 'Photography'. As I remarked earlier, just as he had a deep need to test design so-called classics against lived experience; the same went for photographs:

> ...we should recognize that if the camera has increased our visual riches, we are richer only in bills of credit, most of which cannot be cashed – there can be no direct visual apprehension of scenes which have passed...[25]

But you can, at least (Sir John Soane style, or Sir Nikolaus Pevsner style) visit and examine the sites yourself. His own photographs are the consequences of personal inspection of their subject matter, verifications of what he saw with his own eyes. In his inaugural address in 1988 as the Sheldon H. Solow Professor of Architectural History at the Institute of Fine Arts at New York University, written but not – because of his untimely death – delivered, Banham described himself as, like Pevsner, an 'observational' historian. 'This kind of architectural history', he added, 'has been called, by Robert Maxwell of Princeton, a "rhetoric of presence". I have been there and seen for myself, and that is my licence to speak.'[26] These slides, and his detailed written accounts of buildings, are the products of that lifelong observational practice. The AA's hoard includes photographs of the very varied structures that interested him, including the high-tech buildings on which he was working at the time of his death. I was disappointed not to find any car styling slides but apparently Banham used to borrow them from friends such as Richard Hamilton, to whom Mary Banham returned them.

Our fifth section concerns Banham as photo critic. He wrote enthusiastically about the street photography of both Henderson and Roger Mayne in the *New Statesman* in the early 1960s.[27] At this point, I have to admit to a feeling of disappointment. Faced with a book I feel that he should have liked, John Szarkowski's *The Idea of Louis Sullivan* (1956), Banham reviewed it at cross-purposes. The innovation of Szarkowski's book was to use photography in the service of architectural criticism. For example, Szarkowski displayed – on the right-hand side of one masterly picture – the rigorously expressed structure and civically generous ornamentation of Sullivan's Wainwright Building in St Louis, while pointing his composition like a scornful finger at a bleak and aesthetically/socially boorish tower in the left distance.[28] Szarkowski was as much opposed as Banham to the perfect image of the building separated from its environment, history and use. However, Banham evidently wanted more raw information about Sullivan's structures, not what had become of them. Terrible things had become of them, as Szarkowski's photographs showed. Unfortunately, Banham's review did not address the book's aims but complained instead that it didn't include sectional drawings and axonometric plans.[29]

In his 1974 article, 'Sex and the Single Lens', Banham wrote wittily and interestingly about cameras and the gendering of their design.[30] His article was accompanied by a memorable cartoon of Lord Snowdon, the royal photographer, by Gerald Scarfe: Scarfe conferred a priapic potency on the single-lens reflex slung at the royal waist. However, Banham's most important photographic criticism is his text for *Desert Cantos* by Richard Misrach of 1987.[31] Misrach was thrilled that Banham should consent to write for the first book of an unknown – then – like himself. However, it is not surprising that Misrach's highly original photographs of desert landscapes chimed exactly with Banham's own view of these extraordinary places, because Misrach was deeply influenced in the first place by reading *Scenes in America Deserta*. Banham's essay is titled 'The Man-Mauled Desert':

> The desert that Richard Misrach presents here is the *other* desert. Not the pure unsullied wilderness 'where God is and Man is not', the desert of Christian purification and American longing, but the real deserts that we mortals can actually visit – stained and trampled, franchised and fenced, burned, flooded, grazed, mined, exploited and laid waste. It is the desert that is truly ours, for we have made it so and must live with the consequences.[32]

The next passage refers to the Salton Sea, in south-eastern California. For those who don't know the story, here it is in condensed form. Although a lake existed on its site in earlier times, from circa AD 700 to around 300 years ago, the present one was created by colossal human misadventure. In 1901, the California Development Company, seeking to realize the Imperial Valley's potential for unlimited agricultural productivity, dug irrigation canals from the Colorado River. Heavy silt loads, however, inhibited the flow and new residents of the valley became worried. This prompted the engineers to create a cut in the western bank of the Colorado to allow more water to reach the valley. Unfortunately, heavy floodwaters broke through the engineered canal and nearly all the river's flow rushed into the valley. By the time the breach was eventually closed, the present-day Salton Sea had been formed. It may have been created by disaster but it is now a significant part of the Californian ecosystem. Its features now include the flooded remains of buildings constructed in a 1950s boom in which the area was fleetingly seen as a 'new Palm Springs'. Banham writes (see Plate 6):

> Colour and atmospheric effects like these are still to be seen in the deserts, even in the parts that have been so seemingly altered by the works of men – the proof is here in these photographs. However, the fact that we can see that the terrain has been altered, and that we suspect that the atmosphere may be equally man-made, must alter our appreciation of the beauty that we will see, when we finally bring ourselves to see it. Look well at Misrach's pictures of the Salton Sea, calm as death under its veil of mist, reflecting the stranded trivia of human construction in its mirror-smooth surface. This accidental sea may indeed be – Hell no. It is! – as beautiful as the back shores of the Venetian Lagoon.[33]

I don't need to labour the point that Misrach photographed and Banham celebrated *un*classic desert places, the ones people actually visit, however man-mauled, and that this approach connects with Banham's core interests. Which takes us back to the man himself.

Our sixth and final segue: Banham's self-image. Without necessarily being narcissists, we all become aware of how photographs (and sometimes the people who publish them) do funny things with

our appearance. Sometimes, in self-defence, we attempt to have some say in the proceedings, by selecting our 'better' side, a would-be amusing or ironic expression or an appropriate stage prop. Banham was canny about this, as we might expect. Actually, I think he got the point from an early age – at about three. His nephew Simon Gooch kindly sent me a scan of a photograph showing the infant Banham constructing his own image with the help of well-chosen prop – a toy crane.

I was startled, in preparing this paper, to find that the usually excellent National Portrait Gallery appeared – judging from its website – to have no picture of Banham (this has now been remedied). However, Mary Banham assured me that Charles Saumarez Smith certainly did (when director of the NPG) acquire a portrait of Banham. It is a photograph taken in 1979 by Louis (Bud) Jacobs (then on Banham's faculty at the State University of New York at Buffalo) for a final poster before the Banhams left for California at the end of that year. The Jacobs photograph shows a hirsute and rather piratical-looking Banham, shown mugging ironically to the camera in a way that shows his determination *not* to present himself as conventionally dignified. It is a good choice. But what would you have chosen? There is Banham on his beloved Moulton bicycle in London, which originally appeared alongside a typically arresting title: 'The Atavism of the Short-Distance Mini-Cyclist'.[34] There is Banham on his Bickerton folding bicycle at Silurian Lake by Tim Street Porter, who thinks that Banham himself suggested the photograph. It is a highly memorable image, the cute urban bike in its unlikely, moon-crater setting in the Mojave Desert, Banham in the saddle and wearing desert freak clothes and hat. Variants exist in both black and white and colour. Perhaps the version in colour, which in photographic terms represents the future (according to the philosopher Stanley Cavell), best represents Banham as the 'historian of the immediate future' (see Plate 7).

However, perhaps the NPG might consider representing Banham not only by a suitably un-classic photograph, but by some even less classic video footage? A choice example, preserved at the AA, shows Banham speaking at ArtNet, in West Central Street, WC1. The lecture took place in 1976 and was occasioned by the IG exhibition 'This Is Tomorrow', of twenty years earlier. Banham performs on the video with his typical animation, especially when discussing the arrival on the scene of the miniskirt. He is clad in a Superman T-shirt (Figure 4.4). Two minutes of that would surely make a fitting addition to the National Portrait Gallery.

I would like to finish with something Cervin Robinson told me on that snowy evening in 2005. He remembered an occasion when Banham flew down from Buffalo to give a lecture in New York and – nightmare – got separated from the bag containing his slides. It didn't matter at all, Cervin said: he just conjured up the buildings with his wonderful words.

4.4. Grab from video recording of Banham speaking at ArtNet, London 1976.

NOTES

1. This is an edited version of the eighteenth Reyner Banham Memorial Lecture delivered at the Victoria and Albert Museum, London, on 23 February 2006.
2. My thinking about Banham and photography has been enriched by the help of some very generous individuals. I've had fruitful discussions with Mary Banham; Valerie Bennett and her colleagues in the photo library at the Architectural Association; Robert Elwall, curator of photographs at the RIBA; Richard Hollis, the graphic designer, who worked closely with Banham at *New Society*; Richard Misrach, the doyen of desert photographers, in San Francisco; Frances Terpak at the Getty Research Institute, Los Angeles; the architectural photographer Cervin Robinson in New York; Professor Penny Sparke, editor of *Design by Choice*, a selection of Banham's essays; and the photographer Tim Street Porter in LA.
3. Banham 'Photography', *Architectural Review*, October 1953, pp.259–61.
4. Mark Haworth-Booth, *The Street Photographs of Roger Mayne* (London: V&A, 1986), p.6.
5. Banham 'Photography', ibid.
6. Ibid., p.260.
7. Ibid.
8. Ibid., p.261.
9. Banham, *A Concrete Atlantis: US Industrial Building and European Modern Architecture, 1900–1925*, (Cambridge, MA and London: MIT Press, 1986), p.18.
10. Ibid., p.18.
11. Ibid., pp. 219–22.
12. Paul Venable Turner, *The Education of Le Corbusier* (New York and London: Garland Publishing Inc., 1977), figs. 30, 31.
13. *A Concrete Atlantis*, p.87.
14. Cervin Robinson, *Architecture Transformed* (Cambridge, MA: MIT Press, 1987).
15. Banham, *Los Angeles: The Architecture of Four Ecologies* (London: Allen Lane, 1971), plate 7, p.39.
16. Ibid., plate 120, p.231.
17. Ibid., plate 68, p.148.
18. Ibid., plate 53, p.119 (uncropped version).
19. Ibid., plate 86, p.174 (uncropped version).
20. Lewis Baltz, *The New Industrial Parks Near Irvine, California* (Light Impressions, 1974).
21. Banham, *Los Angeles*, p.175.
22. There are about 5,000 Banham slides in the AA collection, ranging in date from the early 1970s to the late 1980s. Of these, 192 are now viewable online at the AA site www.aaschool.ac.uk/photolib. The online versions are digitally cleaned up. The AA kindly gave me permission to show some of the lecture-worn original slides when I delivered this paper in lecture form.
23. Banham, *Scenes in America Deserta* (London: Thames and Hudson, 1982), p.209.
24. AA Banham Collection slides B6/237 and 240.
25. Banham 'Photography', ibid., p.261.
26. Nigel Whiteley, *Reyner Banham: Historian of the Immediate Present* (Cambridge, MA: MIT Press, 2002), p.400.
27. Mark Haworth-Booth, *The Street Photographs of Roger Mayne*, ibid., pp.76–77.
28. John Szarkowski, *The Idea of Louis Sullivan*, 2nd ed. (London: Thames & Hudson, 2000), p.64.
29. *Architectural Review*, March 1958, p.210.
30. Banham 'Sex and the Single Lens', *New Society*, 19 December 1974.
31. Richard Misrach, 'The Man-Mauled Desert' in *Desert Cantos* (University of New Mexico Press, 1987), pp.1–6.
32. Ibid., p.1.
33. Ibid., p.3.
34. Banham 'The Atavism of the Short-Distance Mini-Cyclist', *Living Arts* 3, 1964.

5.

PETER WOULD ENJOY THESE

LOOKING AT THE EDGES OF THE ARCHITECTURAL VOCABULARY PLUS A DESCRIPTION OF THE KUNSTHAUS GRAZ

peter cook

Reconstructed from memory, 2008
As with most of my lectures, the choice of slides really sets up the dialogue.[1] All through I have kept imagining the chuckle that Peter might have over them and the type of conversation (and anecdotes) that we could have as a result.

1. STAEDELSCHULE CATALOGUE

Having spent much of my career in the role of teacher – as well as simultaneously being a designer-architect – I have come to use all 'tutorials', 'seminars', 'crits' and the like as an extension of the process of mulling over ideas. More interesting architecture comes out of

5.1. Staedelschule catalogue.

teacher-architects than so-called 'hardened' professionals like to admit.

2. MARJAN COLLETTI WITH ANIMALS ON HIS HEAD

5.2. Marjan Colletti with animals on his head.

Colletti has continued from this 'entry' project at the Bartlett to making a heroic Ph.D. and some fine designs.[2] Yet on that day he shaved his head and attached soft-toy animals with Velcro. He talked about 'friendship', 'comfort', 'softness' and these topics continued as an architectural theme over several months.

3. THE 'MOWBOT' AT OSLO ARCHITECTURE SCHOOL

5.3. The 'mowbot' at Oslo Architecture School.

David Greene celebrated the mowbot: the robotic motor-mower, but who would have guessed that the Oslo School of Architecture – not that technologically inclined – would have such a thing buzzing about on the grass roof of some studios and workshops?

4. AN AIRSTREAM CARAVAN NEAR LOS ANGELES, 2007

5.4. An Airstream caravan near Los Angeles, 2007.

Isn't it great that the Airstream is still around? This LA (2005) version is used as an advertising booth and recalls all the delight and unadulterated enthusiasm for the SLEEK, PERFECT, STYLED, AMERICAN-ness of it: without apology.

5. THE 'HOUSE IN THE CLOUDS', THORPENESS, SUFFOLK

Built as part of that crazy seaside retreat for British colonial officers on leave in the late 1920s, the 'House in the Clouds', is a water tower masquerading as a house on a nondescript shaft. Actually, as built, the 'house' is a water tank and the 'shaft' the actual housing. *Until the Suffolk Water Board changed its policy in the 1970s.* Then, they cut through

5.5. The 'House in the Clouds', Thorpeness, Suffolk.

In the famous Moscow Academy of the 1920s, when the new Socialist Constructivist architecture was being hatched, it was possible for a student to make as nutty, romantic, winsome and ORIGINAL a piece as this. Light. 'Toy'-like. Joyous.

7. IAKOV CHERNIKOV: FROM *101 ARCHITECTURAL FANTASIES*

5.7. Iakov Chernikov, from *101 Architectural Fantasies*.

the tank, so that now, the house that was a tank is a house. But in a funny place. I'm sure Peter knew about this one, but before the cut-out happened!

6. NICOLAI SOKOLOV: HEALTH RESORT

5.6. Nicolai Sokolov, health resort.

When I was in the AA fifth year, a small group of us would ask to see 'that Russian book' – held in a special locked cupboard. Under the eagle eye of the librarian, we would salivate over these amazing inventions. Only when, in 1970, I saw Ludwig Leo's Umlauftank in Berlin (the big pink pipe with the blue building over it held up on green legs) did I realize that the 101 fantasies could really be made.

8. GRAZ KUNSTHAUS: 'NEEDLE'

The 'Needle' pays conscious/unconscious/now-it-can-be-told homage to the Constructivist canon.

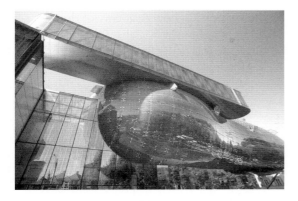

5.8. Graz Kunsthaus, 'Needle'.

9. GRAZ KUNSTHAUS NESTLING INTO THE CITY

If I describe the thing as a friendly animal, bedded down in the basket of Graz (see Plate 8), not doing any harm to anyone, am I exaggerating? Would Peter get the point – feeling about a building as an animal, child, or personality?

10. GRAZ KUNSTHAUS: EISENES HAUS END

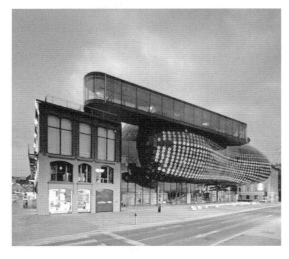

5.9. Graz Kunsthaus, Eisenes Haus End.

Ordered to respect the Austrian 'heritage' – as represented by this, the earliest cast-iron building in southern Austria – and putting a big chunk of budget on it, I had a good laugh when I was told that all the cast-iron parts were brought down from Sheffield! Loony bits of British technology in the mid-nineteenth century. Loony bits of British technology at the beginning of the twenty-first century!

11. SCHLOSS KARLSRUHE ORANGERY

5.10. Schloss Karlsruhe orangery.

Tucked around the side of the nineteenth-century schloss (at the centre of Karlsruhe's radiating spokes of paths and streets) lies a 'room' that only becomes a room when the leaves are out. I had been drawing and talking about such things for years when someone in Germany suggested I took a look at it. Oh! So it's been done ... well, a good idea is a good idea, and we're so hung up about the sanctity of the enclosed 'room' anyway.

12. EAST LONDON 'GREENING' PROJECT

In 2006, Gavin Robotham and I made this project about allotments and the weaving of vegetation in and out of housing for the Venice

5.11. East London 'greening' project.

Biennale. We came up with forty-one new typologies: studio types, hut types, tree types, hydroponic streets, etc., etc. This is a typical corner.

13. ALLOTMENTS NEAR HAMPSTEAD ROAD, LONDON

I only discovered this recently, hidden in the middle of the large 1950s housing estate near Regent's Park. City veg. for all.

5.12. Allotments near Hampstead Road, London.

14. 'SUPER HOUSTON' VILLAGE

5.13. 'Super Houston' village.

In my rerun of the Houston 'drivers' city', I set up a scheme for housing among the trees. Then a series of rhetorical 'dart'-shaped markers: like giant billboards that are themselves buildings. Every mile or so, a group of these set out the existence of a 'village'.

15. 'VEG. HOUSE', STAGE 3

5.14. 'Veg. House', stage 3.

So, continuing the theme of wrapping architecture into vegetation, or vegetation into architecture, the 'Veg. House' explored the idea of hybrid features such as hi-fis wrapped into trees, vegetated furniture, vine-growing in the living-room, soft robotics, etc., etc. – all woven together, developed through six stages.

16. MADRID VILLA AND VERTICAL GARDEN

5.15. Madrid villa and vertical garden.

Only recently have we had the opportunity to explore vegetated architecture in a seriously commissioned project: for a 'boutique department store' in the centre of Madrid. A nineteenth-century villa is preserved and 'cosseted' within a vertical garden of greenery. On the left side is a pair of vegetated 'new build' structures, and delicate glass bridges link across. Within is a two-metre-wide chasm that contains a running stream. All very romantic.

17. 'WAY OUT WEST-BERLIN': DETAIL

5.16. 'Way Out West-Berlin': detail.

Vegetation of another kind: the cactus, but more sinister too, as he (the cactus) becomes 'generator' of a new architecture that takes advantage of the sinister remnants of the old Berlin. In this location, a series of villa gardens and railway sidings. The 'WAY OUT WEST' aspect is also to do with America: the site as the west end of the Kurfürstendamm, as the progeny of (at the time) American-funded Berlin, but also formally to do with the cactus as a 'Western' desert component, etc., etc! Lots of mixed-up stuff that PB might (or might not) dig!

18. MEDINA TOWER, TEL AVIV

My wife's town is Tel Aviv: a raunchy town full of entrepreneurs. This tower is effectively a 'club sandwich' in which each piece of bread or filling is (as with the club sandwich itself) rhetorically independent.

20. PINTO TOWN PLAN: DETAIL

In 3D (see Plate 10), it manifests itself as a series of buildings on legs, with inconsequential but lively insertions of kiosks, stalls, people drifting about. Sports activities on the roof.

21. VALLECAS HOUSING: MADRID

Now under construction is a piece of housing only twenty miles away that carries out some of the principles demonstrated in the Pinto plan (see Plate 11). It is social housing, but lively and jolly and blue, with all the kids hanging out at the corner shop and kiosks.

22. KIOSK: TEL AVIV

The modernist canon suggested tree-lined boulevards, bourgeois dog-walkers who stop at the end of the boulevard for refreshment. Is TA a troubled city? Well not at this one: a jolly entrepreneur has a constant queue of takers for his famous fruit squashes, delicious bananas and succulent oranges (see Plate 12).

23. KIOSK: FRANKFURT

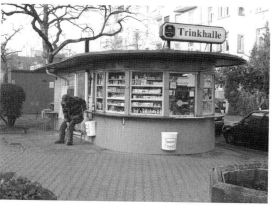

5.18. Kiosk, Frankfurt.

5.17. Medina tower, Tel Aviv.

19. PINTO TOWN PLAN: DIAGRAM

Together with Salvador Perez Arroyo and Eva Hurtado, we made this proposal for extending a little dormitory town near Madrid (see Plate 9). In the diagram we see a series of coincident ideas: breeze, perambulation, showing off, tucking under; a type of nonchalant Acropolis.

Same period. Same formula. Same boulevard, etc. Miserable old codger, sad Turkish incumbent, tired green kiosk. But isn't Frankfurt supposed to be in the privileged world??? Discuss.

24. 'FROTHY COFFEE', CLERKENWELL, LONDON

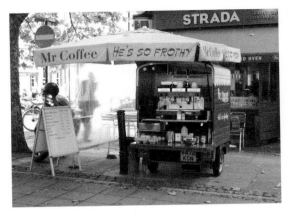

5.19. 'Frothy coffee', Clerkenwell, London.

Peter Banham used to write about fast food joints in the Finchley Road, about vehicles and so on. So he'd like this manifestation: almost 'Archigram'-like in its proposition: the scooter in the metal box. The Gaggia machine doing its 'thing' BUT ALSO a flap-out umbrella to complete the kit!

25. 'GUNGE' WALLS FOR MADRID

I'm pretty sure that PB invented the word 'GUNGE', so he'd know about walls that used up crappy leftover bits and pieces that can be slurped into cement and cast in big chunks: then used as a temporary wall system. Again for the unsuspecting city of Madrid!

5.20. 'Gunge' walls for Madrid.

26. VERBANIA MUNICIPAL THEATRE

5.21. Verbania municipal theatre.

Now we (CRAB STUDIO: Peter Cook and Gavin Robotham with Salvador Perez Arroyo) have won a competition for the Municipal Theatre of this town on Lake Maggiore. It's both friendly and nonchalant: but fully aware (as with Pinto) that small-town atmosphere and life is about the way in which set pieces of architecture must also involve odd nooks and crannies, corners where you can almost hide, as much as the big set-piece aspects.

27. BOOK COVER: *THE CITY SEEN AS A GARDEN OF IDEAS*

5.22. Book cover: *The City Seen as a Garden of Ideas.*

The book really develops some of these things further, so I hope that PB would enjoy it!

NOTES

1. This lecture was delivered at the Victoria and Albert Museum, London, in March 2006.
2. The Bartlett School of Architecture at University College London.

Part II

FROM VEHICLES OF DESIRE TO SUNDAE PAINTERS: SEEING THINGS THE BANHAM WAY

The repertoire of hooded headlamps, bumper-bombs, sporty nave-plates, ventilators, intakes, incipient tail-fins, speed-streaks and chromium spears, protruding exhaust-pipes, cineramic wind-screens – these give tone and social connotation to the body envelope...

'Vehicles of Desire', *Art*, 1 September 1955

Ice cream waggons must be about the biggest invisible objects in residential Britain. If they are 'seen' by adults it is metaphorically – as problems, as threats to the road safety of children, their chimes an invasion of environmental privacy. But next time a waggon enters your field of concerned liberal attention, try looking at it with your eyes instead...

'Sundae Painters', *New Society* 28, no. 601, 11 April 1974

SLEEPING AROUND
A HISTORY OF AMERICAN BEDS AND BEDROOMS

elizabeth collins cromley

In the late 1970s, Peter Reyner Banham was Chairman of the Design Studies Department in the School of Architecture and Environmental Design at the State University of New York in Buffalo.[1] After he left in 1980, I was appointed to fill his position and become the historian for the architecture faculty. While I had not yet met Professor Banham, his books, *Theory and Design in the First Machine Age* and *The Architecture of the Well-Tempered Environment*, had had a major role in shaping my thinking about twentieth-century design. The *First Machine Age* showed me that modernist heroes' words need not be taken at face value and that insights emerge when the mismatch between what is said and what is built is critically explored. *Environment* demonstrated that a fresh lens could throw new light on even the most familiar, often-published masterpieces. However, I had no illusions that I, a mere beginner, could replace someone of his international reputation. So I didn't follow in his footsteps, but I do think that my work has been affected by the openings he created within architectural and design history.

Reyner Banham's work provided the valuable model of a design history that was not obsessed with style questions and did not take aesthetic issues to be more important than all kinds of other issues. For me, his work provided the necessary counter to the

tendency among architectural historians to focus on geniuses and styles as self-justifying objects of study. Although always interested in buildings, Banham also published essays on cars, portable technologies such as the outboard motor, or the design of sheriff's star badges. As Peter Hall observed, he refused 'to put a boundary line around architecture; it merged into the design of everyday objects'.[2] Banham's interest in these aspects of popular culture and in the mentalities of particular eras made a scholarly space in which those of us who follow can take the world of common design as proper grounds for scholarship and tackle its history seriously.

Among American scholars of architecture, in the past twenty-five years or so there has been an effort to broaden architectural history to include everyday environments and common building types, paralleling Banham's willingness to look at the bicycle shed as well as the cathedral. While traditional architectural historians established a canon of noteworthy male architects and their usually wealthy clients, a younger generation of scholars has appreciated vernacular buildings, tried to understand how their builders and inhabitants thought about design and experienced buildings, explored the regional differences in the building of farm landscapes or small towns, and then turned to apply their newly conceived questions to the work of elite architects. For example, Frank Lloyd Wright and Louis Sullivan, pillars of architectural creativity at the end of the nineteenth century, had been admired for their aesthetic achievements, but a new generation wanted to explore how their clients used the houses they designed, or how the real-estate development around their sites influenced their choices.[3]

This essay tests the claim that we should take common design seriously by looking at some aspects of that very familiar household space, the bedroom and its contents. The bedroom suggested itself as a starting point in a larger project of mine on the history of American domestic space, because beds present themselves as the most obvious, the most transparent of any household object, and the meaning of a bedroom seemed the most taken for granted of all the rooms in a house. But the bedroom is also the most unexamined of household spaces, and purposely so, since it represents the private within the privacy of home. Furthermore, it is also the site for many other activities and cultural expressions besides the obvious ones. The sleeping aspect of household life is supported by the house's spatial structure, and as that structure changes, the location of sleeping and the relationships between sleeping and other activities change too. The bedroom as an object of study provides a chance to break down some of the boundaries between design history and architectural history, since architectural space, the activities in that space, and the designed objects that enabled those activities all enact their meanings in concert.

This essay will explore American bedrooms of the eighteenth century through to the early twentieth century, in order to fill in the gap between the word on an architect's plan and the uses and meanings of this room in day-to-day life. Research for this work has been restricted to published articles that document middle-class bedrooms and building plans that label the various rooms in a house. The word 'chamber' often indicates a bedroom but initially meant an inner room, also called a parlour, in which to withdraw from the multiple, busy activities of the traditional hall. Later nineteenth- and twentieth-century house plans often used the term 'chamber' for higher-status bedrooms and 'bedroom' for lower-status ones. The term 'bedroom' will be used to denote all sleeping rooms and this essay will begin my decoding of the bedroom by looking at changing attitudes towards the space that contains the bed. It will then examine the spatial location of the bedroom in a house, the role of 'privacy', who the occupants of a bedroom are, and how personal character may find expression in the bedroom. Also considered are the ways in which

the bedroom has been seen as the site of health concerns and, finally, the bedroom's role in fantasy. None of these issues explains the bedroom fully, but taken together they begin to uncover aspects of its changing meaning in the bourgeois home.

WHERE WILL PEOPLE SLEEP?

In the English or Dutch colonist's house of seventeenth-century America, bedrooms as such were among the missing features. Of course, people slept then, as now, but where they did so in the house shows our seventeenth-century predecessors to have had a very different conception of how space can be divided. In the hall-parlour plan type of seventeenth-century New England, the hall was the site for cooking and eating, light household production, ad hoc sleeping, and a host of other activities done by all the members of the household and their visitors. The other ground-floor room was the parlour, in which the 'best' things, people and occasions had their places. In the parlour was the best bed; along with it were the best tea table and chairs, the mirror, the tapestry table covering, and other fine-quality possessions of the household. The parlour served as the sleeping place for the heads of the household, since they, like the tea table and mirror, had the most elevated status in this house. This was a world that divided space according to the rank and value of its contents, not according to the separate functions that it served.[4]

The earlier seventeenth-century merger of activities in the best parlour was reduced in the eighteenth-century bedroom. In the well-to-do New England household of the mid-eighteenth century, a clarification of room functions accompanied an expansion in the number of rooms and in the amount of circulation space.[5] Generous passages and stairways created a system of movement through the house that did not require people to walk through one room to get to the next. Houses contained many more specialized rooms such as dining rooms, and freed the bedroom of competing uses. In this era's house we find fully developed bedrooms, with bed curtains, chair seats and window curtains all made from matching textiles. Canopied beds echoed for New England householders some of the authority signified by the hangings on royal beds and the roof-like terminations of pulpits and thrones.

Now its inhabitants used the bedroom for daily sleeping and dressing activities, for quiet retirement, and for socializing with their nearest friends and family members. Periodically, at births or deaths, bedrooms hosted more formal receptions. By the eighteenth century, then, a specific room that was focused on the bed and could be called a bedroom had become common in prosperous households, and it continued to be available to the builders of middle-class houses throughout the period we are considering here.

Where a sleeping room should go in relation to other rooms in a house is a complex question. By 1900, house designers tended to gather bedrooms into a group clearly separated from more public activity zones. But in houses of the nineteenth century, bedrooms were often linked directly to the public reception rooms. Designs from Gervase Wheeler's 1855 book, *Homes for the People*, provide examples of houses for rich and poor, set in both urban and rural settings, suggesting preferred bedroom locations. He proposed a two-storey addition on the front of an old house in order to give it an up-to-date villa appearance. On the ground floor were the parlour, dining room and a bedroom. The bedroom has a door communicating with the dining room, and, from there, immediate access to the parlour. On the second floor, which Wheeler

called 'the chamber floor', there were three large bedrooms for other family members.[6] A plan published by Wheeler for a two-storey detached cottage with an attic for a suburban or country location had a ground-floor centre-passage plan with a parlour at the front, a sitting room, a dining room at the rear that communicates with the kitchen, and in the corner of the ground floor a bedroom, linked to the parlour by one door.[7]

Both of these designs provide a separate second floor for the majority of family bedrooms but significantly include a bedroom on the ground floor, which is attached to the most important reception rooms in the house. The master and mistress had their room linked to the principal reception rooms of the house, asserting their authority through spatial location. While a ground-floor bedroom was sometimes appropriated as a guest room, or as a sickroom to save invalids and their carers from climbing stairs, often this room belonged to the heads of the household. In general, the status of mid-nineteenth-century bedrooms decreased with floor level.

Linking master bedrooms to reception rooms became less common in the early twentieth century. *The Delineator*, a magazine specializing in women's fashion and household decoration, held a competition for a 3,000-dollar house in 1909 (Figure 6.1). The first three prizewinners

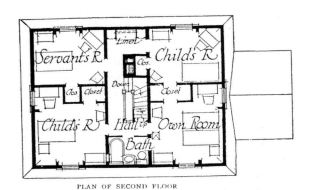

PLAN OF SECOND FLOOR

6.1. Claude Bragdon's house design for *Delineator* magazine, in which all bedrooms – for child, servant, or heads of household – are together on a chamber floor. *Delineator's Prize $3000 House.*

deployed all their bedrooms on second-storey, separate bedroom floors. In the house designed by architect Claude Bragdon of Rochester, NY, the ground floor has a kitchen and dining and living rooms. The bedroom floor has four sleeping rooms: one a servant's room, two bedrooms each marked 'child's room', and a third bedroom called 'own room'.[8] This plan clarifies room location by function rather than by status of occupant, placing all household members' sleeping rooms together on the second level. The privacy of bedroom occupants is enhanced as their access from the principal floor of the house is reduced. The bedrooms tend to have a single door from a corridor, or at most one other door that links the parents' room with a child's, which also enhances privacy. By the early twentieth century, the function-related category, 'sleeping zone', prevailed over rank-related categories such as 'servants' zone' and 'family zone'.

During the same period, designers of single-floor homes also confronted problems in locating the bedroom. The plans for early New York City apartment units with all rooms on one floor often mixed sleeping rooms with the family's other, more social rooms. In Richard Morris Hunt's Stuyvesant Apartments of 1869 (Figure 6.2), a bedroom is linked to the parlour at the front of the building, while other family bedrooms fall between the dining room and the kitchen to the rear.[9] By the first decade of the twentieth century, apartment designers preferred grouping all

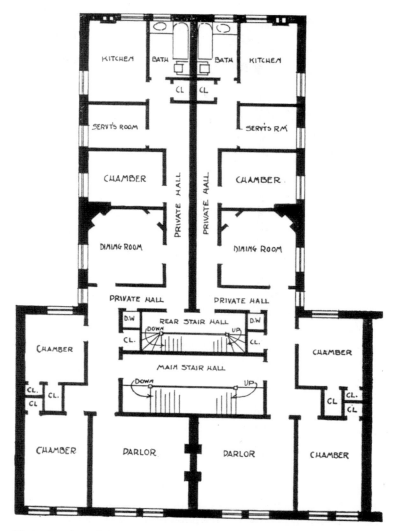

6.2. In the plan of the Stuyvesant Apartments, New York, by Richard Morris Hunt, 1869, a chamber is linked to the parlour and given a street view, while lesser bedrooms look on to a light court.

family bedrooms together in a sleeping zone. A good example is Israel's and Harder's apartment house on Irving Place, where all reception rooms are grouped at the social end of the plan, and all bedrooms, for both family and servant, are segregated at the other, private end. These two zones are separated by the kitchen and service zone.

To make the most of limited space in apartments and small houses, patent furniture manufacturers developed ways of concealing beds. They reasoned that householders could decorate their apartment living rooms with couches and easy chairs for daytime use, and then fold a bed out of a piece of patent furniture for night-time use. Furniture that concealed a bed inside might appear on the outside to be a chiffonier, a piano, a desk, or an armoire (Figure 6.3).

ANDREWS' PARLOR FOLDING BED.
CHIFFONIER STYLE.

ELEGANT
DESIGN!

CELEBRATED
ADJUSTABLE
CABLE
SPRING!

AUTOMATIC!

PERFECT
BALANCE!

SUPERIOR
FINISH!

Illustrated Catalogues, exhibiting latest designs of CABINET, BOOK-CASE AND LIBRARY STYLES, with Price Lists
furnished free on application.

19 Bond Street, New York.
A. H. ANDREWS & CO., 195 Wabash Avenue, Chicago.
27 Franklin Street, Boston.
815 Arch Street, Philadelphia.

6.3. Andrews' Parlor Folding Bed, chiffonier style.
Decorator and Furnisher (December 1885): 104.

Designers of twentieth-century bungalows, two- and three-family flats, and ranch houses also laid out all rooms on one floor and had to manage the relation of bedrooms to social spaces. Two inexpensive prefabricated Aladdin Redi-Cut houses of 1918–19 answer the question of the bedroom's relation to other rooms in the house in radically different ways.[10] One has its bedrooms deployed all around the social spaces, with doorways opening directly into the living and dining rooms; the other has all its bedrooms grouped off a little hallway that completely buffers them from the social spaces. One plan enhances privacy while the other preserves opportunities for intra-familial surveillance.

Although this history of the spatial location of bedrooms at first seems to indicate a development toward a clarification of rooms' uses, towards a room that is purely a bed room, and towards an isolation of all bedrooms in a zone of privacy, the bungalow examples remind us of the complexity of the question. The locations of bedrooms and their spatial relationships to other rooms of the house in one-floor house plans, as well as in two- and three-floor models, show a variety of answers to the problem of bedroom placement, sometimes grouping the bedrooms by their sleeping function, but sometimes locating them in response to other family demands.

SELF-EXPRESSION IN A BEDROOM

While everybody sleeps, different members of the household have different claims to a bed or a room of their own. The bourgeois house of the nineteenth and twentieth centuries typically had at least two if not many more bedrooms, but who got a bedroom of her or his own was an open question. Children were often grouped together in a room and may have had their own single beds but not yet their own bedrooms. Servants, if lucky, were treated the same as children, with one bed per servant, but more than one per room. Boys and girls old enough to be understood to have individual identities could have their own beds and bedrooms. Older sons and daughters each had their own bedrooms, and even invalids had bedrooms designed for their needs. But one of the things one was likely to lose upon marriage was a room of one's own. At the turn of the century, many writers gave the bedroom power to express the self:

> Every opportunity should be given for the development of individuality in a room which
> is preeminently the corner of the home which is truly home to the occupant, where the
> taste of no one, either guest or relative, need be considered.[11]

Bedrooms, among all the rooms in a house, are known for their ability to convey individuality, noted Ella Church in 1877 in her home decorating advice column for the family magazine *Appleton's Journal*: one can tell at a glance the mother's room from the brother's room. In the mother's room, one finds an extra-large and comfortable bed, an easy chair and a table, things used for 'accommodating numerous inmates' (see Plate 13). The bachelor's room (the uncle's or brother's) is full of newspapers, pipes, cigar boxes and photographs of actresses. The young lady's room has muslin flounces on everything, usually either pink or blue; the grandmother's room has an old-fashioned four-poster bedstead, three-storey bureau, and her favourite easy chair. Only in the children's room, with its 'snowy-draped' bed for the six-year-old and a swinging crib for the two-year-old, are sexes combined and individual identity statements blurred.[12]

The other rooms must reflect the life of the whole family and everyone's various occupations, but the bedroom 'is the place for one's personal belongings, those numberless little things which are such sure indications of individual character and fancy ... the one room where purely personal preference may be freely exercised'.[13] Of course, the marital bedroom poses a challenge to self-expression. While the modern married couple's bedroom is almost invariably called the 'master' bedroom, most nineteenth- and twentieth-century descriptions assume a bias towards the wife's needs, listing dressing tables, mirrors tall enough to see the hem of a dress, and lounges on which to rest during the day as necessary elements in the couple's bedroom. Nineteenth-century descriptions often call this room 'mother's', even though father slept there too.

In E. C. Gardner's entertaining 1880s book, *The House That Jill Built After Jack's Had Proved a Failure*, an uncle of the family espouses the 'individuality' position in regard to separate bedrooms for husband and wife:

> The personality of human beings should be respected. The chief object of home is to give each individual a chance for unfettered development. Every soul is a genius at times and feels the necessity of isolation. Especially do we need to be alone in sleep, and to this end every person in a house is entitled to a separate apartment.[14]

Bedrooms test the understanding of the 'mother or house-ruler' in so far as she allows each occupant some space for self-expression, asserted Candace Wheeler in her 1903 *Principles of Home Decoration*. 'Characteristics of the inmate will write themselves unmistakably in the room', Wheeler continued:

> If you put a college boy in the white and gold bedroom, soon sporting elements and an atmosphere of outdoor life will creep in. Banners and balls and bats, and emblems of the 'wild thyme' order will colour its whiteness... In the same way, girls would change the bare asceticism of a monk's cell into a bower of lilies and roses.15

Home decorating books advised parents on the proper decorations for the boys and girls of the family (Figure 6.4). One article suggested making furniture of railroad ties for a boy's room.[16] Girls' rooms had junior dressing tables as well as space for artistic and intellectual development.

What has been represented in these quotes as the expression of individuality was often, instead, an expression constructed out of markers of gender roles. This is made clear by the advice of a keeper of a boarding house on decorating young men's rooms. What might be seen as 'individualiz-ing' in a private setting is revealed to be generic and gender-related in the boarding house. This keeper of the boarding house advises that the pictures in a boy's sitting room should be 'strong,

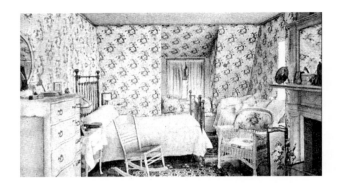

6.4. A young girl's room, from *Ladies' Home Journal*, 1910.

bordering on frisky', with appropriate images including bulldogs, baseball players, college scenes and horses. The pictures in this room should represent 'workaday life – that of a man among men'. But in the young man's bedroom should be works 'prophetic of his home life . . . His pictures there should be soft and inspiring like the caress of a good woman . . . The young man has no mother, sister, wife or child to keep his life sweet and clean, his ideals high and true; the influence of his landlady' is all he has. So give him an American flag to cultivate his patriotism; hang a Madonna in his room, and also a picture of 'the Master'. 'One or two photographs of the mother or best girl should be neatly framed and kept nice – moreover they should be looked at every day'.[17]

The sincerity of advice books in urging that each bedroom's occupant have plenty of latitude in self-expression through the choice of objects and furniture must be questioned. All this advice assigns predictable signs of gender to those presumed individuals. All girls should have ruffled dressing tables; all boys need to decorate their rooms with baseball bats. Young men all need to declare their individuality through 'frisky' pictures of bulldogs; all mothers' rooms must express nurture. It seems that the bedroom's decor shapes its occupant into correct gender roles, rather than that the occupant expresses individual taste in shaping the bedroom.

HEALTH IN THE BEDROOM

While the bedroom affects psychological health, it has a more overt role in matters of physical health. Sleeping is of course essential to health, but many other health concerns occupied authorities on bedrooms in nineteenth- and twentieth-century literature. Catharine Beecher told her readers how to keep the bedroom dust- and bug-free in her 1869 *American Woman's Home*, offering recipes for poisoning bedbugs and advice on beating rugs.[18] Many mid-century writers argued against bed curtains, wallpapers and carpets because they concealed dust and made it impossible to have the bedroom really clean (Figure 6.5). Metal bed frames had their advocates because bedbugs would not live in their joints as they did in the joints of any wooden bed.

The bedroom 'is really the most important room in the house by far and far again', advised Dr Richardson in his home-health magazine articles of 1880.[19] But it is often the room that is least considered in building or furnishing a house. People often turn any unused space, closet, attic or dressing room into a bedroom, ignoring the true needs of sleepers. Instead he urged designers of houses to make sure the bedroom faced south-west for the best breezes, and he urged sleepers

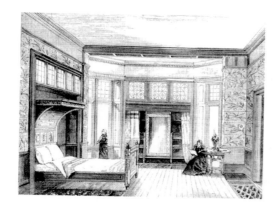

6.5. A curtainless bed promotes a dust-free environment in the healthy bedroom. Henry Hudson Holly, 'Modern Dwellings', *Harper's Monthly*, 1876.

to face east so the body was lined up with the sun's path for greatest health. Health would be protected by locating the bedroom in relation to sun and climate.

By the turn of the century, the most pressing health worry had shifted to the prevention of tuberculosis, which experts believed could be combated by means of fresh air. In order to avoid the 'Great White Plague', some people even gave up kissing their kin, reported *Scientific American* in 1909. 'Fresh air and plenty of it is the best preventive for consumption, the grip, bronchitis, common colds and pneumonia'. The journal even advised using tissue-paper handkerchiefs.[20]

An 1850 article by Harriet Martineau in *Harper's Monthly* gave mock-serious instructions on how to make an unhealthy bedroom:

> Cover the fireplace up so foul air cannot escape during the night; likewise shut the window. Don't use perforated zinc paneling; if you do, foul air will escape. Close the curtains around your bed; they will be especially effective in containing the 'poison vapour bath' if they are of a thick material. Cover yourself with a feather bed so that your skin can't transpire. Likewise wear a tight nightcap.[21]

Martineau's concerns centred not on dust and dirt, but on the body's need for fresh air and good air circulation.

For the early twentieth-century germ-conscious sleeper, fresh air was critical. Popular magazines such as the *Ladies' Home Journal* recommended that people build screened-porch sleeping areas just outside their bedrooms. Patented sleeping bags to use on the porch left only the head exposed, and it was then covered with a hood. Even so, one could get cold going from the warm changing room to the cold outdoor bed. The Porte-Air allowed one to stay warm in bed while breathing fresh air from the outdoors directly through a large tube (Figure 6.6).

Another solution to this difficulty of keeping the body warm while sleeping in the outdoor air was to extend the end of the bed out of the window at night; the sleeper pulled an awning over his head to protect himself from rain. When above the first floor, however, this method could make one feel in danger of falling, and worse yet, the 'bed shows from the outside of the dwelling'.[22] The fresh-air tent was more inconspicuous. It fitted around the open window and extended inwards over the head of the bed and the head of the sleeper (Figure 6.7). This tent had a window on the bedroom side so the sleeper could converse with others in the room, and it could be used in a double bed where only one person wanted the air. If the weather was cold, one could use a

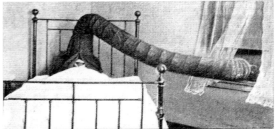

6.6. The Porte-Air gives the sleeper fresh air from outside while allowing him to stay warm in his bedroom. From 'Sleeping Outdoors in the House', *Ladies' Home Journal*, 1908.

When the Porte-Air is Adjusted

6.7. An indoor bed tent covers the sleeper's head, which is exposed to the outside air. From 'Sleeping Outdoors in the House', *Ladies' Home Journal*, 1908.

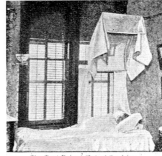
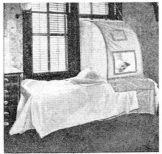

The Tent Raised Out of the Way

When the Tent is in Use

hood with a shoulder cape that left only the eyes, nose and mouth exposed to the air. Although much specialization had gone on within the standard house design, so that many family members had their own rooms where their personalities could be expressed, in sleeping porches they all came together again. A contributor to *Country Life* in 1909 cited an example of a twelve-foot-square sleeping porch used by two adults in a double bed and three strong, healthy children on three cots, all enjoying a bedroom together[23] (Figure 6.8).

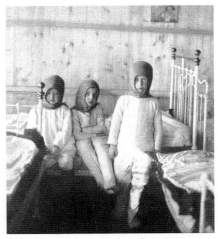

Not Esquimaux, but three healthy, happy Connecticut youngsters winter sleeping garb

6.8. Sleeping porch garb for keeping warm in winter. From C. M. D'Enville, 'Sleeping Outdoors for Health: Outdoor Sleeping for the Well Man', *Country Life in America*, 1909.

6.9. Second-floor plan for a house with sleeping porches designed by C. K. Shilling. From 'A Country Home with Outdoor Rooms', *Country Life in America,* 1909.

By 1909 outdoor sleeping had become immensely popular, observed a contributor to *Country Life*. A 'model house at moderate cost', designed by Ohio architect C. K. Shilling in that year and published in *Country Life*, recognized the new taste for outdoor sleeping and living (Figure 6.9). The dining room and living room each have an outdoor counterpart attached. On the second floor, three of the four bedrooms have attached sleeping porches. These have screens in the summer and canvas shields in winter, with floors of reinforced concrete. The outdoor spaces are incorporated under the main house roof and thus do not read as porches but as part of the body of the house.[24]

A Mr Hoag in the same year described a little wooden house for sleeping out, created as an adjunct to his and his wife's permanent summer cottage. They called it their 'sleeping machine' because it produced a lot of sleep. At 8 × 5 feet, it cost US$20. The house had a shed roof and flaps that opened up on its south and west sides, lined with mosquito wire. The sleeper's head faced south-west to catch the prevailing breezes. This bedroom had broken entirely free of the house and led a life of its own in the backyard.[25]

BEDROOM FANTASIES

Bedrooms may literally break free of houses, but more usually they are places where freedom is found through dreams and fantasies. I conclude with two fantasies of the bedroom. In the first, a journalist of 1902 recollected how mysterious it was to go to bed in her grandmother's huge, canopied, mahogany bedstead; to a child it was so high, and its interior was cavernous and darkened by curtains. She remembered imagining fairies, gnomes, brownies and angels as inhabiting the space enclosed by the room-like bed.[26] Hers is a fantasy of pure interiority, where enclosure is so complete that the inhabitant of the bed advances into a world of imagination.

In the second fantasy, a young man recalled his hall bedroom at the top of a city boarding house as the site for imaginary travel. Although his room was the size of a closet, it had a skylight controlled by dangling ropes, and through it he could look at the sky and the stars. When he

opened the skylight and turned out the gaslight, the moon and stars seemed as near as if he were in a meadow in the country. His room was so small and compact that he likened it to a ship's cabin, and the muffled city sounds to the sea. When covered in snow the skylight gave a greenish light, and he imagined he was in a cave rather than on a ship, 'primitive man in the early wilderness'. He says his room possessed a genius for freeing his imagination to such adventures. The temptations of the Hotel St Regis were nothing to him; he preferred his imaginary voyages in the boarding house hall bedroom.[27] In the cavernous four-poster, the little girl is visited by goblins and angels; in the hall bedroom, the young man sails out towards adventure. Both have their imaginations liberated by their bedrooms. Both fantasies are tied to the particular kinds of beds and bedrooms available at a specific historical moment.

A turn-of-the-century writer speculated, 'Perhaps another generation will see the total disappearance of the bedroom proper, and weary individuals, when night falls, will merely sink to rest on the hygienically-covered floor of their library or sitting-room'.[28] This has not happened for most of us yet. Instead the bedroom has continued to develop along many of these historical lines into the 2000s, its full participation in the social life of the house always restricted by the bed, yet its pure privacy always compromised by other furnishings – if not a tea table, then a TV. 'Personal expression' in the bedroom continues to be dominated by signs of gender. The bedroom continues to serve as a barometer of the ambiguous role of privacy within the family.

NOTES

1. Versions of this lecture, delivered on 10 January 1990, were published in the *Journal of Design History* 3(i). © 1990 The Design History Society; and in Thomas Carter and Bernard L. Herman (eds.), *Perspectives in Vernacular Architecture* IV (University of Missouri Press, 1991).
2. See *A Critic Writes: Essays by Reyner Banham* (Berkeley: University of California Press, 1996), p.xiii.
3. For example, see Richard Longstreth (ed.), *The Charnley House* (Chicago: University of Chicago Press, 2004).
4. Abbott Lowell Cummings, 'Inside the Massachusetts House', in Dell Upton and John Michael Vlach (eds.), *Common Places: Readings in American Vernacular Architecture* (Athens, GA: University of Georgia Press, 1986), pp.219–39, traces the activities of different rooms in period houses through the inventories of their contents.
5. David H. Flaherty, *Privacy in Colonial New England* (Charlottesville, VA: University of Virginia Press, 1972), pp.39–40.
6. Gervase Wheeler, *Homes for the People in Suburb and Country* ([1855]; rpt. New York: Arno Press, 1972), p.387.
7. Wheeler, *Homes*, p.322.
8. Bragdon's design in *Delineator's Prize $3000 House* (New York: B. W. Dodge, 1909) p.26.
9. From Gervase Wheeler, *Homes for the People in Suburb and Country* ([1855]; rpt. New York: Arno Press, 1972), p.387.
10. *Architectural Record* 11 (July 1901), p.479.
11. Ella Rodman Church, 'How to Furnish a House', *Appleton's Journal* n.s.2 (February 1877), p.160.
12. Ibid., p.160.
13. 'The Bedroom and its Individuality', *Craftsman* 9 (February 1906), pp.695–96.
14. E. C. Gardner, *The House That Jill Built After Jack's Had Proved a Failure* (New York: Fords, Howard and Hulbert, 1882), pp.246–47.
15. Candace Wheeler, *Principles of Home Decoration* (New York: Doubleday, Page, 1903), p.61.

16. C. B. Walker, 'Railroad Tie Furniture to Furnish a Boy's Den', *Women's Home Companion* 32 (October 1905), p.48.

17. Tekla Grenfell, 'Renting Rooms to Young Men: How I have Successfully Done It For Years', *Ladies' Home Journal* 25 (September 1908), p.24.

18. Catharine Beecher and Harriet Beecher Stowe, *American Woman's Home* (New York: J. B. Ford, 1869), pp.369–71, 377.

19. B. W. Richardson, 'Health at Home', *Appleton's Journal* n.s. 8 (April 1880), p.314.

20. Katherine Louise Smith, 'Indoor Bed Tents', *Scientific American* n.s. 101 (December 1909), p.423.

21. Harriet Martineau, 'How to Make Home Unhealthy', *Harper's New Monthly Magazine* 1 (June–November 1850), pp.618–19.

22. Smith, 'Indoor', p.416.

23. C. M. D'Enville, 'Sleeping Outdoors for Health: Outdoor Sleeping for the Well Man', *Country Life in America* 16 (May 1909), pp.43–46.

24. C. K. Shilling, (From 'A Country Home with Outdoor Sleeping, Living, and Dining Rooms', *Country Life in America* 16 (May 1909), pp.71–72.

25. C. G. Hoag, 'Sleeping Outdoors for Health: Part VI. A Sleeping Machine', *Country Life in America* 16 (May 1909), p.102.

26. M. MacLean Helliwell (ed.), 'Woman's Sphere', *Canadian Magazine* 20 (1902–1903), p.281.

27. 'The Contributor's Club: Cave-Dwellers, or the Hall Bedroom', *Atlantic Monthly* (July–December 1905) pp.574–75.

28. Helliwell, 'Woman's Sphere', p.283.

7.

'FLASH GORDON' AND AMERICAN AUTO DESIGN IN THE 1950s

frank dudas

PROLOGUE

Peter and I first met at 'Expo '67' in Montreal. He was a special guest of ICSID (International Council of Societies of Industrial Design) and I was the organizer of the ICSID Congress held that year at the World's Fair. Besides the world of design, we shared many interests and views, from Pop culture to industrial archaeology and Formula 1 car racing. We next met at the ICSID Congress in London in 1969; he arrived there after pedalling his way through dense London traffic on a collapsible bicycle with little wheels, which looked inadequate for his bulk. He was as enthusiastic about this little contraption as if he were a bike salesman. Enthusiasm and curiosity were driving forces in Peter Banham's way of looking at the world around him.

When he came to Buffalo in the early 1970s to head the Graduate School of Architecture at the State University of New York (SUNY), he asked me if I would take his students on a day tour of Toronto's building reuse programme; urban philosopher and activist Jane Jacobs had come to live in the city in 1967, and had stirred up interest in redevelopment. In 1975, Peter asked me to take part in the design lecture series at

SUNY. We had often talked about the evolution of design styles. As well as studying industrial design at the Ontario College of Art and London's Royal College of Art, I had a diverse background in product and exhibition design and experience of lecturing on design at engineering facilities. Banham thought that I could therefore bring a different perspective on design to the halls of academe. Thus was born a slide presentation and lecture called 'Flash Gordon and His Influence on the Design of American Cars in the 1950s'. For the next three years, I repeated these annual tours. With the use of seventy-five slides, I tried to show that the styling of American cars in the 1950s could be connected to the look of things in the 'Flash Gordon' Sunday adventure strip of the 1930s. When Mary Banham asked me to give the Reyner Banham lecture in 1991, it seemed apt to do the 'Flash Gordon' talk that we had all previously enjoyed (Figure 7.1).

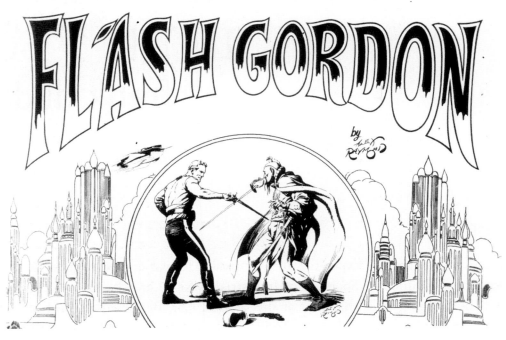

7.1. 'Flash Gordon' – logo.

'FLASH GORDON': HIS INFLUENCE ON THE DESIGN OF AMERICAN CARS OF THE 1950s

Two very important events, which brought change to America, happened in the late 1920s. The first was that motion pictures began to talk in 1927 and the second was Black Tuesday, the day that the New York Stock Exchange crashed. From then on, dreams were better than reality. Hollywood started making movies full of happy, dancing and singing people in Art Deco surroundings. Mostly, the movie characters were rich and drove flashy roadsters. Lean times had people looking for cheap diversions such as movies, radio and newspapers.

It was around this time that adventure comic strips, printed in colour, began to appear in large separate sections of the Sunday newspapers. These imaginative adventures helped create alternative

7.2. Endpaper from the 'Flash Gordon' book, *Into the Water World of Mongo*, 1938–1940. It illustrates artist Alex Raymond's maturing quality and style in the creation of the 'Flash Gordon' design idiom.

worlds where anything would be possible, and comics also sold more newspapers. Interestingly, this seems to have been the time when industrial design started in America and styling became an important means to sell goods by expanding on Art Deco shapes and decorations. Household appliances became streamlined; automobiles were festooned with chromium-plated bits, taking on the look of luxury. The Chrysler Building was decorated with giant hood ornaments and hubcaps, and topped off with an Aztec sunburst (Figure 7.3). At the Rockefeller Center, Art Deco versions of South American motifs were used as decoration.[1] It was certainly not the singularity of the Bauhaus idea that held sway on the American design scene, for industrial design was driven by rapid obsolescence and styling. The look of things became the selling of dreams: the dream of speed and power, the dream of luxury and splendour, the dream of progress and change. The automobile had become the American dream machine. 'Flash Gordon' burst on to the scene in 1934 at the depth of the Great Depression. I will show how this unique and popular comic strip introduced art, design and styling to impressionable youth.

I remember where I was and what I was doing on the very day that I first saw a 'Flash Gordon' strip, now seventy years ago. In the 1930s, Sunday colour comic strips were an important part of home entertainment for American families. Newspaper chains competed to carry the most popular comic strips in order to sell their newspapers. 'The Funnies', as they were popularly known, carried exciting serials to arouse their readers, young and old, into wanting more.

7.3. The Chrysler Building, New York.

7.4. 'Flash Gordon' – capital city of Arboria on the Planet Mongo held up by atomic rays.

Alex Raymond, a young art school graduate, created a new adventure strip for King Features Syndicate in 1934 called 'Flash Gordon', and it became an instant success.[2] In short order it climbed to the front page of the Sunday comic sections in the US newspapers, a sure sign of its popularity with American family audiences. But it was not until 1938 that 'Flash Gordon' first appeared in Canada in the *Toronto Star Weekly*. Raymond drew and wrote this strip until 1944, when he joined the US Marines. After his military service, by his own choice, he never returned to 'Flash Gordon'.

In the beginning, Alex Raymond's drawing and colouring techniques were coarsely executed in a cartoon style much like that of his contemporaries. He used the usual conversation balloons for dialogue, which limited drawing composition and quality. However, in the competition for sales, adventure comic strips such as 'Tarzan and the Apes', 'Prince Valiant', 'Buck Rogers in the Twenty-Fifth Century' and 'Terry and the Pirates' all tried to create more lifelike illustrations. Soon Raymond started to refine his design composition and use of colour. Dialogue moved to the bottom of the picture and now included expanded descriptions that created a new kind of illustrated literature. He drew on the great adventure stories of the past: 'King Arthur and the Knights of the Round Table', 'Robin Hood and his Merry Men', the 'Norse Sagas', 'The Charge of the Light Brigade', and many other adventures, including some that looked like a proper setting for Wagnerian opera. Some inspiration came from the better adventure movies of that time and some of the strip's characters bore accurate resemblance to movie stars such as Errol Flynn, Jean Harlow and Sonja Henie.

Raymond admired the outstanding American illustrators of the twentieth century including Charles Dana Gibson, Matt Clark, Franklin Booth and John LaGatta.[3] Writers such as Jules Verne and Edgar Rice Burroughs inspired the imaginative fantasies that became his trademark as he created adventures that would deal with prehistoric and futuristic images in the same picture frame.[4] We see Flash Gordon, an earthling who came to the Planet Mongo on a rocket ship, destroying a dinosaur-like creature not with a ray gun but a sword. The storyline of mixing the past with the future and enlivening it with mythology and tales from history created a lively environment for the hero and his companions.

To capture the feeling of advanced technology in a distant world, Raymond used modern design sources, so that we can see elements of the Bauhaus, Frank Lloyd Wright, Le Corbusier, and designers such as Norman Bel Geddes, Raymond Loewy, Henry Dreyfuss and Donald Deskey in the cities, buildings and artefacts of Mongo (Figure 7.4). By providing Flash with a constant, beautiful girlfriend, the adventure story brought in love and jealousy. There were always ladies, of the queen or princess sort, who wanted to get their hands on Flash. These diversions spiced the stories with intrigue and glamour, for Alex Raymond was particularly good at drawing the female form wearing next to nothing, which may have added to the strip's popularity.

The principal characters of this fantasy are Flash Gordon, Yale graduate and world-renowned polo player; Dale Arden, a beautiful fellow passenger Flash rescues from an aeroplane crash caused by a fiery comet; and Dr Zarkov, a slightly mad scientist who forces the couple into his rocket ship, which he intends to use to deflect comets being aimed at the Earth by Ming the Merciless, the fiendish emperor of the planet Mongo and aspiring conqueror of the universe. Having saved the doomed Earth, the rocket ship crashes into the planet Mongo and for the second time, and many more times to come, Flash and his companions survive massive accidents. The saga begins as the three earthlings face a succession of battles with Ming's forces and the colourful variety of inhabitants from the nether reaches of planet Mongo.

There are huge cities, 'dazzling like a huge diamond', whose pointed, glistening towers would put New York to shame (Figure 7.5). Perhaps the most whimsical of these is a large, skyscraper mega-structure built on the branch of an enormous tree and connected to a vast forest by wide roadways suspended in mid-air. It should not come as a surprise that the inhabitants are all dressed like Robin Hood and his Merry Men while enjoying the benefits of rocket cars, monorail trains and very convenient elevator devices. However, they still rely on the longbow and sword for battle.

Alex Raymond conjured up a fascinating breadth of things for this weekly comic strip. He was constantly killing off Flash or bringing him near death. Every time, a special injection or electrical device would bring him back as new. Of course, there were a wide variety of tanks, rocket submarines and ships, ray guns and even a ray to make Flash invisible, leaving only his shadow behind. There were wireless hand-held telephones and a television communication system used by Emperor Ming to issue commands to his vassals and threats to his enemies. One of his opponents became so infuriated that he slashed the TV screen to pieces with his sword. There were rocket vehicles of every sort imaginable, from snowmobiles to elevated trains. There was even a thought-projection machine and a very useful ray beam that could tunnel through a solid rock mountain.

For a weekly adventure strip to be a commercial success, it has to stimulate imagination and a desire to see the next issue (Figure 7.6). The 'Flash Gordon' strip cultivated what would now be called a vast after-sales market. There were toys, guns, games, tricycles and wagons; there were

7.5. 'Flash Gordon' – city in the trees.

colouring books, puzzles, helmets and clothing; there was a fifteen-minute nightly radio serial that went on for several years and in 1936, 1938 and 1940 there were twelve-episode picture serials.

I am fascinated by the direct link I believe to exist between the design qualities of Alex Raymond's adventure masterpiece and the work of a generation of industrial designers (see Plate 14). Certainly not as philosophical as the Bauhaus design movement, the American Streamline design style had great commercial validity in the period after the Second World War.[5] Raymond's artistic imagination not only brought us the look of Emerald City in the *Wizard of Oz* and the inspiration for George Lucas's *Star Wars* series, but also it was quite apparent in the look of products by industrial designers in the 1950s. Some of the impressionable young 'Flash Gordon' fans in the 1930s surely ended up as the designers who produced the automobile designs built between 1952 and 1958. To establish the connection, I reviewed the entire adventure strip to find a selection of American cars made during that period. Alex Raymond drew few automobiles in 'Flash Gordon', but it was the rockets, submarines, boats, elevated monorails and setting in which the action happened that created the design idioms that became the decoration in 1950s automobile styling.[6]

7.6. 'Flash Gordon' collage.

While it would have been possible to see prime examples of these cars in renovated condition owned by enthusiasts, there is a kind of unreality about perfect specimens. The better approach – it seemed to me when I was carrying out the research for this lecture in the 1970s – would be to find an auto-wrecking yard that had old cars in the beaten-up condition that was part and parcel of the North American pursuit of planned obsolescence. It would also show the quick flight of styling. Eighty kilometres east of Toronto, I came across a wrecker's yard, founded in 1927, where the wrecks were laid out as a three-dimensional catalogue of makes and years. The automobile stylists had wholeheartedly embraced Alex Raymond's mixed design palette of design idioms. Exuberant wings, rocket hood ornaments, Gothic chromed radiator grills and rocket-like exhausts at the back were the general attributes of all American makes. Nor did the interiors escape the 'Flash Gordon' treatment (Figure 7.7).

7.7. Fine examples of planned obsolescence, each with a debt to 'Flash Gordon': 1952–58 cars, photographed in 1974 at Elliott's Auto Wreckers, Newtonville, Ontario, Canada.

EPILOGUE

I want to end with a comment on my feeling of walking through that auto-wrecker's yard. The experience was like reliving one's own history, for here were the cars that were reminders of events in one's life. As these auto wreckers had been established in 1927, there were still remnants of cars from the beginning of the motor car industry to quite recent times. One could see a first family car, the splendid objects of adolescent desire, the very first brand new car that you owned or the facsimile of the car that played a part in your courting life. In 2008, this yard no longer exists and perhaps all old cars are now expensive recreations or have now been compressed into junk cubes.

NOTES

1. See, for example, Daniel Okrent, *Great Fortune: The Epic of the Rockefeller Center* (London: Penguin, 2003).
2. Alexander Gillespie Raymond or Alex Raymond (2 October 1909–6 September 1956) was born in New Rochelle, New York. In 1929, he enrolled at the Grand Central School of Art in New York. The following year he began working with Russ Westover, the creator of 'Tillie the Toiler', and was introduced to Kings Features Syndicate. Shortly afterwards Raymond transferred to Lyman Young, working on 'Tim Tyler's Luck' until 1933. At the end of that year Raymond was asked by King Features Syndicate to create a Sunday page that could compete with 'Buck Rogers'. He created 'Flash Gordon' and its complementary strip, 'Jungle Jim', an adventure series set in South-East Asia, to fit this brief. Also in 1934, Raymond was signed to draw another strip entitled 'Secret Agent X9', which was scripted by Dashiell Hammett for the *Evening Journal*. In 1944 Raymond joined the US Marine Corps and served in the Pacific. Demobilized in 1946, Raymond created a new daily strip, the police-themed 'Rip Kirby', for which he received a Reuben Award from the National Cartoonists' Society in 1949. Alex Raymond died at the height of his fame, in 1956, after a car accident in Westport, Connecticut, while driving with fellow cartoonist Stan Drake (source: http://lambiek.net/artists/r/raymond.htm).
3. Charles Dana Gibson (1867–1944), lived/active in New York and Maine; Matt Clark (1903–73), lived/active in New York and Ohio; Franklin Booth (1874–1977), lived/active in New York, see Manuel Auad (ed.), *Franklin Booth: American Illustrator* (San Francisco: Auad Publishing, 2006); John LaGatta (1894–1977), lived/active in New York. Further details about all four artists are found in Walt Reed, *The Illustrator in America 1860–2000* (New York: Watson-Gupthill, 2001).
4. Jules Gabriel Verne (1828–1905), French author, pioneered the science-fiction genre. Best known for the novels *Journey to the Centre of the Earth* (1864), *From Earth to the Moon* (1865), *Twenty Thousand Leagues Under the Sea* (1870) and *Around the World in Eighty Days* (1973). See Peter Costello, *Jules Verne: Inventor of Science Fiction* (London: Hodder and Stoughton, 1978). Edgar Rice Burroughs (1875–1950), American author, best known for his creation of Tarzan, in the first of a series of novels, *Tarzan of the Apes*, 1912. However, along with these jungle adventures, Burroughs wrote numerous science-fiction stories such as those of the *Moon, Venus and Barzoon* series, as well as Westerns such as *The Bandit of Hell's Bend*, 1926, and historical novels such as *The Outlaw of Tom*, 1927. See Richard A. Lupoff, *Master of Adventure: The Worlds Of Edgar Rice Burroughs* (University of Nebraska Press, 2005).
5. For more extended discussions of twentieth-century American industrial design see, for example, Jeffrey Meikle, *Design in the USA* (Oxford: Oxford University Press, 2005); Jeffrey Meikle, *Twentieth Century Ltd.: Industrial Design in America, 1925–1939* (Philadelphia: Temple University Press, 1979); Arthur Pulos, *American Design Ethic: A History of Industrial Design to 1940* (Cambridge, MA, and London: MIT Press, 1983); and Arthur Pulos, *The American Design Adventure, 1940–1975* (Cambridge, MA, and London: MIT Press, 1988).

6. See also, for example, Stephen Bayley, *Cars: Freedom, Style, Sex, Power, Motion, Colour, Everything* (London: Conran Octopus, 2008) or Bayley's *Harley Earl* (Design Heroes Series), (London: Taplinger, 1991) or David Gartman, *Auto Opium: A Social History of Automobile Design* (London: Routledge, 1994); Peter Wollen and Joe Kerr (eds.), *Autopia: Cars and Culture* (London: Reaktion, 2001) and Reyner Banham's own writings on car design as seen, for example, in Penny Sparke (ed.), *Design By Choice* (New York: Rizzoli, 1981).

8.
A PAPER ATLANTIS
POSTCARDS, MASS ART AND THE AMERICAN SCENE
jeffrey l. meikle

Few travellers to America in the twentieth century were as enthusiastic or observant as Reyner Banham. And few recognized as fully as he did how much perceptions could be mediated by images seen before one had entered the United States. As he recalled, American magazines and movies offered the 'only live culture' he had known growing up. Never able to abandon their extravagant vision, he tried anyway, learning to drive so he could 'read Los Angeles in the original' as an earlier generation of British travellers had learned Italian so they could 'read Dante in the original'. Cruising the freeways and directly experiencing LA, Banham observed the 'fantasticating tendency' of a built environment that reflected dreams and fantasies of popular media. During his final decade, he published two volumes marking his experience with American visions and realities. One recorded his surprise and delight at discovering the derelict grain elevators and factories of Buffalo whose monumental forms, mediated by grainy half-tone reproductions, had inspired European modernist architecture. Banham was so 'moved by these buildings', so excited to discover they 'were not imaginary', that he devoted a book to documenting the 'tangible fact' of this *Concrete Atlantis*. At the opposite pole, thematically and geographically, was his meditation on the desert lands of the American South-West, *Scenes in America Deserta*, which contained precise descriptions

of natural features and human inhabitants but reserved its best writing for evoking the hallucinatory quality of desert light.[1]

Ordinary Americans of an earlier generation perceived the landscape through a unique variety of picture postcard popular during the 1930s and 1940s – with colourful representations nearly as visionary as Banham's word paintings. One postcard in particular, portraying 'evening colors on the desert', could be used to illustrate Banham's description of a sunset in New Mexico. 'As the sun dipped further', he wrote, 'the color of the mountain had gone down through staring orange to purple-red and finally to a dull incandescent violet before darkness finally claimed it as a black silhouette against the residual sky glow before the stars came out.' This image – and others like it – would have appealed to his appetite for extravagant popular culture. Whether he ever saw such cards, obsolete before he travelled west, he did refer with pleasure to 'the cheapo charm of postcard sunsets'.[2]

Such brightly coloured images now seem uncanny, unreal, even surreal, but for people who visited tourist sites or received postcards from friends and relatives, these images printed on inexpensive card stock, embossed with a so-called linen texture, seemed truly to represent reality. Whether depicting skyscrapers, dams, bridges, cityscapes, world's fairs, or other high-tech miracles, or natural pleasures of rural landscapes and Western vistas, linen view cards portrayed the American scene, even during the Great Depression, as shimmering with utopian promise (see Plate 15). Their delirious colours offered an alternative vision of the United States not found in newspaper wire photos, *Life* magazine's black-and-white pages, or the documentary views of Dorothea Lange and Walker Evans. Until recently these colourful postcards remained submerged in neglected albums and shoeboxes. Gradually, with an awakening interest in mass-culture ephemera, this alternative vision – this paper Atlantis, reworking Reyner Banham's suggestive phrase – has risen into popular and historical consciousness.

Although a picture postcard appears a simple object, lowly and cheap, it serves several functions. First, acquiring a postcard verifies one's presence at a tourist site and conveys possession of that place as one walks away with its image tucked into pocket or purse. Second, although some tourists keep postcards as souvenirs, most send them to friends and relatives. From a recipient's perspective, a postcard may arouse envy if one has not personally visited a particular site, or it may evoke a sense of expanded potential as a reminder of a place to be visited in the future. Third, a postcard saved by a purchaser or recipient may become, years later, a talisman for reconstructed memories. Indeed, its conventionalized image may survive as the only reminder that one really did visit a particular place. Finally, from our perspective, contemplation of a collection of old postcards may animate nostalgia for an enticing parallel world geographically and historically separate from the living present.

Most tourists, however, are simply insisting on 'proof of the authentic'. According to the anthropologist Caren Kaplan, selecting and writing postcards is 'part of a technology of documenting the "real"'.[3] Following her hint, I will examine the picture postcard as a technology of representation by focusing on the vibrantly coloured linen postcard, a uniquely American variant. Between 1931 and the early 1950s, Curt Teich & Co. of Chicago published nearly 50,000 different views of the United States in this format.[4] After sketching a brief history of Teich & Co. and describing how linen views were produced, I will outline an iconography of linen postcards and interpret their significance for people who originally purchased, sent or received them. Finally, I will propose linen postcards as material survivors of a paper Atlantis whose unearthly colours and extravagant perfection evoke, seventy years later, nostalgia for a past that never existed. In a sense, these cards

are wanderers through time. They arrive through inheritance or second-hand purchase from a past they once did inhabit. They reveal much about that past, but their visual images also grievously misrepresent that past. Those who now contemplate these postcards cannot help being colonized by material artefacts whose images originally portrayed not America's reality but an idealized self-portrait at a particular moment in time.

CURT TEICH AND THE LINEN VIEW CARD

The founder of Curt Teich & Co. was born in 1877, learned the printing trade in Germany before immigrating to Chicago in 1895, and went into business for himself three years later.[5] In 1904, during an international postcard fad, he returned to Germany to learn new techniques for printing colour landscape views derived from black-and-white photographs. At that time, the picture postcard was a recent innovation. Since 1898, when the US Congress authorized a penny postal rate for privately printed postcards, local photographers had supplied 'real photo' cards printed directly from photographic negatives. Such views now offer social historians a detailed sense of realism. However, they could not satisfy the demand for inexpensive mass-produced views. About thirty German firms captured the American market for inexpensive postcards by providing monochrome imports whose fine-grained collotype or somewhat coarser half-tone printing conveyed the precision of real photos. They also experimented with colour printing, introducing lithographic washes over half-tones to simulate delicate, hand-tinted photographs. Some processes involved ten or more inks, whose overprinting yielded minutely varied colours. With most American distributors sending orders to Germany, there was room for a competitor based in Chicago. Relying on artists and printers hired away from German firms, Curt Teich & Co. could supply a series of local views in two or three months, while the same might take three to six months if ordered from Germany, with the added cost of shipping and, after 1909, high import duties. Even before the First World War halted imports, the Chicago firm captured a major share of the American market for colour postcard views. Reducing labour and material costs by using only four inks in addition to black, Teich published the delicately tinted 'C. T. American Art' series, which dominated the view card market for two decades but faltered under economic pressures of the Depression.

In 1931, Teich introduced the linen postcard, known as the 'C. T. Art-Colortone', a new type with a distinctive textured finish that was bolder, brighter, more colourful, and less expensive to produce.[6] The process of making a linen view card began with a travelling sales agent. At the end of the decade there were ten agents, each responsible for a particular geographic region. An agent enjoyed considerable autonomy as a designer. He photographed original views and interpreted them to airbrush artists back in Chicago. Travelling extensively, he showed sample cards to proprietors of motels, restaurants and tourist attractions, and tried to convince stationers or druggists to order a full range of local views – supplemented with generic landscapes and comic cards. Sometimes a customer provided a glossy 8 × 10 in. black-and-white photograph as a starting point. Often, however, an agent photographed a scene with a camera whose 4 × 5 in. negative yielded a detailed 8 × 10 in. print. He returned to the customer, glossy print in hand, and sketched a design in pencil on a tissue paper overlay, indicating instructions for retouching, for colours (with a paint-by-number code) and, on a separate sheet, for caption and text. Successful agents attended to customer preferences and company policy but also relied on a personal sense of what would make an effective image.

At the Teich plant, an order was logged and an agent's handwritten instructions transferred to a tracking sheet pasted on a large manilla envelope, the postcard's 'art file'. The order went to the art department, whose staff of about 150 people included male photo retouchers and female colourists. Following instructions, an airbrush artist retouched the photograph by eliminating such offending elements as utility poles, weeds and dilapidated jalopies.[7] The artist clarified lettering on signs, added late-model cars or flags flying above buildings, and exaggerated contrasts to create a dramatic monochrome image. This retouched photo yielded a half-tone printing plate whose lines of tiny black dots provided basic outlines and details of a scene. A watercolourist then prepared a hand-painted, postcard-sized colour proof for the client's approval. After corrections had been made and the client had approved the final design, the next step was colour separation. Using a chart that broke down the coded colours into ratios of red, yellow, and two shades of blue, one dramatically darker than the other, colourists made a card for each basic colour showing where and how intensively it should be printed. These cards were then photographed and printed through a half-tone screen onto photosensitive glass plates, from which copper printing plates were made. Offset lithography in four colours over a black half-tone base yielded complex colour effects. Addressing the sales force, the company praised colour's 'power to attract attention ... to create desire'. Although they touted the 'realism' of Curt Teich's 'natural color reproduction', his son Ralph later referred to the 'fake photography' of 'our fake color cards'.[8]

During the early years of linen production, each sheet of card stock yielded thirty-two different brightly coloured cards. Larger presses later made it possible to 'gang' more than 100 card images on a single sheet. The card stock itself was crucial to the 'C. T. Art-Colortone' process. Rather than printing on the shiny stock of the 1920s, Teich produced the linen finish by embossing the surface with a simulated woven texture as if preparing an artist's canvas. In 1935, the company enthused about the 'striking note of smartness' of the 'linenized effect' and praised these most 'aristocratic of all postcards', 'these beautiful miniature paintings'.[9] In fact the linen finish allowed Teich to produce postcards more cheaply. The texturing disguised impurities in the paper and softened the coarseness of half-tone dots printed with a screen of 133 lines per inch rather than the industry standard of 175. Not only less expensive to print, linen cards displayed brighter, more vivid colours than older postcards.

Within a few years, the new linen postcard, whether published by Teich or by several imitators, became *the* American postcard par excellence. By turns garish, vibrantly alive or shimmeringly unreal, the new postcard offered an ideal medium for expressing democratic aspirations and utopian expectations of a culture that retained a sense of optimism even during the Depression and the Second World War. With European firms producing real photo cards, half-tones or delicately coloured half-tone lithographs, Teich's unnaturally colourful linen postcards were unlike anything else produced before or since. For tourists and other travellers, the wondrous chromatic extrapolations of these cards portrayed the diversities of the American scene until the early 1950s, when Kodachrome processing brought back the real photo card in glossy colour. That development eventually drove the company out of business and eclipsed a series of images so surreal that today we must ask how the culture accepted them as representations of everyday reality.

During the linen card's ascendancy, high-speed offset printing presses in Chicago churned out millions of retouched and colourized images, which were shipped by train and truck to newsagents, stationers, drugstores, souvenir shops and tourist accommodations throughout the United States. These inexpensive, centrally produced images paradoxically served as individual markers of visits to

the cities and sites they purported to represent – whether as romantic as the Alamo or as mundane as Muncie, Indiana. Teich's success was a product of the automobile age. In 1930 there were 23 million automobiles registered in the United States, one for every five inhabitants, up from 8 million in 1920. Miles of paved highway doubled from 1920 to 1930, and doubled again by 1940.[10] Tourist cabins and motels sprang up to provide lodging for salesmen and tourists. So did 'attractions' contrived out of nothing, dependent for their existence on highway traffic – as were gift shops offering maple syrup, handmade baskets, colourful pottery and 'curios' (Figure 8.1). Expansive and diverse, the American scene portrayed by Teich was also a democratized landscape, available to all, 'reduced to a series of discrete units … easily manipulated and readily consumed'.[11]

8.1. 'Phillips Drive-In Cafe: One of the Show Spots, Hot Springs National Park, Arkansas', 1941. Note the girls in Mexican costume serenading tourists, one of whom photographs them.

A POPULAR AMERICAN ICONOGRAPHY

In an essay on postcard views of Paris, Naomi Schor described 'an iconography that was abundant, systematic and cheap' and that 'offered its citizens (and proffered to the world) a representation of itself that served to legitimate in a euphoric mode its nationalistic and imperialist ambitions'. The same could be said of Teich's simulacrum of America, a twentieth-century realization of national promise proclaimed in more muted colours by the nineteenth-century chromolithographs of Currier & Ives. Enthusiast Barry Zaid has described Teich's visually opulent creation as 'a world even better than reality … a world frozen in time'. Katherine Hamilton-Smith, former curator of the Curt Teich Postcard Archives, maintains that 'what exists here is really America as it saw itself'. Less sympathetic is Peter Bacon Hales, a cultural historian who regrets popularization of a 'sanitized, uniform vision of American life and American space' as linen postcards replaced a more complex, realistic tradition of popular photographic views.[12]

The inhabitants of Teich's America could feel comfortable in their possession of it. However daunting its westward expanse, modern ribbons of concrete brought tourists face to face with

8.2. 'Erosion of the Ages, Bad Lands, So. Dak.', 1941. Western landscapes emphasized accessibility by road and situated viewers at scenic overlooks.

unchanging natural wonders. From the gentle pastoral landscapes of the eastern states, across the purple sage and unearthly light of south-western deserts, to the desolate mountains of the North-West, scenic vistas offered possessive oversight and timeless mastery (Figure 8.2). Most linen views hinted at America's lonely immensity in picturesque clichés. Occasionally, however, renderings of nature possessed a hallucinatory sublimity approaching the medium's outer limit, as in a lurid night view of a Hawaiian volcano bubbling with red magma. More often, as suggested by two postcards of the Grand Canyon, humanity was in control. While one card depicted the rustic stone exterior of a so-called 'Indian Watchtower' constructed by WPA labour, the other portrayed the interior of a simulated kiva built into the tower's base. 'In all details', according to a caption, this room 'reproduces the prehistoric … ceremonial chamber, except for the … great windows overlooking the magnificent panorama', at whose splendour a cosmopolitan tourist couple are gazing, masters of all they survey.[13]

Linen postcards conveyed a similar attitude in representing native peoples and members of minority groups, objectifying them as exotic, wholly other, and part of the natural landscape. Native Americans in south-western pueblos and Florida swamps were cast as subject peoples, with faces averted or visible only from a distance (Figure 8.3). These conventions held even when Indians were exhibiting mastery of weaving, basketry or sand painting. The Chinatowns of American cities were alluring by night, dangerous perhaps, and filled by day with picturesque, inscrutable stereotypes. Even more condescending were views of southern black sharecroppers picking cotton, loafing around their cabins, or eating watermelon, accompanied by supposedly droll captions. Such figures – and their natural or pastoral settings – appealed to tourists ambivalent about modern life's continuous transformations.

However, the iconography of linen postcards mostly celebrated technological modernity with an enthusiasm that seems naive to later generations confronted with ecological devastation, global warming and high-tech warfare. Images of highway and railway bridges reflected pride in local achievements and symbolized the bridging of present to future through technological progress. Images of massive dams constructed during the 1930s by the WPA and the TVA demonstrated

8.3. 'Pueblo of Acoma, the Sky City, South of Laguna, N.M.', 1936. Lillian, who posted this card to Oklahoma City in 1938, noted she was 'canning fifteen chickens tomorrow' and would 'bring a few cans home with us'.

what could be accomplished by a strong, unified society. Whether through natural realism or high-tech surrealism (Figure 8.4), views of the Hoover Dam symbolized harnessing of prodigious natural energies. As in many linen images, human beings either did not appear or existed as tiny ciphers providing a sense of scale, though tourists could also acquire reassuring, even pastoral views situating them as overseers of the world's grandest engineering marvel. Tourists of the 1930s and 1940s exhibited keen interest in industrial sites and manufacturing plants. From a Florida sugar

8.4. 'Arizona Spillway and Highway Bridge, Boulder Dam', 1936. Later renamed the Hoover Dam, this structure inspired more Teich linen cards than any other, including a series illustrating its construction.

8.5. 'Carnegie Illinois Steel Co., Tin Mill at Night, Monessen, Pa.', 1937.

cane crusher to a Pennsylvania tin mill reminiscent of Charles Sheeler's River Rouge paintings, industrial scenes on postcards expressed pride in the nation's technological accomplishments (Figure 8.5).

Most transcendent in evoking the sublimity of modernity was the city, source of cosmopolitan urbanity, compellingly portrayed by postcard illustrators in panoramic night views with searchlights probing a deep blue-black sky and dark massings of skyscrapers pierced from within by yellow squares of electric light arrayed in Cartesian grids. Night views enhanced the cubistic forms of the Art Deco skyscrapers that had transformed most American cities during the 1920s (see Plate 16). These abstract forms of night banished the inessentials of the urban scene: irregular outlines of vegetation, random patterns of cloud and sky, even the presence of people. From an expressionist Hollywood premiere night to an impressionist rain-slick Canal Street in New Orleans, linen postcards used light to suggest an unprecedented urban reality shimmering just beyond the everyday experience of most people.

The geographer John Jakle has identified a series of typical elements used in cityscapes 'as icons to symbolize the whole'. His list, which includes 'skylines, bird's-eye views, major streets and nodal points, unusual interior spaces, [and] highly visible landmarks', provides a cataloguing system for Teich's urban views.[14] Cities from New York to Salt Lake City celebrated modernity in bird's-eye views – in the latter case with lines of parked cars stretching away to a mountainous horizon. Night views of major streets represented the speed of transportation, stimulation of desire through window-shopping, and modern life's unprecedented personal anonymity. Linen postcards also displayed nodal points focusing on physical circulation of cars and pedestrians and less tangible circulation of power and influence. A view of Times Square, though crudely printed by a Teich competitor, pulsates with the electric energy of a culture transferring its vital force from production to consumption. Linen postcards both expressed and fostered this ongoing cultural shift as tourists sought to acquire and possess sites they had viewed in reality. As critic Susan Stewart has observed, 'the souvenir reduces the public, the monumental, and the three-dimensional into the miniature', a 'two-dimensional representation' that 'can be appropriated within the privatized view of the individual subject'.[15]

Nowhere was this more obvious than in views of urban landmarks, the most common linen representations. They ranged from universally recognized sites, such as the national Capitol and the Statue of Liberty, to state capitol buildings and obscure halls of city government; from the iconic science-fiction shaft of New York's Chrysler Building, portrayed in clear daylight and in an apocalyptic night-time view, to a Texas courthouse and a bank in Minneapolis, where a Teich illustrator had inserted spiky modernist figures hurrying on important errands. Other cards portrayed churches and art museums, universities and hospitals, train stations and bus terminals, and theatres ranging from Radio City Music Hall to Kansas City's Municipal Auditorium.

Representations of urban life indicated a public whose affluent members enjoyed a comfortable relationship to modernity. Although they might escape to pristine natural realms and observe traditional peoples whose simple pursuits suggested limits to modernity's encroachments, they preferred a fast-paced urban world of consumption, leisure pursuits and recreation, as in linen cards promoting restaurants whose empty interiors invited viewers to imagine themselves enjoying the high life (see Plate 17). Even beach resorts like Atlantic City often appeared not as simple restorative retreats but as exaggerated caricatures of Manhattan, complete with searchlights, neon billboards, and passive crowds pursuing mechanized pleasure. Celebratory utopian urbanism reached iconic apotheosis in representations of world's fairs of the 1930s, especially the Century of Progress Exposition at Chicago in 1933, with spotlights, electrified boulevards and cubistic architecture.

After surveying this iconography of an earlier American scene portrayed by linen postcards, what are we to make of it? For Naomi Schor, a similar collection offers 'not simply a representation of Paris, but a fragment of past Parisian life' and ultimately 'a direct link between the viewer and the viewed'.[16] The situation with respect to Teich linen cards is not so certain. No matter how retouched Schor's French half-tone photographic cards, they retain a verisimilitude that dissolves in the vibrant colours of the American images. This distinction has been made by John Baeder, a former advertising artist who in 1972 began painting roadside scenes – diners and gas stations – taken not from reality but from images of linen postcards. Although respecting the 'clarity, and integrity, and honesty' of real photo cards, he admires 'the other side of reality' of linen cards. Baeder recalls that as a child, however, they 'repelled' him 'because they were so outrageous, so "messed-with", so unrealistic-looking'[17] (Figure 8.6). These images do not link us directly to the viewed, to the reality that provoked their extravagance. Nor can we reconstruct the cultural moment that enabled people to accept shimmering, contrived images as accurate representations of perceived reality. The ability of Teich's illustrators to transform photographic raw materials, to perfect and idealize all aspects of the landscape, reflected the era's exuberant utopianism.

Figuratively stepping behind the artist's airbrush, we realize how contrived these images were. Although some linen postcards so fully retain photographic origins that they suggest colourized stills from a black-and-white movie, others display a crudity almost beyond belief. One card portrays a Kansas City hotel with surrounding structures effaced, and autos and pedestrians rendered in the stylized manner of an animated cartoon. Especially striking are pairs of day-and-night cards derived from a single photographic negative, with cars and pedestrians frozen in position as the sky darkens, flags are lowered, clouds shift and the moon rises. Other pairings from a single-source photograph are more subtle, such as two otherwise identical views of a reflecting pool at the Palace of Fine Arts in San Francisco, one with two swans added because, as an in-house memo observed, the 'competition brought out a card that had swans in the picture, and it sells'.[18]

8.6. 'Somerset Hotel, Miami Beach: Directly on the Atlantic Ocean', 1939. A single artist seems to have done all Miami Beach hotel cards from the mid-1930s into the 1950s, using photographs only as inspiration for fanciful renderings, bright colour fields, jaunty palm trees, and toy-like cars.

Sometimes the manipulation is astonishing. Especially revealing of Teich's production methods is a card from 1938 illustrating a sunset at Black Rock Beach on Utah's Great Salt Lake (Figure 8.7). The art file contains a glossy print of an empty beach photographed in strong daylight by G. I. Pitchford, a Teich agent from the mid-1930s into the 1950s. Travelling the eight states west of the Rocky Mountains, Pitchford was responsible for views of dramatic natural landscapes and brash western cities such as Los Angeles and Las Vegas. He photographed hundreds of original views and interpreted them to airbrush artists in Chicago. In this case, his tissue overlay suggested 'strong reds in sky' for a 'sunset effect'. He directed them to 'put in bathers here as per sample attached

8.7. 'Black Rock Beach, Great Salt Lake, Utah', 1938.

or any other group that might be adaptable'. The published card portrays fourteen enthusiastic young women running through the water towards the viewer, enlivening an otherwise empty scene. It turns out that the same young women, in the same bathing suits and physical attitudes, had romped through the surf at Miami Beach in a Teich card from three years earlier. Someone retrieved the retouched Miami Beach photo from the earlier card's art file, re-photographed it, cut out the bathers, collaged them on to Pitchford's photograph of the Great Salt Lake, retouched everything, and sent the resulting image to the colourists, who arbitrarily changed the colour of one woman's bathing suit. Teich & Co. spared little effort in making up for ordinary reality's often lacklustre appearance.[19]

COLLECTING AND POSTMODERN NOSTALGIA

Here I must admit that only a collector or scholar with access to many linen postcards can make such connections. No doubt few people have noticed, since the day an anonymous artist superimposed two images to create a third, how well-travelled these young women seem to be.[20] My perception of these cards' unreality, or more accurately their surreality, is heightened because I view them not singly, as originally purchased or received in the post, but unnaturally as a group, a collection assembled decades later. These images now evoke responses different from those experienced seventy years ago. Even Schor, who proposed reconstructing Parisian life from half-tone cards, admitted that 'time is not recaptured' through them. For anyone who did not inhabit their time, they yield a 'mnemonic sterility', a 'failure to produce memories'. According to Schor, 'what distinguishes the collection from the souvenir is that a collection is composed of objects wrenched out of their contexts of origins and reconfigured into the self-contained, self-referential context of the collection itself'.[21]

 Most observers of collecting have expressed similar thoughts. Jean Baudrillard maintained that collecting 'represents the most rudimentary way to exercise control over the outer world: by laying things out, grouping them, handling them' – precisely as I am doing now. Addressing agency, Susan Stewart has observed that the collecting 'self' is 'not simply a consumer of the objects' it acquires but also 'generates a fantasy in which it becomes producer of those objects, a producer by arrangement and manipulation'. The fantasy on display in this particular collection is one of nostalgia, which Stewart describes as 'a sadness without an object, a sadness which creates a longing that of necessity is inauthentic because it does not take part in lived experience'. She defines this nostalgic longing in terms appropriate to a collection of two-dimensional graphic images. It arises, she says, from 'the inability of the sign to "capture" its signified, of narrative to be one with its object, and of the genres of mechanical reproduction to approximate the time of face-to-face communication'. An inability to recall the root of one's longing haunts the nostalgia of a contemporary linen postcard collector, for whom face-to-face communication with the object of desire would require impossible time travel along an irremediably broken route separating the celebratory enthusiasm of utopian modernity from the ambivalent pastiches of postmodernity.[22]

 The role of nostalgia for a contemporary collector of old postcards becomes even more problematic if one examines their brief scrawled messages. Only about one in six linen cards offered for sale by dealers has been postally used, and those have been separated by sale and resale from others received by the same person.[23] Only rarely does one find a cache of cards sent by a single

correspondent that might permit tentative reconstruction of a relationship or situation. Instead, we are left with tantalizing fragments whose potential banality is often tempered by an odd turn of phrase or a situation that provokes curiosity about individuals for whom there is no other concrete historical documentation.

For every card whose author is 'having a wonderful time', others mention 'eating my way thru Chicago' or being too 'scared' to go swimming at Corpus Christi because 'a Mexican lady drowned out at N. Beach last nite'.[24] Motorists often total up the daily miles in a neutral tone, but one laments the 'desolate country' between Barstow and Las Vegas and concludes 'the Lord did a poor job when he dumped this mess in California'. Vacationers dwell on the weather but occasionally issue unexpected reports of 'cold weather mixed with earthquakes'. A retiree complains his doctor is 'trying to make a vegetarian out of me'; another reports that 'Mrs. Humphrey's sister had a stroke of paralysis last Tuesday' but 'regained consciousness Friday'. Young people send innocently suggestive notes to sweethearts. Wartime military recruits write home to girlfriends, parents, wives and children before shipping out to uncertain fates. The unlucky and the desperate, travellers drifting ever further from home, refer to dwindling reserves, searches for cheaper apartments, or the necessity of 'moving in with an elderly lady'. One might conclude with Jacques Derrida that 'if you want to understand what an "anatomy" of the postcard might be, think of the *Anatomy of Melancholy*'.[25]

Given the centrality of travel and movement in the iconography and personal messages of linen postcards, it is not surprising that collectors value most highly those which directly represent travel, posing enigmas of departure and arrival. In some of the most resonant images are hints of flight and pursuit, purposeful obscurity, malignant intent carelessly hidden. Night views recall the dread of *film noir* as much as the promise of electricity. Whether portraying a high-roller's jazzed-up view of New York or Los Angeles, or prefiguring the yellow despair of Edward Hopper's *Nighthawks* as in many images of less glamorous cities, such views romanticize the loneliness at the edge of the American night. Many linen postcards, especially those representing interiors of hotel lobbies and restaurants, convey a sense of foreboding, of time suspended at that moment just before something is about to happen (Figure 8.8). Their ominous emptiness invites us to people them with characters and narratives from pulp novels and B-movies, or from postmodern cinematic replications enamoured of kitsch and pastiche.

Historians typically admit to colonizing the past by projecting personal and cultural biases on to it. But in this case the past is colonizing the present. Linen postcards were inauthentic the day they were printed. Mass produced and distributed by Curt Teich & Co. of Chicago, they only approximately portrayed the actual sites where tourists and travellers acquired them. Even so, these postcards are real. They are authentic survivors of the past they inaccurately represent. They are also unlikely survivors. While most postcards were discarded soon after use, these particular cards remained hidden for decades – emerging through auctions and estate sales to be sorted by dealers into artificial categories and sold to collectors. They now convey to contemporary viewers the iconography of an idealized America, an alternate parallel world that never quite existed. Stewart's important distinction between souvenir and collection clarifies this situation. According to her, a unique souvenir such as a lock of hair or a pebble from a beach 'lends authenticity to the past' by directly reminding us of our own prior experience. In the case of a collection of linen postcards, however, 'the past lends authenticity to the collection'.[26]

8.8. 'Lobby/El Patio Hotel', Las Vegas, Nevada, 1940s. Despite a back caption claiming 'refined accommodations', this lobby's mismatched furniture, utilitarian water cooler and plastic table radio suggest threadbare melancholy.

CONCLUSION

This reconstructed vision of the past – this paper Atlantis – appears especially attractive now that the twentieth century has run its entropic course. These postcard images suggest a world in which everyday life, despite the social trauma of the 1930s and 1940s, appeared grander, more colourful, more vibrant, more opulent even, than ever before, owing to continuously expanding processes of modernization and democratization. While many critics have faulted postmodernity as a culture of exhaustion, the past images imprinted on Teich's linen postcards suggest a contrasting culture of overflowing replenishment. These inexpensive but artfully contrived images, viewed quickly and in large numbers, suggest a virtual utopia of representation. In a sense, appropriating two terms coined by Roland Barthes in his study of photography, one might argue that the iconography (or academic cataloguing) of linen postcards offers a *studium*, a taking of the cards on their own terms as products of their culture's understanding of itself. On the other hand, a postmodern experiencing of this collection of unreal views becomes in its totality an irrational *punctum*, an 'element which rises from the scene, shoots out of it like an arrow, and pierces [us]'. The collection as a whole takes us 'outside its frame' into 'a kind of subtle *beyond*', as if it 'launched desire beyond what it permits us to see'.[27]

As the collector and artist John Baeder admits, 'the heightened visual unreality [of linen post-cards] becomes *a* reality' itself.[28] Even so, we can never be sure how fully the original consumers of these often surreal cards understood them as true representations of reality. Although many people inscribed travel or sightseeing itineraries on the cards they wrote, they rarely mentioned the colourful views, unless to state that 'X marks the spot' – the very room – where they had rested along the highway and paused to write a few lines. One suggestive exception was a woman who mailed a card from Tucson to a friend in Seneca Falls in 1937. Referring to the card's portrayal of

several large saguaro cactuses against a desert sky artfully streaked with reds, yellows and purples, she admitted, 'I haven't seen this but they do say it's real'. It would be misleading to read too much into her apparent doubt. The culture of representation has been too radically transformed in the past seventy years to suggest that she intended anything more than a common-sense notion that 'seeing is believing'. From our perspective, however, it is not surprising that this hallucinatory Technicolor realm, with its Oz-like exuberance, fascinates media-saturated collectors for whom the future will never hold out such innocent promise.

NOTES

1. R. Banham, *Design by Choice* (London: Academy, 1981), p.96; R. Banham, *Los Angeles: The Architecture of Four Ecologies* (Baltimore: Penguin, 1973), pp.23, 124; R. Banham, *A Concrete Atlantis: US Industrial Buildings and European Modern Architecture 1900–1925* (Cambridge, MA: MIT Press, 1986), pp.20, 8, 168; and R. Banham, *Scenes in America Deserta* (Cambridge, MA: MIT Press, 1989).
2. Banham, *Scenes in America Deserta*, pp.134, 92.
3. C. Kaplan, *Questions of Travel: Postmodern Discourses of Displacement* (Durham: Duke University Press, 1996), p.61.
4. Printing codes suggest that the company published about 51,000 different linen cards between 1931 and 1978. However, some were printed with humorous comics or advertising material. The Curt Teich Postcard Archives at the Lake County Discovery Museum in Wauconda, Illinois, holds 360,000 individual cards published by Teich & Co. between 1898 and 1974 (including linens) and 'art files' with production materials for 100,000 cards (variously containing source photographs, layout sketches, retouched photographs, watercolour proofs, printing proofs, client correspondence, and samples of fabric and wallpaper used as colour guides). See K. Hamilton-Smith, 'The Curt Teich Postcard Archives: Dedicated to the Postcard as a Document Type', *Popular Culture in Libraries* 3(2) (1995): 5–16. M. Werther and L. Mott's *Linen Postcards: Images of the American Dream* (Wayne, PA: Sentinel, 2002) is an intelligent guide for collectors. I am indebted to Katherine Hamilton-Smith and Debra Gust of the Lake County Discovery Museum for research assistance.
5. On Curt Teich and early postcard history see C. Teich, *The Teich's* [sic] *Family Tree and History* (Chicago: privately printed, 1958); G. and D. Miller, *Picture Postcards in the United States, 1893–1918* (New York: Clarkson N. Potter, 1975), pp.2–31; R. Teich, interview by D. Cochrane (typescript, *c.*1980s), Teich Archives; and H. Woody, 'International Postcards: Their History, Production, and Distribution (Circa 1895 to 1915)', in C. Geary and V. Webb (eds.), *Delivering Views: Distant Cultures in Early Postcards* (Washington: Smithsonian Institution Press, 1998), pp.13–45.
6. On the C. T. Art-Colortone process, see *Sales Pointers* (Chicago: Curt Teich & Co., 1935); Teich, *The Teich's Family Tree*, pp.30–31, 36; W. Watkins, 'How Curt Teich Postcards Are Produced', *Deltiology*, 117 (*c.*1974); and Teich interview.
7. Editors' note: 'Jalopy' is an old, run-down motor vehicle.
8. *Sales Pointers*, pp.3, 6; Teich interview.
9. *Sales Pointers*, pp.10, 9; *Jobbers' Profits* (Chicago: Curt Teich & Co., 1935), p.2.
10. J. Jakle, *The Tourist: Travel in Twentieth-Century North America* (Lincoln: University of Nebraska Press, 1985), pp.121, 126.
11. The phrase refers to a collection of Parisian view cards from around 1900. See N. Schor, 'Collecting Paris', in John Elsner and Roger Cardinal (eds.), *The Cultures of Collecting* (Cambridge, MA: Harvard University Press, 1994), p.273.
12. Schor, 'Collecting Paris', p.252; B. Zaid, *Wish You Were Here: A Tour of America's Great Hotels During the Golden Age of the Picture Post Card* (New York: Crown, 1990), p.7; Hamilton-Smith as quoted by

K. Keister, 'Wish You Were Here!' *Historic Preservation* 44 (March/April 1992), p.55; and P. Hales, 'American Views and the Romance of Modernization', in M. A. Sandweiss (ed.), *Photography in Nineteenth-Century America* (New York: Harry N. Abrams, 1991), p.241.

13. 'The Kiva, Desert View, Grand Canyon National Park, Arizona', Teich 7A-H694, 1937.

14. Jakle, *The Tourist*, p.263. On urban night views from 1905 to 1975, see J. Jakle, *Postcards of the Night: Views of American Cities* (Santa Fe: Museum of New Mexico Press, 2003). On urban view cards and civic uplift, see J. Ruby, 'Images of Rural America: View Photographs and Picture Postcards', *History of Photography* 12 (October–December 1988), pp.336–40; and A. Isenberg, *Downtown America: A History of the Place and the People Who Made It* (Chicago: University of Chicago Press, 2004), pp.42–77.

15. S. Stewart, *On Longing: Narratives of the Miniature, the Gigantic, the Souvenir, the Collection* (Durham: Duke University Press, 1993), pp.137–38.

16. Schor, 'Collecting Paris', p.273.

17. J. Baeder, *Gas, Food, and Lodging* (New York: Abbeville Press, 1982), p.20.

18. Art file 2B-H321, 1942, Teich Archives.

19. Art file 8A-H2750, 1938, Teich Archives.

20. They appeared not only up close, filling the entire image in the surf at Miami Beach (Teich 5A-H910), but also in the upper left portion of a card whose diagonal text announces 'Greetings from Carolina Beach' (Teich 1B-H677), and as a circular centrepiece, surrounded by four other recreational beach scenes, on a generic 'Greetings from...' card (Teich 9A-H1688) existing in versions printed with the names of Hampton Beach, New Hampshire; Wrightsville Beach, North Carolina, and perhaps others.

21. Schor, 'Collecting Paris', pp.255–56.

22. J. Baudrillard, 'The System of Collecting', in Elsner and Cardinal, *The Cultures of Collecting*, p.9; Stewart, *On Longing*, pp.158, 23–24.

23. Probably the majority of postcards were sent through the post by purchasers. However, those obtained as personal souvenirs were more likely to survive.

24. Quotations from handwritten messages are from cards in the author's collection.

25. J. Derrida, *The Post Card: From Socrates to Freud and Beyond* (Chicago: University of Chicago Press, 1987), p.245.

26. Stewart, *On Longing*, p.151.

27. R. Barthes, *Camera Lucida: Reflections on Photography* (New York: Hill and Wang, 1981), p.59. Schor ('Collecting Paris', p.269) refers to 'the Barthesian *punctum*' with regard to individual details of specific cards but does not apply the concept to an entire collection.

28. Baeder, *Gas, Food, and Lodging*, p.32.

9.
FROM PRODUCTION TO CONSUMPTION IN TWENTIETH-CENTURY DESIGN

penny sparke

Peter Reyner Banham has been an inspiration to me throughout my three and a half decades as a design historian (Figure 9.1). I was lucky enough to have his help and support when I was working on my Ph.D. in the 1970s and his unique approach towards the material environment, as well as his questioning of what, at that time, seemed like unmoveable 'truths' in the fields of architectural and design history and criticism, have continually stimulated the enquiries that have motivated my work over the last decades.[1]

If I had to isolate one aspect of Banham's prolific oeuvre that has had a special resonance for me, I would choose a quotation from the conclusion of *Theory and Design in the First Machine Age* of 1960, which struck a special chord with me when I first read it back in the early 1970s.[2] 'Functionalism', he wrote, 'as a creed or programme, may have a certain austere nobility, but it is poverty-stricken symbolically'.[3] While, in reality, his attack was directed at the apologists of functionalist theory – Alberto Sartoris and

9.1. Reyner Banham in Los Angeles, late 1960s.

Sigfried Giedion among them – rather than the designers and makers of modernist buildings and artefacts themselves, Banham's statement highlighted, nonetheless, an overwhelming concern for the importance of symbolism in objects and its neglect by the protagonists of the Modern Movement.[4]

Banham's 1960 cry from the heart had its roots in his own upbringing in 1930s Norwich, where he was raised on a cultural diet, not of high-minded modernism, but rather of Saturday morning American movies. The culture of consumption embodied in those films, as well as in the automobiles (Figure 9.2) and other aspects of Americana that subsequently became the stuff of life for Banham, challenged the orthodox intellectual framework of the training in the historical and critical analysis of architecture and design that the historian/ critic received later at London's Courtauld Institute of Art.[5] Armed with two seemingly conflicting value systems informing the twentieth century's material culture, from the 1950s onwards Banham's self-appointed role – especially through his membership of the Independent Group (IG) – was to resolve the tension between those two systems and, in the words of his fellow IG member, John McCale, to learn to love 'both Bach and the Beatles'.[6]

My own interest in what I also perceived fairly early on, on an emotional level at least, to be the limitations of architectural and design functionalism, and indeed of many aspects of modernist practice as well, has taken me, over the last decades, on a journey which had, at its heart, the

9.2. Buick Roadmaster estate wagon, 1953.

ambitions both to explain its inadequacies and to search either for a viable alternative, or for a way of resolving or accepting differences. That quest has led me through the design manifestations of British Pop culture (Figure 9.3) and its commitment to the ephemeral rather than the universal – the subject matter of my Ph.D. thesis. It also involved me in a flirtation with French linguistic theory in search of a model of design content analysis, and a close involvement with the work of the Italian designer, Ettore Sottsass (Figure 9.4) who, throughout his long career, always stressed the sensorial over the rational, the passive over the active role of the designed artefact. It has also taken me through a study of the work of the American industrial designers of the inter-war years for whom desire took precedence over any rationally conceived social or aesthetic programme; through the theories and practices associated with that evasive, and ultimately unsatisfactory concept, postmodernism; into a growing interest in the material culture of the 'banal' domestic environment of everyday life; and, more recently, into women's history and feminist theory and their relationship with the designed environment, to an interest in the relationships between identities and material and spatial culture, and the subject of the interior, which falls into an intellectual gap between architecture and designed artefacts.

Although, like Banham's, my intellectual and emotional starting points were the symbolic poverty of functionalism, and of much modernist architecture and design, inevitably my path has had its own individual trajectory. Indeed, recognizing that fact himself, in the introduction to my

9.3. Collection of Pop objects designed by Paul Clark, 1960s.

selection of his essays, published in *Design by Choice* in 1981, Peter wrote, in his usual perceptive way, that, 'This is *her* anthology, not mine. Its fascination, for me, is that it is one woman's Banham, and that I have no doubt that other women, men, persons and creatures could construct their own, absolutely true and documented, but totally different Banhams.'[7] My first attempt to understand and to explain the limitations of modernism was rooted in an analysis that looked at the impact of class and age. The importance of mass culture for those young working-class and lower middle-class people who experienced their formative years in the 1960s (myself included) was my starting point for an attempt to analyse the aesthetic and cultural shortcomings of modernism. Gradually, however, the categories of class and age were joined by my awareness of the roles of gender and sexuality and by my realization that my gut response to modernism was perhaps more influenced by the fact that I was female than that I had spent my teenage years listening to pop music, adorning my room with

9.4. Ettore Sottsass pictured in front of a design for Memphis, 1981.

posters and wearing a miniskirt. As a result of that realization – which only fully dawned in the late 1980s – and the births of my three children, my interest turned towards two basic questions, which underpin the focus of this lecture, namely, 'How can we inject the culturally-defined concept of "femininity" into the debate about the relevance or otherwise of modernism to the late twentieth century?' And secondly, 'What are the implications, for women's lives, of modernism's hegemonic power in the area of design in that century?'

Another important influence on my attempt to find a method for addressing, and attempting to answer, those questions came from Carolyn Steedman's 1987 book, *Landscape for a Good Woman*, in which the author demonstrated how subjective experience can, and indeed should, be woven into historical writing and enquiry.[8] That insight led me to explore a new approach to design historical analysis which allowed me to engage with the fact that, historically, women's experience of the material and spatial world has, for social, economic and cultural reasons, been different from men's. My own subjective belief, formed on the basis of experience from childhood onwards, that the symbolic role of banal objects and the concepts of taste and consumption have played, and continue to play, especially important roles within the lives of most women, led me to look to the past – the nineteenth century in particular – to find an explanation for that fact. I have long had an uneasy feeling about the lack of cultural capital – and indeed often the derision – attached to the amateur, yet extremely fulfilling, activities, say, of arranging china ornaments or family photographs on a mantelpiece, or searching for bargains in the January sales, which preoccupied my mother's generation and which still form an important part of many women's lives today, as compared to the more 'serious' pursuits of professional architectural and design practice, and activities linked to the world of the production of goods. It began to occur to me that the unease may be linked in some way to my anxieties about the hegemony of modernist architecture and design.

The acquisition of goods for, and their disposition within, the domestic setting are vital ingredients of the home-making process, an important and necessary element within social and cultural life, as the anthropologist Mary Douglas has made very clear.[9] Where our culture is concerned, those activities are perceived as primarily feminine tasks. They are also, however, essential elements of the cycle of production and consumption that underpins our economy. The manner in which such activities have been marginalized mirrors the ways in which other manifestations of feminine culture, among them the romantic novel, the television soap opera, and so-called amateur activities, such as flower arranging and cake decorating, have been chronically undervalued. Perhaps the dominance of modernist theory and practice through the twentieth century had played a role in that undervaluing. To discover whether that were the case required an analysis of modernism and its formation from a gendered perspective. Whereas Banham found his antidote to modernism in the public, masculine world of automobiles and commercial architecture, I began to search for mine within the material culture of the private, feminine sphere of domestic life.

Roszika Parker has pointed out that twentieth-century concepts of femininity were still deeply imbued with Victorianism.[10] That was especially true in the context of a discussion of domestic femininity as it was in the middle years of the last century, when the so-called 'cult of domesticity' became all-pervasive. It was also at that time that some of the ideas that fed into international modernism were first mooted. The coincidence of those developments was not an arbitrary one, I would suggest, and it has implications for the way in which feminine culture came to be valued in the twentieth century. The increasing physical division of men and women from each other in their daily tasks, which occurred from the early nineteenth century for the middle-class family,

as a result of the advent of the factory, the breakdown of the small family business and, above all, the move to the suburbs, resulted in a growing separation of the world of the rational from that of the emotional, the aesthetic and the spiritual.[11] Taste was seen as inhabiting the latter and thereby became increasingly feminized. The concepts of taste, beauty and femininity became inextricably linked, in fact, such that women came to be seen both as embodiments of the idea of beauty and the exclusive creators of it in the domestic setting. The act of exercising that exclusive form of aesthetic discrimination became increasingly prioritized as the century progressed. As Leonore Davidoff and Catherine Hall have noted in their seminal 1978 text, *Family Fortunes: Men and Women of the English Middle Class 1780–1850*, 'By the 1840s good taste, the capacity not to be vulgar, was replacing salvation as the mark of special status.'[12]

A number of historians of women's lives have remarked on the extent to which, in the mid-nineteenth century, domestic duties – including, by implication, the responsibility for exercising taste – carved out a role for women, which allowed them to enjoy equal status to men. The feminization of taste in the context of 'the cult of domesticity' may have created a schism between the realms of beauty and utility, between those of taste and practicality, but it did not, in itself, necessarily create a hierarchical relationship between those two spheres. In certain ways they can be seen to have complemented each other, rather, in a mutually beneficial manner in the creation of a sociocultural and economic whole. More recently, a number of feminist writers – among them Betty Friedan and Ann Oakley – have focused on the process of feminine domestification, and its separation from the masculine world of work as the raison d'être for much of women's oppression.[13] Undoubtedly, the split between beauty and utility served to render the former vulnerable, causing it to become valued less highly than the latter in subsequent years. That process of cultural prioritization, rooted in a set of gendered value-systems, was to take place gradually, in an international context, over the next half-century.

The exercising of taste values by middle-class women in the mid-nineteenth century took place within the ideological context of domesticity that prevailed at that time. Their choice of objects and decorations had to fulfil the demands for status symbolism and fashionability, which could sometimes conflict with the need to create a domestic haven characterized by its links with the past and physical comfort. Those preoccupations directed the emphasis on to novelty, display and visual conspicuousness for social purposes and, for familial purposes, upon beauty, traditional values and restfulness. Nowhere was that more in evidence than in the Victorian middle-class parlour (Figure 9.5). In material and aesthetic terms, those values were expressed through a preference for naturalistic pattern, ornate surfaces, upholstered furniture, multiple patterns in a single interior, and a general impression of visual complexity. Textiles were used extensively to give the interior a cocooned character, closed off from the distractions of the public sphere.[14]

Feminine consumption and participation in commercial life became increasingly central to the acquisition of the goods needed to create such domestic idylls. Women served to link the world of the marketplace with that of the domestic sphere and to complete the production/consumption cycle. They could, of course, only choose from what was on offer but it seemed as if manufacturers were all too happy to work towards fulfilling the perceived desires of their feminine customers. Simultaneously, a sophisticated system of taste-making emerged to help women form their aesthetic preferences. Advice manuals, exhibitions, shops and goods themselves played a role in this context. There was a strong sense, also, that in undertaking this work, women were not only performing what was perceived as a necessary role but that they were also creating their own self-identities. As

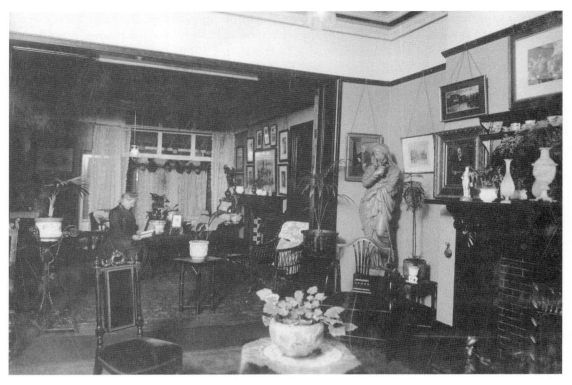

9.5. A Victorian parlour in Manchester, England, c.1890.

Roszika Parker has explained, 'For women, goods are used less to fulfil a productive need than a social and cultural role and a definition of self'.[15]

The first signs that the marriage between women and commerce, and the alliance between the ideology of domesticity and the exercise of taste, were seen to be anything other than beneficial to society and to culture at large came with the first stirrings of the design reform movement which began to make its mark in the mid-century. As early as 1843, for example, A. W. N. Pugin remarked that:

> Well meaning ladies transfer all the nicknackery of the workroom, the toilette-table and the bazaar to the altar of God. The result is pitiable … pretty ribbons, china pots, darling little gimcracks, artificial flowers, all sorts of trumpery are suffered to be intruded.[16]

Already what had become stereotypically feminine was being criticized, trivialized and marginalized according to the value-system of the public sphere. It could only be tolerated, in fact, if it remained within the private sphere of the home. Pugin's spiritual quest for reform was supplemented, later in the century, by numerous other campaigners working in pursuit of a general raising of design standards, seen as being fundamental to the well-being of the nation at large.

A couple of decades later, Charles Eastlake made no bones about laying the responsibility for the degradation of taste at the feet of the middle-class female population, in conjunction with the salesman, when he wrote in his *Hints on Household Taste* (1868) that:

In the eyes of Materfamilias there was no upholstery which could possibly surpass that which the most fashionable upholsterer supplied. She believed in the elegance of window-curtains, of which so many dozen yards had been sent to the Duchess of ---, and concluded that the dinner-service must be perfect which was described as 'quite a novelty'.

And that:

We may condemn a lady's opinion on politics – criticize her handwriting – correct her pronunciation of Latin, and disparage her favourite author with a chance of escaping displeasure. But if we venture to question her taste – in the most ordinary sense of the word, we are sure to offend. It is, however, a lamentable fact that this very quality was until recently deficient, not only among the generally ignorant, but also among the most educated classes in this country.[17]

Similar condemnations were repeated over and over again in the mid-century in Britain by numerous male reformers who questioned the role of fashion in taste decisions, defined taste as being synonymous with feminine superficiality and, above all, advocated a new framework for aesthetic judgements. No longer should that judgement, they maintained, be aligned with the values linked with feminine domesticity and consumption but rather, with the alternative, universal values that derived from the masculine sphere of manufacture, economy and reason. Thus Pugin's *True Principles*, outlined in 1841, which prioritized 'convenience' and 'construction', and to which, in his words, 'good taste … should always be subservient' entered into the general vocabulary of design reform, influencing much that was written after it.[18] Eastlake, for example, showed his dependence upon Pugin when he wrote that, 'no decorative feature can legitimately claim our admiration without revealing by its very nature the purpose of the object which it adorns'.[19]

In the writings of Pugin, Henry Cole, Richard Redgrave, John Ruskin, William Morris, Christopher Dresser, Lewis F. Day and others, the masculine principles of work and utility informed their aesthetic judgement. As the century progressed, the reformers ceased to single out women as the perpetrators of the degeneration of taste but focused increasingly on the sphere of production, centring the debate upon modes of manufacture and the moral and political questions attached to them. Indeed, the very idea of 'taste' became tainted by its links with the marketplace. The only hope for its redemption lay in its return to the worlds of craft and architecture, or in a transformation of the ideological basis of machine production. The links between British nineteenth-century design reform and the fully fledged international Modern Movement of the inter-war years were direct. While Pevsner's teleological account of the influence of the former on the latter clearly failed to recognize the different historical and cultural contexts of the two, there was, nonetheless, continuity between them that was represented by modernism's preoccupation with the world of production as the source of a new aesthetic and theory of design.[20] Although the industrial metaphor supplanted that of craft, the masculine cultural values associated with the world of work, manufacture and the sphere of reason dominated all modernist discussions. The result was the development of an aesthetic vocabulary that was characterized, above all, by its rejection of what was seen as mid-nineteenth century decorative excess. The writings of Adolf Loos provided an important bridge between Britain and Continental Europe in that context and it is significant that Le Corbusier referred both to Ruskin and to Loos in his search for antecedents.

The concepts of 'taste' and 'consumption' were largely absent from the modernist project. The tracts from the 1920s adopted the Fordist world of industrial manufacturing as a key metaphor.

Nowhere was this more evident than in the writings of Le Corbusier, who used what Peter Collins had dubbed the 'Mechanical Analogy' repeatedly.[21] Throughout *Vers Une Architecture*, for instance, were frequent references to the 'engineer' who 'puts us in accord with universal law'; to 'standards' which are 'a matter of logic, analysis and minute study' and to the 'mass-production spirit'.[22] For Le Corbusier and others, mass production was synonymous with the principles of economy, reason, objectivity, standardization, universality and, by extension, democracy. It is interesting to note that, while the context within which Corbusier was working bore little relationship to that within which Eastlake had attacked women as the source of all tastelessness, there existed, nonetheless, a strong continuity in the way in which both reformers defined themselves against something else. For both men that something else was decoration and commerce.

In her book *Modernism and the Decorative Arts in France* the American art historian, Nancy Troy, went to great lengths to demonstrate that it was within the terms of the contemporary debate about decoration that Le Corbusier framed his own architectural and design theories, and that he only defined himself as a staunch opponent of the decorative arts system after having sought to engage with it earlier on (see Plate 18).[23] That conversion added fuel to his vociferousness in rejecting the kind of decoration that he saw around him in the 1920s, a decoration which he saw at its worst in those palaces of commerce, the department stores, where middle-class ladies now spent much of their time. In his short essay, entitled 'Hurricane', for instance, he expressed his disdain for the ubiquitousness of decoration in that particular environment,

> Decoration on all castings (iron, copper, bronze, tin, etc.).
> Decoration on all fabrics (curtains, furnishings, fashions).
> Decoration on all white linen (tablecloths, underwear, bed linen).
> Decoration on all papers.
> Decoration on all pottery and porcelain.
> Decoration on all glassware.
> Decoration in all departments! Decoration, decoration: yes indeed in all departments; the department store became the 'ladies' joy'![24]

He also pointed his finger at the store salesgirls themselves, seeing them as the epitome of the vulgar world of consumption where decoration and novelty abided, thereby linking together commerce, decoration and the feminine in a way that is not entirely dissimilar to Charles Eastlake's account half a century earlier: 'Today decorative objects flood the shelves of the Department Stores: they sell cheaply to shop-girls.'[25] In the place of those decorative objects he posited the primacy of the products of industry, describing them as 'tools of perfect convenience and utility'.[26]

After 1930, modernism became increasingly dependent upon the concept of design, defined by that time in a new, modern sense, having moved far away from its earlier roots in the world of drawing. This transformation of the meaning of the word design denoted a significant ideological shift in the context in which it was used. No longer did it suggest the application of two-dimensional pattern on to form, but rather a complete reworking of the form in question. That new incarnation of the term embodied not only a rejection of the past and a commitment to innovation in and for itself, but also a subordination of the role of the aesthetic to that of the rational problem-solving process. The latter was no longer linked to a set of taste-values rooted in the essentially intuitive activity of buying goods and beautifying the home, but rather in the economic logic of mass production. With that new concept arrived a new generation of professional practitioners

who took their lead from architecture and who saw their role as providing objects for industry that were aligned, metaphorically, to that sphere of manufacture. Following fast on their heels came a generation of design propagandists – in Britain they included Anthony Bertram, Herbert Read, John Gloag and others – who, by isolating it for approval and praise, validated modernist practice. Thus commercial life and feminine culture were excluded from the hegemonic cultural sphere and relegated to the world of mass culture. The institutionalization of modern design was complete by the Second World War, by which time its norms had come to dominate the worlds of design education, museums and design reform.

As Andreas Huyssen has explained in *After the Great Divide: Modernism, Mass Culture and Postmodernism*, of 1986, 'Modernism constituted itself through a conscious strategy of exclusion, an anxiety of contamination by its other: an increasingly consuming and engulfing mass culture'.[27] One way of understanding the motivations of the early architectural and design modernists is in terms of a purification process through which they sought to cleanse themselves of the morally and politically contaminated world of taste and mass consumption. The 'other' that they sought to repudiate was strongly gendered inasmuch as it was rooted in stereotypically feminine values. Feminist historians of art and literature have also seen within modernism signs of a predominantly masculine sensibility, represented by, for example, the dominance of images of the public sphere in modern paintings and poems. As yet, however, little work has been done in this area by design historians who have concentrated upon women's production rather than upon their consumption and the exercise of taste.[28] Even work on the domestic sphere in the twentieth century has tended to emphasize the impact of the 'Household Management' or 'Domestic Taylorism' movement, an attempt by modernism, aided and abetted by women themselves, to colonize and thereby masculinize the home by bringing it into the sphere of the rational (Figure 9.6). Much work needs to be done to rehabilitate feminine culture and its impact on the material environment as it existed, and indeed continues to exist before, within and beyond modernism and, from this perspective, to question the cultural hegemony of modernism, the masculine values of which were embedded within the key design institutions of the twentieth century.

That work needs to focus upon a rehabilitation of the concepts of consumption and taste, the feminine mirror images of production and design. Early cultural theory provided little help in that context. From the words of Thorstein Veblen through to the work of the Frankfurt School and to that of the European postmodern theorists, there have been no attempts to validate the activity of consumption nor to see it as representing anything other than a passive activity responsible for commodification which is seen as having constituted one of the twentieth century's key ills. Much cultural theory has allied itself, ideologically, to modernism and acted as a supporter of that masculine movement. As late as 1968, for example, Jean Baudrillard demonstrated such an allegiance in *The System of Objects*, when he explained that, 'Models move faster than series, they are of the moment whereas series float somewhere between the past and the present, trying to catch up. This aspiration and this permanent deception, dynamically orchestrated by production, constitute the central dimension of the hunt for the object.'[29] In the picture of things that Baudrillard painted, consumption was defined as a passive activity, controlled by the inexorable dynamism of production. He did not review that position until 1981, when he finally acknowledged that, 'When I described objects my denegation of them was almost a moral one, based on the idea of an absolute alternative. But things have changed and it is no longer tenable. There is a feeling today that negation or critique is no longer an effective optic for analysing fashion, advertising or television.'[30]

9.6. Image from Christine Frederick's *The New Housekeeping: Efficiency Studies In Home Management*, 1913.

The pre-eminence of the modernist perspective within design historical and critical writing from the 1930s onwards has obscured from view an account of material culture which could even accommodate, let alone re-evaluate, feminine culture. The systematic devaluation of that culture in terms of its impact on the material environment from Pugin onwards has left us with an unbalanced story that it is hard to redress. This is not just a question of the gender of professional practitioners, nor of the dominant aesthetic language of designed artefacts, but more significantly of the gendered ideological basis of modernism itself. A few historians of consumption have begun to uncover arenas of feminine culture, at least as it impinged on the public sphere, although detail relating to the material expression of that culture is still woefully lacking. Work of recent decades on the subject of the late nineteenth-century department store has begun to rehabilitate the sphere of consumption as a valid arena of leisure, pleasure and rational decision-making. The department store represents, in fact, for these historians, a shift from a production-orientated society to one centred on consumption. Ironically, that shift coincided historically with the early articulations of modernist theory in architecture and design. That reinforces the idea that modernism's agenda was, from the start, one of resistance to that social transformation and to evolve a theory of design which denied the inevitable commercialization and feminization of society.

The work on department stores falls short, however, of a full account of the way in which manufacturers and retailers negotiated consumer tastes, the gendered value-system that under-pinned consumption, and the way in which that was both expressed and reinforced by the goods

in question. An article by the Belgian sociologist Rudi Laermans went some way towards such an exposé, however, emphasizing the importance of the milieu in which shopping took place. He wrote that:

> Several means and techniques were used, sometimes for the very first time, to focus the eye of the wandering female shoppers who were 'just looking'; dazzling decorations, architectural adornments, fairyland lighting and, first and foremost, a sophisticated display of mostly fashionable merchandise.[31]

Fantasy, desire, an illusion of luxury, comfort, novelty, and an appeal to the senses, especially sight, rather than to the logic of the mind were at the forefront of things. Goods functioned almost exclusively on the level of the symbolic, as they clearly did within feminine culture in general. It was not merely the presence of symbolism that was significant, however, but rather the meanings of the symbols employed. The objects within the culture of consumption symbolized all that was valued within the feminine sphere of domesticity, which was in strong contrast to the intended symbolic references of the objects designed by later modernist protagonists to the public world of the machine and industrial manufacture.

The work that has been undertaken on the subject of women and shopping suggests that there is another way of looking at objects, one which stands outside modernism and its claims to rationality, standardization and universality. Not only are those claims not appropriate in the context of a society inhabited by men and women, but they are also, if we follow the argument of David Hounshell in his 1985 book, *From the American System to Mass Production*, ones which had little substance even within the world of mass manufacturing, the source of modernism's primary metaphor.[32] Through this painstaking piece of scholarly research, Hounshell revealed that mass production, in the pure sense that the modernists understood it, was itself a myth, or at least, a mode of manufacturing that only operated at the Henry Ford automobile plant from 1913 up to 1926, up to, that is, the moment of market saturation for the Model 'T' Ford. After that time the much more consumption-orientated approach of the General Motors company, with a strong emphasis on visual appeal, led the way for the industrial manufacture of consumer goods through the rest of this century. Thus Henry Ford's experiment seems little more than an interlude within the culture of consumption that dominated life in the twentieth century. To base a theory of design, which dominated design discourse for the next half-century, on a philosophy of manufacture that lasted for as little as thirteen years, seems, at the very least, to be perverse. Modernism's success, one might suggest, therefore, seems less a result of the appropriateness and timeliness of its assumptions than of the vested interests of its ideological underpinnings with patriarchical interests playing a significant part. If that is the case, and I would like to suggest that it is, then an attempt to redress this balance and to put in place both a historical and a critical framework for an analysis of material culture that takes taste and consumption as its starting points is well overdue.

Since 1994, when this lecture was given, I have continued to explore these themes and questions and to recognize Banham's work as an important influence. My study of the American pioneer interior decorator Elsie de Wolfe (2005) (Figure 9.7), focused, yet again, on questioning the hegemony of rational modernism, this time suggesting design work undertaken in a historicist style can be seen as being equally modern in its day, while my more recent work, *The Modern Interior*, has addressed that subject's dual commitments both to the programme of modernism and to its role as a stage on

9.7. Elsie de Wolfe's design for The Terrace Restaurant, the Colony Club, New York, 1907.

which identities – gendered ones among them – are formed.[33] It is only in that most recent piece of work that I have acknowledged the fact that, to fully understand twentieth-century material and spatial culture, it is not a question of either high or low culture, either masculine or feminine, either modernist or symbolic, but, as Banham well understood and fluently articulated back in the 1950s, of both/and.[34]

NOTES

1. I gave this lecture at the V&A, London, in 1994. I completed my Ph.D. thesis, undertaken at Brighton Polytechnic, entitled *Theory and Design in the Age of Pop: Problems in British Design in the 1960s, a Case-Study for a Methodology for Design History*, in 1975.
2. Reyner Banham, *Theory and Design in the First Machine Age* (London: Architectural Press, 1960). The title inspired that of my doctoral thesis.
3. Ibid., p.320.
4. This thesis underpinned Banham's 1960 book and much of his work with the Independent Group at the ICA in the 1950s.
5. It was at the Courtauld that Banham worked on his study of modernist architecture and learned about the iconography that underpinned the analysis of popular artefacts.
6. John McCale, a member, along with Richard Hamilton, Eduardo Paolozzi, Alison and Peter Smithson, Frank Cordell and others of the Independent Group, utilized anthropological methods to examine popular

culture and to align high with popular culture. This quotation is from his two articles, 'The Expendable Icon', which were published in *Architectural Design* in February and March 1959.

7. Penny Sparke (ed.), *Reyner Banham: Design by Choice* (London: Academy Editions, 1981), p.7.

8. Carolyn Steedman, *Landscape for a Good Woman: A Story of Two Lives* (London: Virago, 1986).

9. Mary Douglas and Baron C. Isherwood, *The World of Goods: Towards an Anthropology of Consumption* (Harmondsworth: Penguin, 1978).

10. Roszika Parker, *The Subversive Stitch: Embroidery and the Making of the Feminine* (London: Women's Press, 1984).

11. The theory of the 'separate spheres' has underpinned much work on the roles of gender in the nineteenth century. See, for example, Leonore Davidoff, and Catherine Hall, *Family Fortunes: Men and Women of the English Middle Class 1780–1850* (London: Routledge, 1987).

12. Ibid.

13. See, for example, Betty Friedan and Brigid O'Farrell, *Beyond Gender: The New Politics of Work and Family* (Johns Hopkins University Press, 1997) or Ann Oakley, *The Ann Oakley Reader: Gender, Women and Social Science* (The Policy Press, 2005).

14. For a full account of the aesthetics of the Victorian parlour see Thad Logan, *The Victorian Parlour: A Cultural Study* (Cambridge: Cambridge University Press, 2005).

15. Roszika Parker, 1984, p.37.

16. Pugin is quoted in ibid., p.21.

17. Charles Eastlake, *Hints on Household Taste in Furniture, Upholstery and other Details,* (London: Longmans, Green and Co., 1872 [1868]), p.7.

18. Augustus Welby Pugin, *True Principles of Pointed or Christian Architecture* (London: Henry G. Bohm, 1853 [1841].

19. Charles Eastlake, 1868, p.169.

20. Nikolaus Pevsner described a direct line of development from William Morris to the architects and designers linked to the German Bauhaus in his book *Pioneers of Modern Design: From William Morris to Walter Gropius* (Harmondsworth: Penguin, 1960 [1936]).

21. See Peter Collins, *Changing Ideals in Modern Architecture* (London: Faber and Faber, 1965).

22. Le Corbusier, *Towards a New Architecture* (London: The Architectural Press, 1946 [1923]).

23. Nancy Troy, *Modernism and the Decorative Arts in France: Art Nouveau to Le Corbusier* (New Haven: Yale University Press, 1991).

24. Le Corbusier *The Decorative Art of Today* (Cambridge, MA: MIT Press, 1987), p.55.

25. Le Corbusier, 1987, p.87.

26. Le Corbusier, 1987, p.81.

27. Andreas Huyssen, *After The Great Divide: Modernism, Mass Culture and Postmodernism* (London: Macmillan, 1986), p.vii.

28. Exceptions include the work of Cheryl Buckley, who has published *Potters and Paintresses: Women Designers in the Pottery Industry 1870–1955* (London: The Women's Press, 1990) and that of Lisa Tiersten, who has published *Marianne in the Market: Envisioning Consumer Society in Fin-de-Siècle France* (Berkeley, Los Angeles, London: University of California Press, 2001).

29. Jean Baudrillard, *The System of Objects* (Paris: Denoel-Gonthier, 1968), p.42.

30. Jean Baudrillard, *For a Critique of the Political Economy of the Sign* (St Louis: Telos Press, 1981), p.24.

31. Rudi Laermans, 'Learning to Consume: Early Department Stores and the Shaping of the Modern Consumer Culture [1860–1914]' in *Theory, Culture and Society* (vol. 10, no. 4, November 1993), p.91.

32. David Hounshell, *From the American System to Mass Production 1800–1932: The Development of Manufacturing Technology in the US* (Baltimore and London: Johns Hopkins University Press, 1982).

33. Penny Sparke, *Elsie de Wolfe: The Birth of Modern Interior Decoration* (New York: Acanthus Press, 2005) and *The Modern Interior* (London: Reaktion Books, 2008).

34. See Banham's essay, 'A Throw-Away Aesthetic' published in Penny Sparke, *Design by Choice*, 1981, pp.90–93.

10.
SAUL BASS
A LIFE IN DESIGN AND FILM; SAUL AND ELAINE BASS: A COLLABORATION IN FILM AND LIFE
pat kirkham

BANHAM, BASS AND ME

It has become customary for those giving this lecture to say something of their encounters with Reyner Banham.[1] I only heard him once – at a conference in the early 1970s. He leaped to his feet after a speaker had thoroughly dismissed the Modern Movement of the 1920s and 1930s, urging us all to imagine ourselves back in the period as progressive Leftists and forcing us to make the choices before them in a world of huge inequalities and substandard workers' housing. To experience his passion and his bringing of history to life by projecting himself and his listeners into the past was a special moment that has stayed with me.

My second formative encounter was with his *Los Angeles: The Architecture of Four Ecologies*, 1971. His validation therein of the so-called 'commonplace', an aspect of design history and material culture that has been for me both sustaining and immensely pleasurable, puts him right up there with William Morris and William Lethaby. What

Banham most validated, however, was my love affair with Los Angeles, which started when I spent three months there in 1971, after completing my first year in what was probably the first design history job in Britain (though the term 'design history' was not then coined). I sold my suede coat, rush matting and a blue Corona typewriter that Banham would have loved and bought a plane ticket.

I am not sure what month *Four Ecologies* was published but I did not discover it before my trip. I used Winter and Gebhard's splendid architectural guide but was always stopping off to photograph other things, from freeway junctions and Disneyland to hamburger joints and plastic 'Spanish Revival' furniture in the local supermarket. When I saw Banham's book, there was *my* LA, complete with photograph of the area where I had lived (Figure 10.1). Here was a kindred spirit. To state that seeing therein the types of design that chimed with me more personally than those I was then studying, and helped to validate interests too long in the academic closet, does not do justice to my sense of 'coming home'. Like so many of us who now think of ourselves as historians of design and material culture, I'm very grateful.

10.1. Postcard of intersecting Los Angeles highways.

I returned to LA in 1983, to interview the designer and film-maker Ray Eames (1912–88), in the hope of better understanding her contribution to, and the gender politics of, the thirty-seven-year partnership with her husband Charles (1907–78). That marked the beginning of a long research project and more trips to LA.[2] Banham, of course, wrote perceptively about the Eameses, particularly the Eames House (1945–49) that was part of the same Case Study house programme as the Bass House (1958).[3] During my research about short films made by the Eameses, another husband and wife team kept cropping up: Saul and Elaine Bass (Figure 10.2). Saul I knew as a famous graphic designer and creator of title sequences for films, such as Otto Preminger's *The Man With the Golden Arm* (1955), and Alfred Hitchcock's *Vertigo* (1958) and *Psycho* (1960), but I could find little information about Elaine. I came to know them both in the early 1990s when writing about the title sequences the Basses were creating for films by Martin Scorsese.[4] By the time Saul died in 1996, I counted them as friends.

That tells you something about my connections to Banham, the Eameses and the Basses, but what about Banham/ Bass connections? Firstly, Saul Bass and Reyner Banham each made significant contributions to the Aspen International Design Conferences where they got to know each other. Secondly, Mary Banham, a great promoter of the types of history and objects covered by these lectures, has told me how much Reyner Banham admired Saul Bass's work.[5] She also told me that she and her husband once had dinner with both Saul Bass and Charles Eames. How I wish I had been there!

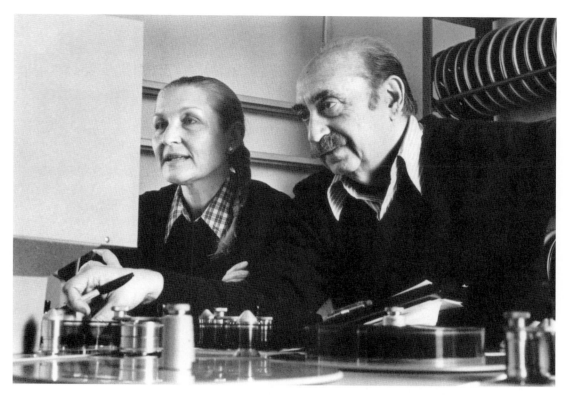

10.2. Photograph of Elaine and Saul Bass in their editing suite, circa 1990.

BECOMING SAUL BASS

By the time Saul and Elaine Bass began collaborating in 1960, Saul's extension of graphic design to film symbols and his title sequences of reductive and evocative intensity had made him world famous. And it is to his story that I turn first. My aims are to illustrate his versatility, map out the main fields in which he worked and suggest differences, as well as connections, between them. Today he is best known as the person who, in the mid-1950s, brought modernist sensibilities to mood-setting movie title sequences – some animated, some live action – and changed the way people thought about symbolizing and opening movies. He also worked as a visual consultant on *Psycho* (1960), *Spartacus* (1960, Anthony Mann; Stanley Kubrick), *West Side Story* (1961, Jerome Robbins; Robert Wise), *Grand Prix* (1966, John Frankenheimer) and *Not With My Wife You Don't* (1966, Norman Panama). Those consultancies included creating sequences *within* movies: for example, he visualized and storyboarded the now (in)famous shower scene in *Psycho*, frequently voted one of the most memorable scenes in cinema (Figure 10.3).

Saul also created opening sequences for television programmes, made TV commercials, directed a feature film, *Phase IV* (1974) and made short films with Elaine. Much of his work outside the film industry was corporate identity design: 'identities' of his that remain in use include AT&T, United Airlines, Avery, Minolta, and The Getty. He also designed album covers, retail displays, toys, tiles, modular hi-fi cabinets, a postage stamp, and illustrated a children's book and magazine articles. With

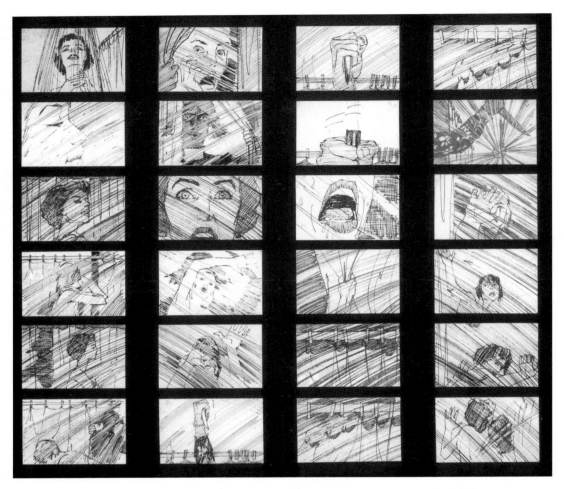

10.3. Storyboard for the shower scene in *Psycho* (1960, directed Alfred Hitchcock). Saul Bass, 1960.

Herb Rosenthal, he designed buildings, play environments and, at the 1968 Milan Triennale, an installation about modern urban life, one of the few things admired by the protesting students who closed down the event. Contemporaries remarked upon this versatility and also upon his searching mind, keen eye, drawing skills, humour and humanity.

EARLY YEARS

How did this boy born in The Bronx to Jewish immigrants in 1920 become 'Saul Bass'? Keen to work in commercial art, as graphic design was then called, he left school in 1936, during the Depression. The Bronx was then a hotbed of radicalism and Saul thrived on the intense intellectual and political debates. By 1937 he was working in a small agency that supplied United Artists with trade advertisements: the 'ass end' of movie advertising, according to Saul.[6] Whereas many of his

generation studied commercial art at college, Saul learned on the job and through evening classes. As he read Marx and Freud, campaigned for Roosevelt and supported anti-fascist causes, he spent one night a week for three and a half years at the Art Students League, Manhattan, in the class of Howard Trafton, a well-respected commercial artist who taught his students both fine art and graphics. Echoes of Trafton's freely brushed letters and crisp modern typography are found in Saul's later work.

Saul's excellence at lettering helped his early career, as did the popularity of movies during the Depression. By 1938 he was earning a good salary working for Warner Brothers as a 'lettering and paste-up' man; by 1940 he was at Twentieth Century Fox as a 'layout man' with more say in designing campaigns. Frustrated because his best work was constantly rejected, the gulf between the modernist design he admired and studio executives demanding posters highlighting Betty Grable's legs became too much. In about 1944, he took a fifty per cent wage cut to work at the Blaine Thompson agency: the only proviso was that he would never again have to design movie advertising.

A major influence was György Kepes (1906–2001), the Hungarian artist-designer who had worked in the German studio of László Moholy-Nagy (1895–1946) and helped him establish the New Bauhaus in Chicago (see Plate 19). Kepes joined the staff at Brooklyn College and Saul enrolled in an evening class (1944–45). Through Kepes, Saul became steeped in European modernism, adopting a rationalist problem-solving approach to design and thinking more consistently about such things as abstraction, montage, spatial forces, inter-penetration of line and plane, advancing and receding forms and colours, the physical modulation of light, montage and the expressive qualities of lettering and type. Much of this was reflected in his work thereafter as, for example, the types of forms he used in the *Vertigo* title sequence and posters (1958; see Plate 20).

Today Kepes's notion of a universal language of vision seems somewhat formulaic and lacking cultural specificity, and his faith in holistic social reformation through graphics and motion pictures somewhat naive. Many former students, including Saul, confessed to finding his ideas, as opposed to design exercises, somewhat obtuse, but all found him an inspirational teacher. Kepes's ideas about the transformative nature of the new media appealed to Saul's politics and validated his way of making a living. Kepes was one of many who took a liking to, and recognized the talents of, this young man, inviting him to collaborate on an exhibition and introducing him to his design 'heroes' including Herbert Bayer (1900–85), who had taught at the Bauhaus, Paul Rand (1914–96) and others. Just as Saul seemed poised to become a 'player' in what later came to be known as the New York School of Graphic Design, however, his employers hauled him back to trade ads for movies.

HOLLYWOOD

Saul moved to Los Angeles in 1946 to work for the Buchanan agency. Most film advertising was done in New York, the centre of the advertising industry, but the head of Buchanan wanted people on the spot in Hollywood to deal with the new 'independent' producers and directors. The latter were making new types of films, often referred to as 'new wave' or 'adult theme' movies, with new types of actors such as Marlon Brando, Jack Palance, Richard Conte and Neville Brand. They called out for new types of advertising. Saul ended up running the Buchanan office but wanted to devote his time solely to design and moved in 1950 to Foote, Cone & Belding to work on their RKO

Pictures account. He certainly had more time for design but little creative freedom. RKO's owner, eccentric millionaire Howard Hughes, was not interested in Saul's ambition to create sophisticated unified advertising campaigns, and Saul's frustration with Hughes's insistence upon sensationalist advertising was the catalyst for Saul setting up on his own in 1952.

He had made quite a name for himself with trade ads for the Stanley Kramer 'independent' production *Champion* (1949, Mark Robson), in which he reversed conventions by minimizing images of the stars, and other films by the 'red' team of independents Kramer (producer), Carl Foreman (writer) and George Glass (advertising), including *The Men* (1950, Fred Zinnemann), a film dealing with issues of masculinity. In 1950, Jonas Rosenfeld, head of advertising at Twentieth Century Fox, commissioned Saul to conceive a campaign for *No Way Out* (1950, Joseph Mankiewicz), a controversial film about racism in the USA, after not only the studio's in-house designers but also leading graphic designers Paul Rand and Erik Nitsche (1908–88) had failed to come up with a campaign that Rosenfeld considered sufficiently compelling.[7] Saul's campaign centred around three symbols – handcuffs, an iron bedpost and the arrows found on prison uniforms – and he, Rand and Nitsche then designed advertisements related to them.[8] He had not yet arrived at the single reductive symbol that would become a 'signature' from the mid-1950s, but it was close.

Commissions outside the film industry came mainly from younger entrepreneurs or executives of relatively young companies seeking to market new types of products and services; Samsonite and the McDonnell Aircraft Corporation were among his early clients. His logo for Lightcraft (1952–53) was probably his first corporate logo and the one he produced in the following year for Frank Holmes Laboratories, a colour photographic laboratory, ingeniously indicated the nature of the company by incorporating colour-processing principles into the symbol. That symbol then became the centre of an identity campaign, much in the way Saul's symbols for movies would provide the basis for wider advertising and identity campaigns.

His designs were changing to bolder, simpler, more symbolic forms as he forged a personal style with greater emphasis on narrative and emotional content and less on European modernism. He stood back from searching for universally applicable formulae and trusted more his own preferences for simplicity, ambiguity and metaphor. Traces of earlier influences resurfaced as he moved toward economic and dramatically simplified forms, often single images with little or no text, qualities he had long admired in early twentieth-century German posters. Fellow designers Will Burtin (1909–72), William Golden (1911–59), Alvin Lustig (1915–55), Leo Lionni (1910–99), Rand and others who, like Saul, were creating more distinctly American modern modes of graphic expression, continued to inspire him, as did the visual directness and moral commitment of artists such as Ben Shahn (1898–1969). Saul understood more deeply than many modernists of his generation that many things were simply not 'knowable'. This dated back to his adolescent interest in artefacts from cultures about which little was known except for evidence from physical remains, and also related to his increasing discomfort with overarching theories, from Marxism and psychoanalysis to European modernism.

There is no definitive 'Bass aesthetic', partly because he drew from such a wide variety of visual and cultural references to 'solve' each commission. But there are recurrent elements, from reduction, distillation and economy, features associated with modernism, to fragmentation, addition, ambiguity and metaphor, features more often associated with postmodernism but which were much in evidence at mid-century. Wit and the seeing of things in new ways are often present, along with

Plate 1. Moulton bicycle.

Plate 2. (Facing Page) Stirling and Gowan Engineering Building, Leicester University, at night.

Plate 3. Archigram 'Walking City'.

Plate 4. Charles and Henry Greene, Gamble House, 1908, Pasadena, California.

Plate 5. (Facing Page) Reyner Banham, 35mm colour slide 1979, *Concrete Central Elevator (Detail)*, Buffalo River, in Buffalo, New York, designed by A. E. Baxter, constructed 1915–17: detail of columns chamfered to prevent frost spalling.

Plate 6. Richard Misrach, chromogenic colour contact print, *Submerged Clothesline, Salton Sea*, 1983.

Plate 7. Tim Street Porter, from 35mm colour slide, *Reyner Banham at Silurian Lake*, near Baker, California, 1980.

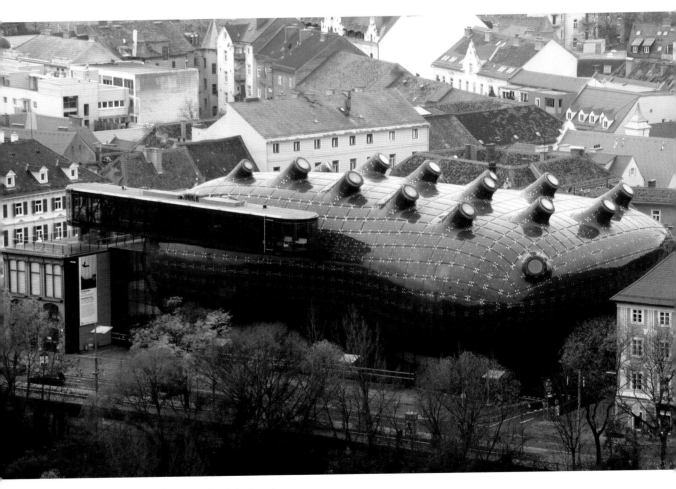

Plate 8. Graz Kunsthaus, nestling into the city.

Plate 9. Pinto town plan: diagram.

Plate 10. Pinto town plan: detail.

Plate 11. Vallecas housing, Madrid.

Plate 12. Kiosk, Tel Aviv.

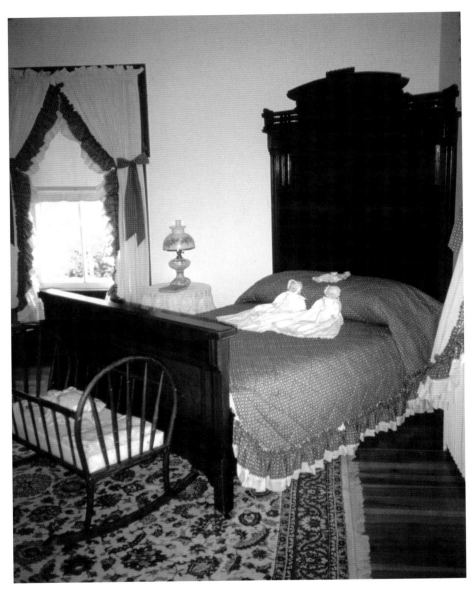

Plate 13. A comfortable Victorian bedroom furnished for parents and a baby. A. J. Miller House, Virginia.

Plate 14. 'Flash Gordon' flying by a building that could have been drawn by Sant'Elia, the Italian Futurist.

C.122—DELAWARE RIVER BRIDGE CONNECTING PHILADELPHIA, PA. AND CAMDEN, N. J.

3A-H963

Plate 15. 'Delaware River Bridge Connecting Philadelphia, Pa. and Camden, N.J., 1933. Describing this as 'one of the World's largest single span suspension bridges', the back caption provides statistics on length, height, distance between towers, and number of lanes.

Plate 16. 'Palmolive Building, By Night, Chicago', 1933. The back caption asserts that its 'spectacular' beams can be seen by 'aviators in the air as far east as Cleveland, Ohio, and as far south as St. Louis, Missouri'.

HOTEL
LOUIS
JOLIET
COCKTAIL
LOUNGE

JOLIET, ILL.

7A-H356

Plate 17. 'Hotel Louis Joliet Cocktail Lounge, Joliet, Ill.', 1937. Interior views often seem the most realistic, perhaps because source photographs contain so many details.

Plate 18. Le Corbusier, Villa Savoye, Poissy, 1928–31.

Plate 19. Layout in *pm* magazine by György Kepes, 1940.

Plate 20. Poster for *Vertigo* (1958, directed by Alfred Hitchcock). Design and art direction: Saul Bass; artists: Saul Bass and Art Goodman, 1958.

Plate 21. Film frame from *Quest* (1983, directed by Saul and Elaine Bass).

Plate 22. *Phase IV* alternate ending frame (Paramount, 1975, directed by Saul Bass).

Plate 23. *Minolta* logo. Saul Bass, 1980.

Plate 24. Images from title sequence for *Casino* (Universal, 1995, directed by Martin Scorsese). Elaine and Saul Bass, 1995.

Plate 25. (Facing Page) Entrance hall of Yale Center for British Art by Louis Kahn.

Plate 26. Suburbia, 1930s: Kenton, North London. Handy for the Underground. Typical target of inter-war campaigners for tougher planning legislation. Local builder. Strong echoes of Arts and Crafts style. Spacious layout.

Plate 27. Suburbia, 1990s: Chafford Hundred, Essex. Handy for Lakeside Thurrock mall, which is a typical target of campaigners against the new Edge City. Barratt houses. Weak echoes of Arts and Crafts style. Tightly packed.

Plate 28. Robots drawn by Mercia Price superimposed in a rural landscape (by Rowland Hilder).

Plate 29. Still from animated sci-fi series *Futurama*, created by Matt Groening (1999–2003).

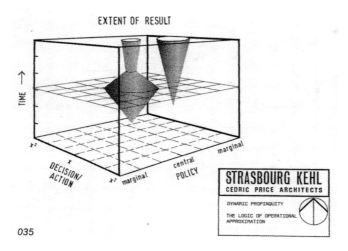

035

Plate 30. Dynamic propinquity, movement and location.

Plate 31. *Snail and Maze* drawing by Kevin Woodcock.

Plate 32. Ray Eames, colour sketch for Charles and Ray Eames Storage Units, 1949.

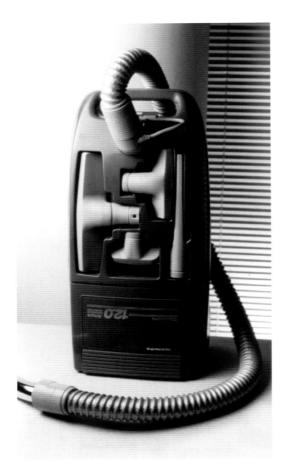

Plate 33. Perkins vacuum canister, open.

Plate 34. The 'Rascal'.

Plate 35. Crash test dummy.

Plate 36. Dr Strangelove (Peter Sellers) with colleagues in the Pentagon's war room (from *Dr Strangelove*, Columbia Pictures, 1964.

finely honed hand lettering and typography, always appropriate to the visual and emotional loads carried. When used symbolically, similar images represented different things: flames in *Carmen Jones* (1954, Otto Preminger), for example, represented passion while those in *Exodus* (1960, also Otto Preminger) represented 'eternal light' and freedom, and those in *Storm Center* (1956, Daniel Taradash) stood for evil and destruction. Human bodies, or parts of them, are evident throughout, particularly the eyes (the organ Saul considered the most vulnerable).

SYMBOLS AND MOVING IMAGES

When, in 1954, Saul made a flame flicker while enveloping a black rose in the opening credits for *Carmen Jones*, a film about love and passion with an entirely black cast, Saul entered the world of moving images. A year later, his animated title sequence for *The Man With the Golden Arm* caused a sensation when, against a jazz-like score, abstract forms came together to form the petrified disjointed arm of a junkie (Figure 10.4). I wish I had a pound for every time someone has told me how they will never forget first seeing it, including would-be young designers who sneaked off school or college to see it, from Charlie Watts in London, to Lella and Massimo Vignelli in Italy

10.4. Storyboard for title sequence for *The Man With The Golden Arm* (1956, directed by Otto Preminger). Saul Bass, 1955.

and Katsui Asaba in Japan. Young Martin Scorsese was so impressed that he began creating Bass-style storyboards. As films got longer, many credits began to be placed at the end: for *Around the World in Eighty Days* (1956, Michael Anderson), Saul rolled them against a witty cartoon reprise of the movie and conveyed them through graffiti for *West Side Story* (1961).

Much-admired film symbols that also featured in opening sequences included the haiku-like eye and tear set within a woman's face (*Bonjour Tristesse,* 1957) and the dissected body in *Anatomy of a Murder* (1958), both films by Preminger, the only director/ producer to consistently press for the fully integrated advertising campaigns offered by Saul to film studios, from titles, trademark, and trailer to main posters, trade ads and album cover. Even with the main posters for *The Man With the Golden Arm*, Saul and Preminger had to accept some versions with faces of the stars added. Furthermore, Saul's posters for *Vertigo* were ordered to be withdrawn a week after the film's release because studio executives blamed their 'artiness' for the film flopping at the box office (the alternatives apparently produced no better results). Saul's posters, with minimal text and devoid of images of film stars, were anathema to studio publicity executives. With huge amounts of money at stake, they were reluctant to break with conventions concerning posters, a crucial interface with the public. Although highly respected for his graphics outside the industry, and for trade ads within it, Saul found it easier to get Hollywood commissions for title sequences and montages with films than for posters. Even when he was paid for advertising campaigns, they were sometimes so messed around with by studio designers that he disclaimed them.

ART GOODMAN

Saul was the sole creative head of the design office that bore his name from 1952 until his death in 1996.[9] Of all the designers who worked for him over the years, there is no doubt that Art Goodman (1926–2008), Saul's 'right-hand man' for over thirty years, was the most important. Louis Dorfsman (1926–2008), former creative director of advertising and design at CBS, described Goodman to me as 'every designer's dream': highly talented, witty and inventive but prepared to remain within Saul's parameters, working up sketches and ideas, encouraging and stimulating without challenging basic ideas or art direction.[10] Saul always praised the abilities of this 'wonderfully talented, funny, shy and self-effacing man', but Goodman insisted the creativity stemmed from Saul, telling me that most people simply could not believe that such a huge amount of highly creative work could emanate from one man.[11] According to Goodman, Saul managed to achieve so much because he was extremely well organized:

> he had that office buttoned down so tightly *precisely* so he could concentrate on designing and making films. I reported to him every day. Even after twenty years I'd feel guilty if I let a small thing through without his 'OK'. The business was Saul. Everything flowed from him and from his huge energy. He took on so much yet never saw himself as overworked.[12]

ELAINE BASS

When Elaine Makatura (b.1927) became Saul's assistant in 1956, she was looking for a more challenging job. Little did she realize it would lead to a long creative and personal partnership. Her route to working in design and film was even more circuitous than his. The child of Hungarian

immigrants living in New York, she came from a poor but musically gifted family. She showed early promise at art and exercised her cinematic imagination by drawing stories, frame by frame, on the sidewalk. From the age of twelve she sang professionally with her three older sisters as the 'Belmont Sisters'. Although the youngest, Elaine was lead singer and soloist. During the Second World War, they sang in service clubs and enjoyed a regular radio spot, but the group disbanded soon after the war when the older sisters married. Had she been less shy and modest, Elaine could easily have had a solo career: recordings made when she was about fifteen reveal a surprisingly mature voice singing 'swing' with touches of Billie Holiday.

She found work in the New York ready-to-wear fashion industry, producing renderings, sketches and working up design ideas for several fashion houses. She first moved to Los Angeles in 1947, settling permanently in 1954. While working in the design department at Capitol Records, someone told her that Saul Bass was looking for an assistant. It was immediately apparent that she and Saul shared similar aesthetic sensibilities. Those sensibilities underpinned their partnership, as did their extremely disciplined approaches to work, strong organizational skills and profound respect for process. Saul described her as 'exceptionally creative', an 'ideas person who also comes up with imaginative ways of making those ideas happen'.[13] He admired and relied upon her sense of what was and was not appropriate, visually as well as musically. Like Saul, Elaine could cut decisively through extraneous matter and, from 1960, she joined him in his quest for finding 'the simple idea', usually with a touch of ambiguity or metaphor, and thinking of ways to express and realize it. The more her ideas proved successful and were appreciated, the more confident she became at proposing them and devising creative ways of achieving visual effects. Everything was open for discussion between them, with ideas constantly tested and contested.

When Saul attended the 'World Design' conference in Japan in 1960, Elaine was left to direct the *Spartacus* title sequence for which she had devised an ingenious method of achieving the main special effect. Having decided that the crumbling away of statues was to be a metaphor for the break-up of the Roman Empire, Saul and Elaine were having problems making it look convincing on screen. Recalling Japanese Bunraki theatre, in which puppeteers dress in black to be 'invisible', Elaine draped herself accordingly on a black set, slowly and carefully pulling away parts of the statues in front of the camera.

Elaine and Saul were married in 1961. Elaine continued to collaborate on film titles and, from 1963, short films – her input into which ranged from design concepts, choice of music and special effects ideas and resolutions to co-directing, co-editing, co-writing and producing. Their first two short films were completed shortly before their first child was born in 1964. Thereafter Elaine managed to combine looking after children and home with working on titles and short films, mainly because in each case they were sufficiently short and discrete for both her and Saul to be able to make time within busy schedules. There were no models for this intermittent and part-time type of partnership: the Eameses, for example, jointly headed a design office and worked together full time on the wide range of commissions undertaken therein. Saul and Elaine likened their collaboration to a 'cottage industry', often working at home or in the otherwise empty office at weekends, with children playing nearby. Goodman often worked with them after the development stage but they always edited alone. Professional camera crews were brought in only when necessary: the trial footage for the title sequence of *Walk on the Wild Side* (1962, Edward Dmytryk), wherein a prowling tom cat provides a metaphor for a story set amidst New Orleans brothels, for example, was shot in the back yard of the Bass office, using the family cat.

Other memorable openings on which Saul and Elaine worked together include the lyrical overture for *West Side Story*, wherein intentionally ambiguous imagery becomes the Manhattan skyline, lifting the Capitol's dome to signify lifting the lid off American politics in *Advise and Consent* (1962, Preminger), and the shape of a child torn out of a newspaper, suggesting both a missing child and a child who may not have existed, for *Bunny Lake Is Missing*, (1965, Preminger). In 1966 came split-screen multiple images of the start of a race in *Grand Prix* and a distorted bandaged face in *Seconds*, a story about a company offering new identities through surgery – both for films directed by John Frankenheimer. Title commissions fell away in the mid-1960s (some directors wanted 'tap dancing' graphics, some to create their own openings and some simply could not afford a Bass opener), but by then Saul and Elaine were making short films and Saul was engrossed in corporate identity campaigns.

SHORT FILMS AND *PHASE IV*

When asked what a graphic designer brought to film-making, Saul stated that visual awareness and a problem-solving approach were useful but good film-making owed more to a sense of story, inventiveness and visual/aural sensitivity.[14] Made for a variety of sponsors, the short films differ in length, content and form. Humour is frequently invoked. Sometimes images are reductive, sometimes not. Some films have a fantasy science fiction feel and make considerable use of special effects, while some draw more on narrative traditions and yet others have the abstract lyricism and technical virtuosity associated with experimental films. Not surprisingly, for people skilled at title sequences, their short films often have non-sequential structures: Saul and Elaine adeptly fashioned impressionistic films out of individual sequences and an accumulation of images, mood and ideas. Even with a strong narrative, their tendency was to let images 'speak' and audiences experience the close connections between image and sound. They used a range of cinematic techniques, including animation, live-action, fast cutting, split-screen, wide-screen, zoom and underwater photography, but believed that the medium had to serve the message. So economical were their ways of working and so magical the effects produced on low budgets with 'low-tech' equipment, that director George Lucas (a former student of Saul's at University of Southern California) showed footage to his staff at Industrial Light and Magic, the company responsible for special effects in a host of motion pictures including the *Star Wars* trilogy, as an exemplar of what could be achieved on a low budget without digital aids.[15]

The Basses' first sponsored films, *From Here To There* (for United Airlines) and *The Searching Eye* (for Kodak), were 'soft sell' advertising. Shown at the 1964–65 World's Fair, these visual essays were seen by about 35,000 people a day over two seasons. Also seen by thousands, probably millions over the years, was the Academy Award-winning *Why Man Creates* (1968, Kaiser Aluminum). Widely used by educators and companies seeking to encourage creativity, it was one of the most successful short sponsored films, commercially and critically. Elaine was less involved with *Why Man Creates*, because their second child was born in 1967, but was back in full partnership for the Oscar-nominated *The Solar Film* (1980), with Robert Redford as executive producer on behalf of Consumer Action Now. It mixes animation and live-action in sequences that vary in tone from lyricism to humour. Each section makes its point effectively, from the creation of the Earth and the sun's influence on plant and animal life, to fossil fuel shortages and the effectiveness of

contemporary solar technology. The segments meld into a continuous whole and viewers absorb a wider message about the power of the sun.

The Basses' fascination with the mysterious and healing qualities of light is best seen in *Quest* (1983) (see Plate 21). Made for the Japanese-based Mokichi Okada Association that calls for holistic regeneration, it tells of a search for life-giving light. Elaine spoke of their belief that 'we are, each of us, a walking bundle of energy to be spent productively' and the film is imbued with her Zen-like spirituality. Much of the visual power comes from images of pure form and the illusion of an ominous, light-starved world achieved through shifting the colour balance of the film towards the blue end of the spectrum. Viewers, like the hero, experience light deprivation and yearn for a warmth that comes only at the end.

Saul viewed the chance to direct the low-budget *Phase IV* (1974), a science-fiction-cum-surrealistic ecological suspense story about the apportionment and control of the resources of Earth, as an opportunity to develop his interest in storytelling, characterization and visual effects in greater depth than titles, montages or short films allowed (see Plate 22). The film would undoubtedly have benefited from a wonderful epilogue about 'Paradise Lost', storyboarded by Saul, but the project fell foul of changes in personnel and budget cuts and was never well promoted by Paramount. Today it enjoys a cult following, not least for its stupendous imagery that more than compensates for the wooden script and acting.

CORPORATE IDENTITY

Corporate identity, not film-making, occupied most of Saul's time from the mid-1960s. Among the bigger campaigns of that decade were Alcoa (1960), Continental Airlines (1967), Bell Telephone (1968) and Quaker (1969), while those of the 1970s and 1980s included United Airlines (1974), Avery (1978), Girl Scouts (1978), Minolta (1980), AT&T (1981), the J. Paul Getty Trust (1983), and Kose (1988, Japan). The 1990s saw campaigns for Minami (1990), Maeda (1990) and JOMO (1993), all companies based in Japan, where Saul's ability to express poetics within corporate imagery was much admired. The following story, which Saul loved to tell, is indicative of his ability to think 'on his feet' (see Plate 23). In 1980, after Saul had finished pitching a concept to Minolta, the retired but revered company founder, whose son then ran the company, expressed his reservations about the need to change the company identity. He picked up a tiny camera and demanded to know how Saul could possibly add a symbol to Minolta's smallest miniature camera without it looking ridiculous. Taken aback, Saul glanced at his financial partner, Herb Yager, who sat smoking his Dunhill pipe. The famous Dunhill trademark, a white spot on the pipe, triggered a new idea. Quick as a flash, Saul replied that he would create the new trademark *inside* the 'O' of MINOLTA. Fortunately, the 'old lion', as Saul referred to the founder, liked the reply and gave the new corporate identity project his blessing.

When Saul died in 1996, he was still working on corporate identity and other graphic projects, including lettering and signage for The Getty Center, Los Angeles and, together with Elaine, on title sequences. Titles resumed when fans of the early titles, who had since become film directors, contacted Saul. He and Elaine made eight sequences between 1987 and 1995, the first for films with James Brooks as director (*Broadcast News*, 1987) or as producer (*Big*, 1988, Penny Marshall, and *The War of the Roses*, 1989, Danny DeVito). These were fairly modest projects, as were those for

Doc Hollywood (1991, Michael Caton Jones) and *Higher Learning* (1995, John Singleton). Grander in scale and more lyrical and poetic was the title-sequence-cum-prologue for Juno Sato's *Tonko/ Dun Huang/ The Silk Road* (1988), an action-packed romantic melodrama that opens with the 1900 'discovery' of eleventh-century scrolls sealed in caves near the ancient city of Dun Huang. Elaine's concept for this sequence, which invites contemplation on the passage of history, was triggered by Percy Bysshe Shelley's thoughts on the evanescence of power in his poem 'Ozymandias', 1818. By contrast, for *Mr Saturday Night* (1992, Billy Crystal), the story of an old Jewish comedian reminiscing about the past, Saul dug into personal memories of Jewish life in the 1940s after they decided to evoke nostalgia for the past through food.

The titles for Martin Scorsese, for *Goodfellas* (1990), *Cape Fear* (1991), *The Age of Innocence* (1993*)* and *Casino* (1995), are among their very best. Writer Nick Pileggi, who collaborated with Scorsese on the first and last films, told me: 'For a director such as Scorsese who is totally committed to every last inch of the film, there is no greater tribute than to hand over the opening of your film to them'.[16] For *Goodfellas*, Scorsese already had a placement for the credits and the music, but not the right lettering or mood. To the powerful opening, with its cold-blooded murder, Saul and Elaine added mesmerizing credits rushing across the screen. The credits recalled those for *Psycho*, but blurred like a car passing at high speed, similar to the one in which the 'Goodfellas' themselves were travelling. Before the murder, the typography is white on black; afterwards red.

For *Cape Fear*, a tale of revenge centring on a psychotic rapist stalking a girl, the Basses created a stunning *noir* sequence based on the notion of submerged emotions and the black potential of the psyche. Pleasing and disturbing images play against each other, as does the idea of surfaces and what lurks beneath them. The lusciously sensual, yet gently restrained, sequence for *The Age of Innocence* alludes to the suppressed desire at the heart of Edith Wharton's novel about life and manners in late nineteenth-century New York. Elaine suggested time-lapse photography of flowers sensually unfolding and dissolving, one into another, and overlaying the flowers with lace and calligraphy from period etiquette books.

I want to close with Saul and Elaine's final project together, the powerful title sequence for *Casino* (see Plate 24). 'Think Dante's *Inferno* and Hieronymus Bosch, set against Bach's *St Matthew Passion*', Saul told me, 'and you'll get an impression of what we're after'.[17] Scorsese opens the film with the Robert De Niro character leaving a casino, turning on the car ignition and the car blowing up. Only then does the title sequence begin. After a body catapulting heavenwards in a fiery mass, there is a disconcerting, yet mesmerizingly seductive, mini-film of shimmering lights in abstract forms; of hyper-reality distorted and made lyrical, not unlike 'the strip' itself. It ends with the same character descending into hell. Pileggi, who wrote the script with Scorsese, stated:

> Their opening is simply brilliant. I was so touched that they had understood the writing; that they knew what the film was trying to do. There must have been a hundred Hollywood films about Las Vegas, certainly endless titles which have tried to capture the essence of that city, but none quite like this ... Elaine and Saul found the perfect metaphor for the film as a whole – for Las Vegas in the 1970s and for descent of the Mafia into Hell.[18]

I offer it as a fitting finale to this lecture about the work of Saul Bass, including that undertaken with his beloved Elaine.

NOTES

1. My lecture was dedicated to Saul Bass (1920–1996). This published version is dedicated to him and to Art Goodman (1926–2008). My lecture, delivered in 2004, was based upon my forthcoming book on Saul Bass that includes his work with Elaine Bass (London: Laurence King Publishing, forthcoming). I want to thank Jennifer Bass, Elaine Bass, Anne Coco, Kristine Krueger, Brad Roberts, Harriet Atkinson and Jeremy Aynsley for their help with this published version of my lecture. My thanks also to everyone who has spoken to me about Saul, Elaine and their work over the years.

2. See Pat Kirkham, *Charles and Ray Eames: Designers of the Twentieth Century* (Cambridge, MA: MIT Press, 1995).

3. Reyner Banham, 'Klarheit, Ehrlichkeit, Einfachkeit … and Wit Too!: The Case Study Houses in the World's Eyes', in Elizabeth Smith (ed.), *Blueprints For Modern Living: History and Legacy of the Case Study Houses* (Cambridge, MA: MIT Press, 1989), pp.183–95. For the Bass House see Esther McCoy, *Case Study Houses 1945–1962* (Los Angeles: Hennessey and Ingalls, 1977), pp.142–53.

4. See Pat Kirkham, 'Looking for the Simple Idea', *Sight & Sound*, 4, February 1994, pp.16–20, 'Saul Bass and Billy Wilder in Conversation', *Sight & Sound*, 5, May 1995, pp.18–21, 'Bright Lights, Big City', *Sight & Sound,* 6, January 1996, pp.12–13, and 'The Jeweller's Eye', *Sight & Sound*, 7, April 1996, pp.18–19.

5. Mary Banham to Pat Kirkham, 2004. An 'anonymous' advertisement for *On the Threshold of Space* (1956, Robert Webb) illustrated in Lawrence Alloway, 'Symbols Wanting', *Design*, vol. 113, May 1958: 24 ('The Arts and Mass Media', *Architectural Design*, February 1958: 84–85), for example, turns out to have been designed by Saul Bass. Design and art direction: Saul Bass; illustration: Al Kallis (Kallis Collection).

6. Much of this text is taken from interviews with Saul Bass and Elaine Bass, and with people who knew and/ or worked with them. My main interviews and conversations with Saul Bass were conducted in 1993, 1994 and 1995 (Los Angeles and London); those with Elaine in 1994, 1995 and 2003 (Los Angeles and London) and, intermittently, ever since.

7. I am grateful to Joe Morgenstern (who interviewed Rosenfeld in 1996) for this information.

8. Saul Bass's name is not on the poster he designed, probably because he was working for Buchanan at the time, but it was published under his name after he went freelance two years later.

9. Elaine went to work for Saul in December 1956. Shortly afterwards, Morris Marsh became a business partner, taking on responsibility for sales and workflow, and the office became known as Saul Bass & Associates (SB/A). In 1960, Saul hired Art Goodman (who had been freelancing for him since about 1957) to help with the realization of design concepts. Goodman's assistant, George Araki, was hired at the same time, as was Nancy von Lauderbach (production manager). Marsh stayed for twenty years, Goodman for over thirty and Araki and von Lauderbach until Saul's death in 1996. In 1978, Saul brought in a new business partner to ensure he could focus on design. Thereafter the firm was known as Bass/Yager & Associates (BY/A).

10. Kirkham/Dorfsman interview, 2003 (New York).

11. Kirkham/Saul Bass interview, 1995 (London) and Kirkham/ Goodman interview, 2003 (Los Angeles).

12. Kirkham/Goodman interview, 2003 (Los Angeles). See also Art Goodman on Saul Bass, untitled notes, nd. Bass Archive.

13. Kirkham/Saul Bass interview, 1994 (Los Angeles).

14. Everett Aison, 'Saul Bass: The Designer as Film-Maker', *Print*, January 1969, p.94.

15. Kirkham/Saul Bass interview, 1994 (Los Angeles) and Marsha Jeffer, *Guide to Quest*, Pyramid Film & Video, Los Angeles, n.d.

16. Kirkham/Pileggi (telephone) interview, 1994.

17. Kirkham/Saul Bass (telephone) interview, 1994.

18. Kirkham/Pileggi (telephone) interview, 1994.

Part III
UNE ARCHITECTURE AUTRE? LOOKING AT THE OVERLOOKED

…while European modern architects had been trying to devise a style that would 'civilise technology', US engineers had devised a technology that would make the modern style of architecture habitable by civilised human beings. In the process they had come within an ace of producing a workable alternative to buildings as the unique means of managing the environment, and had thus come within an ace of making architecture culturally obsolete, at least in the senses in which the word 'architecture' had been traditionally understood, the sense in which Le Corbusier had written *Vers une Architecture*.

The Architecture of the Well-Tempered Environment, 1969

11.
ARCHITECTURE AND THE MUSEUM
A RELATIONSHIP BETWEEN FORM AND FUNCTION
charles saumarez smith

When I was invited to give the Seventh Reyner Banham Lecture in 1995, I was deeply immersed in the process of selecting an architectural practice to look at the overall organization of space at the National Portrait Gallery and to provide a master plan for its future development. I had become conscious of the absence of very much readily accessible secondary literature examining the changing form of museums in the post-war period, and how decisions had been made about the relationship between their form and their function, apart from one or two general, popular surveys.[1] It seemed to me to be a fascinating topic, symbolic of the changing public role and responsibilities and audience for museums and galleries since the Second World War, and also, simultaneously, of the changing status of architecture as an art form and its tendency in recent decades to diversify into a complex range of aesthetic vocabularies.

It is obvious to anyone who studies the architecture of museums that these vocabularies encapsulate assumptions about the act of aesthetic contemplation, about what is felt to be the appropriate way of looking at objects and works of art, as well as revealing

aspirations about the role of architecture in the public domain: civic ambitions or the desire of individual donors to achieve an abstract form of commemoration or the intention of museum committees to demonstrate their internationalism and commitment to the avant-garde. In this way, it seemed to me that examination of museum design ought to provide an effective language for understanding the changing role of museums and that this was an issue deserving of more systematic analysis.

I was encouraged in my sense of the appropriateness of the subject by the discovery, which I did not know at the time that I selected it, that Reyner Banham had himself, not long before he died, been involved in the selection of the architect for the new Getty Museum, which is by far the grandest and most expensive of all the current new museum projects. He had been flown, at the Getty's expense, around the world to examine museum projects in order to assist the selection and, on his return, he himself lectured on this subject of architecture and the museum. So, this lecture is, in a very direct way, a form of homage to a great architectural historian, one who I very much regret that I didn't know, although I corresponded with him just before his death about the establishment of this lecture series when it was going to be the Pevsner memorial lecture series. I also remember him lecturing at the Cambridge School of Architecture in the early 1970s, striding across the stage in a bootlace tie and speaking with exceptional fluency on the air-conditioning systems of the Royal Hospital in Belfast. His writing demonstrates the extent to which he believed that architectural history should be written from the experience of looking at, thinking about, and analysing buildings, and that the absence of an adequate secondary literature was never an impediment to thoughtful and highly original speculation.

Any discussion of the modern museum and its architectural form needs to begin with a brief examination of the museum's classic historical characteristics, since so many of the ways that modern museums are laid out consist of an implicit dialogue with, and commentary on, an always present set of precedents. Many modern museums consist of adaptations of, or additions to, historic buildings; but even when they are built *de novo*, the history of the building type is always expected to be available in the mind.[2]

In England, at any rate, the classic museum type was established by the British Museum, plans for which were first commissioned by the Trustees in 1820 from the architect Robert Smirke, whose designs were approved in 1823.[3] What are the essential components of the British Museum as a building? The first, obviously, is the level of concentration on the ability of the arriving spectator to see and absorb the exterior façade, to take in at a glance the fact that however complex the range of exhibits on display inside, they are subject to a single, consistent architectural order (Figure 11.1). Whether or not one had come to see the Elgin Marbles, to read in the King's Library, or to see the curiosities of the natural history collection, which were originally housed in the rooms above the King's Library, the façade effectively conveyed the message of an organization of knowledge and its subordination to a universal system of classification, which was essentially an Enlightenment ideal.

The second obvious characteristic of the British Museum was the extent to which it was considered inevitable, in the 1820s, that the language of classical antiquity should be used – in the case of the British Museum an Ionic order derived from the Temple of Athene Polias at Priene – as a way of signifying the origins of the museum in the Greek μυσειον, a home to the muses and a shrine to Mnemosyne, the goddess of memory. At the time that the British Museum was built there was a sense of the authority of the classical world and of the extent to which European culture had been constructed through a sequence of adaptations of its classical inheritance. It was felt to be entirely

11.1. The main façade of the British Museum, London.

appropriate that the museum should be constructed as a temple of learning, intended to induce feelings of subordination to the authority of scholarship and admiration for a canonical tradition.

The third characteristic of the British Museum is the extent to which its interior is constructed as a sequence of large, essentially neutral, public halls, which were planned to be the same in style and decoration irrespective of the object type they were intended to contain. There was no desire, indeed an implicit antipathy, to provide any relationship between the interior architecture and a particular set of artefacts. There is no difference, indeed you would not know, which rooms were intended to contain Egyptian or Romano-British antiquities. There was no sense in which a museum might simulate a historic environment, except in the way that it employed an overall language of classicism.

The fourth characteristic of the British Museum is the extent to which the architect has subsumed his personality in the general concept of the museum. There is little sense of individual personality in the design of the building. It might almost as well have been designed by, indeed is very closely congruent to, museums designed by Durand in France, or Schinkel in Berlin, or Klenze in Munich. The museum was conceived of as a universal building type not subject to variations of locality or individual circumstance. In so far as the British Museum is a shrine, it is a shrine to the abstract authority of learning promoted under the aegis of the national state.

It is necessary for me to state the characteristics of the traditional museum for the obvious reason that in the immediate post-war period, museum design consisted of a self-conscious attempt to subvert these characteristics of the traditional museum. In particular, during the 1950s, the literature on museums (and, it is evident in architectural practice) stressed the need to ignore or, as far as possible, abolish any sense of a public façade in line with a belief in the democratization of public institutions.[4] Architects wanted to create a sense of permeability between the outside world and the world of the museum. Where new museums were built, and it is not a period of very substantial new building, strenuous efforts were made to abolish the planarity of the exterior

walls by the use of glass, so as to admit the spectator immediately into the interior spaces, evident, for example, in the additions to the Stedlijk Museum in Amsterdam, where Wilhelm Sandberg was pioneering new forms of access to museums. At the Louisiana Museum, north of Copenhagen, the *locus classicus* of this period of museum design, Knud Jensen, a Danish businessman, created a museum of contemporary art in the middle of the countryside, with a self-consciously anti-consumerist agenda.[5] He wrote:

> One of the most prominent features – and problems – of the epoch we are moving into is *leisure*. We have hardly got it before powerful forces are fighting to seize control of it: the entertainment industry and consumer-mentality ... which is precisely what we want to combat by demanding active interest, and a personal attitude and relation to the material we display.[6]

More commonly at this period, museums and galleries would occupy historic buildings and make strenuous efforts to ignore or disguise the historic architecture or, as in the many examples of newly designed galleries in Italy in the 1950s, treated the historic architecture in a way that was self-consciously ahistorical and essentially abstract. Here the dominant language of display was provided by Carlo Scarpa, who in the Galleria Nazionale in Palermo, the Museo Castelvecchio in Verona (Figure 11.2) and the Museo Correr in Venice, created an idiom of highly aestheticized, open spaces which enhanced the private contemplation of the single work of art.

Museums and galleries were believed to exist in order to allow the spectator to have a private and, as far as possible, an unmediated experience of works of art. The responsibility of the architect, then, was thought to be the need to create an environment that was as studiedly neutral as possible,

11.2. Interior of Museo Castelvecchio, Verona.

draining the space of any form of visual or aesthetic distraction. There was to be no form of intrusion into the realm of looking at and absorbing the formal characteristics of objects on display. As Bruno Zevi wrote in an article in *L'Architettura* in 1958:

> We had been accustomed to museums conceived architecturally on a monumental scale, a shell into which works of art were inserted at a later stage. But now this concept is being reversed: the works of art themselves create the architecture, dictating the spaces and prescribing the proportions of the walls. Each picture and statue is studied for the best possible view: it is then set in the necessary spatial quantity.[7]

One finds in the literature on museum design at this period discussion of the psychology of the conditions of viewing pictures, about how to engineer spaces in order to avoid eye fatigue, and about appropriate forms of lighting. It was the period when John Pope-Hennessy spent a month in Italy every summer and returned determined to box up and disguise, as far as possible, what he regarded as the revolting and distracting original forms of decoration of the V&A Museum, London.

In England, this period and this philosophy of museum design is most conspicuously exemplified by Powell and Moya's rather beautiful small gallery designed for Christ Church, Oxford in 1964, which is scooped out of the ground near the back entrance, so that it is scarcely visible on the outside, but provides inside a series of differentiated and simple, well-lit spaces for the display of paintings and drawings (Figure 11.3). In Germany, it is exemplified by Mies van der Rohe's New

11.3. The interior of Christ Church Picture Gallery, Oxford, by Powell and Moya.

National Gallery in Berlin, commissioned by the Federal Republic in 1961 and providing a set of cool, anonymous and wall-less spaces. Architecture at this period was severely subservient to the experience of works of art.

At this point, one may ask how far this attitude has changed and, if it has changed, why it has changed? Part of the answer must lie in the disinclination of architects to adopt such an ostensibly passive relationship to the contents of the museum and, indeed, the disinclination of patrons to allow their architects to disappear behind such a veil of studied anonymity. Both architect and patron have wanted the museum to be a statement of something more solid and coherent than the abstract contemplation of an individual work of art.

I am not sure when this attitude began to emerge most clearly. In my mind, I date it back to the considerable amount of public discussion surrounding the opening of the Yale Center for British Art in New Haven in 1974, which centred as much on the philanthropic gesture of Paul Mellon in constructing a completely new museum (although he did not allow his name to be associated with it) as on the fact that it was a late work of Louis Kahn inserted into the city of New Haven immediately opposite his early work on the Yale University Art Gallery. The architect and patron were regarded as being at least as important to the design of the building as the collection of paintings.

One of the first major commissions that Kahn had received in the early 1950s was that for the Yale University Art Gallery.[8] It was very much in the style favoured at that period, consisting of a substantial wall of glass allowing the interiors to be readily visible from the street; it has an essentially free-form plan; and the style of display attempted to show works of art in a void, as if they were in an aircraft hangar, with only the ceiling evident as a heavy, criss-cross grid.

But by the time Kahn came to design the Kimbell Art Museum in Fort Worth in 1966, his ideas towards an appropriate museum structure had significantly changed. For a start, he was keen to provide an emphasis on seeing a work of art within a defined space of a room, rather than in open, undefined space. As he wrote in the deliberately mystificatory style that he favoured towards the end of his career:

> The room is the beginning of architecture. It is the place of the mind. You in the room with its dimensions, its structure, its light, respond to its character, its spiritual aura, recognizing that whatever the human proposes and makes become a life. The structure of the room must be evident in the room itself.[9]

So, the Kimbell had a sequence of rooms. Moreover, both Kahn and Richard Brown, the then director of the Kimbell, shared a dislike of the increasing gigantism of many international, institutional museums, such as the Metropolitan Museum in New York. As Kahn said of the experience of museum-visiting, 'The first thing you want in most museums is a cup of coffee. You feel so tired immediately'.[10] He tried therefore to design it, as he described it, as 'a home', representing a reversal of the tendency to provide anonymous public space in favour of interiors which were domestic in feeling and scale. In addition, in the 1960s Kahn had become increasingly interested in the relationship of light to space, attaching a quasi-mystical significance to qualities of top-lighting in the interiors at the Kimbell Art Museum. One can feel, in reading about the intentions of the architect, the extent to which there has been an adjustment in the relationship of architecture to works of art in the experience of the museum. The physical characteristics of the building were expected to hold their own alongside, and independent of, the experience of the works of art. There

was a new drive towards a relationship of planned and carefully controlled reciprocity between the museum as a place to visit and the museum as a publicly accessible collection of works of art. The garden, the library and the café were as important to the visit as individual galleries.

This tendency towards the assertion of the experience of museum architecture in its own right is equally evident at the Yale Center for British Art, where the amount of the building which is available for the display of the permanent collection is relatively small, owing to the fact that the Center was conceived as much as an institution for teaching and research as it was as a public art gallery. The feel of the interiors is of intense attention paid to the qualities of different spaces and, more especially, of the textures of concrete, pale wood and dark, unpolished stainless steel (see Plate 25). That Kahn thought of the Yale Center in architectural terms is evident in his comment at the time:

> I think of the Mellon Gallery as an English hall. When you walk into the hall, you're introduced to the whole house. You can see how the whole interior is laid out, how the spaces are used. It's as though you can walk into the house and meet the whole house and say 'Gee whizz, I think you're great'.[11]

The Yale Center for British Art introduces me to the first general tendency of museum design over the last two decades: that is, the level of hyper-aestheticism in the treatment of interior spaces and the degree to which museums and galleries have been commonly resistant to demands for a greater degree of contextualization in the display of works of art. I don't think that this is necessarily a bad thing, and perhaps demonstrates the continuity and resilience of modernism that museum design should still be dominated by an aesthetic that is essentially abstract; but it is certainly worthy of comment how far museum architecture remains dominated by the desire to provide white spaces. This is the tendency that I would see exemplified by the new galleries and lift which have been inserted so ingeniously into the historic structure of Burlington House by Spencer de Grey and Sir Norman Foster (Figure 11.4). It is the same tendency revealed by the decision on the part of the Natural History Museum to scrap the high-tech entrance desks which appeared not very long ago and which were designed by David Davies, a specialist in shop design, in favour of new ones designed by David Chipperfield, one of the more puritanical of contemporary architects. And I have been interested by the discussion of the choice of Herzog and de Meuron as architects for the new Tate on Bankside, since, as must have been evident to everyone reading the articles about them, the choice of adjectives to describe their work bears such an uncanny resemblance to the many profiles of Nicholas Serota as the Tate's director: cool, rational, cerebral, avant-garde and international. There can be no doubt that a policy of expensive, hyper-trophied reductionism remains, if it has ever ceased to be, one significant strand in the development of post-war museum design.

But there are alternative strands to museum design as well; and one of the purposes of this paper is to draw out the nature of the alternatives and what they suggest about the functions of, and audience for, museums and galleries.

One of the things that has struck me very forcibly in the course of preparing this lecture is the extent to which the Centre Pompidou remains a significant spot in the landscape of post-war museums, an attempt radically to change the concept of what a museum might be, but one which has failed to the extent that one probably doesn't think of it as a museum at all. But in its origin, it was – at least as much as it was an attempt to revitalize the area around Les Halles and provide an

11.4. Axonometric drawing by Sir Norman Foster of the Sackler Galleries at the Royal Academy, London.

appropriate monument to the government of Georges Pompidou – conceived as a replacement for the Musée National d' Art Moderne, previously located at the Palais de Chaillot. The original brief prepared by François Lombard required that it should combine the functions of museum, library and cultural centre into a single entity; the judges included Michel Laclotte, then chief curator of the Louvre, and Wilhelm Sandberg, the retired director of the Stedlijk Museum in Amsterdam; and one of the criteria employed by the jury was precisely that entries should not provide what they described as 'compact and undifferentiated volumes that could be a hospital as easily as a museum'.[12] Georges Pompidou described his intention at the time as follows:

> It is my dearest wish that Paris have a cultural centre, such as they have tried to create in the United States with so far only partial success. This would be at one and the same time a museum and a centre for artistic creation where, side by side, one would find the plastic arts, music, cinema, books and audio-visual media.[13]

In reading the accounts of the gestation of the design for the Centre Pompidou, it seems evident that it was planned very much in the spirit of an anti-museum, a new type of museum which would

be entertaining, accessible, impermanent, free, anti-elitist, devoted equally to design as to fine art, to books and film and street theatre, so that it is a monument as much to the spirit of May 1968 as it is to the power and willingness of a centralizing government to invest in new forms of cultural production. In reading accounts of the choice of Richard Rogers and Renzo Piano, it is impressive how far the competition was genuinely anonymous and how a characteristically diverse committee of architects and museum bureaucrats should have chosen what must have been one of the more adventurous projects submitted and one which had had to be reduced in size in order to fit into the brown cardboard tube when it was sent off on the last day of submission at the all-night post office in Trafalgar Square.

What, one asks, is the legacy of the Centre Pompidou? The answer, considering its gigantic, popular success, seems to me to be surprisingly little. There are resonances of it in the design of the Sainsbury Centre, which would hardly be surprising since Foster and Rogers had met as students at Yale and worked together as Team 4. La Villette, the science park in the suburbs of Paris, is perhaps comparable in the scope of its ambition, its willingness to cross disciplinary boundaries and to play with new architectural forms. And it may be that the Centre for Art and Media Technology that Rem Koolhaas is designing in Karlsruhe will do for the 1990s what the Centre Pompidou did for the 1970s. But I don't, for example, detect any significant intention to diversify the scope of contemporary art in the plans for the new Tate on Bankside. Nor am I aware of any equivalent to the Centre Pompidou in the United States, which might demonstrate how one might transgress the traditional boundaries of art, design, and film.

Instead, if one is looking for alternatives to the hyper-aesthetic tendencies of so much post-war design, then it is to be found most conspicuously in historicism, although, considering that so many museums and art galleries are institutions dedicated in some way to the preservation of history, it is perhaps interesting how little impact historicism has had on new museum design.

The origin of historicism in museum design presumably derives from the recognition that it is highly artificial to try to abstract the experience of looking at pictures from the circumstances in which they were originally intended to be seen; and that one ought, in some way, to approximate, if not simulate, historic conditions of public or private display, by, for example, massing pictures on the wall and by treating pictures, as they so often used to be hung, within an overall scheme of interior decoration, rather than in isolation from their surroundings. At the same time, as part of the conservation movement, there was a recognition that museum buildings were themselves often significant architectural monuments, deserving to be treated with care and attention paid to original architectural features, such as colour, wall surface, ceilings and doors, and original layout. Once again, I view this tendency as marking a shift in the relationship between architecture and collections in the experience of museum-visiting in the early 1970s: when the experience of single works of art was regarded as being dominant and autonomous, then it was logical to treat the surrounding architecture as if it did not matter beyond providing a neutral environment for the experience of viewing pictures; but once it was acknowledged that it was important to view pictures within an appropriate visual and historical context, then it was necessary to pay more attention to the character of the surroundings.

The first evidence of historicism applied to new museum buildings appears in the design of Venturi and Rauch's building for the Allen Memorial Art Museum in Oberlin, Ohio, completed in 1976 (Figure 11.5). Then I assume that it is appropriate to consider as historicist the decision to house the nineteenth-century collections of the Louvre in the Gare d'Orsay. This is a solution,

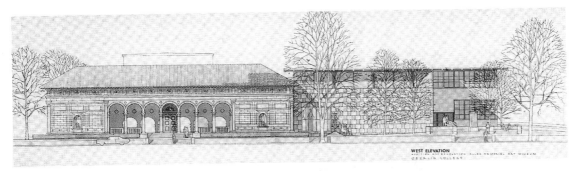

11.5. Presentation drawing of Allen Memorial Art Museum, Oberlin, Ohio by Venturi and Rauch.

designed by Gae Aulenti, which I regard as exceptionally successful in demonstrating how it is possible to combine the overall envelope of a historic building, preserving it and using it in order to provide an individuality to the experience of a new museum with, at the same time, a clearly separate and thoughtful display of works of art, which is suggestive of their history without being reproductive.[14] And it was the spirit of historicism in museum design in the 1980s which accounted for the immense success of James Stirling as a museum designer, most conspicuously at the Staatsgalerie in Stuttgart, but also in the Clore Wing at the Tate and in the new Sackler Building in the Fogg Art Museum in Harvard. I've never seen the Staatsgalerie in Stuttgart, but I don't think that the Clore Gallery has worn particularly well in spite of its recent refurbishment, which has ripped out some of its detailing. It's too mannered, too self-conscious, too imposing of the consciousness of the architect on the experience of the museum visitor for my taste.

This applies also, in my view, to the other great monument of the historicist tendency in recent British architecture, Robert Venturi's Sainsbury Wing at the National Gallery (Figures 11.6 and 11.7). There are aspects of this building which I think are effective: the quality of monumentalism in the staircase and the lighting of the galleries on the top floor; but it makes too many sacrifices to achieve these effects, with exhibitions crammed into claustrophobic galleries in the basement. And it has, even more than the Clore Gallery, an irritating quality of cleverness, the rather heavy-handed parade of learning by an Ivy League professor. In the Sainsbury Wing there is an obvious danger of the relation between the museum and architecture becoming unbalanced, with the architecture taking precedence, drawing attention to itself and deliberately making the spectator feel small.

Historicism has, of course, also been the dominant language of decoration inside British art galleries, at least since Timothy Clifford began to restore Manchester City Art Galleries to their original appearance in the early 1980s. It was a tendency which was followed, although rather briefly, at the V&A, for example in the restoration of the cast courts and the design of the nineteenth-century continental galleries. It is the tendency now most associated with the National Galleries of Scotland, where the galleries have been expensively restored to what was thought to be their original appearance, although with, as far as one can tell, a greater degree of opulence than appears in the nineteenth-century views of the interiors. It is the policy that has been pursued at the National Gallery, where Purcell, Miller and Tritton have supervised the restoration of the interiors to their original nineteenth-century magnificence. And it has been to a large, although not exclusive, extent the policy pursued by the National Portrait Gallery, where Roderick Gradidge produced a highly

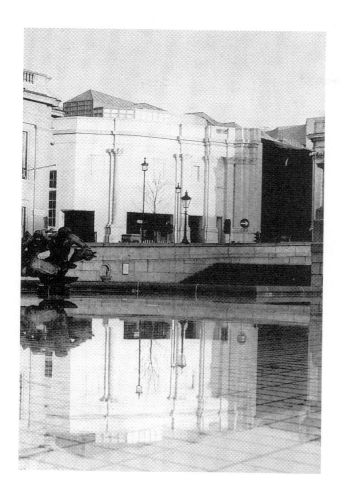

11.6. Sainsbury Wing of National Gallery, London by Robert Venturi.

elaborate and, as far as one can tell, entirely fictional scheme of interior decoration in the entrance hall, giving it an atmosphere where *Gormenghast* meets Cardiff Castle.

This brings me to the 1990s. What are the options available to one in terms of museum design?[15] So far, what I have described are three distinct strands in post-war museum design. The first is what I think of as hyper-aestheticism: the treatment of the interior spaces of the museum as if they are works of art in their own right and the application of sophistication and often minimalism to the qualities of finish and detailing. This was the quality which, as I understand it, won Richard Meier the contract to design the new Getty Museum on an open hillside inland from Malibu. The second tendency is what I think of as technophilia: the treatment of the museum building as a task essentially of engineering, in the provision of a technically inventive shed. I have a feeling from what I have read about the competition that this was the quality that won Norman Foster the competition to design the new courtyard of the British Museum. The third tendency is historicism: the belief that museum design was really much better in the mid-nineteenth century.

There is a fourth tendency as well, which I think may emerge from museum design in the 1990s, which is neo-expressionism: the treatment of design as arbitrary and fragmented, the abolition of rationalism in design in favour of raw experience, the universe not as a potential utopia or as

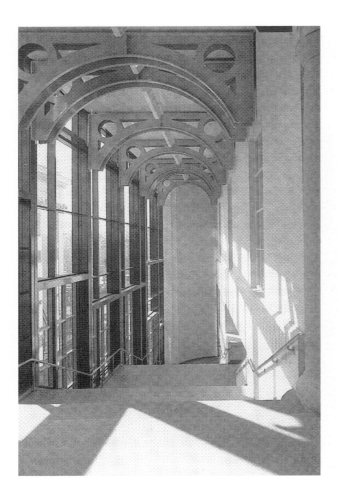

11.7. Interior, Sainsbury Wing of National Gallery, London by Robert Venturi.

a fictive utopia of the past, but as it is, uncooked and theatrical. The idea of the museum as an expressive experience, involving movement, rather than the static enjoyment of single works of art, probably goes back to Frank Lloyd Wright's late work for the Guggenheim, where the design is deliberately organic, conceived of as a totality, rather than separating out a collection into discrete geometric spaces. I'm not sure whether this tendency towards neo-expressionism will emerge, but there are certainly signs of it in the work of Frank Gehry in the Frederick R. Weisman Museum in Minneapolis and of Peter Eisenman in the Wexner Center for the Visual Arts in Columbus, Ohio (Figure 11.8). It appears also in the decision of Peter Noever at the Museum of Applied Arts in Vienna to use each gallery and, indeed, the whole applied arts collections, as an opportunity for wilfully mannered and self-consciously contrived architectural set-pieces, the ultimate victory of architecture over the idea of the museum. And I'm looking forward to Branson Coates's additions to the Geffrye Museum, because Nigel Coates is certainly the designer in this country who is most capable of treating museum design as a theatrical experience, as he moves between the Arts and Crafts Movement and the world of Mad Max.

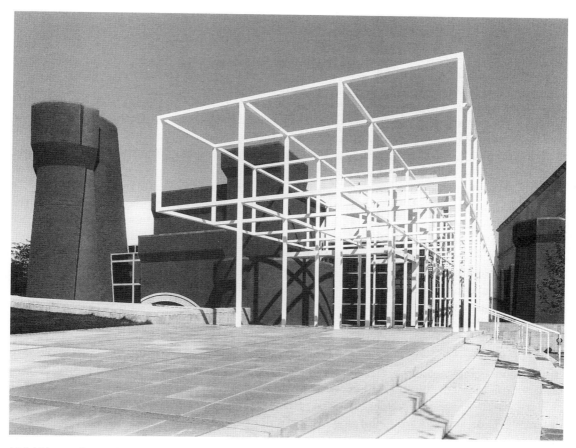

11.8. Wexner Center for Visual Arts, Columbus, Ohio by Peter Eisenman.

So, the time has come to try to draw the threads of this lecture together and to think what are the conclusions of this attempt to look at the changing relationship of architecture and the museum in the post-war period. My first conclusion is the extent to which the tensions in the relationship between quality of architecture and display of collections have provided one of the essential dynamics in the development of museums since the war. Is the museum to be treated simply as the sum of its collections, or does it have a larger responsibility in the provision of public space and public experience and, indeed, public interaction at a time when so much of life and leisure has retreated into the home? Is the experience of the museum to be isolated and fragmented in terms of quality of the relationship between the individual and the single work of art, or should it be seen as having a larger cultural responsibility, accommodating the library, the lecture, access to an information system, and perhaps a cup of coffee? What is the relationship between the overall envelope of the museum and the individual items in the museum's collection? It is a relationship of mutual engagement, which needs to be recognized and accommodated if it is going to be – if, indeed, it can be – resolved.

My second conclusion is the extent to which, if one stands back from the development of architecture since the war, museums have been one of the key elements of architectural expression in

the second half of the century. As industry and housing and now shops have vacated the city centre; as architects and the public have lost faith in town planning and the possibilities of constructing any form of civic order; as popular entertainment has increasingly retreated into the home; so museums have become one of the last remaining sites for openly accessible and democratic urban experience, where individuals may seek to understand their history, their environment, their cultural opportunities and themselves. They are a signal that architects can and should have a part to play in the construction of a symbolic order, where buildings register, like a highly sophisticated barometer, changes in the public construction of culture.

My third conclusion is a more political one. You will remember that at the end of the 1980s, Peter Palumbo floated the idea that we ought to mark the end of the millennium by constructing a series of civic and urban landmarks, which would demonstrate the ability of architecture to enrich the urban landscape. The instrument for fulfilling this ambition has been placed in the hands of the Millennium Commission, but there are worrying signs of a loss of nerve, an absence of any belief in the power of architecture to provide tools of innovation and commemoration, and a tendency to fragment the resources available into a myriad of little projects and small-scale schemes, distributed no doubt with an admirable attention to equity, but a loss of any large-scale ambition or imagination as to the ways that money is likely to be allocated. There are a number of architectural schemes that would make it possible to mark the millennium appropriately, of which the Tate on Bankside is certainly one. I hope they will be built.

My fourth and final conclusion is that, having said at the beginning of the lecture that one of the reasons for my being interested in the relationship of architecture to the museum was the need to commission architects to look at the overall plan and future development of the National Portrait Gallery, it is only fair to indicate how the NPG has chosen to navigate the issue of choice. The answer is that we have deliberately chosen to evade it. For we have selected as architects the practice of Jeremy Dixon and Edward Jones, who do not fit neatly into any one of the categories that I have outlined. They certainly cannot be described simply as hyper-aesthetic minimalists, although there are elements of hyper-aestheticism in the quality of interior spaces of their building for the Henry Moore Institute in Leeds and a degree of thoughtfulness to the relationship it produces between the spaces of the galleries and individual works of sculpture. Nor do I think they can be categorized as technophiles, although their prize-winning design for Northampton Town Hall in the early 1970s is, I suspect, an un-built monument to a 1960s belief in the possibilities of new technology. There are elements of historicism in their work, since they are amongst the generation of architects who were influenced in the 1980s by Leon Krier and the symbolic possibilities of classicism as an architectural language. In short, I hope and believe that they evade easy categorization and instead approach the task of design with a degree of intelligent and independent-minded pragmatism, an element of the spirit, perhaps, of Louis Kahn.

For, in the end, the principal conclusion that I would draw from this attempt to analyse and categorize the different types and styles of museum design in the post-war period is that the task of the museum is to provide some form of rational compromise between the plurality of tasks and responsibilities that the modern museum has to face and which, as has been demonstrated so notably at the V&A, are always threatening to tear it apart.

It is perhaps appropriate to end with a quotation from an article which Reyner Banham himself wrote just before he died in 1988, on the subject of the newly opened De Menil Museum in Houston, Texas. As he wrote:

Recent well-regarded museum designs like the Isozaki/ Polshek project for the rear of the Brooklyn, tend to make — and to be valued for making — major monumental gestures of civic and cultural intention. Standing in conspicuous and history-loaded city-centre locations, they tend to come forward with important messages for the citizenry as a whole.[16]

POSTSCRIPT

The Seventh Reyner Banham Memorial lecture was delivered on Friday 24 February 1995, just over a year after I was appointed as Director of the National Portrait Gallery and so had ceased organizing the annual series of Banham lectures, which had been started as a way of honouring his memory under the auspices of the RCA/V&A MA Course in the History of Design.

It was a very particular moment in the development of museums in Great Britain. After a decade in which there had been relatively few museum developments other than Jim Stirling's Clore Gallery at the Tate on Millbank (1986), Norman Foster's Sackler Galleries inserted into the gap between the eighteenth- and nineteenth-century buildings at the Royal Academy (1991), and the long saga of the Sainsbury Wing at the National Gallery (1991), there was a recognition that Great Britain lagged behind new developments in museums in Europe, most especially in Germany, where Frankfurt had opened a whole series of new museums during the 1980s, and in France, where François Mitterand had sponsored his *grands projets*, including such buildings as the Institut du Monde Arabe by Jean Nouvel (1987). In 1993, John Major's government launched the National Lottery as a way of providing a new source of state funding for new architectural projects, free of the dead hand of Treasury control. One of the good causes which was planned to benefit from the lottery was heritage, and the creation of both the Heritage Lottery Fund and the Millennium Fund by the then Department of National Heritage in 1994 created an atmosphere of intense discussion as to how best to celebrate the new millennium through the creation of ambitious new architectural projects.

It was, in retrospect, a good time to become a museum director. I was able to take up the appointment of Director of the National Portrait Gallery in January 1994, work with the senior staff on drawing up a simple brief for the future development of the building during the summer of 1994, and launch a competition for the selection of an architect during the autumn. We selected Jeremy Dixon and Edward Jones, the architects of the Royal Opera House, just before Christmas 1994. They won the competition as a result of their intelligent analysis of the capabilities of the vacant space that lay between the National Portrait Gallery and the National Gallery and how this might be developed into a new wing, which might have some of the hallmarks of the Sackler Gallery as a discrete intervention into the gap between two historic buildings (Ed would sometimes refer to it as 'our Sackler project'). Jeremy Dixon and Edward Jones were in the audience when I gave the lecture and it was an important moment in the establishment of a working relationship between architect and client. Up until the lecture, they had thought that I was a fogey, knowing that I had been a pupil of David Watkin, and were pleasantly surprised to discover that I had a reasonably well-developed interest in contemporary architecture and design, based on twelve years of postgraduate teaching at the Victoria and Albert Museum alongside Gillian Naylor and Penny Sparke and, not least, on the example of Pevsner and Banham, both of whom used their knowledge of history to inform their interpretation of contemporary architectural and design practice.

I used the lecture as an opportunity to analyse the architectural character and typology of the modern museum. I had become obsessed by a desire to learn about and understand the international precedents for new museum buildings and had bought or borrowed every possible book I could find on the subject, as well as visiting buildings designed by all the competitors for the National Portrait Gallery project. It is odd, and faintly nostalgic, reading the lecture again after fourteen years. I can see all the topics that were a matter of concern at that time. There was an interest in developing museums in such a way as to provide new public spaces, which was very much a feature of the terms of reference of the Heritage Lottery Fund: its Trustees were at least as interested in issues of access, in coffee shops and interpretation, as they were in the development of conventional gallery spaces. There was a concern that public funding should be used to support a high level of quality in new buildings, after a decade in which much new building had been cheap, tawdry and commercial. There was a particular anxiety that the opportunity that the Lottery provided would be blown by the commissioners of the Millennium Fund, who spent money at speed on opportunistic projects, a number of which, like the National Centre for Pop Music, subsequently collapsed. And there was a feeling, which was not peculiar to the Trustees of the National Portrait Gallery, that it was a good moment to create an architectural monument, which would be intellectually adventurous and break the mould of previous architectural conventions.

So, if Jeremy Dixon and Edward Jones's Ondaatje Wing at the National Portrait Gallery (2000; Figure 11.9) has a sense of intellectual adventure, a feeling that it belongs in a sequence of key

11.9. The interior of the Ondaatje Wing, National Portrait Gallery, London.

museum buildings stretching back to Louis Kahn's Kimbell Museum in Fort Worth, opening up a previously Victorian building to new audiences, who were now able to soar up to the top-floor galleries on an escalator as if they were consumers in the department store of culture, giving them a spine running alongside the existing galleries and displaying Tudor paintings in a semi-abstract way, then this is in some significant way owing to the opportunity which was provided by the Reyner Banham lecture of being able to analyse and think about the evolution of the modern museum as a building type and to provide clarity as to the ways in which the form could be developed in the future.

NOTES

1. The most systematic study of modern museums appears in John Coolidge, *Patrons and Architects: Designing Art Museums in the Twentieth Century* (Fort Worth: Amon Carter Museum, 1989). In addition, there are general surveys in James Steele (ed.), *Museum Builders* (Academy Editions, 1994) and Douglas Davies, *The Museum Transformed: Design and Culture in the Post-Pompidou Age* (New York: Abbeville, 1990); and a more practical guide to museum planning in Joan Darragh and James S. Snyder, *Museum Design: Planning and Building for Art* (Oxford: Oxford University Press, 1993).
2. The most accessible general histories of museums as a building type appear in Nikolaus Pevsner, *A History of Building Types* (London: Thames & Hudson, 1976), pp.111–38 and *Palaces of Art: Art Galleries in Britain 1790–1990* (Dulwich Picture Gallery, 1991). Helen Searing's *New American Art Museums* (New York: Whitney Museum of American Art, 1982) offers a useful short history of the museum as a building type in the USA.
3. For the early history of the British Museum, see J. Mordaunt Crook, *The British Museum: A Case-Study in Architectural Politics* (Allen Lane, 1972).
4. The best general survey of new museums in the 1950s and 1960s appears in Michael Brawne, *The New Museum: Architecture and Display* (London: Architectural Press, 1965).
5. There is a useful discussion of the Louisiana Museum in Coolidge, ibid., pp.18–25.
6. Karl Jensen, 'Louisiana: A New Danish Museum', *Museum Journal*, 60(9) (December 1960): 226–28.
7. I have been unable to locate the original source for this quotation, which appears in Brawne, ibid., p.30. There is a discussion of the design of the Museo del Castello Sforzesco by Mario Labo and Roberto Pane in *L'Architettura*, IV(33) (July 1958): 152–63.
8. For the work of Louis Kahn, see David B. Brownlee and David G. De Long (eds.), *Louis I. Kahn: In the Realm of Architecture* (New York: Rizzoli, 1991).
9. Louis Kahn, 'The Room, the Street and Human Agreement', *AIA Journal*, 56 (September 1971): 33.
10. Brownlee and De Long, ibid., p.223.
11. Ibid., p.233.
12. For discussion of the plans for the Centre Pompidou, see Nathan Silver, *The Making of Beaubourg: A Building Biography of the Centre Pompidou, Paris* (Cambridge, MA: MIT Press, 1994).
13. *Le Monde*, 17 October 1972.
14. For a discussion of the Musée d'Orsay, see J. Jenjer, *The Metamorphosis of a Monument*, (Paris: Electa Moniteur, 1987).
15. A recent survey of museum design appears in 'Musei', *Domus Dossier*, vol. 2, 1994.
16. Reyner Banham, 'In the Neighborhood of Art', *Art in America*, June 1987, p.126.
17. Since the Banham lecture was first published, there has been a huge efflorescence of interest in the topic. I myself published further on the issues in 'Museums and the Metropolis', *Museum Management and Curatorship*, 15(3) (1996): 259–69 and '"In a New Light": Issues in the Display of Portraits at the National Portrait Gallery', *Museum Management and Curatorship*, 16(4) (1997): 371–82. In addition, there are at least three important surveys of the architecture of museums: Victoria Newhouse, *Towards*

a New Museum (New York: Monacelli Press, 1998); Michaela Giebelhausen (ed.), *The Architecture of the Museum: Symbolic Structures, Urban Contexts* (Manchester: Manchester University Press, 2003); and Andrew McClellan, *The Art Museum from Boullée to Bilbao* (Berkeley: California University Press, 2008).

12.
NON-PLAN REVISITED
OR THE REAL WAY CITIES GROW
paul barker

One of these days, perhaps, a blue English Heritage plaque will be cemented on the outside of the Yorkshire Grey pub in Holborn, at the corner of Theobalds Road and Grays Inn Road. If the plaque ever fights its way through the advisory committees, it will commemorate the fact that here the idea of Non-Plan – or, at any rate, the word – was born, one day in 1967.[1]

That day, the urban geographer Peter Hall and I went out from the offices of the magazine *New Society* – of which I was then the deputy editor and he was a regular contributor – to have a glass of beer and a sandwich. *New Society* was a magazine of social enquiry. One of its abiding passions, from its launch in 1962 to its demise in 1988, was to try to see the world as it was, and not how it was supposed to be.[2] The magazine was usually perceived as centre-left, but it was always fiercely non-partisan. It was in the honourable tradition of Dissent. One commentator said that, in its pages, 'Ideas were always more important than ideology'.[3] In *Too Much*, his cultural history of the 1960s, Robert Hewison wrote that *New Society* became 'a forum for the new intelligentsia'.[4] It drew, especially, on the emergent disciplines of sociology, anthropology, psychology, human geography, social history and social policy.

Peter Hall and I were talking together because urban change was always one of my own – and the magazine's – deepest interests. My approach was then, and remains now, that of social anthropology, respecting popular choice. I was always much influenced by

the urban studies of Michael Young and Peter Willmott,[5] which focused on the patterns people created for themselves. From the other side of the Atlantic, I was influenced by the writings of the sociologist Herbert Gans. In September 1967 I had run in *New Society* long extracts from his study, *The Levittowners*, in which he showed how a spirit of community flourished within a despised form of American suburban speculative housing.[6] Earlier in the year, I had also published Lionel March's analytical defence of building in lines (including ribbon development) rather than clusters.[7]

At that date, Peter Hall and I had both grown disillusioned with the way urban planning often worked out in practice. As Reyner Banham noted in his book, *Megastructures*, Hall was to be just about the first writer in Britain to blow the whistle on tower blocks as a form of social housing.[8] For my part, I had lived in Stepney for five years, at a time when comprehensive redevelopment, masterminded first by the London County Council and then the Greater London Council, destroyed huge tracts of perfectly good terrace housing.

So often, and this continues to be true, an urban plan was said to be fulfilled when it had only been completed. No one checked whether it did the job it set out to do. The same shortcoming pervades much architecture: almost all interest ceases, among the professionals, once the building is built. The architecture journals recycle interminably what the building was intended to do, not what it has actually done. Only the users continue to worry about that.

Over our sandwiches that day in late 1967, we asked ourselves the question: could things be any worse if there were no planning at all? America seemed to offer an alternative view of what could, or could not, be built. In particular, it seemed to be less bogged down in questions of aesthetics, which planners seemed then – and seem to me now – ill-qualified to judge. We were, in our own way, striking a blow against notions of 'good taste'. As a historical footnote, it is worth observing that *Learning from Las Vegas* was not published until five years later, in 1972.[9]

Between the two of us, the idea emerged of advocating a public experiment in letting public demand take its course, and seeing if it really could be any worse than what was prescribed by government or by local councils. A truly contemporary style might then emerge. The name 'Non-Plan' was, I think, mine. But there was the usual batting to and fro that always takes place in such circumstances. I would not want to claim sole credit (or blame).

The concept was very strongly influenced by the essays that Reyner Banham had been writing for *New Society*, many of them reprinted in the 1997 collection, *A Critic Writes*, and by the designs and conversations of the architect Cedric Price, who had also appeared in the magazine.[10] Since 1965, Banham had been the regular design and architecture critic in *New Society*'s 'Arts in Society' columns. When we wondered who our other collaborators should be, Banham and Price were the obvious names. Both of them agreed immediately.

Our idea was to take various tracts of countryside and hypothesize what might happen if they were subjected to Non-Plan. Naturally we chose the rural tracts whose apparent despoliation was guaranteed to cause most offence. We were trying to make our point in the most forceful possible way. The wider polemic would then be written around these three case studies.

With his East Anglian roots, Reyner Banham opted for Constable Country (not the Stour valley, but the area around Royston and Stansted, which had no Foster airport at that time). Cedric Price opted for southern Hampshire, which for these purposes we called Montagu Country. Peter Hall opted for the East Midlands, on the edge of the Peak District; to maintain the pattern of fancy nomenclature, we called this Lawrence Country. It was my task to write an introductory overview.

The conclusions were written by Peter Hall and myself. But every section contained something from every writer, and we all agreed everything that appeared.

On 20 March 1969, I published a special issue of *New Society* under the title 'Non-Plan: An Experiment in Freedom'.[11] It was illustrated mainly by specially taken night-time photographs of illuminated signs in and around London: signs for petrol, launderettes, supermarkets and burger bars. It was a protest against the taste establishment that the Situationists in 1968 Paris might have approved of.

Non-Plan produced a mixture of outrage and stunned silence. Not only professional planners, but also Fabian socialists and many architects, were furious. In 1969, Christopher Booker published *The Neophiliacs*, his attack on the passion for change that had characterized Britain from the mid-1950s.[12] He took virulent issue with a Price design which *New Society* had published; Non-Plan itself appeared too late for inclusion in his onslaught.[13] It was certainly imbued with the desire for change (neophilia); but it was hard to categorize. It argued that, in design and in planning, what ordinary people wanted, rather than what 'experts' said they ought to want, was the best guide. Was this conservatism or anarchism, or both?

Ideologically, Non-Plan was the beginning of a rollback against one variety of detailed prescription peddling. It was perhaps ten years ahead of its time. The environmentalist Colin Ward was to write this about Non-Plan:

> If I were to choose an article (endlessly cited by me) which most epitomized everything I believe in, in one particular field, and which was valuable to me just as a legitimation of opinions I seemed to be alone in advocating, it was ... 'Non-Plan: An Experiment in Freedom'.[14]

In our advocacy of Non-Plan, we opened with an item from *The Times*, which, in its advertising, was still able to call itself 'the Top People's paper'. It said: 'A dispute has arisen about a booklet, *Dorset Building in Rural Areas*, just issued by Dorset County Council, and aspiring to be a guide to good design for people building houses in the countryside'. So their architecture correspondent wrote. He was, in fact, J. M. Richards, who was also the long-time editor of the *Architectural Review* and a fervent modernist. He went on:

> Most of the examples that it illustrates and recommends as models are utterly commonplace, the sort of house to be found in any speculative builder's suburban estate. This view is shared by the Wilts and Dorset Society of Architects, which, through its president, Mr Peter Wakefield, has asked for the publication to be withdrawn.

This news item, we felt, illustrated the kind of tangle we had got ourselves into, and often find ourselves in today, also. Somehow, everything must be watched; nothing must be allowed simply to 'happen'. No house can be allowed to be commonplace in the way that things just are commonplace. Each project must be weighed, and planned, and approved, and only then built, and only after that, more often than not, discovered to be commonplace after all.

Professor Michael Hebbert, of the University of Manchester, noted in 1998 that London, in particular, has been saved from many disasters by the absence of too much planning.[15] The regular trumpet-calls to turn London into a kind of Paris would have resulted in disaster. London is essentially an anarchic city. Unfortunately, however, it has not been saved from every such disaster. It was often the Victorian suburbs, and their unfortunate inhabitants, who paid the price. In

J. M. Richards' report for *The Times* the word 'suburban' was used as an automatic sneer-word. This is a standard feature of most architecture criticism.

Yet the suburbs of London are one of its greatest achievements as a city. In *The Village in the City*, Nicholas Taylor reports on a visit to London by a young Italian architect.[16] His well-meaning hosts took the visitor on a tour of those few isolated examples in London of monumental architecture that begin to match up with the best in Europe. But such excursions turned out to bore the visiting Italian. He kept insisting on stopping the car, instead, in perfectly ordinary speculative builders' avenues and drives and crescents of the 1920s, and exclaiming on their exquisite design.

In his great book, *London: The Unique City*, Steen Eiler Rasmussen emphasizes that London has always grown by adding suburb on to suburb.[17] Many of these houses – and some of them are very attractive – have no known architect. In many cases, even the name of the builder is a mystery. Many were put together from a kind of kit of parts. All the houses in the same neighbourhood would share the same design of banisters or cornices. They might, however, pay silent homage to some distant original that counted as Art-with-a-capital-A, in the same way as acre after acre of English suburbia pays homage to the houses that Voysey built. (Voysey's own houses may be few and far between, and often rather disappointing when you find them. But he and Palladio are probably unique in the extent of their influence. And if you were to tot up the actual numbers of houses created in Britain under Voyseyian auspices – inglenooks, gables and all – Voysey would win the competition, hands down.) The test of a house, after all, is not just its fitness for the purpose for which it was built, but its continued fitness and adaptability to the purposes that will come along down the years. You might call this the Non-Plan test.

Non-Plan had very practical consequences. Peter Hall (now Professor Sir Peter Hall, of University College London) carried the thinking forward. In our Non-Plan special issue we had acknowledged that our ideas might not be applicable in London. The problem of what to do with Docklands undercut this argument. In 1977, Peter Hall gave a paper at the annual conference of the Royal Town Planning Institute, which proposed 'enterprise zones' in the run-down parts of cities; these were small Non-Plan zones.[18] After the first Thatcher administration was elected in 1979, enterprise zones were introduced as a Non-Plan experiment. Without enterprise zones, we would have no MetroCentre Gateshead and no Canary Wharf. These are design icons, accurately symbolic of social change.

In fact, ever since it was published, Non-Plan has kept flowing along as an idea, a kind of underground river. It came to the surface again in Architectural Association seminars on the subject in 1997. Is this because we may again be falling into the trap of over-detailed prescription, the English vice of bossiness? Governments are again encouraging planners to take aesthetics into account; that is, they are being encouraged to prescribe what is beautiful for you. But what makes us think that in this we are that much wiser than those who, in the past, were convinced they, too, had the monopoly of wisdom?

TWO CASE STUDIES

There are, in Britain, thriving examples of Non-Plan from the past. There are also examples of something very close to Non-Plan in the present, even outside the limited experiment of the enterprise zones. The inter-war London suburbs are the most striking example of the former. The growth of 'Edge City' around out-of-town shopping malls is the prime example of the latter.[19] In

design, the inter-war suburbs are unique to Britain and its ex-colonies. The malls are, in essence, an American import. This change tells one something about what happened in Britain during the twentieth century, not only in design, but also socially.

Kenton is just such an inter-war suburb, and it is fruitful to see how successfully it has evolved, in spite of a design that has been as much mocked, down the years, as the American Levittown was. It was the Non-Plan of its day. Situated at the meeting point of the London boroughs of Harrow and Brent, Kenton is a place that few people, other than those who live there, have ever heard of. It is classic Mike Leigh country: anonymous North London suburbia.[20] I would like to focus here on Mayfield Avenue, Kenton, which dates from 1926 (see Plate 26). The London *A-to-Z* lists thirty-two Mayfields in many varieties, to suit an estate agent's imagination. There are Mayfield Crescents, Closes, Drives, Gardens, Roads and Avenues. Suburban land companies in the first half of this century liked vaguely rural names with undertones of Housman, Elgar and Morris dancing. There are suburban Mayfields all over England.

The avenue is a street of semi-detached houses. I revisited it in February 1998. At that date, in some of the houses, the original black-and-white gable was still intact. The avenue is handy for the Underground station which caused Kenton to burgeon and flourish like a leylandii cypress, or euonymus, or pampas grass, or of course privet: the plant *par excellence* of the suburbs. Like many such places, Kenton's location is hard to pin down historically. The main road is lined with shopping parades. The south side was in Wembley (now bundled into the London borough of Brent). The north side was, and is, in Harrow. For many years — long before anyone spoke about anything called an electronic village — the offices of the *Gramophone* magazine were on Kenton Road. This was the bible for every aspiring Kenton householder who invested in a veneered cabinet in order to play shellac 78 rpm records of Brahms or Al Bowlly.

Mayfield Avenue's spec-development semis are now, perhaps, at the bottom of their fashion-ability cycle. There is nothing smart about them. But they are amazingly adaptable containers. That is one test of the Good House they pass with flying colours. The beauty of them is that you can pour into them whatever uses you want. They were built for the first generation to have vacuum cleaners and valve radios. They are now adorned with lacy black satellite dishes. They are the kind of houses — not only in London but also across the whole of Britain — where many people live, much of the time. About a third of the houses in Britain are semi-detached: the classic national balancing act between privacy and price.

At first glance, Mayfield Avenue looks as if it had been stamped out with a template. In this, if in nothing else, it resembles a Georgian terrace (or, you could argue, a Barratt estate of 1980s or 1990s executive homes). In another living tribute to Voysey, all the houses in Mayfield Avenue are bow-fronted semis with gables. The houses face a front garden and a grass verge of uniform width. But if you walk through, you see that, over these past seventy-three years, it has become a design theme with innumerable variations.

It is important, for example, to mark off your territory as your own. No. 40 is in fact the only house in the avenue that still uses privet, fronting the pavement, for this purpose. The alternatives include a brick wall (perhaps covered with variegated ivy) or wrought iron fencing. A pre-cast concrete balustrade, from a builder's catalogue, can add a classical touch. Even the street numbers tell a story, differentiating owner from owner. The most casual tactic is to stick on the door-side those slanting grey rhomboid numerals from DIY stores. Other owners go to town with their house numbers, like an arithmetician on a spree.

Doors matter in the design-and-variation pattern of Mayfield Avenue. One house has a brand-new door, which makes a deliberate gesture to 1926 with leaded lights and stained glass. For the spirit of 1926 still hovers over Mayfield Avenue. But few gardens survive in their original form or with their original purpose. There is a wild proliferation of crazy paving. No two layouts are the same. It may be all one plain colour, or there may be a Liquorice Allsorts mixture of pink, white, blue and grey.

The crazy paving is highly functional. It is for parking on. Mayfield Avenue is a paradise for cars. Every house was originally built with double wooden doors alongside. Behind these, the owners could keep their Bullnose Morris or Austin Seven, which they only took out at weekends. Now, proper garages have been constructed, in a dozen baroque styles. But most of the time, most cars – perhaps because many of the households seem to own two or even three – sit out in the open. At No. 22, a London taxi parks on the crazy paving. At No. 39, four cars are parked on the crazy paving; no front garden is left at all. Vehicles are, by now, central to the look of Mayfield Avenue, as of almost all other streets in Britain. You may like this, or you may not. But it is a fact of visual and social life. Even where householders have integral or separate garages (as in Mayfield Avenue) they are more often used for table tennis or for storage – a first move towards the American 'rumpus room' – rather than for putting cars in.

The semi-detached house, of course, gives you neighbours, but not too many of them. As a social and design invention, it is an extraordinary success story. Messrs Berry Brothers sell a wine they call 'Good Ordinary Claret'. Mayfield Avenue is a Good, Ordinary Street.

NON-PLAN NOW

This is the story of Non-Plan 1926 and its evolution since. But what of Non-Plan now? In 1969, we were not attempting to make predictions. Forty years later, it was striking how much change has taken the direction we were advocating, in spite of what the planners decreed. (This is true internationally, also. There are close parallels in the growth of cities, in spite of wide disparities in their planning regimes.) In Britain, two main forces have driven us far more in the direction of Non-Plan than anyone ever foresaw when we wrote in *New Society*.

The first is the ever-expanding passion for moving around. Nor is this likely to halt, in spite of governmental finger-wagging. The continuing increase in car ownership is not due to a higher proportion of the population getting cars. It is due to the rise in the number of second cars. And these second cars, which tend to be slightly smaller than the other, are usually driven by the woman in the house. Those who speak of cutting back on second cars ignore the gender aspect of car ownership. If a young mother is to continue to juggle her job (often part-time), her children (including the school run) and her shopping, it is very hard to do it without a car. Or, come to that, without a one-stop shop, like Sainsbury's or Tesco.

Ever since the first out-of-town regional shopping centre opened in Gateshead in 1986, these Non-Plan tendencies have been propelled forwards like a Formula One car. Being set up in enterprise zones, both MetroCentre Gateshead and the Canary Wharf complex were exempt from planning controls as well as having many tax advantages. No one had expected the London Docklands to have anything other than low-key housing, workshops and warehousing. Nor would the politicians and planners of Tyneside and Wearside ever have contemplated anything like MetroCentre, which might undercut Newcastle city centre or push Sunderland even further downhill.

I have become fascinated by the new shopping malls which, in Britain, Gateshead MetroCentre launched. They are living examples of Non-Plan in the 1990s, crushing planning intentions underfoot. I was helped to understand them by reading Joel Garreau's remarkable book, *Edge City: Life on the New Frontier*,[21] which examines the impact the shopping mall has had on the shape of the traditional American city. American cities have been turned inside out, like an old glove. The malls have become the heart of new Edge Cities. Around the mall grow houses, offices, warehousing – all far away from the old city centre. In effect, the city centre is shifted closer to the most vigorous sector of the city: its suburbs. This has recently been happening in Britain, however many hands are wrung, regulations drafted, and editorials written in opposition to it.

Like inter-war suburbia, it is Non-Plan in action, evolving the style of our time. Like those suburbs – arguably, like all suburbs – Edge City cries out for an anthropological perspective on design. We must try to understand, not just condemn it. If these designs did not work, they would be discarded. No one is building them as a design experiment, or because of a wish to put a personal design stamp on the landscape.

The East London version of Edge City is Lakeside Thurrock, which opened in 1990. I first went to it in 1993. The postcards they sell at the information desk show the mall lit up by night, with fireworks exploding up above it. This is how the management would like you to remember it – as something very much in the Blackpool, Margate or Clacton tradition. But, externally, most of the time it looks much bleaker: the main design feature is car parks, both ground level and stacked.

I went into Lakeside from a car park through the glass doors of 'Lillywhites of Piccadilly Circus'. This is a symbolic perception-shift. This store is, of course, several miles from Piccadilly Circus itself. It has a fine East London display of white trainers. The various British malls are not as alike as they first seem. They all have a local, almost vernacular twist. After all, very different people use them. In his American research, Joel Garreau rapidly discovered it was no use talking to architects about shopping malls. They mostly despised them, and knew nothing about them. The people to talk to were the developers. But this was not to say there was no design to the malls. Garreau gives an entertaining list of the design principles of American malls and their surroundings. You can see their equivalents at Lakeside, which was designed by Chapman Taylor following American models.

Garreau begins with 'A' for Animated Space. This is the place in which an attempt is made to overcome barrenness and sterility by the addition of anything that suggests life, especially flags. I passed a set of flags on my way into Lakeside. 'A' is also for Active Water Feature: any man-made body of water from which you are not supposed to drink. A fountain bubbles up next to the Lakeside flags. At Lakeside's lake, there is some more Active Water: a high-rising jet. But if you move your eye from these pleasant frivolities, you see again the stacks of car parks. These are a reminder that, in the gospel according to Garreau, 'A' is also for Ample Free Parking. This is, he argues, the touchstone distinction between Edge City and the old downtown. It is also why 'Lillywhites of Piccadilly Circus' is at Lakeside.

Garreau works his way through the alphabet. He offers a handy *vade mecum* for Lakeside design. 'B', for example, is for Blue Water. This is what is put into the fountains of malls, Garreau reports, to offset the unsightliness of the coins that people throw in, as well as the grout that washes off from the tiling. All the decorative water inside the Lakeside mall is blue. And so Garreau continues, all through the alphabet. One of the biggest of all the British malls has opened in an old chalk quarry outside Dartford in Kent. It is actually named after one of Garreau's listed features: Bluewater.

In his counter-attack against the easy critics of the malls, Garreau quotes the patron saint of inner-city regeneration, Jane Jacobs. In *The Death and Life of Great American Cities*, she stated that 'The bedrock of a successful city district is that a person must feel personally safe and secure on the street among all these strangers'.[22] In a mall, you meet no alkies, beggars or pickpockets.

With their Non-Plan impetus, the malls destroy some town centres but not others. MetroCentre Gateshead has not, in fact, destroyed the centre of Newcastle-upon-Tyne, which on the whole relies on a better-off group of customers and on customers who want to slip out to shop during their lunch hour, or on their way home from work. MetroCentre has, however, undercut many other places. And this is no surprise. If the alternative were Sunderland's miserable high street, or the dismal shopping precinct in Peterlee New Town, you too would prefer to go to MetroCentre. Peterlee New Town is a sad failure, in spite of a first master plan by Lubetkin, and subsequent aesthetic control by Victor Pasmore. It is a living (or, rather, half-dead) lesson in the advantages of Non-Plan over planning and design from above. At Dagenham, the London County Council built its dreary inter-war Becontree estate. The design of the houses is a diluted version of Arts and Crafts. It would be fine if there were not so many of them. Becontree covers four square miles, with hardly a pub or a decent shop. Building began in 1923. Seventy years later, and five miles away, Becontree acquired a substitute centre: Lakeside Thurrock.

In Garreau's alphabetical list, one crucial component is 'E' for Executive Homes. These gravitate towards the malls, like bees towards nectar. They began building them at Bluewater, even before the mall opened. Lakeside has its 'new community' of Chafford Hundred, which sprang up about 300 yards from the mall (see Plate 27). A primary school, a family pub and a Safeway's were soon in place. A private health and sports club and crèche were promised soon.

THE CONTINUING SIGNIFICANCE OF NON-PLAN

Edge City is only the most extreme example of what is happening. Everywhere has been sub-urbanized, both town and country, both socially and (often) in design. Non-Plan unashamedly implies suburbanization. Everywhere in today's Britain you see suburban pride of ownership. There is further evidence in any council estate of houses, not flats. A personal version of Non-Plan has chipped away at the planned design certainties and monotonies. Front doors tell the story of right-to-buy.

To reflect on Non-Plan and on its suburban manifestations is inevitably to reflect on the cyclical nature of fashion. These manifestations may be attacked as un-aesthetic, even anti-aesthetic, and the very opposite of good taste. But it is a safe prediction that, in the normal course of things, suburban semis like Mayfield Avenue's, and even executive homes like Chafford Hundred's, will come to be cherished aesthetically, just as industrial terrace houses – which were also once mocked, and destroyed, as slums – are now cherished. By the same token, I await with confidence the first Grade II listed regional shopping mall.

I have done a great deal of walking around British cities, towns and villages. I have increasingly come to endorse the conclusions we came to, all those years ago. Growth that happens without too much prescription is best. It is, of course, fine to lay down some very basic negative rules, and Non-Plan was never hostile to this; for example, this belt of land shall not be built on; or no building in this city centre shall be higher than ten storeys. But, outside that, as little should be done as

possible. *Positive* planning is all too often a disaster. For a start, it is usually based on incorrect forecasts about the future. No one is clever enough to know, in advance, how cities will grow.

Non-Plan, as a concept, is essentially a very humble idea. At the heart of Non-Plan, in both social and design terms, is the thought that it is very hard to know what is good for other people. Notoriously, few architects live in the kinds of house they have advocated for others to live in. Few planners have hung around to see the effect of the plans that looked so delightful on the drawing board. As an idea, as a form of liberation, Non-Plan is still very much alive and kicking.

POSTSCRIPT

The lecture, reproduced here in an abbreviated form, was delivered, as a retrospective, thirty years after the original Non-Plan proposal was published in the pages of *New Society*. We are now at the fortieth anniversary. So any further comment is a sort of re-retrospective.

Given the risks of prediction, it is perhaps surprising that the trends we first focused on continue largely to be true. The language of discussion has changed. Suburbs, for example, are now more often attacked on supposed ecological grounds. But the carbon footprint maths is much less clear-cut than many campaigners argue. The one-time Modern Movement criticisms are now much less often heard. It has become clearer, with every passing year, that modernism, which was once a rallying cry, has turned out to be a style, like Art Nouveau, Palladianism, Perpendicular or any other. (This reassessment is true in literature and the visual arts, not just in architecture.) Looking at huge glass and steel office blocks, ablaze with electric light, which are loudly proclaimed to be eco-friendly, I wonder if Sustainability will also be seen, before long, as yet another style.

Whatever the change in language, there is still, almost always, the same old undertow of snobbery: an elitist suspicion of the choices for their own lives that people prefer to make. I have continued to keep track of what has happened at the places I have mentioned, and at many others. Inevitably, there have been changes in style and presentation. But malls, retail parks and the suburbs they sustain – and are sustained by – continue to flourish. They must be doing something right. In his *Maxims for Revolutionists*, Shaw wrote: 'Do not do unto others as you would that they should do unto you. Their tastes may not be the same'.

NOTES

1. An earlier, longer, version of this lecture, which was delivered at the Victoria and Albert Museum on 13 March 1998, was published in the *Journal of Design History*, 12(2) (1998): 199. Paul Barker expands the theme of the lecture in *The Freedoms of Suburbia* (London: Frances Lincoln, 2009).
2. For a fuller account of the ethos and history of the magazine, see Paul Barker, 'Painting the Portrait of "The Other Britain": *New Society* 1962–88', *Contemporary Record*, 5(1) (summer 1991).
3. Melanie Phillips, 'Commentary', *The Guardian*, 26 February 1988.
4. Robert Hewison, *Too Much: Art and Society in the Sixties* (London: Methuen, 1986).
5. Michael Young and Peter Willmott's collaboration began with *Family and Kinship in East London* (London: Routledge & Kegan Paul, 1957).
6. Herbert J. Gans, *The Levittowners: Ways of Life and Politics in a New Suburban Community* (London: Allen Lane, Penguin Press, 1967). Extracts published in *New Society* as 'An Anatomy of Suburbia', 10(261) (28 September 1967).

7. Lionel March, 'Let's Build in Lines', *New Society*, 10(251) (20 July 1967).

8. Reyner Banham, *Megastructures: Urban Futures of the Recent Past* (London: Thames & Hudson, 1976). Peter Hall, 'Monumental Folly', *New Society*, 12(317) (24 October 1968).

9. Robert Venturi, Denise Scott Brown and Steven Izenour, *Learning from Las Vegas* (Cambridge, MA: MIT Press, 1972).

10. Mary Banham (ed.), *A Critic Writes: Essays by Reyner Banham* (Berkeley: University of California Press, 1996). An earlier *New Society* selection appeared in Paul Barker (ed.), *Arts in Society* (London: Fontana, 1977; new edition published by Nottingham: Five Leaves, 2006). Cedric Price, 'Pop-Up Parliament', *New Society*, 6(148) (29 July 1965); 'Potteries Thinkbelt', *New Society*, 7(192) (2 June 1966).

11. Reyner Banham, Paul Barker, Peter Hall and Cedric Price, 'Non-Plan: An Experiment in Freedom', *New Society*, 13(338) (20 March 1969).

12. Christopher Booker, *The Neophiliacs* (London: Collins, 1969).

13. Cedric Price, 'Pop-Up Parliament', ibid.

14. Colin Ward, quoted in *Contemporary Record*, ibid. See also Colin Ward, *Social Policy: An Anarchist Response* (London: London School of Economics, 1997).

15. Michael Hebbert, *London: More by Fortune than Design* (Chichester: John Wiley & Sons, 1998).

16. Nicholas Taylor, *The Village in the City* (London: Temple Smith, 1973).

17. Steen Eiler Rasmussen, *London: The Unique City* (Harmondsworth: Penguin, 1960).

18. Peter Hall, 'Greenfields and Grey Areas', paper presented at Royal Town Planning Institute's annual conference, Chester, 15 June 1977; reprinted in Peter Hall, *The Enterprise Zone: British Origins, American Adaptations*, Berkeley: Institute of Urban and Regional Development Working Paper no. 350, 1981. Colin Ward followed up Non-Plan from a different perspective with his concept of a 'Do-It-Yourself New Town' (first proposed in 1975). This linked the experience of the pre-war 'plotlands' in the English countryside with 'the post-war adventure of the self-built settlements that surround every city of Latin America, Africa or Asia'. See Colin Ward, 'The Unofficial Countryside', in Anthony Barnett and Roger Scruton (eds.), *Town and Country* (London: Jonathan Cape, 1998).

19. 'Edge City' is a concept developed by Joel Garreau in his *Edge City: Life on the New Frontier* (New York: Doubleday, 1991).

20. Kenton is touched on in the classic study of London's twentieth-century spec-built suburbia – Alan A. Jackson, *Semi-Detached London: Suburban Development, Life and Transport*, 1900–39 (London: Allen & Unwin, 1973). Mike Leigh, British playwright and film director (born 1943); plays include *Nuts in May* (1976) and *Abigail's Party* (1977).

21. Garreau, ibid. For a longer historical perspective, see Kenneth T. Jackson, *Crabgrass Frontier: The Suburbanization of the United States* (New York: Oxford University Press, 1985).

22. Jane Jacobs, *The Death and Life of Great American Cities: The Failure of Town Planning* (New York: Random House, 1961).

23. George Bernard Shaw, 'Maxims for Revolutionists' (The Golden Rule, line one), *Man and Superman: A Comedy and a Philosophy*, 1903 (London: Penguin, 2000).

13.
TIME
ARCHITECTURE'S TOUCHSTONE
cedric price

I will start with a quotation that is very important.[1] It is a statement that was made by Sir Geoffrey Vickers in his book *Value Systems and Social Progress* (1968): 'There are many situations in which to be systematically late is to be systematically wrong.'[2] On arriving here, I saw a model of this V&A place and it reminded me of a meeting that was held here to further the new building that has been proposed.[3] At this meeting I asked Libeskind, the architect, 'What would you like the life of this building to be?' and he wouldn't answer at first. But he's a polite man, and so he smiled with sympathy in his eyes and I repeated the question. 'How long would you like this building to last?' and he said: 'Forever.' It gave me a shudder. That was the architect of this new building, and he is not alone in wanting to design things for ever. I find it really very disturbing. The business of Geoffrey Vickers' quotation is that he's saying that if you're too slow, if you haven't done it by time, you're systematically wrong. Not to be fast, but to be slow, is wrong.

The reason for the subject of this lecture is that I have recently – over the past year or so – been reading a number of books that have been linking these things together: amongst them, Stephen Hawking's *A Brief History of Time* and Brian Greene on string theory in *The Elegant Universe*. A number of people are trying to link everything, $e = mc^2$ with time: for example, Roger Penrose at Oxford is working on his twister theory and Lee Smolin's book, *Three Roads to Quantum Gravity*, I find particularly useful.[4] None

of these books has found the secret of life, but they are working towards it in various ways. A lot of people are doing such work, but is there an architect interested? No; or I haven't met one. Architects think it is automatically assumed that you are worthwhile if you are an architect: that is enough for them. It is not only depressing, but it shows a staggering ignorance and a lack of intellect. If it was just architects going down a lonely road it might be all right, but they have a social duty, so they are lousing up everyone because they do not accept that they have a brief that they share with a lot of other people and disciplines. That brief requires an intellectual rigor, translated into architectural brilliance, that is lacking in the products that we have to see and live with. (Except for mine, which are very few in number, but are exceedingly good!)

The other person who interests me is Anton Zeilinger, an international physicist. In a recent interview he was asked about experiments he did in 1977 which proved to some degree his theory of teleportation, which is not very far from *Star Trek*: teleportation in relation to molecules.[5] If they are making discoveries and proposals and experiments in this field, when you compare it with the architectural galaxy that is presented to new students as the way ahead for the rest of their lives, it is a bit uneven. There is a great deal to learn from other people's works. I am always interested in reducing the intellectual gap between what I am doing as an architect and what the general run of clever people and advanced society is in general concerned with, and working on.

Another quotation that is valuable is from Bertrand Russell:

> Indeed the whole notion that one is always in some definite place is due to the unfortunate immobility of most of the large objects on the Earth's surface. The idea of place is only a rough practical approximation, there is nothing logically necessary about it and it cannot be made precise.[6]

If you put that together with the first quotation, you can start to build up what I see as a constructive doubt by very distinguished thinkers and doers. That constructive doubt is being expressed in a language that society can easily start to understand and this is probably why Stephen Hawking's book was a best-seller bar none. What I am suggesting you can share with me is to learn to love the following words: 'doubt', 'incompleteness', 'aiming to miss', 'calculated uncertainty', 'approximation' and 'anticipating the future'. Up to now we have had sloppy words, which do not mean anything except in a schoolroom, such as 'Georgian architecture', 'early English architecture', 'postmodern': loose, witless phrases and very coarse approximations (I have told you approximations can be good, but these are slovenly). These phrases are given credence by architectural historians and architects both now and in the past, but are not good enough. I have some of my own definitions of the ages of architecture: 'use', 'misuse', 'disuse', 'reuse' and 'refuse'. The last one caused a laugh, and quite rightly so in architectural terms, and yet it was no less absurd than the answer I was given by Libeskind.

Another quotation, turning now to discuss time in a particular sense (it may be time-present or time-future, that does not matter at the moment), is from *Alice Through the Looking Glass*:

> 'Well, in *our* country', said Alice, still panting a little. 'You'd generally get to somewhere else – if you ran very fast, for a long time, as we've been doing.' 'A slow sort of country!' said the Queen. 'Now, *here*, you see it takes all the running *you* can do to keep in the same place. If you want to get somewhere else, you must run at least twice as fast as that!'[7]

Lewis Carroll, *Alice*'s author, was also a mathematician: this is important. It introduces an element of time, which is speed, when it is related to distance. Everything has a speed and a limited life, even the Houses of Parliament, even the Pyramids. We don't know the limits at the moment but, by God, it won't be on judgement day, for either the Houses of Parliament or the Pyramids, or indeed the Buddha in some rock in Afghanistan. We used to break images in the Reformation, blow up the west front of Wells Cathedral, deface the images and this was a sign that we were breaking out of the yoke of parochial religion, dictated from Rome, and flexing our muscles a bit, not having those craven idols. But that was history, wasn't it, now we criticize the Taliban for blowing up the Buddha. Daft, daft I call it. Speed, of course, is not necessarily just an assumed intellectual exercise that can be talked about. I say that you can rate the speed of the house in which you live, you are born with a certain speed, which might be written in your genes; we don't know yet.

Back to architecture: harbours, for example. The really successful harbour is the one that doesn't have any ships in it at all: they are all out doing things. They might be getting coals from Newcastle, tin trays or selling slaves; I don't mind what period it was done at, but they are all out doing things: good, bad and indifferent. But they all need to call in at the port. The tramp steamers got a port of call and they would go from one port to another, not back to base. That was the definition of tramp steamers. You don't necessarily need two ports: it might be many ports. Now take another type of transport: airliners are a bit different; again, you don't want to see Concorde on the tarmac, you want it flying, but it's got to fly somewhere and it has got to be on another tarmac (just like architectural teachers, never happier than on the tarmac in a country that isn't their own). Whereas the navigator can chart routes, you have lighthouses to tell you where not to go, which is an interesting equation in speed and avoiding disasters. Harbours: they want to be open, friendly and accessible, both for boats going out and boats coming back. There are charts that you can buy – which, rather like a sailor uses navigational charts that tell you the depths of the sea, where the rocks and lighthouses are; there are lots of maps that you can get overprinted on ordinary Ordnance Survey, which show you in purple dots where there is still room to fly into London or Chicago airport, varying as the space becomes less available. One assumes that once you're up amongst the clouds you are free just to point to where you want to go. It is not like that at all: it is a chart that is very carefully related to heights, but it doesn't matter how close, how luxurious the aircraft, it has to take off and land at fixed points. People talk about London airport being the busiest in the world, but it's only half of the equation: you don't know where the other halves are. This is roughly hinting that there are limits on speed that are intermediate limitations, such as milestones. There is no point in having only one milestone, because it has a number and the numbers have to change therefore you know it is a mile since you saw a milestone; you need to see a different milestone. It is involving the now in the future: how many miles do I need to go? All this business about the future and speed is related to time.

Let us look at some slides:

Horses, trams, elevated railways, pedestrians, people crossing the road (Figure 13.1): movement, exchange and time. I could talk about the architecture but it's not really very interesting, what I would draw from this is the safety of relevant speeds, routeing and the form that it results in.

Labels within the image:

GULLY · VENTILATOR · GAS & WATER PIPES

PNEUMATIC DISPATCH GOV.T TUBE

SEWER

METROPOLITAN RAILWAY

DRAIN

PROPOSED HAMPSTEAD MIDLAND NORTH WESTERN &
CHARING CROSS JUNCTION RAILWAY

13.1. Cross-section of the proposed Hampstead Midland North-Western and Charing Cross Junction, c. 1890.

13.2. The *Queen Elizabeth* arriving in New York harbour.

Perret's town (*not illustrated*): the cathedral and one or two concrete tower blocks, caravans with wheels which are not occupied as continuously as the flats; but the cathedral is very seldom occupied, but that's built to last because God never knows when he needs to call on the people. You have a cathedral and it points the right way but in effect the HMS *Queen Elizabeth* (Figure 13.2), which is not pointing the right way as America is on the horizon, is picking up some people who are in their cabins spending a limited time on a familiar route, but they are going to the great unknown, hoping that New York harbour is still waiting for them so they can get off.

Plate 28 is an image, drawn by my sister Mercia, of robots. She imagined them; I don't think she saw them. Certainly the Rowland Hilder (1905–93) bridge and the Kent farmhouse and the Dutch elm and the swans were there, so we are quite prepared to think that Mercia did see these things. Mixing the speed and the relevance and the actuality.

Then you look at *Futurama* on television (see Plate 29): it's very hard to see where the ground is, but you're not interested, you're more interested in the flying traffic lights and the dogs, the robot

thugs and the two walking about, the JFK airport advert. It's giving a hint – not a very important one – but it's one that everyone can understand.

Plate 30 is a Cedric Price cube, drawn in perspective but that doesn't matter; the real thing that matters is the red grid, which is the time it was drawn. The shapes are the building of a town hall and an urban butterfly park, affected by time (you can see the axis) but also affected by various policies or actions. Where actions or decisions vary, the shape of the resulting cone alters. The top area, the area of the ellipse, all of which can be measured, is the extent of the result at the end of that degree of time. The space between the two shapes – the two spinning tops – is safe, free; it is nothing. This was entitled 'The Logic of Operational Approximation' or 'Ships that Pass in the Night': the cones don't do any harm to each other, as they are separate in time, space and translation. This was from a series of travelling exhibitions organized by Hans Ulrich Obrist (*not illustrated*), my working drawing for a show in Bangkok: even the drawing is just a list of instructions, rather like Bertrand Russell's message earlier. Smolin (who I referred to earlier) wrote a book, *Quantum Gravity*, and entitled Chapter 4: 'The Universe Is Made of Processes, Not Things'. That is key to what Russell was talking about forty years earlier.

Just because I am talking about time, it does not mean that I've forgotten the other three dimensions and their resultant effectiveness, or danger, or capacity for wanting to be known. For example, the oil rig (Figure 13.3), which was placed off a floating crane in December in the North Sea, had a very limited time of location from the crane to the fixed stalk in the sea. It had to be engineered so that one thing went to the other; needed to know the weight but did not necessarily need fixed foundations as it was off a floating crane, but it would need fixed foundations for its eventual location.

That space doesn't exist any longer (*not illustrated*) – it's been built on with a new hotel – but it did exist long enough not only to be photographed for people to experience that space and to experience it through papers of the *New Yorker*, so there's a bit of useful distortion there (one of my good words).

That is in the City (Figure 13.4). When the architects designed those buildings, they did not think the IRA would do such a tricky thing as bomb it. The bank probably said to their shareholders that it was built for a lifetime: 'Look at our model', 'Speak to our architect', but someone not a hundred miles away had another view of what should happen to the City of London at that moment: 'We'll have a bomb there.' How long the bomb took to make, I don't mind, or how long it took to repair (which they did). But it was the instant – unforeseen circumstances – the awareness of time doesn't have to be well ordered.

The snail wanting his lettuce leaf does not speak the same language as the people who use a maze for other reasons (see Plate 31). I'm interested in this mixed generation of timing, mixing the alphabets of perception and resultant designs. Don't worry about not speaking the same language: the thing about evidence of whether something has happened, such as a flight or boat journey, we sometimes get wrong. We get things in the past wrong even more than predictions in the future, because we have a stake in the future – I am talking about people other than architects – you have

13.3. Oil rig and floating crane.

13.4. IRA bomb blast at St Mary Axe,
City of London, 1992.

a stake in the future and you are damned if you are going to get it wrong. In fact you ignore my phraseology of 'doubt' and 'calculated uncertainty' being good words, but if you look back you see how often society in general gets it wrong. We are assuming the past can be read because it's there. But architects have to be wary of this because if their building falls out of use before it becomes *refuse*, you have *misuse* and *disuse*: it's a very tricky game. These people, whom I quoted earlier, wouldn't find architecture difficult, they have moved on (like thinking). Time past, as opposed to time future, is a dangerous distorter, but it's a lovely danger for the future, because you have a stake in the future. The next thing is that because architecture is so slow and because of the responsibility to society that each architect owes, you've got to do a bit of prediction; it's jolly prediction because you are going to share it.

In conclusion, let us become rather parochial with this final example and turn to thinking about how we can be clever in the future. The Mir has just come down on Earth in the Pacific Ocean (Figure 13.5): they spotted it from a hotel in Tahiti (there's a photograph in your paper tonight captioned 'The Last Days of Mir'); they had it mapped out very well and knew exactly where it was going to come down. Before it hit the sea, there were one or two lumps, which weighed over 40 tonnes, white-hot; just over the horizon was the South Atlantic and there, a week ago, the largest

13.5. Mir spaceship coming down to land in the sea.

oil rig in the world started sinking. It was anchored to the sea bed but a leg started giving way and it started falling over. It had 300,000 tonnes of oil on board, and they were desperately trying to keep the thing afloat while it was listing at 24 degrees (twice that of the Leaning Tower of Pisa), with nine men trying to shore it up, all of whom were killed. In contrast, the computer programme in relation to Mir had been worked out months ago – it even had a booster to make sure that it entered the Earth's atmosphere at the right place and was tracked all the way by visual computer modelling. The whole world could have been thankful if the Mir had come down with 40-tonne white metal bits just alongside the oil rig that was sinking, setting the 300,000 tonnes of fuel on fire. Those men would not have died in vein; the world would have thanked those who had the intelligence to have landed their wreck on such a lot of oil pollution. The only thing that is sad is that it didn't happen, but it could have done. That chance is now gone; there won't be another Mir, those men died in vain, and we have been polluted. Every day, whatever we do: the awareness of time as a meaningful fourth dimension is key.

NOTES

1. This is an edited transcript of the lecture given by Cedric Price at the V&A Museum, London, in 2001.
2. Geoffrey Vickers, *Value Systems and Social Progress* (London: Tavistock, 1968).
3. At the time of this lecture, architect Daniel Libeskind was developing his project to build a 'Spiral' extension to the V&A, in which modern design would have been showcased. This planned project was dropped in 2004.
4. Stephen W. Hawking, *A Brief History of Time: From the Big Bang to Black Holes* (Toronto: Bantam, 1988); Brian Greene, *The Elegant Universe: Superstrings, Hidden Dimensions, and the Quest for the Ultimate Theory* (London: Jonathan Cape, 1999); see, for example, Roger Penrose and Wolfgang Rindler, *Spinors and Space-Time* (Cambridge, New York: Cambridge University Press, 1984) and R. Penrose and C. J. Isham, *Quantum Concepts in Space and Time* (Oxford: Clarendon, 1986); Lee Smolin, *Three Roads to Quantum Gravity* (London: Weidenfeld & Nicolson, 2000).
5. Anton Zeilinger is an international physicist, who started working in the 1970s on the foundations of quantum mechanics and neutron interferometry. For further information go to, for example, http://www.quantum.at/zeilinger. The popular television science fiction show *Star Trek* featured a fictional teleportation machine to transport people or objects.
6. Bertrand Russell, *ABC of Relativity* (London: Kegan, Paul & Co., 1925).
7. From Lewis Carroll, *Alice Through the Looking Glass*, Chapter 2.

ENCLOSED BY IMAGES
ARCHITECTURE IN THE POST-SPUTNIK AGE
beatriz colomina

I am very honoured by your invitation to give the Reyner Banham memorial lecture. Honoured and moved, since Banham occupies a very important place in my formation as an architectural scholar. *Theory and Design in the First Machine Age* was the first history of architecture book I actually read. It was not because I had to. It was my first year in the School of Architecture of Valencia and we hadn't got on to history yet, not even design – just drawing, in its multiple, sometimes very technical forms, along with physics and maths. Architecture in Valencia was part of the Polytechnic University and the first two years were shared with the engineers. It was torture. One day I picked up a book from my sister's boyfriend, who was studying architecture three years ahead of me. I remember it distinctly. It had a purple cover and the content was printed on very cheap, yellowish paper. It was the Spanish version of *Theory and Design* by some press in Buenos Aires. That was a time when some of the best books in architecture came to Spain via Argentina. I read it and re-read it several times, probably because I couldn't understand half of what it was saying. I had no context. By the end of the year I had the book completely underlined – every time I read it something else seemed important

– and full of little notes in the margins. That was 1970, my first year at the university. Needless to say, I never returned the book. By the time I went to New York in the autumn of 1980 with a fellowship to do research towards my dissertation, the purple book came with me.

It wasn't because it had become important to me in the intermediate years: on the contrary. Fed up with the very technical approach of the Valencia school, I had transferred to Barcelona, where there was a very intense architectural discourse, but only influenced by the Italians: Manfredo Tafuri and the group around him in the Institute of Venice (Cacciari, Ciucci, Rella, Dalco etc.). Nobody in Barcelona in those years seemed to have any use for Banham, or for any Anglo-Saxon author for that matter. Only Frenchmen and Italians seemed to have anything to say. But I had brought the purple book with me and would check it now and then.

The book did not come with me to New York because I had taken my library with me. I had gone there with one suitcase for what I thought would be just a year, and, of course, I never went back. I brought the book with me because it was part of my essential library, up there with the Robert Musil, Thomas Mann and Marcel Proust novels, the Walter Benjamin books, which to my astonishment I discovered for the most part didn't even exist in English. So what if I had read these books already, as my then boyfriend pointed out. That was exactly why I needed them.

At Columbia University I found Kenneth Frampton more interested in his own, recently published, account of modern architecture than in others', so again there didn't seem to be a context for my purple book, except that one day, out of the blue, or so it seemed to me, like in a dream, Banham himself turned up at Columbia University to deliver three lectures. I watched in disbelief how Frampton left the building just before each one of them. Banham had changed in California, he said to me the next day, when I enquired. But all the students went down to the auditorium, which was also packed with architects from New York, and in came Banham; to my amazement – I didn't really have a picture of him – he had a long beard and a big medallion hanging from his neck. He looked like a hippie and was so incredibly charismatic that I immediately wanted to be like him. (Fat chance, of course. But one has to aspire to something in life.)

He was telling the fascinating story of his latest research into the silos of Buffalo – that would become his last book, *A Concrete Atlantis* – all peppered with anecdotes of his research, complete with a ghost story, I seem to remember. He seemed to be speaking from the top of his head but at the end of the first lecture, when the crowd cleared the room, I found a piece of paper lying on the floor of the auditorium. It had two columns labelled 'Right' and 'Left' and below a list of numbers: '1. 2. 3… ', and names of buildings or architects next to them. It was very neat, all typed up. Suddenly, I realized that it was Banham's list of slides as he had presented them to us that evening during his lecture. And then I came to the realization, which has become very important to me, that the most important thing in a lecture, the thing that you can never leave to chance, is the images. Because while Banham may not have had a manuscript for the lecture – or he may have yet seemed so natural, so spontaneous to me – with slides you couldn't take any chances: they have to be organized, orchestrated, and the list typed up. This is essentially the most important thing I have learned from Banham: the importance of images in modern architecture, the circulation of these images.

As Banham noted precisely in *A Concrete Atlantis*, the Modern Movement was the first move-ment in the history of art based exclusively on 'photographic evidence' rather than on personal experience, drawings or conventional books. And while he was referring to the fact that the American silos and industrial buildings that became icons of the Modern Movement were not

known to the architects from 'direct' experience, but only from photographs, the work of these architects themselves, as I claimed in my book *Privacy and Publicity*, following in the steps of Banham, became known almost always through photography and the printed media.

The influence of Banham on my work, I now realize, cannot be overestimated. Consider what he had to say about Loos in *Theories and Design*, a passage that I quoted in *Privacy and Publicity*, and that put me on a completely different line of thinking than that of the Italian thinkers of the 1970s, so venerated in Barcelona. Banham wrote, very straightforwardly, with none of the convolution of the Italians: 'When Loos arrived in Paris he was already famous, but his fame was due to his writings – some of which had been translated in French, rather than to his buildings, which seem to have been known only by hearsay.'[1]

In retrospect I can see – and this invitation has made me very conscious of it – the many subtle ways in which Banham's thinking has affected my work on modern architecture and the media. As I moved away from that 'heroic period', as the Smithsons liked to call it, into 1950s America, I find in Banham again the most incisive moments, not so much about the architecture, the buildings, but about the means by which that architecture had become known. In thinking about the work of the Eameses, for example, I am immediately drawn to the point in his writing on the Case Studies programme where he says:

> For most Europeans – and some Africans, Australians, and Japanese to whom I have spoken – the Case Study era began around Christmas 1949. By that time the magazine *Art and Architecture* had achieved a sufficient degree of penetration into specialized bookstores and architectural libraries for the impact of the first of the steel-frame Case Study houses to trigger – as British architect Peter Smithson said – 'a wholly different kind of conversation'.[2]

That first steel-frame house was, of course, the Eames House, number 8 of the Case Study house programme in California, into which the Eameses moved precisely on Christmas Eve 1949. Note that the significance of the house for the Smithsons, in Banham's account, seemed to lie less in itself than in its capacity to provoke a discussion. The history of architecture is not simply the history of buildings, but of what we make of these buildings: the theories we have about them, the photographs we take, and the conversations we have. Good architecture is always a provocation.

The main lesson I have learned from Banham has been to pay very close attention to everything, the whole galaxy of things spinning around buildings, but particularly the images. This lesson becomes even more urgent today, as it seems that buildings are a spin-off of images, rather than the other way around.

We are surrounded today, everywhere, all the time, by arrays of multiple, simultaneous images: in the streets, airports, shopping centres and gyms, but also on our computers and television sets. The idea of a single image commanding our attention has faded away. It seems as if we need to be distracted in order to concentrate, as if we – all of us living in this new kind of space, the space of information – could be diagnosed en masse with attention deficit disorder. The state of distraction in the metropolis, described so eloquently by Walter Benjamin early in the twentieth century, seems to have been replaced by a new form of distraction, which is to say, a new form of attention.[3] Rather than wander cinematically through the city, we now look in one direction and see many juxtaposed moving images, more than we can possibly synthesize or reduce to a single impression. We sit in front of our computers on our ergonomically perfected chairs, staring with a fixed gaze at

14.1. Christopher Faust, *Suburban Documentation Project*. Metro traffic control, Minneapolis, Minnesota, 1993.

many simultaneously 'open' windows through which different kinds of information stream toward us. We hardly even notice it. It seems natural, as if we were simply breathing in the information (Figure 14.1).

How would one go about writing a history of this form of perception? Should one go back to the organization of the television studio, with its wall of monitors from which the director chooses the camera angle that will be presented to the viewer; or should one go to Cape Canaveral and look at its mission control room; or should one even go back to the Second World War, when so-called situation rooms were envisioned with multiple projections bringing information from all over the world and presenting it side by side for instant analysis by political leaders and military commanders?

But it is not simply the military or war technology that has defined this new form of perception. Designers, architects and artists were involved from the beginning, playing a crucial role in the evolution of the multi-screen and multimedia techniques of information presentation. While artists' use of these techniques tends to be associated with the Happenings and expanded cinema of the 1960s, architects were involved much earlier and in very different contexts, such as military operations and governmental propaganda campaigns.

Take the 1959 'American National Exhibition' in Moscow, where the government enlisted some of the country's most sophisticated designers. Site of the famous 'Kitchen Debate' between Richard Nixon and Nikita Khrushchev, the exhibition was a cold-war operation in which the Eameses' multi-screen technique turned out to be a powerful weapon.[4] To reconstruct a little bit of the atmosphere: the United States and USSR had agreed in 1958 to exchange national exhibits on 'science, technology and culture'. The Soviet exhibition opened in the New York Coliseum at Columbus Circle in New York City in June 1959, and the American exhibition opened in Sokolniki Park in Moscow in July of the same year. Vice-President Nixon, in Moscow to open the exhibition, engaged in a heated debate with Khrushchev over the virtues of the American way of life. The exchange became known as the 'Kitchen Debate' because it took place – in an event that appeared impromptu but was actually staged by the Americans – in the kitchen of a suburban house split in half to allow easy viewing (Figure 14.2). The Russians called the house the 'Splitnik', a pun on 'Sputnik', the name of the satellite the Soviets had put into orbit two years before.

What was remarkable about this debate was the focus. As historian Elaine Tyler-May has noted, instead of discussing 'missiles, bombs, or even modes of government … [the two leaders] argued over the relative merits of American and Soviet washing machines, televisions, and electric ranges'.

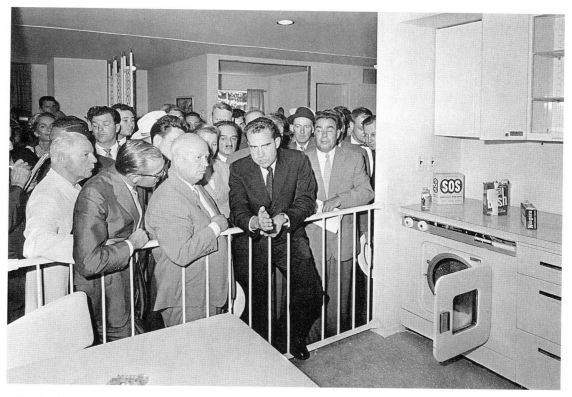

14.2. 'The Kitchen Debate': Nikita Khrushchev and Richard Nixon in front of American kitchen, 'American National Exhibition' in Moscow, 24 July, 1959.

For Nixon, American superiority rested on the ideal of the suburban home, complete with modern appliances and distinct gender roles. He proclaimed that this 'model' suburban home represented nothing less than American freedom.

The exhibition captivated the national and international media. Newspapers, illustrated magazines and television networks reported on the event. Symptomatically, *Life* magazine put the wives instead of the politicians on its cover. Pat Nixon appears as the prototype of the American woman depicted in advertisements of the 1950s: slim, well groomed, fashionable and happy. In contrast, the Soviet ladies appear stocky and dowdy, and while two of them, Mrs Khrushchev and Mrs Mikoyan, look proudly towards the camera, the third one, Mrs Kozlov, in what Roland Barthes may have seen as the *punctum* of this photograph, cannot keep her eyes off Pat Nixon's dress.[5]

Envy: that is what the American exhibition seems to have been designed to produce (despite vigorous denials by Nixon in his debate with Khrushchev: 'We do not claim to astonish the Soviet people');[6] yet not envy of scientific, military, or industrial achievements but envy of washing machines, dishwashers, colour televisions, suburban houses, lawnmowers, supermarkets stocked full of groceries, Cadillac convertibles, make-up colours, lipstick, spike-heeled shoes, hi-fi sets, cake mixes, TV dinners, Pepsi-Cola, and so on. 'What is this', the newspaper *Izvestia* asked itself in its news report, 'a national exhibit of a great country or a branch department store?'

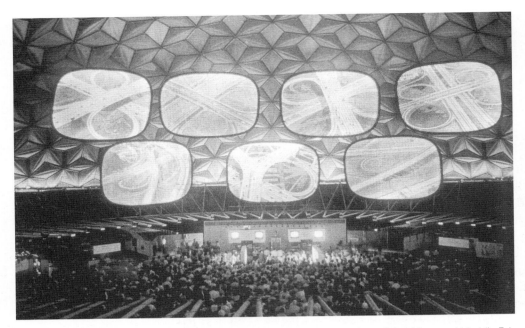

14.3. Charles and Ray Eames, *Glimpses of the USA*, showing the interior of the Moscow World's Fair auditorium, 1959.

It was for this context that the Eameses produced their film *Glimpses of the USA*, projecting it on to seven screens, each 20 x 30ft, suspended within a vast (250 feet in diameter) golden geodesic dome designed by Buckminster Fuller (Figure 14.3). More than 2,200 still and moving images (some from Billy Wilder's *Some Like It Hot*) presented 'a typical work day' in the life of the United States in nine minutes, and 'a typical weekend day' in three minutes.[7] Thousands and thousands of images were pulled from many different sources, combined into seven separate film reels and projected simultaneously through seven interlocked projectors.

The Eameses did not simply install their film in Fuller's space: they were involved in the organization of the entire exhibition from the beginning. Jack Masey of the United States Information Agency (USIA) and George Nelson, who had been commissioned by the USIA to design the exhibition, brought them on to the team. According to Nelson, it was in an evening meeting in the Eames House in Los Angeles, culminating three days of discussions, where:

> all the basic decisions for the fair were made. Present were Nelson, Ray and Charles (the latter occasionally swooping past on a swing hung from the ceiling), the movie director Billy Wilder, and Masey.[8]

According to Nelson, by the end of the evening a basic scheme had emerged:

(1) A dome (by 'Bucky' Fuller).
(2) A glass pavilion (by Welton Beckett) 'as a kind of bazaar stuffed full of things, [the] idea being that consumer products represented one of the areas in which we were most effective, as well as one in which the Russians ... were more interested'.

(3) An introductory film by the Eameses, since the team felt that the '80,000 square feet of exhibition space was not enough to communicate more than a small fraction of what we wanted to say'.[9]

The multi-screen performance turned out to be one of the most popular exhibits at the Fair (second only to the cars and colour televisions).[10] *Time* magazine called it the exposition's 'smash hit',[11] the *Wall Street Journal* described it as the 'real bombshell', and US officials believed it was 'the real pile-driver of the fair'.[12] Groups of 5,000 people were brought into the dome every forty-five minutes, sixteen times a day.[13] Close to 3 million people saw the show, and the floor had to be resurfaced three or four times during the six-week exhibition.[14]

But the Eameses were not just popular entertainers in an official exhibition, and *Glimpses of the USA* was not just a series of images inside a dome. The huge array of suspended screens defined a space within a space. The Eameses were self-consciously architects of a new kind of space. The film breaks with the fixed perspectival view of the world. In fact, we find ourselves in a space that can be apprehended only with the high technology of telescopes, zoom lenses, aeroplanes, night-vision cameras and so on, and where there is no privileged point of view. It is not simply that many of the individual images that make up *Glimpses* have been taken with these instruments. More importantly, the relationship between the images re-enacts the operation of the technologies.

The film starts with images from outer space on all the screens – stars across the sky, seven constellations, seven star clusters, nebulae – and then moves through aerial views of the city at night, from higher up to closer in, until city lights from the air fill the screens. The early morning comes with aerial views of landscapes from different parts of the country: deserts, mountains, hills, seas, farms, suburban developments, urban neighbourhoods. When the camera eyes finally descend to the ground, we see close-ups of newspapers and milk bottles at doors, but still no people, only traces of their existence on Earth.

Not by chance, the first signs of human life are centred on the house and domestic space. From the stars at night and the aerial views, the cameras zoom to the most intimate scenes: 'people having breakfast at home, men leaving for work, kissing their wives, kissing the baby, being given lunchboxes, getting into cars, waving good-bye, children leaving for school, being given lunchboxes, saying good-bye to dog, piling into station wagons and cars, getting into school buses, baby crying'.[15] As with the Eameses' later and much better-known film, *Powers of Ten* (1968),[16] which, incidentally, reused images of the night sky from *Glimpses of the USA*,[17] the film moves from outer space to the close-up details of everyday life. In *Powers of Ten*, the movement would be set in reverse, beginning in the domestic space of a picnic spread with a man asleep beside a woman in a park in Chicago and moving out into the atmosphere and then back down inside the body, through the skin of the man's wrist to microscopic cells and to the atomic level (Figure 14.4). Even if *Powers of Ten*, initially produced for the Commission on College Physics, was a more scientific, more advanced film in which space was measured in seconds, the logic of the two films was the same. Intimate domesticity was suspended within an entirely new spatial system, a system that was the product of esoteric scientific-military research but which had entered the everyday public imagination with the launching of Sputnik in 1957. Fantasies that had long circulated in science fiction had become reality.

Glimpses, like the 'Splitnik' house, displaced the US–USSR debate from the arms-and-space race to the battle of the appliances. And yet the overall effect of the film is that of an extraordinarily

14.4. Charles (in lift) and Ray Eames, outside their office filming the picnic scene for the first version of *Powers of Ten*, 1968.

powerful viewing technology, a hyper-viewing mechanism that is hard to imagine outside the very space programme the exhibition was trying to downplay. In fact, this extreme mode of viewing goes beyond the old fantasy of the eye in the sky. If *Glimpses* simulates the operation of satellite surveillance, it exposes more than the details of life in the streets: it penetrates the most intimate spaces and reveals every secret. Domestic life itself becomes the target, the source of pride or insecurity. The Americans, made insecure by the thought of a Russian eye looking down on them, countered by exposing more than that eye could ever see (or at least pretending to, since 'a day in the life of the USA' became an image of the 'good life', without ghettos, poverty, domestic violence or depression).

II

What kind of genealogy can one make of the Eameses' development of this astonishingly successful technique? It was not the first time they had deployed multiple screens. In fact, the Eameses

were involved in one of the first multimedia presentations on record, if not the first. Again it was George Nelson who set up the commission. In 1952 he had been asked to prepare a study for the Department of Fine Arts at the University of Georgia in Athens, and he brought along Ray and Charles Eames and Alexander Girard. Instead of writing a report, they decided to collaborate on a 'show for a typical class' of fifty-five minutes. Nelson referred to it as 'Art X', while the Eames called it 'A Rough Sketch for a Sample Lesson for a Hypothetical Course'. The subject of the lesson was 'communications',[18] and the stated goals included 'the breaking down of barriers between fields of learning ... making people a little more intuitive ... [and] increasing communication between people and things'.[19] The performance included a live narrator, multiple images (both still and moving), sound (in the form of music and narration), and even 'a collection of bottled synthetic odours that were to be fed into the auditorium during the show through the air-conditioning ducts'.[20] Charles Eames later said, 'We used a lot of sound, sometimes carried to a very high volume so you would actually feel the vibrations.'[21] The idea was to produce an intense sensory environment so as to 'heighten awareness'. The effect was so convincing that apparently some people even believed they smelled things (for example, the smell of oil in the machinery) when no smell had been introduced, only a suggestion in an image or a sound.[22]

It was a major production. Nelson described the team arriving in Athens:

> burdened with only slightly less equipment than Ringling Brothers. This included a movie projector, three slide projectors, three screens, three or four tape recorders, cans of films, boxes of slides, and reels of magnetic tape.[23]

The reference to the circus was not accidental. Speaking with a reporter for *Vogue*, Charles later argued that '"Sample Lesson" was a blast on all senses, a super-saturated three-ring circus. Simultaneously the students were assaulted by three sets of slides, two tape recorders, a motion picture with sound, and peripheral panels for further distraction.'[24]

The circus was one of the Eameses' lifetime fascinations, so much so that in the 1940s, when they were out of work and money, they were about to audition for one.[25] They would have been clowns, but ultimately a contract to make plywood furniture allowed them to continue as designers. And from the mid-1940s on, they took hundreds and hundreds of photographs of the circus, which they used in many contexts, including *Circus* (their 180-slide, three-screen slide show accompanied by a soundtrack featuring circus music and other sounds recorded at the circus), presented as part of the Charles Eliot Norton Lectures at Harvard University that Charles delivered in 1970, and the film *Clown Face* (1971), a training film about 'the precise and classical art of applying make-up' made for Bill Ballentine, director of the Clown College of Ringling Brothers' Barnum and Bailey Circus. The Eameses had been friends with the Ballentines since the late 1940s, when the Eameses had photographed the circus's behind-the-scenes activities during an engagement in Los Angeles.[26] Charles was on the board of the Ringling Brothers College and often referred to the circus as an example of what design and art should be, not self-expression but precise discipline:

> Everything in the circus is pushing the possible beyond the limit – bears do not really ride on bicycles, people do not really execute three-and-a-half-turn somersaults in the air from a board to a ball, and until recently no one dressed the way fliers do... Yet within this apparent freewheeling license, we find a discipline which is almost unbelievable...
> The circus may look like the epitome of pleasure, but the person flying on a high wire, or

executing a balancing act, or being shot from a cannon must take his pleasure very, very seriously. In the same vein, the scientist, in his laboratory, is pushing the possible beyond the limit and he too must take his pleasure very seriously.[27]

The circus, as an event that offered a multiplicity of simultaneous experiences that could not be taken in entirely by the viewer, was the Eameses' model for their design of multimedia exhibitions and the fast-cutting technique of their films and slide shows, where the objective was always to communicate the maximum amount of information in a way that was both pleasurable and effective.[28]

But the technological model for multi-screen, multimedia presentations may have been provided by the war situation room, which was designed in those same years to bring information in simultaneously from numerous sources around the world so that the president and military commanders could make critical decisions: 'There is a recognized mission for everyone involved. In a crisis there can be no question as to what needs to be done.'[29] A number of the Eameses' friends were involved in the secret military project of the war rooms, including Buckminster Fuller, Eero Saarinen and Henry Dreyfuss, whose unrealized design involved a wall of parallel projected images of different kinds of information (see Figure 14.5 later).[30]

A number of wartime research projects, including work on communications, ballistics and experimental computers, had quickly developed after the war into a fully fledged theory of information flow, most famously with the publication of Claude Shannon's *Mathematical Theory of Communication* in 1949, which formalized the idea of an information channel from sender to recipient, whose efficiency could be measured in terms of speed and noise. This sense of information flow organized the 'Sample Lesson' performance. The Eameses said they 'were trying to cram into a short time, a class hour, the most background material possible'.[31] As part of the project, they produced *A Communication Primer*, a film that presented the theory of information, explaining Shannon's famous diagram of the passage of information, and was subsequently developed in an effort to present current ideas in communication theory to architects and planners and to encourage them to use these ideas in their work. The basic idea was to integrate architecture and information flow.

If the great heroes of the Renaissance were, for the Eameses, 'people concerned with ways of modeling/imaging ... not with self-expression or bravura ... Brunelleschi, but not Michelangelo',[32] the great architects of our time would be the ones concerned with the new forms of communication, particularly computers: 'It appeared to us that the real current problems for architects now – the problems that a Brunelleschi, say, would gravitate to – are problems of *organization of information*.'[33]

The logic of information flow was further developed in the Eameses' 1955 film, *House: After Five Years of Living*. The film was made entirely from thousands of colour slides the Eameses had been taking of their home over the first five years of its life,[34] shown in quick succession (a technique called 'fast cutting' for which the Eameses won an Emmy Award in 1960) and accompanied by music composed by Elmer Bernstein.[35] As Michael Braune wrote in 1966:

> The interesting point about this method of film making is not only that it is relatively simple to produce and that rather more information can be conveyed than when there is movement on the screen, but that it corresponds surprisingly closely with the way in which the brain normally records the images it receives. I would assume that it also corresponds rather closely with the way Eames's own thought processes tend to work. I

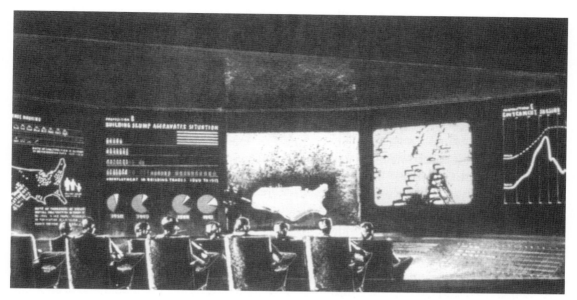

14.5. Henry Dreyfuss, presidential war situation room. Project view.

think it symptomatic, for instance, that he is extremely interested in computers ... and that one of the essential characteristics of computers is their need to separate information into components before being able to assemble them into a large number of different wholes.[36]

This technique was developed even further in *Glimpses*, which is organized around a strict logic of information transmission. The role of the designer is to orchestrate a particular flow of information. The central principle is one of compression. At the end of the design meeting at the Eames House in preparation for the American exhibition in Moscow, the idea of the film emerged precisely 'as a way of compressing into a small volume the tremendous quantity of information' they wanted to present, which would have been impossible to do in the 80,000 square feet of the exhibition.[37] The space of the multi-screen film, like the space of the computer, compresses physical space. As the *New York Times* described it, 'Perhaps fifty clover-leaf highway intersections are shown in just a few seconds. So are dozens of housing projects, bridges, skyscrapers, supermarkets, universities, museums, theatres, churches, farms, laboratories and much more.'[38]

But the issue was much more than one of efficiency of communication or the polemical need to have multiple examples. The idea was, as with the 'Sample Lesson', to produce sensory overload. As the Eameses had suggested to *Vogue*, 'Sample Lesson' tried to provide many forms of 'distraction' instead of asking students to concentrate on a singular message. The audience drifted through a multimedia space that exceeded their capacity to absorb it. The Eames–Nelson team thought that the most important thing to communicate to undergraduates was a sense of what the Eameses would later call 'connections' among seemingly unrelated phenomena. Arguing that awareness of these relationships was achieved by 'high-speed techniques', Nelson and the Eameses produced an excessive input from different directions that had to be synthesized by the audience. Likewise, Charles said of *Glimpses*:

We wanted to have a credible number of images, but not so many that they couldn't be scanned in the time allotted. At the same time, the number of images had to be large enough so that people wouldn't be exactly sure how many they have seen. We arrived at the number seven. With four images, you always knew there were four, but by the time you got up to eight images you weren't quite sure. They were very big images – the width across four of them was half the length of a football field.[39]

One journalist described it as 'information overload – an avalanche of related data that comes at a viewer too fast for him to cull and reject it ... a twelve-minute blitz'. The viewer is overwhelmed. More than anything, the Eameses wanted an emotional response, produced as much by the excess of images as by their content.

The multi-screen technique went through one more significant development at the 1964 World's Fair in New York. In the IBM Ovoid Theater (Figure 14.6), designed by the Saarinen office, visitors boarded the 'people wall' and were greeted by a 'host' dressed in coat-tails who slowly dropped down from the IBM ovoid; the seated 500-person audience was then lifted up hydraulically from the ground level into the dark interior of the egg, where they were surrounded by fourteen screens on which the Eameses projected the film *Think*.[40] To enter the theatre was no longer to cross the threshold, to pass through the ceremonial space of the entrance, as in a traditional public building. To *enter* here was to be lifted in front of a multiplicity of screens. The screens wrapped the audience in a way reminiscent of Herbert Bayer's 1930 'diagram of the field of vision', produced as a sketch for the installation of an architecture and furniture exhibition[41] (Figure 14.7). The eye could not escape the screens, and each screen was bordered by other screens. Unlike the screens in Moscow, those in the IBM building were of different sizes and shapes. But once again, the eye had to jump

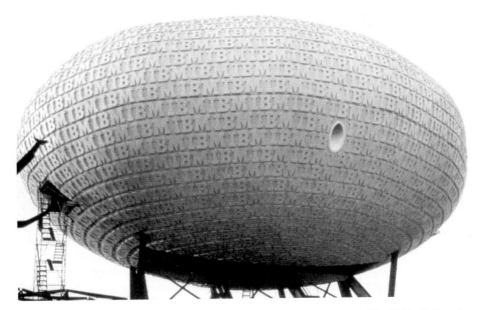

14.6. Eero Saarinen and Associates, IBM Pavilion for the New York World's Fair, 1964–65. Exterior of Ovoid Theater.

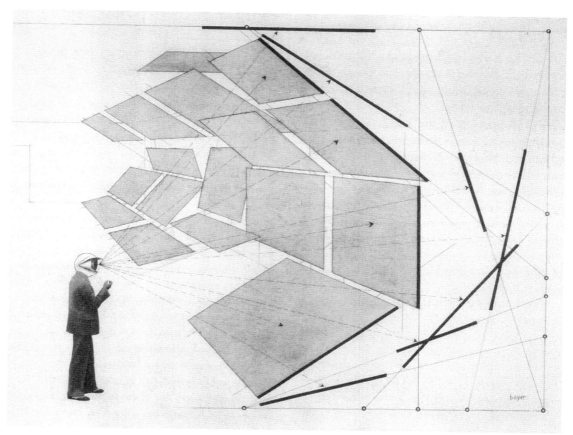

14.7. Herbert Bayer, *Diagram of the Field of Vision*, 1930.

from image to image and could never fully catch up with all of them and their diverse contents. Fragments were presented to be momentarily linked together before the connections between them were replaced with others. The film is organized by the same logic of compression, its speed intended to be the speed of the mind. A 'host' welcomed the audience to 'the IBM Information Machine', 'a machine designed to help me give you a lot of information in a very short time… The machine brings you information in much the same way as your mind gets it – in fragments and glimpses – sometimes relating to the same idea or incident. Like making toast in the morning'.[42]

In addition to the multi-screens, the dome in Moscow housed a huge RAMAC 305 computer, an 'electronic brain' that offered written replies to 3,500 questions about life in the United States.[43] The architecture was conceived from the very start as a combination of structure, multi-screen film and computer. Each technology created an architecture in which inside/outside, entering/leaving, meant something entirely different, and yet they all coexisted. All were housed by the same physical structure, Fuller's dome, but each defined a different kind of space to be explored in different ways. From the 'Sample Lesson' in 1953 to IBM in 1964, the Eameses treated architecture as a multi-channel information machine and, equally, multimedia installations as a kind of architecture.

III

All of the Eameses' designs can be understood as multi-screen performances: they provide a framework in which objects can be placed and replaced (see Plate 32). Even the parts of their furniture can be rearranged. Spaces are defined as arrays of information collected and constantly changed by their users.

This is the space of the media. The space of a newspaper or an illustrated magazine is a grid in which information is arranged and rearranged as it comes in: a space the reader navigates in his or her own way, at a glance, or by fully entering a particular story. The reader, viewer, consumer, constructs the space, participating actively in the design. It is a space where continuities are made through 'cutting'. The same is true of the space of newsreels and television. The logic of the Eameses multi-screens is simply the logic of the mass media.

It is not by chance that Charles Eames was always nostalgic for his time as a set designer for MGM in the early 1940s, continually arranging and rearranging existing props at short notice.[44] All Eames architecture can be understood as set design. The Eameses even presented themselves like Hollywood figures, as if in a movie or an advertisement, always so happy, with the ever-changing array of objects as their backdrop.

This logic of architecture as a set for staging the good life was central to the design of the Moscow exhibition. Even the famous kitchen, for example, was cut in half not only to allow viewing by visitors but, most important, to turn it into a photo op for the 'Kitchen Debate'. Photographers and journalists knew the night before that they had to be there, choosing their angle. Architecture was reorganized to produce a certain image. Charles had already spoken, in 1950, of our time as the era of communication. He was acutely aware that the new media were displacing the old role of architecture. And yet everything for the Eameses, in this world of communication that they were embracing so happily, was architecture: 'The chairs are architecture, the films – they have a structure, just as the front page of a newspaper has a structure. The chairs are literally like architecture in miniature ... architecture you can get your hands on.'[45] In the notes for a letter to Italian architect Vittorio Gregotti accompanying a copy of *Powers of Ten*, they write: 'In the past fifty years the world has gradually been finding out something that architects have always known, that is, that *everything* is architecture. The problems of environment have become more and more interrelated. This is a sketch for a film that shows something of how large – and small – our environment is.'[46]

In every sense, Eames architecture is all about the space of information. Perhaps we can talk no longer about 'space' but, rather, about 'structure' or, more precisely, about time. Structure, for the Eameses, was organization in time. Their technique of information overload, used in films and multimedia presentations as well as in their trademark 'information wall' in exhibitions, was used not to 'overtax the viewer's brain' but precisely to offer a 'broad menu of options' and to create an 'impulse to make connections'.[47]

For the Eameses, structure was not linear. They often reflected on the impossibility of linear discourse. The structure of their exhibitions has been compared to that of a scholarly paper, loaded with footnotes, where 'the highest level of participation consists in getting fascinated by the pieces and connecting them for oneself'.[48] Seemingly static structures like the frames of their buildings or of their plywood cabinets were but frameworks for positioning ever-changing objects. And

the frame itself was, anyway, meant to be changed all the time. These changes, this fluctuating movement, could never be pinned down.

The multi-screen presentations, the exhibition technique and the Eameses' films are likewise significant not because of the individual factoids they offer or even the story they tell, but because of the way the factoids are used as elements in creating a space that says, 'This is what the space of information is all about.'

Like all architects, the Eameses controlled the space they produced. The most important factor was to regulate the flow of information. They prepared extremely detailed technical instructions for the running of even their simplest three-screen slide show.[49] Performances were carefully planned to appear as effortless as a circus act. Timing and the elimination of 'noise' were the major considerations. Their office produced masses of documents, even drawings, showing the rise and fall of intensity through the course of a film, literally defining the space they wanted to produce. With *Glimpses*, the Eameses retained complete control over their work by turning up in Moscow only forty-eight hours before the opening, as Peter Blake recalls it, 'dressed like a boy scout and a girl scout', clutching the reels of the film.[50] A photograph shows the smiling couple descending from the plane, reels in Charles's hands, posing for the camera (Figure 14.8). As he later put it,

14.8. Charles and Ray Eames arriving in Moscow for the installation of the 'American National Exhibition'.

'Theoretically, it was a statement made by our State Department, and yet we did it entirely here and it was never seen by anyone from our government until they saw it in Moscow . . . If you ask for criticism, you get it. If you don't, there is a chance everyone will be too busy to worry about it.'[51]

The experience for the audience in Moscow was almost overwhelming. Journalists speak of too many images, too much information, too fast. For the MTV and the Internet generation watching the film today, it would not be fast enough, and yet we do not seem to have come that far either. The logic of the Internet was already spelled out in the Eameses' multi-screen projects. Coming out of the war mentality, the Eameses' innovations in the world of communication, their exhibitions, films and multi-screen performances transformed the status of architecture. Their highly controlled flows of simultaneous images provided a space, an enclosure; the kind of space we now occupy continuously, without thinking.

NOTES

1. Beatriz Colomina, *Privacy and Publicity: Modern Architecture as Mass Media* (Cambridge, MA: MIT Press, 2000), p.44.
2. Reyner Banham, 'Klarheit, Ehrlichkeit, Einfachkeit . . . and Wit Too! The Case Study Houses in the World's Eyes', in Elizabeth A. T. Smith (ed.), *Blueprints for Modern Living: History and Legacy of the Case Study Houses* (Los Angeles: Museum of Contemporary Art; Cambridge, MA: MIT Press, 1989), p.183.
3. See, for example, Roy Tiedemann (ed.), *Walter Benjamin: The Arcades Project* (Cambridge, MA: Harvard University Press, 1999).
4. Elaine Tyler May, *Homeward Bound: American Families in the Cold War Era* (New York: Basic Books, 1988), p.16. See also Karal Ann Marling, *As Seen on TV: The Visual Culture of Everyday Life in the 1950s* (Cambridge, MA: Harvard University Press, 1994).
5. *Life*, 10 August 1959.
6. Khrushchev: 'You Americans expect that the Soviet people will be amazed. It is not so. We have all these things in our new apartments.' Nixon: 'We do not claim to astonish the Soviet people.' 'Setting Russia Straight on Facts about the US', *US News and World Report*, 3 August 1959, pp.36–37.
7. John Neuhart, Marilyn Neuhart and Ray Eames, *Eames Design: The Work of the Office of Charles and Ray Eames* (New York: Harry N. Abrams, 1989), pp.238–41. See also Hélène Lipstadt, 'Natural Overlap: Charles and Ray Eames and the Federal Government', in Donald Albrecht (ed.), *The Work of Charles and Ray Eames: A Legacy of Invention* (New York: Abrams, 1997) pp.160–66.
8. Stanley Abercrombie, *George Nelson: The Design of Modern Design* (Cambridge, MA: MIT Press, 1995), p.163.
9. Ibid., p.164.
10. 'The seven-screen quickie is intended as a general introduction to the fair. According to the votes of Russians, however, it is the most popular exhibit after the automobiles and the color television.' Max Frankel, 'Image of America at Issue in Soviet', *New York Times*, 23 August 1959.
11. 'Watching the thousands of colourful glimpses of the U.S. and its people, the Russians were entranced, and the slides are the smash hit of the fair.' 'The U.S. in Moscow: Russia Comes to the Fair', *Time*, 3 August 1959, p.14.
12. 'And Mr. Khrushchev watched unsmilingly as the real bomb-shell exploded – a huge exhibit of typical American scenes flashed on seven huge ceiling screens. Each screen shows a different scene but all seven at each moment are on the same general subject – housing, transportation, jazz and so forth. U.S. officials believe this is the real pile-driver of the fair, and the premier's phlegmatic attitude – not even smiling when seven huge Marilyn Monroes dashed on the screen or when Mr Nixon pointed out golfing scenes – showed his unhappiness with the display.' Alan L. Otten, 'Russians Eagerly Tour US Exhibit Despite Cool Official Attitude', *Wall Street Journal*, July 28, 1959, p.16.

13. Max Frankel, 'Dust from Floor Plagues US Fair', *New York Times*, 28 July 1959, p12.
14. Pat Kirkham, *Charles and Ray Eames: Designers of the Twentieth Century* (Cambridge, MA: MIT Press, 1995), p.324. From an interview with Wilder by Kirkham in 1993.
15. Charles and Ray Eames, *Glimpses of the USA*, working script, box 202, 'The Work of Charles and Ray Eames', Manuscript Division, Library of Congress, Washington, DC.
16. *Powers of Ten* was based on a 1957 book by Kees Boeke, *Cosmic View: The Universe in Forty Jumps*. (New York: John Day Co. Inc., 1957). The film was produced for the Commission on College Physics. An updated and more developed version was produced in 1977. In the second version the starting point is still a picnic scene, but it takes place in a park bordering Lake Michigan in Chicago. See Neuhart, Neuhart and Eames, *Eames Design*, pp.336–37 and pp.440–41.
17. See handwritten notes on the manuscript of the first version of *Powers of Ten*. Box 207, 'The Work of Charles and Ray Eames', Manuscript Division, Library of Congress, Washington, DC. The film is still referred to as *Cosmic View*.
18. 'Grist for Atlanta Paper Version', manuscript, box 217, folder 15, 'The Work of Charles and Ray Eames', Manuscript Division, Library of Congress, Washington, DC.
19. Neuhart, Neuhart and Eames, *Eames Design*, p.177.
20. George Nelson, 'The Georgia Experiment: An Industrial Approach to Problems of Education', manuscript, October 1954, quoted in Abercrombie, *George Nelson*, p.145.
21. Owen Gingerich, 'A Conversation with Charles Eames', *American Scholar* 46(3) (summer 1977): 331.
22. Ibid.
23. Nelson, 'Georgia Experiment'.
24. Allene Talmey, 'Eames', *Vogue*, 15 August 1959, p.144.
25. Beatriz Colomina, 'Reflections on the Eames House' in Albrecht, *The Work of Charles and Ray Eames*, p.128.
26. Neuhart, Neuhart and Eames, *Eames Design*, p.373; Bill Ballentine, *Clown Alley* (Boston: Little, Brown, 1982).
27. Charles Eames, 'Language of Vision: The Nuts and Bolts', *Bulletin of the American Academy of Arts and Sciences*, October 1974, pp.17–18.
28. Neuhart, Neuhart and Eames, *Eames Design*, p.91.
29. Charles Eames, 'Language of Vision', pp.17–18. See also the typescript of the actual lecture in box 217, folder 12, 'The Work of Charles and Ray Eames', Manuscript Division, Library of Congress, Washington, DC.
30. Barry Katz, 'The Arts of War: "Visual Presentation" and National Intelligence', *Design Issues* 12(2) (summer 1996): 3–21. I am grateful to Dennis Doordan for pointing out this article to me.
31. Gingerich, 'Conversation with Charles Eames', p.332.
32. Notes for second Norton lecture, box 217, folder 10, 'The Work of Charles and Ray Eames', Manuscript Division, Library of Congress, Washington, DC. Eames is referring here to 'Professor Lawrence Hill's Renaissance'.
33. 'Communications Primer' was a recommendation to architects 'to recognize the need for more complex information ... for new kinds of *models* of information'. Eames, 'Grist for Atlanta'.
34. Colomina, 'Reflections', *passim*.
35. Charles and Ray Eames won an Emmy Award for graphics for their rapid cutting experiments on *The Fabulous Fifties*, a television programme broadcast on 22 January 1960, on the CBS network. It included six film segments made by the Eames Office. Schrader, 'The Poetry of Ideas: The Films of Charles Eames', *Film Quarterly*, Spring 1970, p.3.
36. Michael Braune, 'The Wit of Technology', *Architectural Design*, September 1966, p.452.
37. See Abercrombie, *George Nelson*, pp.163–64.
38. Frankel, 'Image of America'.
39. Ibid., p.333.
40. Mina Hamilton, 'Films at the Fair II', *Industrial Design*, May 1964, pp.37–41.

41. Arthur A. Cohen, *Herbert Bayer: The Complete Work* (Cambridge, MA: MIT Press, 1994), p.292. Mary Anne Staniszewski, *The Power of Display: A History of Exhibition Installations at the Museum of Modern Art* (Cambridge, MA: MIT Press, 1998), pp.25–28.
42. Script of the IBM film *View from the People Wall* for the Ovoid Theater, New York World's Fair, 1964, 'The Work of Charles and Ray Eames', Manuscript Division, Library of Congress, Washington, DC.
43. 'US Gives Soviet Glittering Show', *New York Times*, 25 July 1959.
44. Colomina, 'Reflections', p.129.
45. Gingerich, 'Conversation with Charles Eames', p.327.
46. 'Powers of Ten – Gregotti', handwritten notes, box 217, folder 11, 'The Work of Charles and Ray Eames', Manuscript Division, Library of Congress, Washington, DC.
47. Ralph Caplan, 'Making Connections. The Work of Charles and Ray Eames', *Connections: The Work of Charles and Ray Eames* (Los Angeles: University of California Press, 1976).
48. Ibid., p.45.
49. 'To Show a Three-Screen Slide Show', manuscript detailing the necessary preparations for an 'Eames three-screen, six-projector slide show' with 'sound' and 'picture operation procedure', illustrated with multiple drawings, 14pp., box 211, folder 10, 'The Work of Charles and Ray Eames', Manuscript Division, Library of Congress, Washington, DC.
50. Peter Blake, in *An Eames Celebration: The Several Worlds of Charles and Ray Eames*, WNET Television, New York, 3 February 1975, quoted in Kirkham, *Charles and Ray Eames*, p.320.
51. Eames in Gingerich, 'Conversation with Charles Eames', p.333.

Part IV

APPARATUS, CLIP-ON, GIZMO, SOFTWARE, HIGH-TECH: FUTURISM, DESIGN AND TECHNOLOGY

The man who changed the face of America had a gizmo, a gadget, a gimmick – in his hand, in his back pocket, across the saddle, on his hip, in the trailer, round his neck, on his head, deep in a hardened silo. From the Franklin Stove, and the Stetson Hat, through the *Evinrude* outboard to the walkie-talkie, the spray can and the cordless shaver, the most typical American way of improving the human situation has been by means of crafty and usually compact little packages, either papered with patent numbers, or bearing their inventor's name to a grateful posterity.

'The Great Gizmo', *Industrial Design* 12, September 1965

15.
A HISTORIAN OF SCIENCE AND TECHNOLOGY CONFRONTS GENDER AND DESIGN
ruth schwartz cowan

An interesting thing happened at a conference on gender and design that was held at the City University of New York (CUNY) in November 1995.[1] The conference, which was called *Re-Visioning Design and Technology: Feminist Perspectives*, was organized by Joan Rothschild, a historian of technology; in her introduction to the conference programme, Dr Rothschild explained that the conference had three objectives and one overarching goal. The three objectives were: firstly, to engage design professionals in conversation with scholars; secondly, to engage scholars who think about design in conversation with scholars who think about technology; and thirdly, to use feminist theory and/ or gender analysis to under-gird those conversations. The overarching goal was to 'meet the challenges for transforming our environments in a society in which traditional distinctions and hierarchies are breaking down and being transformed'.[2]

One of the speakers at the conference was Nancy Perkins, an industrial designer.[3] At one point in her presentation, Ms Perkins illustrated her talk with a picture of a

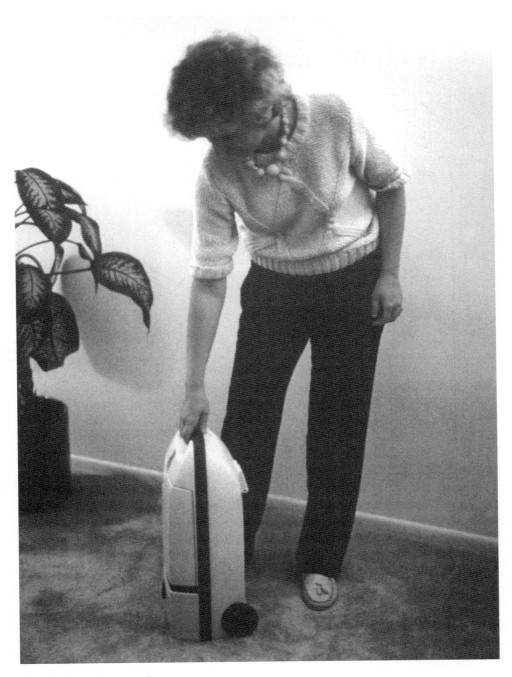

15.1. Perkins vacuum, standing.

vacuum cleaner that she had designed in the 1980s (Figure 15.1). She had decided to talk about this vacuum cleaner, she said, partly because of what one woman had said about it when it was market-tested in a focus group: it 'looked like it was designed by a woman'. 'Since I was observing in confidence behind the glass', Ms Perkins went on to say, 'I couldn't ask her what she meant by her remark'.[4]

At this point, someone in the audience interrupted to say that she could understand what that anonymous woman had meant – and a lively discussion ensued about what characteristics of that vacuum cleaner looked feminine or looked like a design concept only a woman could have had. One member of the audience thought that it was feminine because it was a pastel colour: light blue. Another thought that it was meant to appeal to women because its shape resembled a make-up case, a compact. Yet another thought that the rounded edges were significant; the whole thing was womb-shaped.

Ms Perkins seemed to me to be annoyed by this conversation; she averred that the colour had been chosen by a man, a marketing specialist – and she indicated that she wanted to go on with her talk. She was particularly proud of this design, she went on to say, because, 'size, weight, balance, and ease and versatility of use were important design criteria' (Figure 15.2). In top view, closed, we could see that the cleaner looked very compact, not in the sense of being like a case to hold facial powder, but in the sense of holding the motor, bag and vents in a very small space, 'making the product actually, and in appearance, as lightweight as possible'.

The body of the cleaner, Ms Perkins explained, is also very well balanced, for ease of use, because the motor is in the rear, opposite the handle, and the wheels are also in the rear, 'allowing the unit

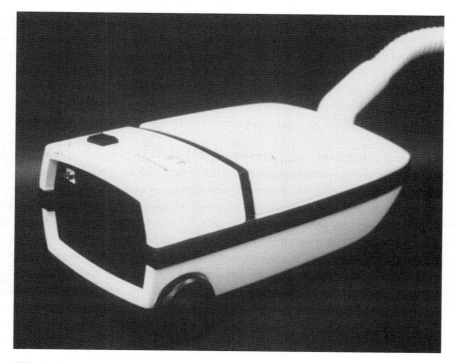

15.2. Perkins vacuum, rear.

to be rolled into vertical storage without the user having to lift it'. Top view, open (see Plate 33), revealed a set of very cleverly designed compartments, meant to hold the various hose-end cleaning tools.

The vinyl bumper (visible in Figures 15.1 and 15.2) protects both the cleaner itself and the furnishings of the household from abrasion (see Figure 15.2). The controls are on the top rear surface, which means that they can be operated by foot pressure. Like the bumper, the wheels, the compartment lid edge and the control button, the padded handle is in a contrasting colour, meant to communicate, immediately, that the machine is user-friendly.

As Nancy Perkins finished her paper, I could hear some nervous giggles from some segments of the audience and several long sighs of recognition from other segments. The giggles meant, I think, 'Ooops! I was really off base, wasn't I?' The outflows of breath meant, I suspect, 'Of course! How stupid not to have thought of it! This machine was designed by a woman because only someone who had spent hours hauling and pushing a standard vacuum cleaner would have understood how to make the work a bit less awful.'

UNDERSTANDING THE SOCIAL ACTORS

There are several morals that I want to draw from this story that I have been recounting with Nancy Perkins's help, but before I get to them, I need to step back from it and make a few remarks that stem from my background in the social studies of technology. There are four different groups of actors in this story: three of them social, one of them material. The three social actors are all gendered female, sometimes in reality, sometimes in stereotype. The first set of social actors is women designers (who might have their training in industrial design – as Nancy Perkins does – or in graphic design, or interior design, or fashion design, or architecture or engineering – or perhaps no training at all except what they learned on the job). The second set is consumers of designs, like the anonymous woman in the focus group. Stereotypically, when designs are for household goods or household furnishings, or for objects to grace the bodies of women and children, consumers of the designs are gendered female. The third set of social actors were the people in the audience for *Re-Visioning Design and Technology*, who were feminist scholars, virtually all of whom were – and, I suspect, continue to be – women.

The fourth set of social actors is material – the objects and the technologies that the first set of actors designs and the second set purchases, and on which the third set comments. (Notice the use of the preposition 'on' in the previous sentence: designers and consumers are the subjects of active verbs; they get to do things with technologies. Scholars are linguistically more passive; they get to comment *on* what other people *do* with objects.) The idea that objects are social actors is a commonplace to historians and sociologists of technology, as Joan Rothschild, the organizer of the conference knows – even if the notion that objects are social actors seems oxymoronic to others.

If you think of the relationship between objects and behaviour the way we historians of technology do – 'we shape technologies and technologies shape us' – you will begin to understand why we believe that objects are not passive in the social world, or that objects actually have a powerful influence on how people behave. This influence arises partly because people use objects to do work (in which case we call the objects tools). Tools affect human behaviour by organizing the ways in which people relate to each other when they are working. Another part of the social

influence of objects arises from the fact that people use objects as symbols. Symbols affect human behaviour by communicating status, or intentions, or personality, or culture, thereby influencing the way in which people react to each other.

The notion that objects should be included in the analysis of social systems derives from a theoretical approach to studies of technology that is called actor-network theory; actor-network theory is actually a branch of a broader theoretical approach to technology studies that is called social construction theory. This brief discussion of both theories, along with my earlier analysis of the three social groups who participated in the narrative with which I began this essay, will (I hope) make it easier to understand the morals that I derive from the otherwise unremarkable discussion that ensued in that lecture hall in New York in November 1995.

SETS I AND 3: WOMEN DESIGNERS AND FEMINIST SCHOLARS

First moral: Many women designers do not generally agree with feminist scholars who assert that women design differently from men, or who assert that there are inherently feminine design principles.[5] This kind of disagreement – about whether women think differently or design differently than men – appears not just in the literature on gender and design, but also in the literatures on gender and science, medicine and engineering: indeed, on gender and all the technically based professions. After having done a fair amount of talking and reading about this subject, I have the very strong impression that, in general, technically trained women do not believe that what they do when they do the work for which they have been trained is *mentally or aesthetically* affected by their gender. Many feminist scholars who contemplate the products of that technical work – the designs for objects, the analyses of data, the buildings, the computer programs – disagree; they think that women *do* think differently from men *and* that that difference ought to be respected and encouraged because, if allowed to flourish, feminine ways of thinking would enhance and improve these professions.[6] My own research and reading give me no basis for deciding who is right in this debate, but they do give me some insight into why it exists in the first place.

First reason: the notion that women think and design differently from men is a notion which was used (and, in some quarters, still is used) precisely for the purpose of keeping women *out* of the technical professions.[7] Women, it was once said, were subjective, not objective, so they might be able to teach science, but could never do it; women, some men declared, were holistic and not mechanical thinkers, so they could care for plants, but never study them; women were nurturing but not analytic, so they could be nurses but not physicians; methodical but not creative, so they could copy designs but never innovate, so they could count the stars but never understand them; better at reading than at maths, so they could be poets but not physicists. On and on it went, for decade after decade, no matter how irrationally and inconsistently, through much of the nineteenth century and most of the twentieth, as more and more women received secondary and post-secondary education, as more and more women tried to broach the walls of the increasingly prestigious technically based professions.[8] I would be surprised to discover a woman designer, architect, engineer, physician or scientist who had entered one of those professions before 1990 who had not been told that there was some inherent, innate, instinctive, or inborn reason why she could never be successful. And, as a result, I would also be surprised to discover a successful woman designer, architect, engineer, physician or scientist currently over the age of fifty who could tolerate

receiving the same essentialist message – that women think and design differently from men – from, of all people, a *feminist* scholar.

Indeed, during the discussion period that followed her paper, Nancy Perkins located a slide that she had not originally intended to show (and which does not appear in the published version of her paper): an automobile battery that had been commissioned by a major manufacturer. The terminals of the battery were located on an angled surface that made access to them more universal, so that retailers could reduce inventory (Figure 15.3). No one would have guessed, she remarked, that that battery design had come from the hand/eye/brain of a woman – but it had. And there was nothing, she added, about her own sense of herself as a woman that had contributed to her decision to design that innovative, angled surface.

15.3. Perkins Diehard automobile battery.

At this juncture, a member of the audience remarked that because women designers had to earn their livings by working for patriarchal institutions they had to suppress their femininity in order to succeed. Both the battery and its designer, this commentator continued, must have conformed to the needs of hegemonic corporations that oppress women while simultaneously destroying the environment.

I had heard this kind of argument before: in seminars about subjects as diverse as the history of genetics, the development of environmental ethics, the medicalization of pregnancy and the design of cooperative housing. Patriarchy and technology, the argument goes, are equally oppressive of women; science is, furthermore, a hegemonic and capitalist pursuit so it cannot be progressive; science, technology, patriarchy and capitalism are, together, going to destroy civil society and the environment. Briefly put, when this argument is discussed in the context of the technically based professions, it pits the practitioners, generally liberal feminists who believe that equal opportunities for women can be obtained within the existing social structure, against the scholars who are radical feminists, convinced that equality can never be achieved unless the existing social structure is destroyed.

Just as the debate about gendered thinking was not worth exploring within the confines of this essay, so too the debate between liberal feminist practitioners and radical feminist scholars is

too large a subject to explicate here – except, once again, to comment on the reasons why those debates have alienated so many women practitioners (designers and architects, but also scientists, physicians and engineers) from the feminists who comment on what they do.

After also having done a fair amount of talking and reading about this subject, I believe that I understand how women practitioners react when they are confronted by radical feminists. 'I have made a difficult life choice', the practitioner says to herself, 'and here you are, telling me that that difficult choice was a mistake because it has required me to suppress my own identity. How do you presume to know, one way or the other?' 'I have fought hard to enter my chosen occupation', the female professional might also consider saying to her feminist critic, 'and you are telling me that that fight was contrary to my own best interests. I have worked hard to be successful in that occupation, and you are telling me that my work – the new technology that I pioneered, say, for ultrasound examination of the uterus, the effort that I made to unravel the DNA of HIV – is also contrary to the interests of the society in which I live. You have some bloody nerve.' 'I regard myself as an autonomous subject', she might continue, to herself or out loud, 'but you talk about me as if I am the victim of forces beyond my control. I see myself as a creative person who has spent my life breaking out of stereotypes, but you are trying to reimpose those stereotypes on me. I am a woman who finds deep, existential pleasure in what I do – and you, who call yourself a feminist, are trying to deny me that pleasure, are trying to deny that my effort to become a surgeon, or an industrial designer, or a chemist, or a chemical engineer was worth the battle.'

Here lies the second moral of my story: discourses such as these lead far too many women in the technical professions to reject feminism, no matter how hard they have struggled, along with feminists, to achieve equal opportunity in their chosen fields. From the perspective of women in engineering, science and design, feminist scholars simply do not get it – and are all too willing to denigrate what they do not understand. I once tried to persuade a famous feminist book agent to help me sell a book on women engineers. 'I can't think of anything more boring,' she said, 'why would any thinking woman want to become an engineer?' This is not, of course, the kind of feminist, or feminism, likely to attract the interest of even the most stereotype-battling technically proficient woman.

SETS 2, 3 AND 4: WOMEN CONSUMERS, FEMINIST SCHOLARS AND THEIR REACTIONS TO OBJECTS

Third and fourth morals: Feminist historians need to start thinking of ordinary women and women consumers as workers, not as workers in the marketplace (which, of course many of them are), but as workers in their homes, people who do housework – and, usually, a lot of it. A corollary of this moral is another one: feminist scholars need to remember to write about ordinary women or women consumers not as hapless victims of false consciousness, or unwitting victims of defrauding manufacturers, marketers and advertisers, but as people who have interests that they understand fairly well. To put these morals another way, feminist historians need to remember that when we step out of our studies and lecture halls, we are ordinary women and women consumers: women, that is, who do at least some housework. Furthermore, if we believe that when we go out into the marketplace to buy personal goods, our purchases are as much about the organization of housework (broadly understood) as they are about displays of status – then we need to remember that most consumers think exactly the same way; if we believe that we have good reasons for buying the

things that we buy, and if we believe that we have good taste, and if we believe that we have worked too hard for our money to spend it foolishly, *then everyone else does too,* not just everyone else in the present, like the woman in front or the man behind at the check-out counter, but everyone else in the past as well, the people on whose behaviour we historians are trained to comment.

Oddly, I first learned this lesson when I was a graduate student in the history of science, back in the early 1960s. Do not for a minute think, I was taught by my instructors, that the people who believed that blood-letting was an effective therapy, or that stones fell to the ground because they were attracted to the centre of the earth, or that flames burned upward because phlogiston was lighter than ordinary air, were stupid. They weren't – and if you would take the trouble to put yourself in their places, to evaluate the evidence that they themselves had at hand, to appreciate the reasons why they thought what they thought, you, too, would come to understand that they were evaluating the knowledge of the past and the experiences of the present to do the best they could with what they had. Taking the people of the past as seriously as they took themselves is the stuff, I think, of good historical work, whether in the history of science or the history of design or the history of anything else.

I had to learn this lesson again when I began the research that led to my book about the history of household technology, *More Work for Mother*.[9] One of the first file folders that I opened was labelled 'Resistance'. I was sure that I would find lots of housewifely Luddism out there in the land of *The Ladies' Home Journal* and *The Woman's Home Companion*. Indeed, feminist theory of the 1970s, in which I believed passionately at the time, predicted that I would find lots of resistance to the industrialization of the home amongst housewives, because housewives, being superb craftspersons, would resist de-skilling (although they surely would not use that word), would resist losing pride in their work, and would resist trading home-made for factory-made.

As it turned out, after a decade of research, that file folder had almost nothing in it. A snippet or two from one local newspaper or another, about the rich widow in town who refused to have her mansion electrified or her horse and buggy replaced by an automobile. There were a few other snippets from memoirs, about a servant who never learned how to properly defrost a refrigerator (because, the memoirist said, she missed the regular visits from the ice man), or about the grandmother who refused the gift of a vacuum cleaner (because, the memoirist thought, she believed that an unbeaten rug was not properly cleaned).

All my other folders were filled to the brim. Over and over again, whether writing in public venues or private ones, whether reacting to coal stoves or canned peaches or electric refrigerators, American housewives of the nineteenth and twentieth centuries said that they wanted labour-saving devices and labour-saving foodstuffs. Over and over again, middle-class American women voted with their feet to fire their laundresses and buy washing machines; over and over again, poorer American women voted with their purses, as soon as they could, to replace handmade pasta with store-bought, or a washing line with an electric dryer.

Over and over again, I had to ask myself why. Could all these women, not thousands, but millions of them, have been victims of false consciousness? Have failed to see what should have been right before their eyes, failed to understand what was really in their own best interests? Could every single one of these consumers, some of them very well educated or, at least, very knowledgeable about the ways of the world, have been blinded by the false claims of patriarchy or the even falser claims of capitalism? Surely not. But if surely not, then what was going on here?

Only when I remembered my teachers' instructions – to force myself to appreciate the reasons why people in the past thought what they thought and did what they did, to walk, in other words, in the shoes of the people I was studying – did I come to understand that housewives of the past really *did not much like* the conditions under which they laboured – and were happy to adopt new technologies, new objects, new housing designs that held the promise of reorganizing that labour. My primary sources fairly shouted this lesson at me, once I bothered to notice. Nineteenth-century American women were happy to plug up their fireplaces and plumb venting pipes from coal stoves into them because less bending was required when you cooked over a stove and more foodstuffs could be prepared with the same fire – no matter how delightful I thought it was to cook over an open fire a few days a year when I was on vacation. Twentieth-century immigrant tenement dwellers moved as quickly as possible, from one apartment to another, so as to acquire first, an indoor toilet, then, maybe, running hot water, then electric lights, then a washing machine in the basement, all so that they could improve the sustenance and maintenance of themselves and their families without so much back-breaking work – no matter how much I imagined that they were reluctant to give up the skills they had learned in the places from which they had emigrated.

If nostalgia is a trap for historians, I came to realize, then feminist theory is a trap as well. Nostalgia had fooled me into thinking that because I basically did not hate doing housework under late twentieth-century conditions, my predecessors must have felt the same way, although the conditions under which they laboured were so vastly different. Feminist theory had forced me to look at housework as work, but it had misled me into thinking that housework was just like work in the job market, when it had not been in the past and was not in the present. Housewives do not get paid, so they are not employees, which means that they cannot be alienated from their labour the way the theory said they should be. Furthermore, since housewives benefit directly from their own labour (they eat the food they cook and wear the clothes they wash), they knew fairly well when some new tool will either ease that labour or make it more productive, so they cannot be fooled (at least not for long) into making unbeneficial investments in tools. Perhaps just as significantly, housewives know that they produce status, really, as well as symbolically: that clean clothes for your husband can be read as, and also lead to, white collar work for your husband; that better nutrition for your children can be read as, and also lead to, better health for your children, which meant both less work for you and better opportunities for them. Like the doctors who once believed that blood-letting would relieve fevers, nineteenth- and early twentieth-century housewives who bought into industrialization were evaluating what they had known in the past and what they experienced in the present, and were doing the best they could with what they had, despite late twentieth-century feminist convictions to the contrary.

I learn this from the interchange between Nancy Perkins and the feminist scholars in her audience; or rather, I learn this lesson from the difference between the way the audience reacted to her vacuum cleaner design and the way the anonymous consumer in the focus group probably did. The feminist scholars had distanced themselves from the vacuum cleaner as a tool to organize work and saw it only as a symbol, as a piece of art, designed by a woman, they thought, because of its colour and its form. The consumer, however, had seen it as a tool with which to do her household work, work with which she was very familiar and which, she assumed from the design, the designer was also familiar: hence a woman. This vacuum cleaner was lighter and better balanced than others on the market, so it would be easier to move. This vacuum had soft bumpers, which meant that it would not damage furniture and walls, creating additional work to be done when the vacuuming

was finished. This vacuum cleaner held the hose tools in its body, meaning that the work would not be interrupted in searching for the tools, lessening the time it took to do the work overall. Small wonder that consumers liked the machine (according to the marketing report, it was preferred, by a wide margin, to others that were sampled by that focus group) and small wonder that one woman worker would recognize the vacuum cleaner as likely to have been produced by someone else who was familiar with the exigencies of the work.

My brief foray into the literature of feminist design history has provided far too many examples of scholars who need to learn the lesson the anonymous consumer appears to have learned experientially: that in addition to being status symbols, the vast majority of household objects and household designs are tools intended to help organize various kinds of work. When we react to the aspects of material culture, the objects, the technologies, that the people we are studying actually used, lived in, displayed or purchased, we need to *discipline* our reactions – just as my teachers taught me to do in graduate school – by walking in the shoes of the people we are studying. We should, for example, never disparage the tastes of the people we are studying, without at least first exploring the tastes of our subject's relatives, friends, neighbours and community. In addition, when studying the purchasing habits of people in the past, we should never assume that household consumption patterns are determined only by desires to display status, without at least first exploring the manner in which those purchases may have affected the organization of household work, that is the manner in which those purchases made household work (of various kinds) more efficient and/or productive.

In the literature on gender and design, I have found many instances in which those scholarly imperatives were not taken as seriously as they should have been, instances in which scholars let their own feminist ideology get in the way of a proper, multi-faceted explanation. Two examples will, I hope, suffice. In *Making Space: Women in the Man-Made Environment*, the authors (who go by the collective name, MATRIX) dismiss as false consciousness the expressed views of working-class women who, when asked, said that they wished to have parlours in their council flats, and who, when they actually did have parlours, decorated them with knick-knacks that required a great deal of cleaning.[10] These authors assume that it would actually be better for working-class women to have more and better spaces in which to work, rather than rooms that created more work while serving no function other than status display. This analysis ignores, at its peril, the likelihood that the women who were queried actually felt they needed a room in which to relax, a room devoted, in other words, to *not* working. Each of the MATRIX authors no doubt appreciates the value of having, as Virginia Woolf did, 'a room of her own': a study, a room in which to write, a room that validates the writing that scholars do as work. Why not, then, stretch to imagine (and to validate, rather than denigrate) the fact that women who do hard, physical labour for much of the day, might need a room, a feminine-looking room, in which to relax, a room decorated with objects that reflect their own tastes and their own precious memories? Similarly, in *Living in a Man-Made World: Gender Assumptions in Modern Housing Design*, Marion Roberts dismisses the attitudes of working-class women in Britain who told the Tudor Walters Committee, during the First World War, that they disliked communal kitchens as a mis-guided need 'for signs of greater prosperity and autonomy', when that aversion may in fact have arisen from the material conditions of communal cooking, such as the difficulties that arise when many workers need to access the same tool – an oven or a sink – at the same time.[11]

Feminist scholars surely know that women's work is work, but they seem to forget that lesson, as I once did, when commenting on the behaviour of ordinary women of the past (and, sometimes, the present). We all say that we know that objects are multi-valenced, but we sometimes forget that one of those valences is the tool-valence. We sometimes forget, in other words, that objects organize work, making work more efficient or productive or enjoyable, at the same time as they express status. All of us – radical feminist scholars, liberal feminist scholars, as well as non-feminist scholars – need to remember that when we put on our scholar's cap, our commentator's robes, we need, first, to sympathize with our subjects before we make historical, sociological and aesthetic judgments about them.

CONCLUSION

When she set about organizing *Re-Visioning Design and Technology: Feminist Perspectives,* Joan Rothschild, as I said earlier, had three objectives and one overarching goal: to engage design professionals in conversation with scholars; to engage scholars who think about design in conversation with scholars who think about technology; to use feminist theory and/or gender analysis to under-gird those conversations; and, as a result, to 'meet the challenges for transforming our environments in a society in which traditional distinctions and hierarchies are breaking down and being transformed'.[12]

I have not been able to share Dr Rothschild's optimism, neither as a member of the audience at the conference nor as a reader of the volume of papers that resulted – and writing this essay was an effort, on my part, to try to understand why. There are, I now think, four reasons. The conversation between design professionals and design scholars did not go well because the former perceived that the latter were, to put it as politely as possible, unsympathetic. The conversation between the scholars who think about design and the scholars who think about technology did not go well either, because the single most important concept that could have laid the foundation for that conversation – that objects are tools, affecting people by organizing work – was never expressed. Feminist theory could not possibly have inspired any of those conversations because feminist theory, as it was then constituted, either ignored or misunderstood both the work that women designers do and the work that typical women do, namely housework.

Finally, and most crucially, the participants could not have met the challenges involved in transforming the built environment even if their conversations had gone smoothly, because representatives of the other gender had gone missing at the conference, or had not been invited. Those challenges – eliminating sprawl, reducing emissions, decelerating the use of carbon-based fuels, alleviating debilitating work, building for the world's poor, making diverse environments accessible – are much, much too complex for women designers, women scholars and feminist theorists, no matter how numerous, untraditional and unhierarchical, to tackle alone. The text for the exhibition catalogue, *Goddess in the Details: Women in Product Design,* contains a quote from Margaret Mead which expresses this thought succinctly: 'When an activity to which each [sex] might have contributed is limited to [only] one sex, a rich, differentiated quality is lost from the activity itself'.[13] Rich and differentiated are surely amongst the many qualities that the activity of designing for the future is going to require.

NOTES

1. I am writing this essay in 2008, more than a decade after I gave the Banham Lecture on which it is based. When I delivered the lecture, I was Professor of History, State University of New York, Stony Brook. A fair amount has been written about gender and design since 1996, but I fear that I have not been paying much attention to it, because my research has turned in a different direction. I apologize, in advance, to those who will find that what I have to say here is entirely, or even partially, passé.

2. Joan Rothschild, 'The Conference Story', in the conference booklet, *Re-Visioning Design and Technology: Feminist Perspectives* (November 1995), copy in the author's possession. See also the published volume of papers from the conference: Joan Rothschild (ed.), *Design and Feminism: Re-Visioning Spaces, Places and Everyday Things* (New Brunswick, NJ: Rutgers University Press, 1999) esp. Joan Rothschild, 'Introduction: Re-Visioning Design Agendas', pp.1–6.

3. Nancy Perkins, FIDSA, is an industrial designer and planner of consumer products, contract interior components, industrial equipment, and mass-transit vehicles. She has been granted patents for housewares, appliances, automotive aftermarket and architectural components. She received her B.F.A. in industrial design from the University of Illinois, Urbana and is a Fellow of the Industrial Designers Society of America.

4. Nancy Perkins, 'Women Designers: Making Differences', in Rothschild, *Design and Feminism,* pp.120–25; quotes are on p.123.

5. Association of Women Industrial Designers, *Goddess in the Details: Product Design by Women* (exhibition catalogue, 1994).

6. The most well-known discussion of this subject arises from the work of Evelyn Fox Keller, most especially her biography of the geneticist Barbara McClintock: *Barbara McClintock: A Feeling for the Organism: The Life and Work of Barbara McClintock* (San Francisco, CA: Freeman, 1983). Many feminist scholars read Keller to say that women do science differently, more holistically, than men, despite the fact that Keller, who has a Ph.D. in physics, denies this. See my review, Ruth Schwartz Cowan, 'Women and Science: Contested Terrain', *Social Studies of Science*, 25(2) (May 1995): 363–68.

7. This is precisely what lay behind what has come to be called, in the US, the 'Summers affair', when Lawrence H. Summers, then the President of Harvard University, said, in a speech in January 2005, that he did not think women should be encouraged to be scientists. See http://wiseli.engr.wisc.edu/news/Summers.htm.

8. For an introduction to these pervasive stereotypes and their effects on women's entry into the technical professions, see Margaret Rossiter, *Struggles and Strategies: Women Scientists in America, to 1940* (Baltimore: Johns Hopkins Press, 1982) and Margaret Rossiter, *Women Scientists in America: Before Affirmative Action, 1940–1972* (Baltimore: Johns Hopkins Press, 1995).

9. Ruth Schwartz Cowan, *More Work for Mother: The Ironies Of Household Technology From The Open Hearth To The Microwave* (Basic Books, 1983).

10. MATRIX, *Making Space: Women and the Man-Made Environment* (London: Pluto Press, 1984).

11. Marion Roberts, *Living in a Man-Made World: Gender Assumptions in Modern Housing Design* (New York: Routledge, 1991), p.34.

12. See note 1.

13. Uncited, *Goddess in the Details*, p.47.

16.
MATERIALS AND DEMATERIALIZATION
THE FUTURE OF INDUSTRIAL DESIGN
tomás maldonado

I have always held Banham and his work in great esteem.[1] During the 1950s and 1960s, he was at the forefront of discussions concerning architecture and industrial design. Although, to be truthful, I did not always agree with him, I always appreciated his rigour and originality as a scholar, his lucidity in analysing the social and cultural processes of our times, his fascinating intellectual versatility. I also liked what others probably found irritating: his coherent non-conformism, his scathing attitude towards a culture for initiates that had lost all contact with ordinary people.

In recent years, and in Italy in particular, theories have been developed to suggest that there are two different and opposed types of design: on the one hand, 'cold design', pertaining to the world of industrial production and mass consumption; and on the other hand, 'warm design', the parsimonious product of the select few for the artistic and cultural gratification of the select few.

The judgement value implicit in the use of notions such as 'cold' and 'warm' is evident: 'cold' design is clearly inhuman, whereas 'warm' design is human to a degree. Now, apart from the fact that these thermal metaphors are somewhat arbitrary, I should also like to point out that this so-called 'warm' design is anything but new. If we take

an objective look at the design of the pre-industrial era we shall discover that it was all 'warm' design – that is, craft products for the few.

The latter-day contraposition of 'cold' and 'warm' design really amounts to little more than an attempt at passing off as a radical novelty what was, in fact, already the object of widespread discussion at the end of the last century and the beginning of this. A substantial case in point is the vexed question of the decorative arts within the much-discussed context of the relationship between art and industry. The ensuing debate involved men of the calibre of William Morris, William R. Lethaby, Frank Lloyd Wright, Adolf Loos, Peter Behrens, Hermann Muthesius and Henry van de Velde. For the fact is that in the history of ideas, certain subjects are forever surfacing anew. The phenomenon is exasperating, perhaps necessary, but hardly very exciting, particularly when you realize that current arguments are couched in the same terms as those of the past, but end up by being less persuasive.

The point that I am trying to make is not that there is anything wrong in trying to design objects that elude the constraints of industrial production and instead embrace more or less traditional artistic values. This is, after all, a democratic society, and people are free to design pretty much whatever they like. However, what is slightly irritating is the way the champions of so-called 'warm design' tend to claim absolute hegemony in the field, denying any sort of value to other kinds of design, especially that of the stigmatized 'cold' variety.

'Coldness' has become a characteristic not only of the formal or stylistic features of given products, but also of vast sectors of the manufacturing industry that they belong to. In this way transport vehicles are said to be 'cold', as are consumer electronics, computers and telecommunications equipment, electrical appliances for the home, cameras, office furniture and equipment, machinery and tools used in industry, agriculture and forestry; in other words, in all those sectors in which industrial design has been most active. At this point it is clear that the real *bête noire* is industrial design, in the sense of product design.

The aim is to demolish the credibility, and indeed the topicality, of industrial design. Not that this is an isolated objective: far from it. It is part and parcel of the recent trend that tends to attribute absolute autonomy to so-called 'design', seen as something very different (and to some extent opposed) to 'industrial design'. For whereas this latter has always done its best to define its particular range of action, 'design' has never bothered with worries of this sort. The tendency to free the concept of design from all disciplinary constraints and to enhance it with absolute, all-embracing values is particularly evident in the exuberant field of 'Italian design'. I shall now take a closer look at this phenomenon.

The first thing that comes clearly into focus is the enormous disparity between a programme that postulates design without frontiers, and the somewhat limited goods sectors that such design actually caters to: furniture, lighting, decorative objects, tableware, fabrics. To put it briefly, 'Italian design' is largely operative in the world of interior design. By this I do not mean that industrial design in Italy only consists of interiors. There are, certainly, in this country excellent design works done in other goods sectors. However, the fact remains that in Italy today it is interior design that predominates. Indeed, it is in this field that 'Italian design' has made a name for itself throughout the world. To be fair, the name has actually changed slightly over the years: Archizoom, Super-studio, Ichimia, Memphis, Post-Memphis, etc. The substance has changed little, however: since the mid-1960s, it has mostly been concerned with provoking and deriding current tastes in interior design.

With its overtones of Pop Art, its late Dada effects and its ready (and occasionally ironic) use of stylemes belonging to the Biedermeier, the Wiener Werkstätte and the Art Deco traditions, this tendency did at least manage to shake up the suffocating conformism typical of upper-class and upper middle-class interiors in industrialized countries. To be precise, we are referring to the reassuring period furniture (be this real or fake) and/ or to equally reassuring (and occasionally also fake) items pertaining to the classical modern tradition. Granted, launching an attack on this sort of conformism was facilitated by the gradual rise of a consumer elite in industrialized countries: an elite that was still somewhat restless and uneasy about its new *pouvoir d'achat*, and therefore felt cramped in traditional home surroundings that spoke for unwavering continuity. Unwavering continuity was the last thing that this new elite looked for in objects for the home. Apparent precariousness was much more to its liking: objects that express the aesthetics (and the ethics) of what is short-lived; slightly silly, but amusingly irreverent, items that give people something to talk about – in other words, conversation pieces. Italian design has certainly made its mark, albeit on a restricted number of people. For where the Louis Seize secretaire once stood there is now a multi-coloured ziggurat of a sideboard, to say nothing of the host of cult objects that have replaced the bibelots of yesteryear.

However, if we compare the conformism of the past with that of today we are bound to admit that we have at least gained something in terms of internal dialectics. For, as the designers of the new conformism have themselves been the first to claim, the objects of their invention are deliberately ephemeral, devoid of any lasting value. In this sense the conformism that creates these items is also ephemeral, in that it is speedily consumed by consumption. Such conformism means being not so much 'with it' as 'ahead of it'. This trend goes against the idea of industrial design as product design, favouring a revival of the Arts and Crafts movement, yet at the same time seeking support in a dogmatic exaltation of certain remarkable technological innovations.

Industrial design is held to be fading as a discipline, and even as a profession, in view of the fact that the material reality of objects (and therefore the objects themselves) is said to be gradually dissolving. In other words, in industrial society as we know it (call it post-industrial society if you will), objects are supposed to be about to forgo the central role that they have played until now. And as objects retire from the scene, the stage will be taken over by messages and processes.

Such is the explanation given, not only for the vast increase in the overall volume of messages and processes in our computerized society, but also for the decrease in size and weight of objects pertaining to certain leading sectors of production and consumption. This phenomenon is now often referred to as dematerialization, and is explained in terms of the miniaturization of component parts made possible by recent progress in microelectronics. Miniaturization of this sort may appear to upset the material reality of objects as we know them today by cancelling their physical identity, or indeed contributing to their actual disappearance as technical objects.

At this point we should take a brief look at what is happening in the world of consumer electronics, those artefacts devised for home entertainment and communication. Certain of these products, even entire categories of them, have reached crisis point and have ultimately been wiped off the market in industrialized countries.

In actual fact, this has rarely been the result of simple elimination or removal. New products do not usually take the place of earlier ones *ex abrupto*. The substantial novelty of a product – for instance, its highly innovative technological content – asserts itself by means of derived or secondary novelties. Moreover, when one product becomes obsolete it is rarely replaced by just one

new product. What usually happens is that the appearance of an innovative product gives rise to a process of proliferation and diversification. In other words, where once there was a single product there is now a whole range of new products. And by range we do not only mean the splintering of supply by means of variations of a given model, but also the collection of new products, and service-products that are directly or indirectly generated by the innovative product.

For this reason, the usual line about generalized dematerialization seems to me to lack convincing proof, at least as far as our present state of knowledge is concerned. At best it is a mere hypothesis, an attractive one perhaps, but one that is bound to give rise to objections. In a physical environment whose material nature grows before our very eyes – suffice it to look round – it seems a nonsense to suggest that we are living in an age of generalized dematerialization. In certain sectors, as we have seen, there is certainly a tendency of this sort, but it has in no way contributed to an overall decrease in the material mass of things in our industrialized world. To the contrary, we are alas witnessing an atrocious increase in this mass, to say nothing of the appalling mass of waste that has followed in its wake.

Another point made by the dematerialization theorists concerns the explosive role played by the technics of new materials and of advanced materials such as polymers, ceramic and metal composites, electronic and magnetic materials, new alloys, and so on. There is, of course, no denying that in given manufacturing sectors – for instance, the automobile industry and its derivations – the introduction of new materials has contributed to the decrease in weight of individual products. In fact, lighter materials now largely replace steel. Data pertaining to the weight of cars in the United States make this quite evident, and are taken by certain experts as a sign that the automobile industry is now tending towards low material intensity where once this intensity had been remarkably high.

However, in my view, such considerations are hardly convincing and should not be used as an argument in favour of theories of global dematerialization. The simple and proven fact that light materials are now replacing heavy ones does not necessarily mean that we are heading down the road leading to low material intensity production. The reason for this is that weight is not the only possible parameter for judging the intensity of materials. Indeed, if we adopt a different parameter – for instance, one that takes the volume of materials used worldwide into account – we could come to what I see as much more reasonable conclusions. That is, that the current tendency is not towards low material intensity production, but towards production that favours a high intensity of light materials. If this is so, as I believe, then it is futile to talk about the dematerialization of materials. The new materials may be light, but they nevertheless embody a strong materiality of their own. Moreover, in view of their increased subtlety, they are better able to penetrate our material world than were their predecessors. Whether you like it or not, the materiality of materials is tough enough to withstand the assault of would-be detractors.

In recent times, the marvels of new materials have often been exalted with dithyrambic passion. Such enthusiasm probably owes something to the press offices of the industries in question, and indeed to the mass media in general, ever anxious to embrace whatever seems new. However, over and above the persuasive potential of laudatory campaigns of this sort, it might be a good idea to take an objective look at the impact that new materials have, or could have, on the world of production and consumption.

I should now like to take a look at another approach to the dematerialization of materials that I personally find quite stimulating, at least from the speculative point of view. I am referring to the view according to which ours is becoming a world in which the physical and cultural depth of

things is decreasing, one in which the two-dimensional nature of surfaces and of the messages that these communicate is what prevails; a world in which matter seems to be reduced to a thin screen on to which a variety of transitory messages are projected.

It is widely held that what is actually taking place is a process of superficialization, in that there is no longer anything really visible behind the surface of things. Surfaces no longer display the structure of material as they once did. Instead they conceal it, being characterized by a sort of opacity, in that their constituent structure remains hidden, concealed from the observer. By contrast, the surface of traditional materials is claimed to be an example of transparency, in that their innermost material reality is easily perceivable.

If I am not mistaken, this is explained by the fact that the former are held to be highly artificialized, whereas the latter are not. The traditional materials mentioned, as an example, are wood and stone. And this is where the reasoning begins to look shaky, first and foremost because it is historically far from proven that in the past the surfaces of traditional materials were unadulterated and were thus transparent in the sense mentioned above. In actual fact, such materials were usually covered by other materials that made it difficult to understand the real nature of what was beneath. In other words, these materials were also highly artificialized. In all ages, there has been widespread use of facing and veneering techniques aimed at enhancing the surface of objects with aesthetic and symbolic embellishments, or indeed at covering up materials rightly or wrongly held to be of little value. Wood and stone have themselves been thus treated.

The subject of the relationship between surface and substratum materials is known to have been close to the hearts of the Austrian and German architects at the beginning of the twentieth century. The question gave rise to the great ornament debate, which in time grew extremely heated. It is well known that the foremost animator of the discussions that ensued was Adolf Loos. Both he and others were convinced that ornament had played an important part in the degeneration of taste in architecture and the applied arts of the time, and the imitation of materials was held to be one of the first causes of this degeneration.[2] This was inevitably so, for ornament in one way or another resorted to the imitation of materials. The result was that the outburst against ornament was inseparable from a similar crusade against the imitation of materials. It is no coincidence that Loos should have used his proverbial sarcasm to sharpen his polemics against wallpaperers, decorators and plasterers. For their jobs involved covering up materials: covering walls and ceilings with wallpapers, fabrics, wood or plaster. Nevertheless, in his famous 'covering-over law' ('*Gesetz der Bekleidung*'), Loos proved to be a little more accommodating: things should be worked such that it was not possible to mistake a particular material with what it was faced with or covered in. In other words, wood could be painted any colour, as long as it was not wood colour. So what Loos accepted was facing or finishing that did not imitate other materials; nor the same material, for that matter, in that a common wood should not be painted up to look like a fine wood.

Although this version is less categorical, Loos's statement in favour of the authenticity of materials nevertheless rings out loud and clear. So the authenticity of materials can no longer be discussed in Adolf Loos's terms. In his day, people were not as aware as they are now of the inherent artificiality of the vast majority of materials. They simply were not culturally open to such ideas. Instead they idealized the so-called traditional materials, convincing themselves that these were absolutely natural. The outcome was a form of prejudice of Romantic inspiration: a nostalgic and naturalistic version of certain popular traditions concerning materials.

There is no doubt that the time has now come to treat materials and the question of their authenticity in more realistic terms. And this means accepting that our views (or prejudices) on the subject change in time. In other words, we need to recognize that our idea of authenticity is changeable, just as our image of these materials is changeable. This being the case, we may well wonder whether it is still reasonable to talk about the authenticity of materials in times when these are being increasingly artificialized. Can we really talk about authenticity when it comes to polymers, for example? I actually believe that we can, as long as what we are after is a positive rather than a negative value. What I mean is that, in the case of polymers, the imitation of other materials should be avoided not out of respect for some rather vague or anachronistic tenet concerning the purity of materials, but because imitation makes a nonsense out of the true potential of polymers.

Although in the near future the texture of such materials will probably become more agreeable as well as more protective, this does not necessarily mean that the world is undergoing a process of dematerialization. Setting surface and material against each other is really a fairly ludicrous idea because, all things considered, all surfaces, including facing materials – plastified laminates, for example – express the material nature of the material itself, which in its turn expresses the material nature of its own surface. And so the more our senses are stimulated by the surface of materials, the more we relate to their materiality.

This point is important if we wish to prevent the so-called dematerializing effect of new materials from being used as an issue to impair the role of industrial design. Industrial design must have a primary role in the development of new products based on these technologies. However, it is worth repeating that the true role of industrial design is still that of giving form to objects that are considered structuring elements in the human environment.

Of course, the objects also pertain to the world of communications. Designing objects today often means designing interacting systems, that is communication systems. However, a large part of the industrial designer's task still involves giving shape to material objects that are used in fairly traditional ways, and are appreciated for their material qualities.

Yet the problems that follow in the wake of the dematerialization theories do not end here. It is not enough to insist, as we do, that the job of industrial design is to effect no less than to affect the material nature of objects. For this, though obvious enough, actually neglects what I think is an important point: the fact that the objects we are talking about belong to a social and cultural reality in which our relationship with objects and their material nature is ambiguous, to say the least. Consumer societies demand increasing numbers of objects, the more grossly material the better; and at the same time, the members of these societies also create (and dream about) a world of objects whose materiality is ever decreasing.

I am convinced that this contradictory state of affairs must feature in any serious analysis of the present and future tasks of industrial design. The reason for this is simply that the dematerialization ideology is bound to influence or indeed distort things as we perceive them in the material world. Indeed, it is tempting to condemn the uncontrolled growth of objects, but this would deprive us of the chance to explore the other facet of our problem. That is why we create (and dream about) a world of objects whose materiality is decreasing; why we should be so attracted by evanescent worlds and non-things.

The collective imagination seems to have gone off on a ghostly tangent in the direction of dematerialized objects, of shadowy images of things. Polish philosopher and writer, Stanislaw Lem (1921–2006), developed a sophisticated and provocative theory about the causes and effects of the

strange delight that modern culture takes in pursuing illusory constructs that can take the place of reality. Appropriately enough, he called his theory 'Phantomology', later making a metatechnical addition to his first idea and calling it 'Phantomatics'. In Lem's view, 'Phantomology' and 'Phantomatics' should together try to find out how and why our society has ended up behaving like a formidable mega-machine that produces phantasmagoria. A mega-machine destined to produce a 'world in which', as Lem put it, 'the absolute abiding principle is that no one can feel sure of dealing with natural reality'. Indeed, it grows daily more difficult to distinguish the images of events from the events themselves.[3]

Lem, who was not only a philosopher but also an expert on science fiction with a bitingly mocking pen of his own, helped show up the ambiguous position of this type of fiction, poised between science and para-science. For him, in science fiction, all worlds are possible, especially those that seem impossible according to our present state of knowledge. In actual fact what we are really dealing with is a sort of marvels industry, in the Surrealist sense of the word 'marvellous'. The products with which this industry furnishes the market often make use of the 'dematerializing effect', as in the case of space operas and horror films.

Of course, these are fictitious appearances that we are no more likely to accept as reality than we are fairy tales, fables or other works of pure fantasy. Yet the stunning realism of these effects is such that our attitude to what we are seeing is bound to change. In the case of such films, although we know it is all fiction, we do not really feel so sure about it. The incredible becomes somewhat more credible. I believe that this phenomenon should not be underestimated. The whole question of the greater credibility attributed to fiction (and dematerialization is only one example of this) is closely linked to the question of the growing role in our culture of increasingly sophisticated techniques for representing the visible world. Yet these techniques have a long history of their own. They are the result of an articulated process of historical development that has lasted more than five centuries. At this point it is evident that the discovery of visual perspective on the part of the mathematicians, architects and artists of the 1400s was in the end bound to lead to the production of images that are ever more true to reality by means of mechanical and electronic devices.

Every society has its own representation systems. In the case of our own, the system produces on a planetary scale images that are destined to be experienced as being more real than reality itself. However paradoxical this may sound, it is clearly illustrated by the development of photography and then moving pictures and television. With computer graphics, the whole process is taken a radical step further, especially as regards the most recent achievements concerning the production of virtual worlds.

Thirty years ago, when all this was still unknown, Ernst Gombrich made a passing comment that most of us at the time found somewhat cryptic.[4] On examining a description of Purgatory in the *Divine Comedy*, in which art's ability to reconcile the sense of vision with the other senses – *'li occhi e 'l naso'* – seemed to resolve the conflict between illusion and reality, he observed: 'What Dante couldn't know, because he had never seen really illusionist pictures, is that this conflict might extend into the sphere of vision itself.' He then added: 'I believe we have here the reason why the perfection of illusion was also the hour of disillusionment.'

There is no doubt that today we are approaching the critical threshold beyond which the 'perfection of the illusion' destroys itself, because if the illusion is no longer distinguishable from reality, then no further perfection of the illusion is imaginable. This would certainly seem to be the logical consequence of the almost excessively sensational developments made recently in the

production of virtual realities. We can illustrate this by the fact that by donning an Eye-Phone, a Data Glove, and a Data Suit we are able to enter illusory reality and experience it as if it were real (or almost real). In other words, we are now able to explore from the inside a reality that is the double of our own: something like projecting ourselves into a video game. And we can do this without running any risks, in that our actions within this space would be carried out vicariously, by our double, our digital alter ego.

This quick look at virtual worlds has brought with it some fairly negative opinions. But the fact is that I simply cannot set aside certain doubts that I have on the subject. Is it right to maintain that this nascent culture of virtuality ('hyper-virtuality' might be a better term) is bound to herald a sort of irreversible alienation between us and the real world? In other words, are we justified in stating that interaction with virtual worlds can never enrich our cognitive and operative relationship with the real world, but only detract from it?

In the end, the whole question boils down to what has been called the 'cognitive value of the imaginal'. There is no doubt that measuring this value is fairly arduous. It is a matter of finding out whether extremely high-fidelity computerized image production, which is the practice and products of eidomatic activity, can really enrich our experience, can supply us with more experience than we would have had without the aid of these images, in an *empirical* relationship with reality. In other words, we need to discover whether or not image production of this sort can carry out cognitive functions.

I have to admit that I would give an affirmative answer to the question of whether extremely high-fidelity computerized images can be considered experiences. Yet, I am aware that in so doing, I am just asking to be accused of contradicting myself with regard to what I have just said on the subject. On the one hand, I appear to denounce the fact that virtual realities separate us from experience; and on the other, I am prepared to admit that such realities take place inside and not outside the borders of experience. There is no doubt that these two views do not fit together. However, the real contradiction lies in the subject itself. There is a basic ambivalence couched within virtual realities; indeed, within the whole culture of virtuality. And it is this ambivalence that we shall have to deal with if we are to resist the temptation to interpret the phenomenon unilaterally.

There are clearly substantial epistemological implications in this subject. In some respects, virtual realities are merely models produced by computers. However, they also stand for a new threshold in the age-old history of modelling techniques that have contributed so greatly, especially since Galileo's times, to scientific experiment and to technological innovation. Granted, the question pertaining to the cognitive role of models is certainly not new. Philosophy of science has been dealing with the subject for some decades now. What research into artificial intelligence has done, along with the ensuing scientific, technical and philosophical debate, is to revive and extend the whole context of the question.

In this context, virtual realities take on a particular meaning. There is no denying that, as models, virtual realities embody something original, something that distinguishes them from earlier models: that is, their syncretic nature. For they are indeed the outcome of a convergence of three techniques of model-building that have hitherto been used separately: emulation, simulation and mathematical formalization. It is this very syncretic nature of theirs that allows computer models to offer scientific and technical research, as well as industrial design, a number of aids that were previously unthinkable. And it is up to us to decide what use to make of them: on the one hand,

to increase alienation in the name of the ideology of universal dematerialization; or on the other, to contribute to our design achievements.

NOTES

1. This is the transcript of the lecture given at the V&A Museum, London, on 28 February 1992.
2. References are to Adolf Loos, 'Ornament and Crime', written 1908, found in *Ornament and Crime: Selected Essays*, trans. Michael Mitchell (Riverside, CA: Ariadne Press, 1998).
3. Theories proposed in Stanislaw Lem's *Summa Technologiae* (Krakow: Wydawnictwo literackie, 1964). See also Peter Swirski, *A Stanislaw Lem Reader* (Evanston, IL: Northwestern University Press, 1997), which includes the translation of an essay in which Lem discusses his *Summa Technologiae* on computers, virtual reality, and its uses and abuses.
4. E. H. Gombrich, *Art and Illusion* (London: Phaidon, 1972), p.236.

17.

AN UNKNOWN OBJECT OF FOUR DIMENSIONS
richard hamilton

Editor's note: What follows is a typotranslation by Richard Hamilton and Ecke Bonk of Marcel Duchamp's notes *in the infinitive* translated from the French by Jackie Matisse, Richard Hamilton and Ecke Bonk. The talk was not written, it was extemporized by Hamilton projecting illustrations from a copy of the book from his laptop.

We reproduce here a selection of Duchamp's translated notes with some relevant annotations by Hamilton and Bonk appended to the typotranslation. The numbers on the annotations refer to pages in the book. Note 31 applies to Duchamp's attitude to colour in general, conceptual rather than aesthetic. The note refers to the preceding three pages and other notes not illustrated here.

During the period in which Marcel Duchamp was struggling to affirm the dominance of mind over hand in the creative process, he habitually recorded his thoughts on any available scrap of paper. It is paradoxical that, when he decided to make his notes public, he chose to reproduce exactly his autographic script. While repudiating the painter's touch in his artworks, he found no option other than to let the trace of his own hand reveal the thought in his texts.

A handwritten text by any thinker of distinction has its fascination, but it was in the name of scholarship that manuscripts penned by James Joyce or T. S. Eliot were

reproduced long after their books had appeared in print. Duchamp's writings are unique in that the premeditated form of their initial publication shows them raw, spontaneous, and unpolished. The author accepted their unresolved character: the propositions are, in general, speculative, often expressed in the infinitive. The first notes to be published (in the normal sense of that word) were specific to the *Large Glass* (1915–23), but a few 'jottings' referring to readymades were added. A limited edition of 300 near perfect collotype facsimiles of the originals was printed in 1934 under Duchamp's direct supervision (and at his own expense). The loose documents were contained in a box bound in green flock-paper.

This mode of publication posed a challenge to wider circulation, so the contents lay largely unread; the *Green Box* was admired for its form and its perversity and loved as a work of art. Several notes were put into type, and one, translated into English, had been published, in 1932, in the Surrealist issue of *This Quarter*. But these efforts served only to expose the inherent difficulties that lay in the translation, specification and printing of the text/image.

What the manuscript demands is a transcription that retains the original's graphic complexity. To convey the information contained in the facsimiles requires that the words, sketches, and diagrams be integrated into a new isomorph. Variations of typeface, tone and colour can simulate changes in the writing medium; preserving the deletions and insertions reveals the development of ideas — even erratic spacing and punctuation can contribute to our understanding of the flow of thought. Conveying all this subtlety stretches the capabilities of metal type to its limits. Letterpress printing lives in a world 23 millimetres thick, with each cast-metal character occupying its own space, locked in a rectangular grid. Although offset lithography and phototypesetting finally transported print to a two-dimensional flatland, the links with metal were hard to break.

Since the publication of the *Green Book* in 1960, advances in computer science have brought about a transformation in the dissemination of ideas of greater consequence than that introduced by Gutenberg and Caxton with the invention of movable type. Publishing software has removed many of the limitations fundamental to letterpress printing and the complex project of rendering Duchamp's notes in English can now be undertaken in an environment in which the writer/ translator/typographer/designer is free to move over the hypothetical platen of the press unhindered. QuarkXPress provides typesetting resources with limitless possibilities of text control. Bézier curves can translate Duchamp's intensely personal graphic expression into mathematically defined lines in harmony with the objectivity of type. The very existence of these new tools invited an attempt to open the *White Box* to an audience that had found the *Green Box* typotranslation useful.

When the *White Box* first appeared, more than thirty years after the *Green Box*, the relationship of the two collections of notes was not understood. It has taken time to appreciate that the distinction between them is small. All of the notes were written over the same period, and they all pertain to the same quest — to engage in an art of rigour and purpose, stripped of pretension, affectation, and commercialism, and above all devoid of vanity. The detachment that pervades his subject matter is also the strategy by which Duchamp contrived an art which is his alone.

The *Green Box* is a selection from a great many notes — Duchamp said that its purpose is to act as an 'ideal catalogue' for the *Large Glass*. More than a catalogue, it is a commentary and a manual, a key, a map, and an instruction book. The notes are less casual and random than they appear — there is little hard information missing. If the *Large Glass* had suffered the fate of total destruction (instead of the serious damage that occurred in 1927), a reconstruction would have been possible given only the *Green Box* plus a few fragments of the wreckage for specific colour references. The

undertaking would not have been made easier, nor the result been less accurate, with the *White Box* at hand, but its contents tell us a great deal more about the artist's inspirations, as well as his extraordinary aspirations.

Dimensionality was a major preoccupation throughout Duchamp's working life. In the lower part of *La Mariée mise à nu par ces célibataires, même* he used traditional, one-eyed, perspective conventions to represent on a two-dimensional surface a precisely defined three-dimensional construction. The interrelated components of his saga are situated with metrical precision in an illusory space behind the transparent plane that supports them. Time, the dimension from which painting remains singularly aloof, is implied in the form and functioning of mechanical and chemical elements engaged in an interplay of activity described in the notes.

Attempts to provide an interpretation of the Virgin/Bride persist. Psychoanalysts, art historians, scholars, and cranks compete in a seemingly endless series of strippings intent on 'revealing' her mythologic origins. Shards from self-indulgent digs are dusted off and brandished as evidence of 'the source.' Christianity, Hinduism, Zen, Freud, the cabala, numerology, alchemy – each is probed for an answer to the burning question, 'What does it mean?' Is it an allegory of the Assumption of the Virgin, a mechanical invocation of Kali, or a re-vamping of some other readymade theology? Duchamp, the agnostic, is content for her to be all things to all men. We are told by Octavio Paz in *Marcel Duchamp or The Castle of Purity* that 'Duchamp has said that she [the Bride] is the two-dimensional shadow of a three-dimensional object which, in its turn, is the projection of an unknown object of four-dimensions: the shadow, the copy of a copy of an Idea.' That statement is a poetic confirmation of the detailed evidence explicit in his *White Box* notes.

The *Large Glass*, and its twin *Étant donnés* (1946-66), are metaphors for concepts at the verge of comprehension. It is not until the *White Box* notes reveal their message that we can hope to glimpse the power of Duchamp's imagination pushing his mind across the barriers of multidimensional space. The series of drawings and paintings produced in Munich over a period of a few months in 1912, at the same time that Duchamp began to accumulate his notes, is science fiction illustration half a century ahead of its time.

The Munich period climaxed with an image of startling originality – the *Bride* painting that had been immediately preceded by *Passage from the Virgin to the Bride*. The *Passage*, like the *Nude Descending a Staircase* (1911) and several other paintings, had been inspired by Marey's chrono-photographic studies of movement. *Bride* restructures the description of movement into a new formal entity: this representation of some unknown object/being, given birth by a form moving through space, appears as though delivered from another dimension – a space/time materialization. The reason Duchamp's *Bride* melds so naturally with the graphic styles of the magazine *Astounding Science Fiction* and paperback science fiction covers of the 1950s is that he was immersed in ideas that would feed the novels of van Vogt and other writers decades later.

Duchamp's science was self-taught. Taking information from any source – mathematical treatises, illustrated magazines, or the observations of a curious man trying to make existence intelligible – he processed his enquiry into a visualization. Amateur he may have been but his disregard for dogma, his acceptance of the random nature of both the physical world and personal relationships, his systematic application of chance techniques into his work and, not least, his exploration of language and meaning anticipated the ideas that were to revolutionize science in the twentieth century. Heisenberg's uncertainty principle, von Neumann's Monte Carlo method, Gödel's incompleteness theorem, and Wittgenstein's verdict on the sayable sentence are matched

by Duchamp's invention of 'ironic causality' and the 'beauty of indifference'. Duchamp liked to argue that a work of art is completed by the spectator – ergo, there is no single definitive work of art. In any case, colours fade, metals oxidize and all matter undergoes the inevitable drift to uniformity postulated in Boltzmann's second law of thermodynamics. The seeing mind is not a constant, and a work of art is a particularly capricious object: because social mutations, the whims of fashion, and the manipulations of markets make for a notably unstable environment. Duchamp had little interest in the tenet of permanent value. Choice was an irrelevance – an unnecessary distraction. One snow shovel was much like another, and there was negligible difference between the bottle rack he bought from the Bazar de l'Hotel de Ville and another standing next to it in the department store. He was satisfied if a reconstruction of his Large Glass was a *'copie conforme'* of the 'original' in Philadelphia. Given his indifference to the 'unique' and his unconcerned acceptance of the ephemeral, it is a wonder not only that his oeuvre is treasured and studied with increasing enthusiasm but that time is proving its indomitable permanence.

It is Duchamp's description of what a work of art might be that endures: art is the depiction, the token, the emblem of something in his head, the messenger that carries the meaning. Supporting these tantalizingly fragile objects, strengthening and continually revitalizing them, are the words. Language is an integral part of the process that generates the image, and a dialogue is maintained throughout its slow fabrication. An 'illuminatoresque Scribism' bonds image and word – each shedding light upon and adorning the other.

On -

illuminatoresque

Scribism

in painting

(Plastic form for

plastic form

talionism)

2 The note proposes that the interplay between text and image, such as that found in a medieval illuminated manuscript, could be the model for a painting.

Plastique does not easily translate; the *form/medium* sense of the French is lost in 'plastic for plastic'. *plastic form for plastic form* is an uncomfortable but preferable compromise [see also note p. 4].

Talionism – Eye for eye, tooth for tooth, hand for hand, foot for foot. Old Testament biblical law is less about revenge than a balanced requital. Verso, 1913

Frosted glass

and rust of

different metals

(As <u>colours</u> to

use in

the "<u>splasher</u>"

46 The note is attached to note p. 47
with a pin [see also note p. 16].
Verso:
(Corn Exchange) *Bank*
(5th Av +) *9th Street*

steel.
—————— Raw

worked .

nickel.
—————— nickel plated

~~and~~ nickel .pure . } diff. of sheen .

Platinum.
———————— bright to matt .

Plas

Copper. matt .
——————

 yellow .

 polished .

aluminium . matt. dark -
——————————

 iron.
 ——— Blue. Purple. of iron

 to be used for big architectures

Iron . ultramarine , black , lake , Pr Blue, White.
(On light
ground)
Steel . White, Yellow, black. (dark ground)
ochre.

nickel . White. cobalt. grey. green. (on dark
ground)

Platinum . White cobalt blu ,. Green, black (dark ground

aluminium.White, Pr blue, Yellow., ochre.

Wood .

mica

Glass transparent colourless Juice. –

Mica. transparent Yellow Juice.

Copper - Cad Yellow . red . black . white . raw S.

Tests.

<u>nickel</u> : White Lemon Yellow-Green (Graduated towards grey Yellow
 Blue
 for the shadows)

<u>Platinum</u> : White brilliant Yellow Black .

<u>Aluminium</u> . White . Black . Brilliant Yellow . Prss Blue .

<u>Steel</u> : Black . Pruss B. . Brilliant Yellow . White.

<u>Iron</u>

31 Duchamp's notes concerning colour
 stress the physical composition
 of his pigments. The ingredients
 used to create the appearance of
 a particular metal should be true to
 the substance of the subject rather
 than to its optical appearance. For
 the Munich painting of the *Bride* he
 had opted for earth pigments (ochre,
 burnt umber, terre verte). In the
 Large Glass, the pigments used to
 paint the bachelor apparatus were
 often metallic oxides (white and red
 lead, cadmium yellow, cobalt blue,
 ferrous oxides etc.). The notes take
 colour further from aesthetic choice
 with references to frosted glass, rust,
 shoe polish, tea, and toothpaste.
 Beautiful black [see notes pp. 24 and
 25] is incongruous until this black is
 understood to be the pure perceptual
 negative produced by a mixture of
 complementaries

(9

PLACE
ONE CENT
STAMP HERE

FOREIGN
TWO CENTS

3‖

Milky way

1‾2‾

or Louis XV clouds

Like the legs of *the Grinder*

The clouds are

preferably in soap

–(sha**v**ing)

THIS SPACE FOR ADDRESS ONLY

CARD

POST

WRITE MESSAGE BELOW

Lead embossed

hammered or

dimpled ~~is~~

is less

dense

L̸o̸u̸i̸s̸/X̸V̸/c̸l̸o̸u̸d̸s̸

"GOOD TIMES"
IN HERSHEY, PA.
THE CHOCOLATE
TOWN
HOME OF THE
HERSHEY
CHOCOLATE CO.

41 The translation of *capitonné* offered by the dictionary is *padded*. A letter to Arne Ekstrom exists in which Duchamp insists on *tufted*, saying *this is not a 'term de metier'*, but he agreed that *'tufted'* could be put between quotation marks. The surface of a mattress pulled together with knotted thread might be said to be *tufted*. *Capitonné* is specific to the kind of *buttoned* padding used to upholster furniture, also padding on a door or wall (or even a lead-lined coffin), held in place with broad headed nails. The effect is a *dimpled* surface, which makes sense in the context of *embossed and hammered*

Do not forget the painting of Dumouchel: Pharmacy = snow effect, dark sky, dusk, and 2 lights on the horizon (pink and green).

51 The sketch, an early study for the *Large Glass*, shows *lighting gas* extruding from the *capillary tubes* and breaking into *needles* of solidified gas as it emerges. These *spangles* arc across the *sieves* until discharged by the *pump* as a liquid. The more freely drawn background features (top right) are less readily identifiable in the *Large Glass* but their position relative to the sieves suggests an association with a *boxing match* drawing dated 1913. *Pharmacy* (1914) is an assisted readymade in an edition of three purchased reproductions of a landscape with two added coloured spots. Duchamp shows no reluctance in referring to this work as a *painting*

Linear Perspective.[3]

Plan view

D indicates the distance

from [point of sight]

Plotted in perspective :

AD, FD, GD, CD are

the verticals

? see photos made for the
perspective of the standard stops
and the red fellows -

59 There is a distinction between the
words *plan* and *plane* in English that
does not exist in French. Something
seen in 'plan view' requires that the
eye be perpendicular to the plane
viewed. The context sometimes
suggests that this difference is implicit
in the French. We have chosen to
adopt the inferred English rather than
to translate the French *plan* as *plane*
whenever it appears.
Standard stops refers to the large
schematic painting on canvas
titled *Network of stoppages* that
Duchamp made with the intention
of photographing it from an angle
to create a perspective view of the
capillary tubes attached to the top
of the *nine malic moulds*, referred
to in the text as *the red fellows*.
Watermark on original: *Pantheon Mill*
[as are pp. 63, 65, and 92]

Truisms –

In a sp. 2 str. lines which
 intersect determine the
 pl or 2 dim. continuum

In a sp. 3 lines intersecting
 at the same pt. determine
 a 3 dim. space

In a pl. 3 lines intersecting
 do not determine a sp.
 therefore in a space 4 lines
 intersecting do not determine
 ~~the~~ hyperspace

67 Duchamp uses the word *continuum*
 in relation to one-, two-, and three-
 dimensions. Continuum becomes
 étendue when he refers to four-
 dimensional space. Since Einstein's
 special theory of relativity (1905), the
 fourth dimension has been linked
 with time [see Duchamp's footnote,
 rubric 4]. His general theory of
 relativity (1917) was made famous
 in the popular press when the 1919
 eclipse of the sun confirmed his
 prediction that gravity must bend
 light [see Duchamp's footnote to p.
 4]. Duchamp's fourth dimension is
 Jouffret's *four-dimensional geometry
 of space* [see note p. 81]. In current
 terminology *étendue* is *hyperspace*

Ceiling

A

back of shop

F

Garden

D

O

C

Court yard

E

balcony

Floor

B

Space
Hyperspace
{ see differences
defined by
n dim.
geometries

ABCDEF. Points in space to which are ~coming~ attached
(from one side, one end) the threads tangent to the new
body O. From the point of tangency these threads wind up
"snail-like" and tend towards a ~new~ new

~statify~ point of gravity.

Hence The body O 1st is tangential to the space

2nd Its shape is determined by this new point (provisional
point of gravity), whose property of distraction ~is only~
~a property~

113 The spatial model used by
 Duchamp is that of the stage in
 the French theatre. An English
 actor must learn that the right
 wing of the stage is to the right
 when facing the auditorium – this
 equates with *Jardin* in the French
 theatre; the left wing is the *Cour*
 when French performers face the
 balcon (downstage) with the *arrière
 boutique* (upstage) behind them

18.

DESIGNING THE FUTURE
AN INDUSTRIAL
DESIGNER'S PERSPECTIVE
tom karen

BIOGRAPHY

Tom Karen was born in Vienna in 1926 and grew up in Czechoslovakia. He left just before the outbreak of the Second World War in 1939, escaping to Belgium, then to France and in 1942 travelled via Lisbon to the United Kingdom. Karen studied aeronautical engineering at Loughborough College, working for the next ten years in the aircraft industry. He went on to study industrial design at the Central School, London, followed by four years in Ford's design studio from 1955. Tom Karen was the first tutor on the posgraduate Vehicle Design course at the Royal College of Art. He won the Institute of British Carriage and Automobile Manufacturers (IBCAM) national car design competition in 1958 for his radical concept, 'The Rascal' car. He joined David Ogle Associates in 1959, and then worked briefly as designer at Hotpoint and Phillips, before taking up the role of managing director and chief designer of Ogle (later Ogle Design Ltd.) in 1962, where he remained until 1999. At Ogle he was responsible for the Bush TR130 Radio, the Bond Bug and Reliant Scimitar GTE cars, an award-winning series of truck cabs for Leyland and the Kiddicraft 'Helta Skelta' marble run. His company's designs for crash test dummies particularly attracted the attention and approval of Reyner Banham, who visited the Ogle design studios. Banham had himself

trained as an engineer and recognized the dummies' contribution to safety testing, and their lifelike behaviour.

The subject of my lecture is my own background as an industrial designer – about Ogle Design, which occupied most of my working life – and some visions for the future. One of my grandfathers was the Viennese painter Arthur von Ferraris, the other an engineer who ran the family business (bricks and cement). It has been suggested that this gave me the right genes to become a successful industrial designer.

While at Ford, my design for the 'Rascal' (see Plate 34) won the Institute of British Carriage and Automobile Manufacturers (IBCAM) national car design competition in 1958.

I worked at David Ogle Associates for a spell from 1959, moving briefly to design white goods at Hotpoint and then to set up and manage the Philips design studio. One Saturday in May 1962 an ex-colleague rang me to say that David Ogle had been killed in a car crash. The following Monday, unexpectedly, I had a phone call from a director in his business inviting me to go and see him. On the Saturday I had a meeting with John Ogier and John Whitmore, who were partners in the car side of Ogle, and was offered the job of managing director and chief designer: it proved an amazing turning point in my career. When I arrived at Ogle, car-making was losing money and, on the design side, the largest client, Bush Radio, gave us six months' notice. It was not an auspicious start, but we kept Bush and wound down car-making and moved on.

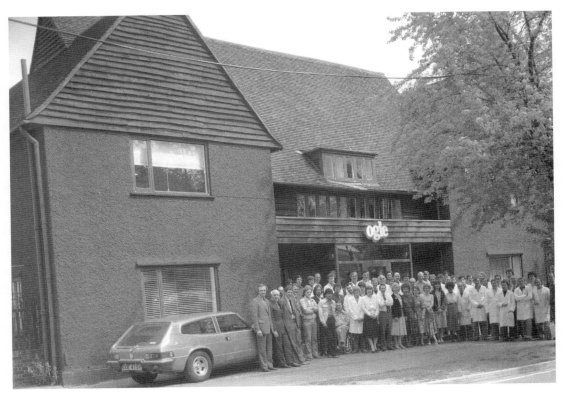

18.1. The Ogle team, 1980.

David Ogle moved the company to large premises in Letchworth in 1960 (Figure 18.2), to start manufacture of the attractive Ogle Mini and to open a model shop. We later acquired the neighbouring site, and in 1980 put up a 5,000 ft sq. building suitable for making very large models. Figure 18.1 shows all of Ogle's staff and board members in 1980 gathering outside our offices, a former Country Gentlemen's Association building, which I had remodelled and repainted in brown. My Reliant Scimitar GTE can be seen parked outside. Ogle grew steadily to become one of Britain's largest organizations specializing in product design. What was special about Ogle? We tackled an exceptionally wide range of products – from truck cabs to toys – and a very capable model and prototype department enabled us to turn a car body design into a running prototype, which no other independent UK design office could do (Figure 18.2). There was a meshing of skills with model-makers able to make a creative contribution to the design process. We produced results fast and the dedication of the team was such that they worked for twenty-four hours non-stop on some occasions.

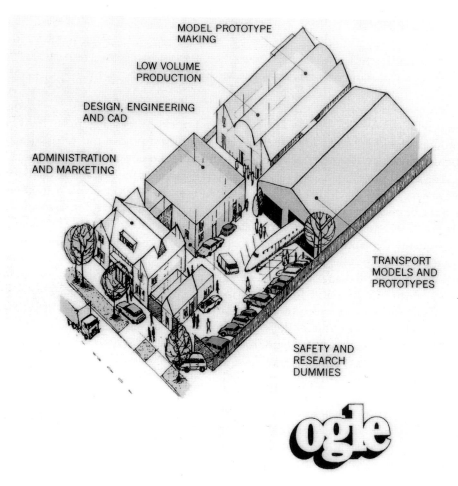

18.2. The Ogle site at Letchworth, 1980.

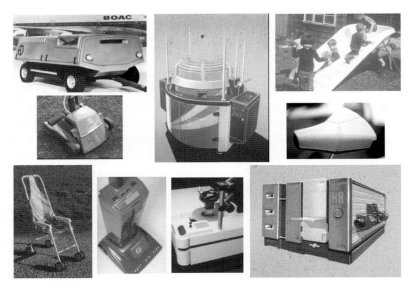

18.3. The range of Ogle products. Clockwise from top left: ground power unit for aircraft, knitting machine, children's slide, bicycle saddle, sack printing machine, workstation with microscope, vacuum cleaner, pushchair, mower.

I enjoyed tackling a very wide range of products, from trucks to toys (Figure 18.3). We gave the same attention to all of them and had major successes. For the purpose of the lecture, I majored on the more high-profile ones. Examples illustrated here are a ground power unit for aircraft, a knitting machine, a slide safe for small children, a mower, a bicycle saddle using a skinning foam technique, a folding pushchair, a vacuum cleaner, a workstation with microscope and a sack printing machine.

I designed the best-selling radio in 1960s Britain (Figure 18.4). The TR130 had a lensed window for the scale, its leatherette PVC covering produced a softening effect and the chrome die-casting gave a look of quality that appealed to buyers. We produced another radio that Bush sold in India, which became a best-seller there.

Launched in 1968, the Reliant Scimitar GTE (Figure 18.5) was the first ever sporting or Gran Turismo Estate (hence the initials). It was described by Ian Morton in the *Evening Standard* as having 'one of the most handsome and significant body lines to come out of Britain for some time', but its novel design displeased others. The long roof and 'waistline' – the line between the 'body' and the 'greenhouse', or top section of the car – rising all the way to the back has influenced almost every car to this day. The rear seats folded down flat so that the car could carry four, three or two passengers with a varying load space. The GTE also put Reliant on the map as a respected car-maker.

I liked to do speculative, exploratory work and this led us into safety research (see Plate 35): we developed and manufactured crash test dummies or mannequins. In the 1960s I set up a department for this, adding to our design and model-making activities. With Geoff Platten in charge, we worked with MIRA (the Motor Industry Research Association) – the leading independent provider of safety testing equipment – to develop a number of dummies. They had anatomically correct weight and centre of gravity for every part of the body and the right range of movements. Ogle

18.4. Bush Radio TR130.

18.5. Reliant Scimitar GTE.

18.6. The Bond Bug, 1970.

dummies were exported to every car-maker in the world that wanted to sell in Europe. Other dummies were used for rescue training and even film work.

I always wanted to design a sporting, two-seat three-wheeler (Figure 18.6). Through a great piece of luck I got the chance to create what became the Bond Bug launched in 1970: probably the most enjoyable project of my career. The first prototype we built had a body that was much simpler to build than anything Reliant (owners of Bond) had ever produced: a minimum number of components, one door, a flat windscreen with a single wiper, and every fibreglass body shell came straight out of moulds without any undercuts. I also persuaded our client to let us design the bold graphics and to paint all Bugs the same colour: orange. Although not a commercial success, there are still Bug enthusiasts all round the world.

My children were mesmerised by a fixed, wooden marble run. It occurred to me that if one of these could be assembled in different ways, it would offer a challenge before the reward (Figure 18.7). We prototyped one and sold the design to Kiddicraft, which they marketed as 'Builda Helta Skelta'. A very simple design, the toy was made up of only three tooled components. In production since 1970 and much copied, it has given pleasure to many thousands of children.

On America's West Coast, a cult had developed for a children's bicycle made by the company Schwinn. It had tall handlebars, a curvaceous frame and rugged tyres. Raleigh wanted to compete in this market and their marketing director came to us requesting a design with the same appeal, but a different flavour (Figure 18.8). I decided to focus on a large wheel and tyre for the back and a smaller one at the front, like a dragster or Formula 1 car that transmits its power through the back wheels. The frame was made up of straight tubes and the 'gear shift' was very car-like. We offered Raleigh only three or four proposals, all with the same ingredients, all very close to the final design and developed some parts for the prototype. The Chopper was launched in 1969 and became a design icon: and a generation of children either had one or desperately wanted one.

18.7. The Kiddicraft marble run.

The Aston Martin show car of 1972 (Figure 18.9) featured an all-glass roof bonded to a tubular structure (with the tube theme continued inside), the rear seat could accommodate a tall person sitting diagonally across the car, and among twenty-two lights in the back, six indicated progressive braking – the harder you braked the more lights came on – a safety feature that deserves to be used on modern cars. The Aston was much admired at international shows.

Leyland's range of truck cabs, starting with 'Roadtrain' launched in 1980 (Figures 18.10 and 18.11), won design awards for setting new standards of comfort and ergonomic design. Driving a

18.8. The Raleigh Chopper, 1969.

18.9. Aston Martin show car, 1972.

truck is a demanding job and I wanted the interior to be like that of a Porsche, with seats covered in fabric based on 'West of England' cloth from a Savile Row tailor's. Much attention was paid to ergonomics: the location and design of instruments and controls, handholds and footholds to climb up to clean the widescreen, lights to make it safe to climb out at night. To achieve the 'non-aggressive' look, the focus was on the driver, sitting behind a TV-shaped windscreen, instead of featuring a macho grille. Sausage shapes were used throughout to give a consistent theme. We did other pioneering work on commercial vehicles. Probably our greatest success is a van designed for a continental manufacturer. We did the concept, built a full-size model and proposed how the body should be made. It was launched in 2001, won numbers of design accolades and sold exceptionally well. The client's policy is not to give credit to outside agencies.

In the 1990s, we did important work in aerospace. This culminated in a proposal for a successor to the Boeing 737, seating 200 passengers and with a more refined cabin (Figures 18.12, 18.13 and 18.14). The fuselage was made up of three horizontal 'bubbles' creating more space and providing lift. A welcoming entrance had windows in the ceiling to give a feeling of 'espace vitale' and passengers would then face a coffee bar where they could stretch their legs and socialize. Overhead bins were replaced with accessible floor to ceiling racks. Telephones and Internet stations would be provided. Some seats were grouped around tables for families and friends travelling together. Cramped unisex toilets were replaced with proper ladies' and gents' cloakrooms.

To brighten London, I floated the idea, more than twenty years ago, of roofing over Regent Street with glass, pedestrianizing it and providing moving pavements down the middle, to make it the greatest shopping street in the world. Another idea was to build circular floating cities using shipbuilding techniques. These would be attractive for densely populated countries with sheltered water – Holland and Japan come to mind – where inhabitants would be safe from floods and earthquakes. In the Persian Gulf, such structures would cause minimum damage to the seabed. The world faces a very challenging twenty-first century. There are many opportunities for fresh thinking about design. Part of that will be to take more care of global resources: making virtues out of necessities, and doing so elegantly, will have to be a guiding principle.

18.10. Model of Leyland Cab proposal, 1980.

18.11. Leyland Roadtrain cab, 'sausage' theme, 1980.

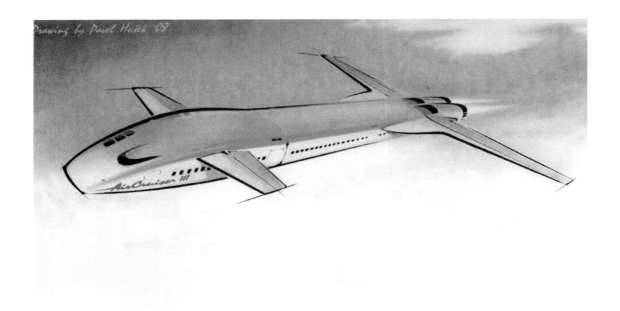

Drawing by Pavel Hušek '08

18.12. Aircruiser II, 2001 (exterior sketch).

18.13. Aircruiser II, 2001 (interior model).

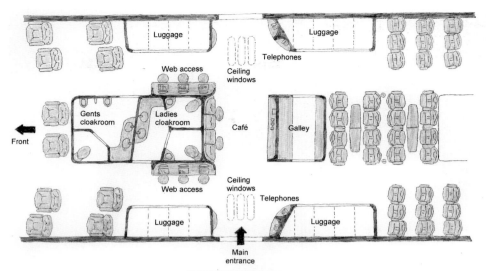

Luggage

Telephones

Web access

Ceiling
windows

Luggage

Gents
cloakroom

Ladies
cloakroom

Café

Galley

Front

Web access

Ceiling
windows

Telephones

Luggage

Luggage

Main
entrance

AIRCRUISER II Cabin plan view

18.14. Aircruiser II, 2001 (interior drawing).

ROTWANG AND SONS
THE SOUL OF THE DESIGNER IN THE MACHINE AGE

christopher frayling

The evil design genius behind the modernist *Metropolis* was called Rotwang.[1] He laid down the ground rules for future cinematic depictions of the perils of over-reaching, from Frankenstein to Dr Strangelove. H. G. Wells reacted strongly against this tendency in his film *Things to Come*, released ten years after *Metropolis*. But others had a soft spot for Rotwang. Fritz Lang went on to make *Woman in the Moon*, a celebration of modern design, with technical advice from early rocket scientists who later went on to develop the V2 missile. Dr Strangelove was a direct descendant of Rotwang, but he was also a parody of Dr Wernher von Braun, uniting two traditions of public discourse about mid-twentieth century design. This essay brings together a tight-knit series of films about the city, explores the inter-textual debate between them and relates them to a battle in the public domain over the soul of the designer. It begins with Fritz Lang's *Metropolis* (1926) and ends with Stanley Kubrick's *Dr Strangelove* (1963).

'In the middle of the city was an old house' (Figure 19.1). This title-card from *Metropolis* introduces us to the man whose inventions make the city function. Thea von Harbou's novel, on which her screenplay was based, fills in a few more details:

> There was a house in the great Metropolis which was older than the town. Many said that it was older, even, than the cathedral... Set into the black wood of the

19.1. Rotwang's old house on 113th Street (from *Metropolis*, 1926).

door stood, copper-red, mysterious, the seal of Solomon, the pentagram...It was said that a magician, who came from the East, had built the house in seven nights...but the house was stronger than the words on it, was stronger than the centuries. It hardly reached knee-high to the house-giants which stood near it. But it remained.[2]

Fritz Lang believed that 'an audience learns more about a character from detail and decor, in the way the light falls in a room, than from pages of dialogue'. This was a fashionable theory of film design in the mid-1920s – the architect Robert Mallet-Stevens wrote about it in a series of influential articles – and Lang epitomized it with his presentation of Rotwang in his house which modernity is unable to repress. In later interviews, Lang also referred to the battle, at the heart of the film *Metropolis*, between 'modern science and occultism, the science of the medieval ages. The magician was the evil behind all the things that happened'. 'I dabbled in magic', he added, 'Mrs von Harbou and I put it in the script'.[3]

Rotwang is the modern scientist who wears a belted medieval smock (Figure 19.2); his desk is lit by coils of neon light, while his shelves are crammed with worm-eaten, leather-bound folios; his pitch-roofed, gingerbread Gothic house – on 113th Street – is surrounded by high-tech skyscrapers and zigzag steel girders; his laboratory-workshop is filled with retorts on stands, neon tubes, curved vessels, diagonal electrical cables across the ceiling, arrows and chevrons and much bubbling glassware – but in the fireplace there are some bellows, like at an alchemist's, and a stuffed crocodile

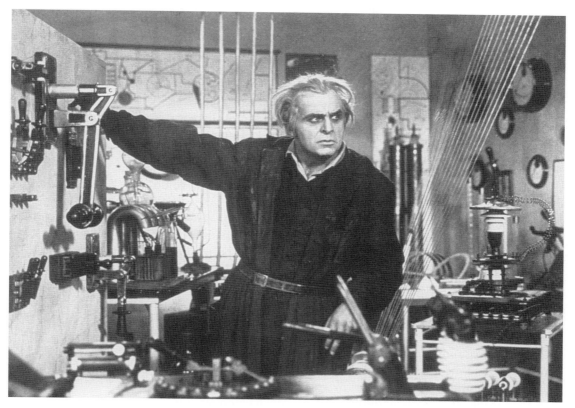

19.2. Rotwang (Rudolf Klein-Rogge) in his laboratory (from *Metropolis*, 1926).

would not be out of place. Rotwang himself has unruly white hair, and a black metal right hand – the result in the film of some unnamed laboratory accident – which protrudes like a gauntlet from his gathered sleeve. The novel, again, fills in some of the details. Apparently, the scientist's hair turned that colour when his girlfriend Hel 'went from Rotwang to Joh Fredersen, the Master of Metropolis', and then died while giving birth to her child, Freder. On his meeting Rotwang, four weeks later, Fredersen found that the dense, disordered hair over the wonderful brow of the inventor was snowy white, and in the eyes under this brow the smouldering of a hatred which was very closely related to madness.[4] The scientist admits to Fredersen that he has lost his arm, his heart and even his head.

His physical appearance is an outward and visible antithesis of the moral of the film: 'There can be no understanding between the hands and the brain unless the heart acts as mediator.'[5] The evil genius's understanding comes from somewhere else – not from harmony and balance between head, heart and hand. His house faces the cathedral, but it has no windows so he cannot see it. On the wall of the laboratory, and etched in relief on the front door, is the inverted pentagram of the magician.

Some have interpreted Rotwang as an anti-Semitic caricature of Albert Einstein complete with Star of David on his wall: but Einstein in 1926 did not yet look anything like the wild-haired celebrity of the post-war period, and the star is in fact a 'seal of Solomon' – a masonic reference.

So it is much more likely that Einstein modelled his appearance on Rotwang than that Rotwang modelled his appearance on Einstein. Still, a recent reading of *Metropolis* contends that Rotwang is 'dressed like Rabbi Loew in Paul Wegener's 1920s film *The Golem*, a cold and rational scientist … [and an] archetype of cold rationality … seen as a mortal danger to the spirit of the community [German spirituality]'.[6] This is a tempting take on the film: Thea von Harbou later enthusiastically embraced Nazism. According to her ex-husband Fritz Lang, Hitler and Goebbels loved the movie when they saw it 'in a small town', and there are sequences of choreographed mob activity – in both novel and film – which seem very frightening indeed: 'Dark, angry waves were the heads before Freder. These waves [of the mob] frothed, raged and roared. Here and there a hand shot up into the air.' In the debate about the impact of *Metropolis* on design in the real world, it has been argued that the 'Moloch' sequences, set in huge underground furnaces, could have helped prepare the visual ground for the furnaces of concentration camps.[7]

Certainly, von Harbou likes to describe the machine-city as 'wanting living men for food', its furnaces requiring 'the endless stream of human beings processed through the machine room'.[8] But the sinister implications of all these references may have been created by hindsight. Rotwang is passionate, not cold and rational. More than anything else, he resembles a medieval alchemist. Just as the film itself collides images from the avant-garde with numerous and bewildering references to ancient mythologies, so the modern city collides with its medieval origin, with a house built above the catacombs of 'the thousand-year-old dead'. It would have been very strange indeed if as early as 1926, Germany's biggest-ever film, partly pitched at the coveted American market, were to have been crass propaganda for the Nazis. It may well, on the other hand, have picked up on mid-1920s nationalism, and the fear of communism.

The literary origins of *Metropolis*, by von Harbou's own admission, lay in Oswald Spengler's then-fashionable *The Decline of the West* (1918), which emphasized the 'devilish and occult powers' of the machine as human beings increasingly attempted to control the forces of nature, and also the 'Faustian' pact which had been entered into by Western man, and especially by Western elites. This Faustian pact was like a secularized form of original sin. For Spengler, modern architecture did indeed have its roots in the cathedrals of 'the Gothic'. Such sweeping generalizations were very much to von Harbou's taste: *Metropolis*, too, was written in a broad-brush, cliché-ridden style that nevertheless absorbed ideas which were a part of the Weimar Republic. The 'social question' – whether technology would liberate or enslave; where the class struggle would lead – was certainly in the ether of Weimar Germany, as was the image of the metropolis as a 'machine-city' energized by boilers and furnaces rather than today's digital space of flows. The Czech word 'robot', meaning industrial slave labourer, had recently been coined, and a central theme of *Metropolis* was whether the performance of repetitive manual tasks could dispense with human workers altogether – substituting robotic labour, with fleshly costumes hiding their metallic insides.[9]

Rotwang was played by Rudolf Klein-Rogge, who had become a superstar as Fritz Lang's master criminal in the two-part *Dr Mabuse* of 1922. Mabuse was a brilliant, evil genius prone to insane rages who used 'all human knowledge' – especially his knowledge of science, technology and hypnotism – to exploit the dark side of indecisive contemporary society. The actor recalled, in 1926, how bizarre the Rotwang experience had been, especially the mixture of science and mysticism:

> It was strange to me, not being a technician, and one who does not know even how
> to repair an electric bell. A huge, impressive and uncanny chamber [built at the studio

in Neubabelsberg] represented the laboratory of the renowned inventor, Rotwang. Full of complicated and puzzling apparatus, machines, induction coils, resistances, switches, cables, fly-wheels, transmission tables, upon which were different formulae, boiling chemicals in bowls, tables of glass, intricate wire connections, and a number of mysterious objects. I was overcome with a very strange feeling...[10]

Klein-Rogge is here describing the most celebrated sequence in the film, when the physical likeness of the saintly Maria is somehow transposed into the robotic Maria (known in the novel as 'Futura' or 'Parody'). Rotwang has been researching for some time how to create a robotic simulacrum of his beloved Hel, but has recently decided instead to give his prototype robot the features of the virginal and maternal Maria – so that 'she' can sew mayhem among the city's workers and symbolize their redundancy on behalf of the Master of Metropolis. Exactly why Rotwang should take part in this purely destructive exercise – apart from self-hatred and sheer devilment – is never made clear in novel or film; later he will talk of bringing down the Master, his son, the workers and the entire machine-city in a cataclysmic and joyful apocalypse. At the end of the bravura transformation scene, a tent of electric rays over the genuine Maria's sleeping body – a mixture of Faustian mumbo-jumbo and high technology – turns the shapely metallic robot on the throne in front of the pentangle into a sexy *agente provocateuse*. The robot's mask was derived from a drawing for a ballet by Oskar Schlemmer – *Mask in Yellow and Black* (1923) – just as the controls in the machine room were probably based on Kurt Schmidt's Constructivist drawing, *Man at the Control-Console* (1924); the costumes for the ladies of the night in the city nightclub were taken from a Bauhaus collection by Schlemmer; and the glass statue on Joh Fredersen's coffee table was probably based on a Peter Behrens design.[11] Yet Rotwang's lair managed also to look like the *mise-en-scène* of an alchemist's laboratory. Rotwang even has a magic wand, which glows. When he waves it, the metallic robot, Maria, grows a flesh-and-blood outer skin in a form of cybernetic birth. The sequence is entirely visual; there is no dialogue, not even a title card to explain what is going on. It is not in the novel at all.

The creation scene was to inspire the equivalent moments in countless Hollywood horror movies from the early 1930s onwards – whether Colin Clive, or Bela Lugosi, or Boris Karloff, or Lionel Atwill, or Vincent Price was the one throwing the switches – but it has never been surpassed. Critics at the time, many of whom were disappointed with the film's naive social message and melodramatic plot, enjoyed it more than anything else – as an example of *Metropolis*'s visual sophistication and Fritz Lang's childlike enjoyment of high-tech devices. It was, they said, a celebration of the power of film itself.[12]

The following year, Fritz Lang featured another engineering designer – a rocket specialist – as one of the central characters in his last silent film and his last film for UFA (Universum Film AG), *Die Frau im Mond* (also known as *By Rocket to the Moon*, *Woman in the Moon* and *Girl in the Moon*). If *Metropolis* was the first big-budget science-fiction film, *Die Frau* was the original serious space travel film. In fact, the original idea had been contained in the first draft of *Metropolis* where, according to Lang, 'the son of the Master [was] to leave at the end and fly to the stars. This didn't work out in the script but it was the first idea for *Woman in the Moon*.'[13] The scientist in the story was Professor George Manfeldt (Klaus Pohl), and the film begins with him giving a spirited lecture to an audience of sceptical colleagues: 'I believe the moon is rich in gold, and that the day will come when a manned rocket will fly to the moon and bring back the gold to earth.'

Up to then, cinematic moonshots had been propelled by Jules Verne/George Méliès-style space guns. Méliès's *Le Voyage dans la Lune* (1902) had involved a bullet-shaped spaceship fired from the barrel of a mile-long cannon, like in Verne's version, *From the Earth to the Moon* (1865). Rockets were associated with the black powder variety. But in *Woman in the Moon* it was powered by mixing and burning alcohol (as a liquid fuel) and liquid oxygen (as an oxidizer) – the first modern rocket on the screen. And there were other innovations in Lang's film: the first multi-stage rocket rolled out from a huge assembly building, the first scenes of weightlessness. Willy Ley, an early rocket buff in Germany, who emigrated to New York in 1935, wrote that 'the first showing of a Fritz Lang film was something for which there was no equivalent anywhere' in terms of preparing the public for scientific possibilities and making them seem familiar or acceptable. The countdown, another first, intended to show the audience – in the cinema and via the announcer on the set – what was about to happen, was invented for *Die Frau im Mond*; Lang combined it with numerous shots of clocks and dials ticking away.

So in the year when the first major American science-fiction comic strip, called 'Buck Rogers', appeared – in newspaper form in those days, with the emphasis on hand-to-hand action and punching the evil Killer Kane for democracy on Saturn in the twenty-fifth century – Fritz Lang's film was at least making a serious effort to get its space odyssey right. The credits emphasized 'our especial thanks to Prof Hermann Oberth of Nürnberg for assistance in the preparation of the film', notably the testing and launch of the rocket. The Romanian-German Oberth, whose 1923 book *The Rocket into Interplanetary Space* had launched the whole craze for manned and unmanned spaceflight in Weimar Germany, had come to Berlin in autumn 1928 to work as Lang's 'scientific advisor' in return for Lang's help in raising money for the development of his real-life rockets programme, then in its infancy. Lang persuaded UFA film to pay for the launching of a rocket – devised by Oberth – during the premiere of the film. At the gala premiere of *Die Frau* in Berlin's West End (October 1929), the frontage of the UFA Palace cinema was covered with a gigantic animated panel showing the Earth and the moon against a starry sky and a projectile-like moon rocket making round trips between them. It was a publicist's dream.[14]

American audiences were confused by the story of *Metropolis* – especially in the cut-down version they saw – and their film critics on the whole found it far too dark and brooding. The staple Hollywood diet of movies about the future was still at the stage of low-rent serials about meteors, rejuvenation potions and mad scientists using invisible rays to shoot down flying machines. So Hollywood's reply to *Metropolis* (explicitly reviewed as such by German critics) was much more cheerful, gleaming and upbeat.[15] *Just Imagine* (David Butler, 1930) was planned just before but released at the beginning of the Depression. It featured a fully electrified skyscraper city in the year 1980, where everyone travels by helicopter or air taxi: there are nine levels of traffic and Irish cops in the sky directing it. *Just Imagine*, the first ever science-fiction musical with lots of jolly songs about the good old days, was a box office disaster. Its relentless jollity seemed out of place following the stock market crash, and its storyline about young lovers proving themselves, giggling Martian twins in silver Deco outfits, and jokes about a twinkling fun city of the future already seemed dated in 1930. *Just Imagine* put Hollywood off big budget science-fiction films for a generation, ghettoising the genre into serials and comic strips. This was Hollywood's response to *Metropolis*.

In London, meanwhile, H. G. Wells was also confused by *Metropolis*. He first saw the film at the London Film Society and in a fury penned a review which described its vision of the future as 'the silliest imaginable':

It gives in one eddying concentration almost every possible foolishness, cliché, platitude and muddlement about mechanical progress and progress in general served up with a sauce of sentimentality that is all its own...[16]

Wells did not like 'ultra-skyscrapers' and a city sectored into box-like workers' dwellings (down below), the consumer base (street level) and rococo pleasure gardens for the bosses (up above); he did not like zombie-like ranks of operatives shuffling to work in shifts of ten hours, and the projection of mid-1920s labour disputes into the future ('the hopeless drudge stage ... will lie behind us', he said), and he did not like the bustle and chaos of contemporary New York nightlife writ large in a story purporting to take place in the future. Above all, he did not like Rotwang and his great experiment, which to Wells was 'the crowning imbecility of the film'. 'By some abominable means Rotwang has squeezed a vast and well-equipped modern laboratory into this little house. It is ever so much bigger than the house, but no doubt he has fallen back on Einstein and other modern bewilderment.' German cinema, he added, tended to feed 'a national fantasy which capers forever with a broomstick between its legs'.[17]

When, seven years later, H. G. Wells had the opportunity to reply to *Metropolis* – in his own big budget film – with help from director William Cameron Menzies and designer Vincent Korda, he opted for a shiny white, underground, hygienic city centre which looks like a vast hotel atrium rather than the 'ultra-skyscrapers' of *Metropolis*; a city in which technology has liberated city-dwellers from drudgery and where the planning is very loosely based on the radical urban surgery proposed by Le Corbusier (Figure 19.3). At the start of filming *Things to Come* Wells wrote to the design team:

> ...in the final scenes we are presenting a higher phase of civilization than the present, where there is greater wealth, finer order, higher efficiency. Human affairs in that more organised world will not be hurried, they will not be crowded, there will be more leisure, more dignity. The rush and jumble and strain of contemporary life due to the uncontrolled effects of mechanism, are not to be raised to the *n*th power. On the contrary they are to be eliminated. Things, structures in general, will be great, yes, but they will not be monstrous. ALL THE BALDERDASH ONE FINDS IN SUCH A FILM AS FRITZ LANGE'S [SIC] *METROPOLIS* ABOUT ROBOT WORKERS AND ULTRA SKYSCRAPERS ETC. SHOULD BE CLEARED OUT OF YOUR MINDS BEFORE YOU WORK ON THIS FILM. As a general rule you may take it that whatever Lange did in *Metropolis* is the exact contrary of what we want done here...

This memo was published in the *New York Times* on 12 April 1936, and as an appendix to Wells's book version of the film. By then, Wells knew that the finished film had not lived up to his huge expectations, that his own inexperience in the medium had led him to confuse 'sequences which slipped quite easily from my pen' with sequences which would be straightforward to film, and that, frankly, on screen the people living in his city of the future resembled nothing so much as 'celluloid dolls living on tabloids in a glass lavatory'. So his memo was a classic example of getting his own punch in first – before the critics and the public.

Wells wanted *Things to Come* – the first British epic of its kind – to present a positive view of the future and the benefits to be gained from new technology, sources of energy and planning. He wanted 'a spectacular cosmopolis ruled by men of science and affairs'. But he had never written for mainstream cinema before. This extract from the huge original treatment describes the rebuilding

19.3. Cabal (Raymond Massey) and his freemasonry of science plan the future of the planet (from *Things to Come*, 1936).

of Everytown after the obliteration of aerial bombing of 1936 and subsequent sleeping sickness; it shows the image of science that Wells desperately wanted to communicate:

> A triumphant musical sequence ... a sequence of creative work and power. Flashes to give a crescendo of strenuous activity ... This will have to be drawn from contemporary stuff, but that stuff must be *futurised* by putting unfamiliar flying machines in the air, projecting giant machines in the foreground, making great discs and curved forms swing and rotate enigmatically before the spectator. Emphasize by banners, streamers and inscriptions:

> RESEARCH
> INVENTION
> WORLD PLANNING and
> SCIENTIFIC CONTROL

> There is a progressive improvement in ... the neatness and vigour of the machinery as the series goes through.[18]

So, not Rotwang in his alchemist's lair; but a 'freemasonry of science' rebuilding a much more rational and efficient world. The Bauhaus teacher and artist László Moholy-Nagy – who was in London at the time – contributed a few visual ideas, but most of them ('no walls but skeletons of

steel, screened with glass and plastic sheets') proved too abstract to be of much use. Le Corbusier himself was approached, but politely declined saying that he thought the people living in the city of tomorrow were far too old-fashioned and preachy in their attitudes and besides he wasn't too fond of underground cities. In the end the architecture of Everytown 2036 – built on the rubble of Everytown 1936 – was derived by Vincent Korda from Norman Bel Geddes's *Horizons* (1932) plus parts of Le Corbusier's *Vers une architecture* (1923), while the plastic or rhodoid furniture was based on items from the latest Heal's catalogue.[19] The resulting underground piazza looked like a gigantic white ribcage.

The most controversial invention of the new regime, though, was the space gun (Figure 19.4) that propels the young couple into outer space at the spectacular climax of *Things to Come*: its

19.4. The space gun, based on H. G. Wells's written instructions (from *Things to Come*, 1936).

design was closely based on H. G. Wells's written instruction that it provide a visual balance to the destructive technology of the opening air raid, with its smaller-scale anti-aircraft gun pointing towards the stars from Everytown Square. The transformation scene would 'balance the first war crescendo' in the same way. So the audience would experience first the negative, then the positive. But ignoring the deep symbolism, the *Journal of the British Interplanetary Society* pitched in with the comment that the huge bullet-shaped projectile was 'based on an outstanding misconception' in that it would exert a force of about 435 tons on each of the astronauts and immediately reduce them to raspberry jam; no scientist had seriously considered the 'gun' idea of space travel 'since the days of Jules Verne'. There was even a cinematic precedent for an explosion-boosted rocket in 1929's *Woman in the Moon*. H. G. Wells, with his much-publicized views on the dreaded Fritz Lang, would not have been amused.[20]

But perhaps the most significant impact of *Metropolis* and *Woman in the Moon* was back home in Germany, and not just within film. A visitor to the secret German rocket centre at Peenemünde on the Baltic coast about 250km north of Berlin, in summer 1943, was to describe his first view of the A-4 missile, which was soon to be renamed by the Nazi Ministry of Propaganda as The Vengeance Weapon 2 (popularly known as the V-2), the world's first supersonic ballistic missile and the first to be fired in anger:

> I saw them – four fantastic shapes but a few feet away, strange and towering above us in the subdued light. I could only think they must be out of some science fiction film – *Die Frau im Mond* brought down to Earth. I just stood and stared, my mouth hanging open for an exclamation that never emerged… They fitted the classic concept of the space ship – smooth, torpedo-shaped … resting tip-toe on the points of four swept cruciform fins… They were 46 feet tall and by all odds bigger than anything I had ever dreamed of.[21]

The reference to *Die Frau im Mond* was not fanciful. On 3 October 1942, the first fully successful launch of an A-4 rocket had taken place from Peenemünde: it travelled 190km, reached a height of 80km, and in the process broke all the existing world records for speed and altitude. On the side of the rocket was painted the *Die Frau im Mond* logo, which had often been used – in an aspirational way – during the research stage.[22] Fritz Lang's film had directly led to the formation of the most important gathering of rocket specialists in late Weimar Germany – the *Raketenflugplatz* or Rocketport group, who met in northern Berlin. Among its most enthusiastic members was the eighteen-year-old Wernher von Braun who – some sources claim – had already helped out on the set of *Die Frau im Mond* as 'one of Hermann Oberth's assistants'. Within a few years, von Braun and several of his early colleagues would be experimenting in strict secrecy with larger-scale rockets for German army ordnance, and all amateur rocket groups would be forcibly suppressed. By 1937, von Braun would be technical director of hundreds of employees at the military research and development centre on the Baltic coast. By spring 1943, he was managing 'detainees' from concentration camps in the underground A-4 factory near Nordhausen in Thuringia, including from a branch of Buchenwald called Dora.[23] The designer of this huge underground facility was Hans Kammler, the SS engineer who also created the crematoria at Auschwitz. By autumn 1944, some 3,225 of von Braun's V-2 rockets had been fired at London and Antwerp, killing more than 4,000 civilians.

Two days after Hitler's suicide, on 2 May 1945, Wernher von Braun negotiated his surrender to the Americans in Bavaria. One of the engineers on his team explained the thinking behind this

move: 'We despise the French, we are mortally afraid of the Soviets, we do not believe the British can afford us; so that leaves the Americans.' The V-2 may not, in the end, have turned out to be the super-weapon Hitler had hoped it would be, but the advancing Allied powers, as well as von Braun himself, fully understood its longer-term importance. Fourteen tons of archive, hidden down a secret mine shaft, were part of the negotiation. Wernher von Braun flew to the United States in September 1945. He was followed there by 120 Peenemünders, hand-picked by himself, who joined him in Fort Bliss near El Paso, Texas, to work for the US Army. By April 1946, V-2s were being test-launched at White Sands Proving Ground, New Mexico. By 1950 the group had transferred to Huntsville Alabama, where they rapidly became the pace-setting rocket development team – under von Braun's direction – in the USA.[24]

In the relocation process, the A-4/ V-2 became the mother and father of all subsequent guided missiles and space booster vehicles. The rocket had travelled the 300 miles to London; why couldn't it now travel upright into space? Von Braun simply adapted his style of design management – minus the slave labour of course – to his adopted culture. Von Braun soon realized that his talents as a showman would have to be used to persuade government to fund an independent space programme.[25] He had already started work on a novel about a mission to the planet Mars, and completed it in the early 1950s: the novel did not succeed in finding a publisher, but the appendix – full of technical data – was separately published as *The Mars Project* (1955). In 1958, he published a fictional account of the *First Men on the Moon*, which was reprinted in *Reader's Digest* early in 1961. He was also involved in an influential series of articles in *Collier's Magazine*, beginning in March 1952, focused on conquest of space, as space exploration was then known.[26] Von Braun's infectious enthusiasm, plus his cold war drum-beating about how the Soviets might get there first, soon attracted the attention of another showman who – much more than von Braun at the time – had his finger on the pulse of America: Walt Disney.

In spring 1954, shortly after the *Collier's* series of articles ended, Walt Disney was urgently seeking material for the *Tomorrowland* segments of his weekly television programme which would begin broadcasting on the ABC network later that same year.[27] The first of the programmes, *Man in Space*, was broadcast on 9 March 1955. It opened with the kindly face of Walt Disney himself, standing in the studio library with a model rocket, in V-2 style, in his hand. There followed a tracking shot of the 'Science Department' of the Disney organization – models of rockets, drawing boards, shirt-sleeved draughtsmen, and people in lab coats. In fact, this 'Science Department' was a promotional concept that never existed, but which, in the words of historian Mark Langer, consisted of 'the corner of a studio set' where male and female extras posed as studio science workers.[28] Then, it was the turn of 'one of the foremost exponents of space travel, Dr Wernher von Braun' – who, looking a little awkward in a trim white shirt and red tie, standing in front of a whiteboard, explained the thinking behind the prototype design of his 'four-stage orbital rocket ship' with help from Disney's animators. He concluded with the punch line: 'If we were to start today on an organized and well-supported space programme, I believe a practical passenger rocket could be built and tested within ten years'.[29]

Meanwhile, von Braun helped Disney to design the 80ft-high needle-nosed rocket – a one-third scale model of an atomic spacecraft – that welcomed Disneyland visitors to Anaheim into the 'Trip to the Moon' ride, an attraction which itself drew heavily on the television programme. And von Braun helped to design the ride itself. It was all part of his campaign to attract public support and government funding – and it worked. It was also part of his campaign to do something about his

image problem. 'Rocket science' became a synonym for 'difficult to understand' at around this time – and von Braun would do something about that, too.

In 1958, the year that Wernher von Braun published his *First Men on the Moon*, British novelist Peter George (under the pseudonym of Peter Bryant) published *Two Hours to Doom* – later retitled *Red Alert* – a suspense novel about a maverick strategic air command general who is suffering a nervous breakdown and as a result orders a flight of bombers to attack Russia; the governments of both nations try to recall and stop the attack, but one B-52 carrying two 15-megaton bombs gets through. *Two Hours to Doom*, which takes place between 09.45 and 12.15 GMT on one nightmare of a day, concludes with the hope that such a mistake could never happen again and that a nuclear treaty can be signed as quickly as possible.[30]

Director Stanley Kubrick, having recently made one important anti-military statement in *Paths of Glory* (1957), set on the French battlefront of the First World War, had become fascinated by the idea of 'a nuclear war being started by accident or madness'. He felt personally vulnerable, he said. By the time he came across *Red Alert* in 1961, the idea of an accidental war was very much in the news.[31] Kubrick at first tried to transpose the serious, suspenseful tone of *Red Alert* – complete with much technical data about planes and bombs – into a screenplay that was 'a straightforward melodrama'. Peter George was an ex-RAF officer who knew a lot about aircraft and their crews: he had recently become active in the Campaign for Nuclear Disarmament. But somehow the idea of accidental global annihilation was too outrageous and fantastic for melodrama. It was 'a hideous joke'. As Kubrick later said, 'How the hell could the president ever tell the Russian premier to shoot down American planes? Good Lord, it sounds ridiculous.' So, the straightforward adaptation of *Red Alert* was abandoned and first the playwright Jules Feiffer and then the novelist Terry Southern supplemented the collaboration with Peter George. 'Black humour', said Terry Southern, 'was the way to go', and the story turned into a high-octane political cartoon – full of grotesque characters in realistic settings, increasingly manic comedy as the crisis escalates, and dark satire at the expense of the political and military powers that be.[32] In the novel, there were basically three settings – the airbase, the cabin of the B-52 and the war room – and the film was shot in a variety of styles to suit them: documentary realism, extreme close-ups and German expressionism. This latter style was reserved for the title character, the scientist-strategist or 'nuclear wise man' whom Kubrick invented for the film, *Dr Strangelove*, with his subtitle: or *How I Learned to Stop Worrying and Love the Bomb*.

The character of Strangelove (see Plate 36) is a reincarnation of Rotwang from *Metropolis*, just as the cavernous war room set in which he operates was partly based on Berlin-born film designer Ken Adam's memories of having seen *Metropolis* in the mid-1930s: *Metropolis*, he said, was part of 'the foundation of my visual education'.[33] The war room is one part concrete bomb shelter, one part oval light-ring illuminating a global poker game, one part animated map or scoreboard showing the flight paths of nuclear weapons, and three parts paranoia. And Strangelove, with his black-gloved right hand, crimped white hair – a lock of which falls over his forehead as he does his terrifying calculations – and his strange love of apocalyptic destruction – his displacement of mega-deaths into desire – is the Rotwang of the nuclear age. Both thrive on mass destruction. But that gloved arm suffers from an involuntary jerk which keeps threatening to 'Sieg Heil' the president at unexpected moments, as if, in Peter Sellers's words, 'the arm hated the rest of the body for having made a compromise – that arm was a Nazi'.[34] Some commentators have referred to the character as 'a composite figure, comprising elements of... Edward Teller and Henry Kissinger'.[35] But Stanley Kubrick was to recall that 'neither Peter [Sellers] nor I had ever *seen* Kissinger before the film was

shot': Kissinger was one of Kennedy's security advisers at the time, and was not yet in the public eye.[36] As to Edward Teller, the father of the hydrogen bomb and archetypal scientist-strategist of the period, apart from the idea of an apocalyptic 'nuclear wise man' there are no parallels with the character of Strangelove: Teller was obsessed with security, the product of his own Jewish childhood in Budapest during the rise of Nazism; he felt more deeply than most 'how horribly precarious life can be' and his solution lay in mind-bogglingly powerful hydrogen fusion weapons. Kubrick would *never* have transformed this man into an unreconstructed Nazi. Teller has been called 'the real Dr Strangelove' – partly because of his connection with the super-bomb, partly because of his strong views on the Red Menace and partly because of the way he tended to treat his senior scientific colleagues. All very interesting, but nothing to do with Peter Sellers's portrayal in the film.

Peter George was as explicit as he dared to be, that Strangelove was without question a wheelchair-using version of Wernher von Braun. His novelization of the screenplay (this time under George's real name) was published late in 1963; its part-serious, part-comic tone is mid-way between *Red Alert* and Kubrick's finished film:

> Doctor Strangelove ... had long exerted an influence on United States defence policy. He was a recluse and perhaps had been made so by the effects of the British bombing of Peenemünde, where he was working on the German V-2 rocket. His black-gloved right hand was a memento of this. He was not sure whether he disliked the British more than the Russians...[37]

Ken Adam confirms that both Stanley Kubrick and Peter Sellers had Wernher von Braun in mind when they shaped the character of Dr Strangelove.[38] His appearances are filmed in expressionist style, as he enters the action from darkness or is given a halo by the oval light-ring. The rest of the film – outside the war room – is filmed in a more documentary style. Strangelove is first seen in the background, when the president utters his immortal line to the squabbling advisors: 'Gentlemen, you can't fight in here. This is the war room.' The scientist's final appearance shows him drawing strength from the nuclear holocaust, so that at the very moment of ignition he can propel himself out of his chair, take one small step for humanity and shout the line 'Mein Führer – I can walk!' His strange love of mass destruction has created this miracle. It is a crazy parody of an erection, as Strangelove at last regains some minimal contact with his own body – uniting head, heart and hand. Peter Sellers's increasingly excitable accent between these two moments seems partly based on a viewing of Wernher von Braun's performance in Disney's *Man in Space*. The New York photographer Weegee, who specialized in high-contrast pictures of murder scenes, was employed by Kubrick as a technical consultant on the black-and-white cinematography of *Dr Strangelove*. Some have suggested that Sellers's accent as the scientist was based on Weegee's German-New York intonations. But Dr Strangelove isn't New York: he is parody German – learning – English. Von Braun is a much more likely source.[39]

Dr Strangelove – or Rotwang plus von Braun – has retained his impact into the age of inter-continental ballistic missiles and the strategic defence initiative rather than bombers as the first line of defence, and into an era when fears of terrorism have taken over from fears of accidental nuclear war; Strangelove and his war room. When President Reagan first came into office, he is said to have asked for directions to the Pentagon war room – so real was Ken Adam's concept of what it must look like.[40] In fact there isn't one. It is a bizarre fact that Ken Adam and Wernher von Braun both studied at the same school in Berlin – the Französische Gymnasium – at the same time in the early

1920s, though not in the same year. One went on to design *Dr Strangelove*; the other became the model for the title character. The continuation of the dynasty of Rotwang and sons was assured. A tight-knit series of films about the city, starting with *Metropolis* and ending with *Dr Strangelove* – both of them films which feature crazy designers who conjure up gigantic energies, sorcerers who are no longer able to control the powers of the underworld they have called up by their spells – represents at one level an inter-textual debate about the very soul of the designer in the machine age.

NOTES

1. This essay began life as the Reyner Banham Memorial Lecture given at the V&A Museum, London, on 17 October 2003. Reyner Banham was one of the first to promote the history of design as an area for serious study, his writings in *New Society* between 1965 and 1988 anticipate almost the whole agenda of today's 'cultural studies' and his *Theory and Design in the First Machine Age 1922–1988* (Oxford: Butterworth Architecture, 1960) remains one of the great scholarly polemics in support of modernism.
2. T. von Harbou, *Metropolis* (London: The Readers' Library, 1927), pp.55–56.
3. See P. Bogdanovich, *Fritz Lang in America* (London: Studio Vista, 1967), p.124. On Lang's views about 'detail and decor', see also D. Neumann, *Film Architecture – Set Design from Metropolis to Blade Runner* (Munich and New York: Prestel, 1996), pp.94–103. Mallet-Stevens's collected essays on film design are in R. Mallet-Stevens, *Le décor au cinéma* (Paris: Séguier, 1996), esp. pp.11–30. An interesting variation on the 'magician' theme is in T. Gunning, *The Films of Fritz Lang* (London: BFI, 2000), pp.64–68.
4. See T. von Harbou, *Metropolis*, pp.59–61.
5. Ibid.
6. Citation of Anton Kaes in T. Elsaesser, *Metropolis* (London: BFI Film Classics, 2000), p.56.
7. See, for example, Elsaesser, *Metropolis*, pp.47–49.
8. See T. von Harbou, *Metropolis*, pp.42–50.
9. On other sources of *Metropolis*, see Elsaesser, pp.12–15 and on the 'social question' pp.42–44.
10. R. Klein-Rogge, *The Creation of the Artificial Human Being* (in *Metropolis* premiere presentation brochure (London: UFA/Wardour Film Ltd., Marble Arch Pavilion, 1927), unpaginated.
11. See Elsaesser, *Metropolis*, pp.17–22.
12. See Gunning, *The Films of Fritz Lang*, pp.64–68.
13. In Bogdanovich, *Fritz Lang*, pp.125–26.
14. See M. J. Neufeld, *The Rocket and the Reich – Peenemünde and the Coming of the Ballistic Missile* (New York: The Free Press, 1995), p.5 (the premiere), pp.11–13 (Oberth's rocket) and pp.5–16 (Oberth). See also W. von Braun and F. I. Ordway III, *History of Rocketry and Space Travel* (London: Nelson, 1966), pp.40–60.
15. On *Just Imagine*, see Neumann, *Film Architecture*, pp.112–15.
16. See C. Frayling, *Things to Come* (London: BFI, Film Classics, 1995), pp.45–50.
17. Ibid.
18. The original treatment, together with the release script, is in L. Stover, *The Prophetic Soul – a reading of H. G. Wells's 'Things to Come'* (North Carolina: McFarland, 1987). For the rebuilding of Everytown sequence, see pp.157–58 and pp.261–67.
19. On the design of *Things to Come*, see Frayling, *Things to Come*, pp.62–65, 67–75. For Moholy-Nagy's contribution, see T. Senter, 'Moholy-Nagy's English Photography' (in *Burlington Magazine*, no. 944, November 1981, pp.659–71).
20. See Frayling, *Things to Come*, pp.65–67.
21. See Neufeld, *The Rocket and the Reich*, pp.1–3.

22. On the *Frau im Mond* logo, see Neufeld, *The Rocket and the Reich*, pp.68, 164.

23. On von Braun and the early rocket programme, see Neufeld, *The Rocket and the Reich*, pp.23–39, pp.48–58; also von Braun and Ordway, *History of Rocketry*, pp.64–84. This rocket programme is still very controversial in the literature. The controversy is summarized in T. Gehrels, *Of Truth and Consequences* (*Nature*, 372(8) (December 1994): 571–72) and T. Radford, *Cosmic!* (*London Review of Books*, 5 March 1998, pp.13–14). On von Braun, Hitler and Buchenwald see Neufeld, *The Rocket and the Reich*.

24. On von Braun's surrender and matters arising, see Neufeld, *The Rocket and the Reich* pp.258–60, 267–71.

25. See H. E. McCurdy, *Space and the American Imagination* (Washington: Smithsonian Institution, 1997) pp.29–30. McCurdy relates this to von Braun's German experiences on pp.14–15, 22–24.

26. See McCurdy, *Space and the American Imagination*, pp.35–41.

27. On Walt Disney and *Man in Space*, see S. Watts, *The Magic Kingdom – Walt Disney and the American Way of Life* (Boston and New York: Houghton Mifflin Co., 1995), M. Langer, 'Why the Atom Is Our Friend – Disney, General Dynamics and the USS Nautilus' (*Art History*, 18(1) (March 1995): 63–96; and McCurdy, *Space and the American Imagination*, pp.41–45.

28. See M. Langer, ibid.

29. Wernher von Braun in *Man in Space* (Walt Disney Productions, 1955), first broadcast 9 March 1955.

30. P. Bryant (Peter George), *Two Hours to Doom* (London: TV Boardman, 1958).

31. On the political context for this, see M. Coyne, 'Seven Days in May' in A. Aldgate, J. Chapman and A. Marwick (eds.), *Windows on the Sixties*, (London: IB Tauris, 2000), pp.70–87. Also G. W. Linden on *Dr. Strangelove* in J. G. Shaheen (ed.), *Nuclear War Films* (Carbondale, IL: Southern Illinois University Press, 1978), pp.58–67, and T. Christensen, *Reel Politics* (New York and Oxford: Basil Blackwell, 1987), pp.111–17.

32. On the genesis of the film *Dr Strangelove* see A. Walker, *Stanley Kubrick, Director* (London: Weidenfeld and Nicolson, 1999) pp.114–58; P. McGilligan, *Backstory 3 – Interviews With Screenwriters of the 1960s* (Berkeley and London: University of California Press, 1997), pp.376–79; and E. Sikov, *Mr Strangelove – A History of Peter Sellers* (London: Sidgwick and Jackson, 2002) pp.189–99.

33. Author's conversation with Ken Adam, 10 July 2003; see also D. Sylvester, *Moonraker, Strangelove and Other Celluloid Dreams* (London: Serpentine Gallery, 1999) pp.68–70.

34. Sikov, *Mr Strangelove*, p.194.

35. For example, R. D. Haynes, *From Faust to Strangelove* (Baltimore and London: Johns Hopkins University Press, 1994), p.199.

36. Sikov, *Mr Strangelove*, p.194.

37. P. George, *Dr Strangelove Or: How I Learned to Stop Worrying and Love the Bomb* (London: Transworld Publishers, 1963), pp.34–35. To clinch it, on p.141 Strangelove refers slightingly to the 'so-called concentration camps'.

38. Author's conversation with Ken Adam, 8 July 2003.

39. On the Weegee thesis, see Sikov, *Mr Strangelove*, pp.193–94.

40. Author's conversation with Ken Adam, 10 July 2003.

CONTRIBUTORS

Harriet Atkinson is Research Fellow in Design History at the Royal College of Art, London.

Jeremy Aynsley is Professor of Design History at the Royal College of Art, London.

Mary Banham is an artist, editor and curator.

Paul Barker is a writer and broadcaster, and is former editor of *New Society*.

Tim Benton is Professor of Architectural History at the Open University.

Peter Cook is an architect and Professor of Architecture at The Bartlett School of Architecture, University College London.

Beatriz Colomina is Professor of Architectural History at Princeton University.

Elizabeth Collins Cromley is Professor of Architectural History at Northeastern University, Boston.

Frank Dudas is an industrial designer and design educator, and was a founding partner of industrial design firm Dudas Kuypers Rowan Ltd.

Adrian Forty is Professor of Architectural History at The Bartlett School of Architecture, University College London.

Christopher Frayling is Professor of Cultural History and Rector of London's Royal College of Art.

Richard Hamilton is a leading British artist.

Mark Haworth-Booth is Visiting Professor of Photography at the University of the Arts, London.

Tom Karen is an industrial designer and was previously managing director and chief designer of Ogle Design Ltd.

Pat Kirkham is Professor of Design History at the Bard Center for Studies in the Decorative Arts, New York.

Tomás Maldonado is Professor Emeritus at the Polytechnic of Milan.

Jeffrey L. Meikle is Professor of Art History and American Studies at the University of Texas at Austin.

Gillian Naylor was Professor of Design History at the Royal College of Art, London, and a founding member of the joint RCA/ V&A History of Design course.

Cedric Price (1934–2003) established Cedric Price Architects in 1960 and was an influential writer and thinker on architecture.

Charles Saumarez Smith is secretary and chief executive of the Royal Academy, London.

Ruth Schwartz Cowan is the Janice and Julian Bers Professor of the History and Sociology of Science at University of Pennsylvania.

Penny Sparke is Professor of Design History and Pro Vice-Chancellor (Research and Enterprise) at Kingston University, London.

SELECT BIBLIOGRAPHY OF WRITINGS ON PETER REYNER BANHAM, 1988–2009

This bibliography covers the period since Peter Reyner Banham's death in 1988. It does not, therefore, include his own writings (which are listed at length in the bibliography of Mary Banham et al., *A Critic Writes*, which covers the period up to 1990). Instead, it focuses on writings about Banham and his context, in the English language.

JOURNAL ARTICLES

Banham, Reyner, 'A Black Box: The Secret Profession of Architecture', *New Statesman and Society* (12 October 1990): 22–25.

Bluestone, Daniel, 'Academics in Tennis Shoes: Historic Preservation and the Academy', *The Journal of the Society of Architectural Historians*, 58(3) (September 1999): 300–303.

Dimendberg, Edward, 'The Kinetic Icon: Reyner Banham on Los Angeles as Mobile Metropolis', *Urban History*, 33 (2006): 163–76.

Grieve, Alastair, '"This is Tomorrow", A Remarkable Exhibition Born From Contention', *The Burlington Magazine*, 136(1093) (April 1994): 225–32.

Margolin, Victor, 'Design History or Design Studies: Subject Matter and Methods', *Design Issues*, 11(1) (spring 1995): 4–15.

Michael, Vincent, 'Reyner Banham: Signs and Designs in a Time Without Style', *Design Issues*, 18(2) (spring 2002): 65–77.

Mitchell, Edward, 'Lust for Lifestyle', *Assemblage*, 40 (December 1999): 80–88.

Myers, Julian, 'The Future as Fetish', *October*, 94 (autumn 2000): 62–88.

Neumann, Eva-Marie, 'Architectural Proportion in Britain 1945–1957', *Architectural History*, 39 (1996): 197–221.

Poute, Alessandra and Marissa Trubiano, 'The House of Light and Entropy: Inhabiting the American Desert', *Assemblage*, 30 (August 1996): 12–31.

Schumacher, Thomas L, 'Architectural Paradise Postponed', *Harvard Design Magazine* (Fall 1998).

Vidler, Anthony, 'Toward a Theory of the Architectural Program', *October*, 106 (fall 2003): 59–74.

Vidler, Anthony, 'Still Wired After All These Years?' *Log*, 1 (fall 2003): 59–63.

Whiteley, Nigel, 'Banham and "Otherness": Reyner Banham (1922–1988) and his Quest for an Architecture Autre', *Architectural History*, 33 (1990): 188–221.

Whiteley, Nigel, 'Olympus and the Marketplace: Reyner Banham and Design Criticism', *Design Issues*, 13(2) (summer 1997): 24–35.

Whiteley, Nigel, 'Modern Architecture, Heritage and Englishness', *Architectural History*, 38 (1995): 220–37.

Whiteley, Nigel, 'Design History or Design Studies', *Design Issues*, 11(1) (spring 1995): 38–42.

Whiteley, Nigel, 'Learning from Las Vegas and Los Angeles and Reyner Banham', *Visible Language*, special issue on 'Relearning from Las Vegas', 37(3) (2003): 314–30.

Wigley, Mark, 'The Architectural Cult of Synchronisation', *October*, 94 (autumn 2000): 31–61.

BOOKS

Banham, Reyner, *A Critic Writes: Essays by Reyner Banham*, selected by Mary Banham, Paul Barker, Sutherland Lyall and Cedric Price (Berkeley: University of California Press, 1996).

Forty, Adrian, 'Reyner Banham, "one partially Americanized European"', in Louise Campbell (ed.), *Twentieth-Century Architecture and its Histories* (London: Society of Architectural Historians of Great Britain, 2000).

The Institute for Contemporary Art, *Modern Dreams: The Rise and Fall and Rise of Pop* (Cambridge, MA: MIT Press, 1988).

Massey, Anne, *The Independent Group: Modernism and Mass Culture in Britain 1945–1959* (Manchester: Manchester University Press, 1995).

Maxwell, Robert, 'Banham – Historian', and 'Banham – the Man', in Maxwell's *Sweet Disorder and the Carefully Careless: Theory and Criticism in Architecture* (Princeton, NJ: Princeton Architectural Press, 1993).

Ockman, Joan (ed.), *Architecture Culture 1943–1968: A Documentary Anthology* (New York: Rizzoli, 1993).

Pawley, Martin, *Theory and Design in the Second Machine Age* (Oxford: Basil Blackwell, 1990).

Robbins, David (ed.) *The Independent Group: Postwar Britain and the Aesthetics of Plenty* (Cambridge, MA: MIT Press, 1990).

Vidler, Anthony, introduction to the reprint of Reyner Banham, *Los Angeles: The Architecture of Four Ecologies* (Berkeley: University of California Press, 2000).

Vidler, Anthony, 'Futurist Modernism: Reyner Banham', Part 3 in Vidler, *Histories of the Immediate Present: Inventing Architectural Modernism* (Cambridge, MA and London: MIT Press, 2008).

Whiteley, Nigel, *Reyner Banham: Historian of the Immediate Future* (Cambridge, MA and London: MIT Press, 2002).

Whiteley, Nigel, 'The Puzzled *Leiber Meister*: Pevsner and Reyner Banham', in Peter Draper (ed.), *Reassessing Nikolaus Pevsner* (London and Burlington: Ashgate, 2004).

THESIS

Erten, Erdem, 'Shaping "The Second Half Centruy": *The Architectural Review* 1947–1971'. Ph.D. dissertation, History and Theory of Architecture, MIT, 2004.

LIST OF PLATES AND ILLUSTRATIONS

1.9. Office in the City National Bank of Tuscaloosa, USA, from 'L'Art décoratif d'aujourd'hui', *L'Esprit nouveau* No. 24, June 1924. © Foundation le Corbusier.

1.10. The liner *Aquitania* compared to Notre Dame, the Tour St Jacques, the Arc de Triomphe and the Hotel Crillon in Paris, *L'Esprit nouveau* No. 8, May 1921, p.847. '*Des yeux qui ne voient pas: les paquebots*'. © Foundation le Corbusier.

1.11. Page of notes for the lecture at Lausanne, February 1924. © Foundation le Corbusier.

1.12. One of Le Corbusier's boxes of slides for his American lecture tour in 1935. © Foundation le Corbusier.

1.13. Cover of proceedings of the conference 'Design 1900–1960', Newcastle 1975.

1.14. Page spread from 'Detroit Tin Revisited', Banham's lecture at the 'Design 1900–1960' conference, Newcastle upon Tyne, 1975, showing the Brian Tait-Russell white Cadillac.

1.15. Page layout from Reyner Banham's lecture 'Detroit Tin Revisited', Newcastle, 1975.

2.1. Pottery type forms from Gottfried Semper, *Der Stil in den technischen und tektonischen Künste*, vol. 2, 1863, p.80.

2.2. Situla and hydria from *Der Stil*, vol. 2, p.4.

2.3. Pot with basketwork decoration from *Der Stil*, vol. 2, p.84.

2.4. Tomb of Midas from *Der Stil*, vol. 1, p.429.

2.5. (a) Late Roman bronze enamel dish and (b) drawing showing expansion of central pattern from *Spätrömische Kunstindustrie*, pp.191–2.

3.1. Reyner Banham on a Moulton bicycle, London, 1960s.

3.2. Ford Mustang. © National Motor Museum.

3.3. François Dallegret, 'Transportable Standard of Living Package'. © François Dallegret.

4.1. Anonymous photograph of ladies exercising in a gymnasium, from the exhibition 'Parallel of Life and Art', Institute of Contemporary Arts, London, 1953. Reproduced from the *Architectural Review*, October 1953, pp.259–61.

4.2. Reyner Banham, uncropped gelatine-silver photograph of *Johnie's Wilshire, Miracle Mile*, 1962. © Getty Research Institute, Los Angeles.

4.3. Reyner Banham, uncropped gelatine-silver photograph of *Townscape of Freeway-Land*. © Getty Research Institute, Los Angeles.

4.4. Grab from video recording of Banham speaking at ArtNet, London 1976. © Architectural Association, London.

5.1. Staedelschule catalogue. © Peter Cook

5.2. Marjan Colletti with animals on his head. © Peter Cook

5.3. The 'mowbot' at Oslo Architecture School. © Peter Cook

5.4. An Airstream caravan near Los Angeles, 2007. © Peter Cook

5.5. The 'House in the Clouds', Thorpeness, Suffolk. © Peter Cook

5.6. Nicolai Sokolov, health resort. © Peter Cook

5.7. Iakov Chernikov, from *101 Architectural Fantasies*. © Peter Cook

5.8. Graz Kunsthaus, 'Needle'. © Peter Cook

5.9. Graz Kunsthaus, Eisenes Haus End. © Peter Cook

5.10. Schloss Karlsruhe orangery. © Peter Cook

5.11. East London 'greening' project. © Peter Cook

5.12. Allotments near Hampstead Road, London. © Peter Cook

5.13. 'Super Houston' village. © Peter Cook

5.14. 'Veg. House', stage 3. © Peter Cook

5.15. Madrid villa and vertical garden. © Peter Cook

5.16. 'Way Out West-Berlin': detail. © Peter Cook

5.17. Medina tower, Tel Aviv. © Peter Cook

5.18. Kiosk, Frankfurt. © Peter Cook

5.19. 'Frothy coffee', Clerkenwell, London. © Peter Cook

8.8. 'Lobby/El Patio Hotel', Las Vegas, Nevada, full-colour postcards F10630, 1940s. Despite a back caption claiming 'refined accommodations', this lobby's mismatched furniture, utilitarian water cooler and plastic table radio suggest threadbare melancholy

9.1. Reyner Banham in Los Angeles, late 1960s. © Penny Sparke

9.2. Buick Roadmaster estate wagon, 1953. © National Motor Museum

9.3. Collection of Pop objects designed by Paul Clark, 1960s. © Penny Sparke

9.4. Ettore Sottsass pictured in front of a design for Memphis, 1981. © Penny Sparke

9.5. A Victorian parlour in Manchester, England, *c.*1890. © Manchester Studies and Local Archives, Central Library

9.6. Image from Christine Frederick's *The New Housekeeping: Efficiency Studies In Home Management* (New York: Garden City, Doubleday, 1913)

9.7. Elsie de Wolfe's design for The Terrace Restaurant, the Colony Club, New York, 1907 (New York: The Century Company, from Elsie de Wolfe *The House in Good Taste*, 1913)

10.1. Postcard of intersecting Los Angeles highways

10.2. Photograph of Elaine and Saul Bass in their editing suite, circa 1990. © Academy of Motion Picture Arts and Sciences

10.3. Storyboard for the shower scene in *Psycho* (1960, directed Alfred Hitchcock). Saul Bass, 1960. © Academy of Motion Picture Arts and Sciences

10.4. Storyboard for title sequence for *The Man With The Golden Arm* (1956, directed by Otto Preminger). Saul Bass, 1955. © Academy of Motion Picture Arts and Sciences

11.1. The main façade of the British Museum, London. © George Washington Wilson Collection, University of Aberdeen

11.2. Interior of Museo Castelvecchio, Verona. © CISA A. Palladio; Photo Stefan Buzas

11.3. The interior of Christ Church Picture Gallery, Oxford, by Powell and Moya. © Christ Church Picture Gallery. Photo taken by M. Dudley

11.4. Axonometric drawing by Sir Norman Foster of the Sackler Galleries at the Royal Academy, London. © Foster + Partners

11.5. Presentation drawing of Allen Memorial Art Museum, Oberlin, Ohio by Venturi and Rauch. © Courtesy of VSBA

11.6. Sainsbury Wing of National Gallery, London by Robert Venturi. © Phil Starling

11.7. Interior, Sainsbury Wing of National Gallery, London by Robert Venturi. © Phil Starling

11.8. Wexner Center for Visual Arts, Columbus, Ohio by Peter Eisenmann. © Kevin Fitzsimons

11.9. The interior of the Ondaatje Wing, National Portrait Gallery, London. © Colin Streater

13.1. Cross-section of the proposed Hampstead Midland North-Western and Charing Cross Junction, *c.*1890. © Fonds Cedric Price/Collection Centre Canadien d'Architecture/Canadian Centre for Architecture, Montréal

13.2. The *Queen Elizabeth* arriving in New York harbour. © Bettmann/Corbis/Martin Cox

13.3. Oil rig and floating crane. © British Petroleum (UK)

13.4. IRA bomb blast at St Mary Axe, City of London, 1992. © The Baltic Exchange

13.5. Mir spaceship coming down to land in the sea. © NASA

14.1. Christopher Faust, *Suburban Documentation Project*. Metro traffic control, Minneapolis, Minnesota, 1993. © Christopher Faust

14.2. 'The Kitchen Debate': Nikita Khrushchev and Richard Nixon in front of American kitchen, 'American National Exhibition' in Moscow, 24 July, 1959. © AP/Wide World

14.3. Charles and Ray Eames, *Glimpses of the USA*, showing the interior of the Moscow World's Fair auditorium, 1959. © The Eames Office

14.4. Charles (in lift) and Ray Eames, outside their office filming the picnic scene for the first version of *Powers of Ten*, 1968. © The Eames Office

14.5. Henry Dreyfuss, presidential war situation room. Project view. © From: Barry Katz, 'The Arts of War: "Visual Presentation" and National Intelligence', *Design Issues*, vol. 12, no. 2, summer 1996, p.7

INDEX

'cult of domesticity', 132, 133
cultural theory, 137
culture
 Americanization, 51
 'high' and 'low', 4
CUNY, *see* City University of New York
Curt Teich & Co., 5, 112, 113–15, 119–21, 122–3,
 124n4
Cutty Sark, 9

Dada, 231
Dallegret, François, *54*
Dante Alighieri, 235
Davidoff, Leonore, 133
David Ogle and Associates, 253, 254–6, *254, 255,*
 256
Davies, David, 165
Day, Lewis F., 135
The Decline of the West (Spengler, 1918), 268
decoration, 136
Delineator (magazine), 88, *88*
dematerialization, 7, 231–2, 234, 235, 237
De Menil Museum, Houston, 172
democratization, 3, 56–7, 161
department stores, 138
Derrida, Jacques, 122
Desert Cantos (Misrach, 1987), 69
deserts, 57, 67, 69, 111–12
design
 'cold' and 'warm', 7, 229–30
 democratization of, 3, 56–7
 'Flash Gordon', 104
 gender and, 7, 217–28
 'machine age', 9
 modernism, 2, 136
 theory and, 47–58
 see also design history; design metaphors;
 industrial design
Design by Choice (1981), 2, 56, 129–30
designers
 film representations, 7–8, 265–79
 Karen, 7, 253–63
 women, 7, 217–19, 220, 221–3, 227
design history, xi, xii, 3, 44, 47, 278n1
 Banham's influence, 85–6
 consumption, 52
 feminist theory, 5

metaphors, 45
modernism, 138
Design History Society (UK), 2, 27
design metaphors, 3, 33–46
 future of, 44–5
 modernism, 40–3
 Ruskin, 34–5
 Semper, 35–40
design reform movement, 134, 135
Deskey, Donald, 104
'Detroit Tin Revisited' (1975), 27–9
Diagram of the Field of Vision (Bayer, 1930), 208,
 209
Diehard automobile battery, 222, *222*
dimensionality, 241
dioramas, 25
Disney, Walt, 275–6, 277
Dixon, Jeremy, 172, 173, 174–5
Doc Hollywood (film, 1991), 153
Docklands, 180, 182
domestic architecture, 53
domestic space
 bedrooms, 4, 85–97
 femininity, 132, 133, 134, 139
 Glimpses of the USA, 203, 204
 masculinization of, 137
 photography, 64
Dorfsman, Louis, 150
Dorset Building in Rural Areas, 179
Douglas, Mary, 132
dress, 44, 46n27
Dresser, Christopher, 135
Dreyfuss, Henry, 104, 206, *207*
Dr Mabuse (film, 1922), 268
Dr Strangelove (film, 1963), 8, 265, 276–8
Duchamp, Marcel, 7, 239–52
Dudas, Frank, 4, 99–109
Dun Huang (film, 1988), 153–4
Dupain, Max, 63

Eames, Charles and Ray, 6, 144, 199, 200, 202–12,
 202, 204, 211
Eastlake, Charles, 134–5, 136
East London 'greening' project, 76–7, *77*
ecological critique, 1
ecological sustainability, 185
Edge Cities, 183, 184